Australia • Australia • Art and Australia • Angry
Australian Artist • Australian: National Australia • Art in
Communist Quarterly • Australian Journal •
Manuscripts • Meanjin • Ern Malley's Journal •
Present Opinion • Tomorrow • Venture •
anarchism • Angry Penguins • Ern Malley •
Atyeo, Sam • Au... Penguins •
Australianism •
George • Bellet... New Writing • Academy of Art •
Bergner, Yosl •
Boyd, Robin •
Bush, Charles •
Christesen, Cl...
• Communist P...
conservatism •
Counihan, Noel •
Frank Dalby •
Russell • Evatt,
Rah • Francis, W...
Donald • Gleeso...
Haefliger, Paul...
• Hele, Ivor •
• Hester, Joy • Herbert, Harold •
humanism • Ingamells, Hans •
James, Richard Haughton, Rex • internationalism •
Jindyworobaks • Johnston • Jazz •
series • Kershaw, Alister, George...
liberalism...

RICHARD HAESE

REBELS AND PRECURSORS
The Revolutionary Years of Australian Art

ALLEN LANE

Copyright © Richard Haese, 1981

First published by Penguin Books Australia, 1981

Allen Lane
A Division of Penguin Books Ltd
536 Kings Rd, London SW10 OUH
Penguin Books Australia Ltd,
487 Maroondah Highway
Ringwood, Victoria, Australia

ISBN 0 7139 1362 2

Designed by George Dale

Typeset in Cochin by The Dova Type Shop, Melbourne
Made and printed in Australia by
Hedges and Bell Pty Ltd, Maryborough, Victoria

CIP

Haese, Richard, 1944-
 Rebels and precursors.

Bibliography.
Includes index.
ISBN 0 7139 1362 2.

1. Painting, Australian—History—20th century.
I. Title.

759.994

Published with the assistance of the
Literature Board of the Australia Council and the
Visual Arts Board of the Australia Council

CONTENTS

INTRODUCTION

The claim is often made that Australians have a unique capacity for turning their backs upon that which is richest in their heritage. A more accurate assessment is that they have an even greater capacity for distorting that heritage to make for themselves a more comforting mirror. Nowhere is this more apparent than in the period spanned by this book, the two decades between the Great Depression and the beginnings of the Cold War. These were years of unparalleled intellectual and artistic ferment; they were also years that afforded scant comfort to most Australians, least of all the artists and writers who are the subject of this study. This book is about the development of a core of Australian artists: Sidney Nolan, Albert Tucker, Arthur Boyd, John Perceval, Yosl Bergner, Noel Counihan, Russell Drysdale and others — artists central to contemporary Australian art. It is also about their friends, patrons, allies and enemies — a portrait of a period, a generation and its art. What characterized that art above all else was a deep and pervasive concern for realism, the reality of human social and psychological experience at a time of unremitting crisis and intense intellectual struggle. This preoccupation, filtered and given form through surrealist, expressionist or social realist modes of art produced images that are amongst the most uncompromising and authoritative records of the Australian experience.

Such records were not a product of either social or intellectual isolation. The artists and the circumstances in which their works were produced are as remarkable as the images themselves. Artists and writers lived together, talked, argued, and exchanged ideas on levels and in ways that have few parallels. In part this communalism was necessitated by the actively hostile or uncomprehendingly indifferent world in which radicals found themselves in the 1930s and 1940s. It was also, however, a part of the new social values that seemed indissolubly linked with the character of their art. As artists they were also highly articulate. It was this degree of political and intellectual self-awareness and ability to communicate with force and insight in both words and paint that ultimately produced a revolution in Australia's cultural life.

This book about painting and the politics of painting aims to trace the course of a distinctly liberal and liberalizing cultural tradition, one of

the least recognized of seminal traditions in this country. Such a tradition was forged at a time of almost unbroken political crisis. The 1930s and 1940s, as the era of Hitler and Stalin, were intensely political years marked by ideological crusades and cynical opportunism, the conflicting claims of nationalism and internationalism, and the experience of economic depression and total war. The impact of this climate on Australian artists was profound; these events made it possible to anticipate imminent revolution — nothing less than a violent and total overthrow of established order — and Australian radical art reflected in full measure the intensity of that climate. The transition from the radical left-wing certainties of the 1930s to a more complex and shifting set of values and moral imperatives in the 1940s helped condition the emergence of a radical and innovative modernism. On one level the consequence was a revivification of Australian art, on another a rediscovery of Australia and a sense of being Australian. Though they did not know it at the time, the artists of the 1940s had established an informed and many-levelled heritage to which Australians could return in the continuing quest for identity and sense of place.

We are dealing with a period in which Australian artists and writers made their first real contact with a twentieth century sensibility. Such an assertion begs many questions. If the modernist movement in art is accepted as one of the most powerful expressions of such a sensibility, then how is it defined? Modernism as a broad concept resists ready and narrow definitions, given its complex and contradictory character. What is clear, though, is the dualistic nature of modernist art. On the one hand it involved a profound investigation into the nature of art itself — into the formal language and means of expression on the one hand, and into the wellsprings of the creative act itself on the other. Artists addressed themselves not only to extending the vocabulary of form but also the means by which new forms and images might be generated. The second feature of modernism is that with this investigation went a search for new social and intellectual roles for art and the artist: early links between bohemian attitudes and anarchism, the constructivist alliance with engineering and architectural practice, the surrealist's search for a political role — all are aspects of this exploration. The spirit of modernism may be understood less in the rites of artist-mystics or as a diversion for bourgeois patrons than in its potential as an expression of a questioning and questing sensibility — a liberalizing and humanizing capacity.

The contradictions as well as the rich diversity of modernism are fully present, if somewhat belatedly, in its Australian variant. If, as this book argues, modernism emerged here in a full sense only by the early 1940s, then the international character of its European origins was an important but brief interlude. What then emerged was an art that was recognizably Australian. 'Recognizably' is the operative word since Australian artists cannot be said to have extended modernism in comparable ways to those of their American contemporaries. They did, however, succeed in

turning it to their own unique ends. Modernism, and specifically expressionism and surrealism, enabled radical artists to reject all traditionally accepted modes of representation and to reach out towards new expressions of the Australian experience. The absorption of the European modernist tradition into an Australian artistic milieu was a preliminary step for a rediscovery and re-examination of an authentic and local cultural tradition. This search was in turn a reaction against the conservative pastoral tradition that had its origins in the Heidelberg School, while retaining all that was best in that vision. It was also directed against earlier prevailing views of modernism which had developed between the two wars.

The Australian art world of the 1940s became an arena in which individualism and anarchism confronted and challenged collectivism and authority from both the left and the right. The fight against the Australian Academy of Art, the struggle for the Contemporary Art Society, the Archibald Prize litigation, the complex and far-reaching manifestations of the Ern Malley hoax and the wranglings that took place in the National Galleries of Victoria and New South Wales were all campaigns in this critical conflict. There was much at stake in each of these battles and none was a simple affair between two protagonists; the consequences were invariably ironic and the echoes still resound. The artists whose fundamental liberalism had predisposed them and their supporters to a radical and experimental modernism had the least tangible support and fewest resources in the struggle for a new art and a new deal for the Australian artist. The new deal failed to survive the realities of the post-war world. Eventually the new art triumphed, although full recognition was delayed until the early 1960s and the revelation of the 1962 'Rebels and Precursors' exhibition. In spite of this celebration, however, much has been lost — more than the actual disappearance of many key works or their absence from public collections. We have ignored or misunderstood too many of the ideas and values that underpin the paintings, or we have distorted them beyond recognition — values and ideas whose importance remains undiminished for present and future generations of Australians and anyone seeking to understand Australian culture. At its best Australian painting of the 1940s proclaimed the need for a more fundamental realization of the Australian experience, both past and present. It may be the art of our past, but the values and the traditions of which it formed a key part and to which it still testifies continue also in one guise or another to sustain and inform an Australian sensibility.

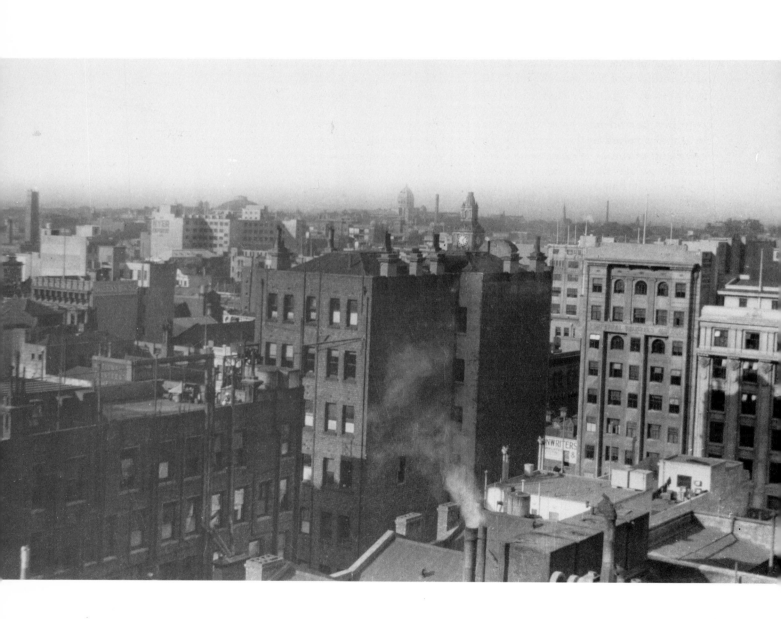

CHAPTER ONE
REACTION AND PROGRESS
A Cultural Crisis and Problems
of Orientation in the 1930s

the young people at their easels were, in the Melbourne of that time, the representatives of bohemia, the intellectual *avant-garde* of an era still waiting to be proved.

George Johnston (1964)

No other period has thrown the dilemmas of the Australian artist into such sharp relief as the years that stretched from the Great Depression to the end of the 1940s. In terms of creative fertility, the singular character and power of the art produced, and of the unique climate that prevailed, it has been matched only by the more widely celebrated period of the 1880s and early 1890s. The earlier period had its upheavals, but nothing so far-reaching and wrenching in their consequences as the poverty of the 1930s and the crisis of World War II. These events exploded the forms of Australian art and culture which, whatever the earlier flirtations with modernism, had appeared fixed since the turn of the century. Changes in art were related directly to an undermining of deeper social and political structures that resulted from the shattering for many of the certainties of the Australian and British past.

The era of the Heidelberg School in the late nineteenth century has been called 'The Golden Age of Australian Painting'. This book deals with a period that is more sombre-hued, intellectually both tougher and more abrasive. That character reflects the crises of these turbulent years, but also stems from the special nature of the radical intelligentsia that helped to drag Australia, at last, into the twentieth century. It was a time when artists refused to see themselves or be seen by their literary friends as painters in a narrow sense. They could be and were both poets and painters, social critics and aestheticians, ideologues and craftsmen, literary editors and art activists — the old categories were irrelevant. Noel Counihan might challenge the ideological line of the Communist Party and Sidney Nolan write long letters on contemporary theories of schizophrenia; the artist's curiosity was more than intellectual: it was an inquiry into the contemporary world as a prelude to changing it.

While any account of the main threads of Australian cultural history is necessarily a tale of two cities, Melbourne and Sydney, events in Adelaide and Brisbane were germane. The central focus of this study,

Opposite The square mile of Melbourne in the 1930s: this view from above Flinders Lane shows a low skyline broken only by the post office clock tower and the domes of the Public Library and Exhibition Building; heartland not only of business but also of an Australian bohemia that nourished radical movements in art during this decade

1

however, is Melbourne. As was the case half a century before, Melbourne in the early 1940s became the most exciting place for young artists to be. It was in Melbourne that the battle-lines were most clearly defined, art at its most uncompromising, and conflicts between ideas, individuals and institutions sharpest and most bitter — so much so that some fled to Sydney to avoid its more destructive aspects. To understand the milieu and its art is to grasp the essence of the radical changes that characterize the period.

The 'Rebellious Generation'

The artists who were drawn into the Contemporary Art Society, founded in Melbourne in 1938, were among the most dynamic members of a new intellectual movement that developed in the 1930s. The emergence of that diverse group (born largely between 1915 and 1925) represents one of the most significant changes of the period.[1] Its members were raised in the smug social and cultural climate of the 1920s, but many of them had been severely hit by the effects of the Great Depression. The members of this rebellious generation — men like Albert Tucker, Sidney Nolan, Noel Counihan, Max Harris, John Reed and Bernard Smith — created a movement of revolt more volatile than anything hitherto seen in Australia. They were revolutionaries both in step and out of step with the times, men of the twentieth century in a society struggling to come to terms with the modern world and its history. With much in common, they were also divided in their views on the nature of society, nation and culture, and of the art that could give expression to authentic Australian experience.

The paintings that appeared on the walls of the huge C.A.S. exhibitions in Melbourne, Sydney and Adelaide during this period testify to the fact that something quite extraordinary was taking place in Australian art. It was something that cannot be explained solely in terms of overseas influences. In part a response to external stimuli, it represented at its best an Australian modernism as distinctive as anything comparable in Britain or America during the war years. Based on a new intellectual and aesthetic awareness on the part of artists and their associates, it was a product of many factors that related to the ending of Australian social, economic and cultural parochialism: the shock of the depression, the trauma of war, the return of Australian students from abroad, the arrival of immigrants and of refugees from fascism, and greater ease of communication during the 1930s. Paradoxically, it was fuelled also by the enforced isolation resulting from the spread of the war after 1941.

All these factors determined the growth of an intellectual movement characterized by an unprecedented awareness of radical politics. Artists of an earlier generation, such as Tom Roberts, may well have identified painting with political and social values related to the labour movement.

But it is fair to say that, until the 1940s, no Australian artist had seriously considered the possible relationship between art and a desire for thorough-going social and political change. Operating out of the C.A.S., and with wider social, political and cultural links, artists and their supporters now began to canvass new ideological and aesthetic possibilities for art as well as for the role of the artist in a fluctuating world.

They looked at two areas, which represent the two main threads of the story of Australian modernism. The first was the discovery of the European modernist tradition and its transplantation. The second concerned the rediscovery and re-examination of an authentic Australian cultural tradition. This questioning took place in the face of a conservative backlash and an all too apparent trivialization of art by popularizers. There was an acute sense, rarely felt with such intensity before or since, of the thinness of local art and cultural life and of the strictures imposed by those who presumed to set its standards and lay down its forms. It was evident, too, that an even greater danger than artistic orthodoxy lay in the philistine character of Australian life and the degree to which this debased the values of what culture there was. The revolt against both was based on a new sense of professionalism and a new awareness of the possibilities of an art rooted in the experience of the individual and of twentieth century society. These were the ingredients of a new Australian modernism which appeared by 1943. By then the more radical artists had broken from European prototypes and had begun to chart a new course for Australian painting.

Options in the Thirties

The direction of this course was dictated in important ways by the deep differences in conceptions of art and life underlying the bitter conflicts between artists in the late 1930s. In this time of intense intellectual flux, what options were open to discontented art students and young radicals? For anyone seeking art training in Melbourne in the 1930s there was the National Gallery School under W. B. McInnes, Will Rowell and Charles Wheeler; tuition under Max Meldrum or one of his followers such as A. D. Colquhoun; or the Bell-Shore School. In Sydney the principal choice was between the highly conservative National Art School in Darlinghurst and Julian Ashton's Sydney Art School. In the 1930s Rah Fizelle and Grace Crowley offered an alternative based on modernist principles. The artist could, of course, go it alone.

Conservatism and the National Gallery School
The older of the law-givers and luminaries had been nourished in youth by the excitement and energy of the 1890s. They were years of exuberance, the bohemian character of which found expression in the irreverence and energy of gatherings such as those of the 'Prehistoric Order

of Cannibals'. This had brought together such diverse talents and personalities as, for example, Percy, Norman and Lionel Lindsay, Ernest Moffit, Will Dyson, Hugh McCrae and Max Meldrum. Forty years later, after the values of such men had been tempered by training and experience, brother was divided from brother, and youthful friendships were broken in the ideological and cultural divisions of the 1930s.

Conservatives such as Lionel Lindsay understood, or thought they understood, the values they wished to preserve. Conservatism is inevitably a rearguard action, and the fight, in the face of change, became more and more desperate. As modernism gained a hold, the conservatives closed their ranks even more. What ought to have been clear was that the old establishment was in its death throes and a new one was being born.

One common thread running through the warp of conservative values was that modernism in art was symptomatic of a social and cultural decline in the wider modern world. For such men as J. S. MacDonald, director of the National Gallery of Victoria, a sick society inevitably presented a diseased face to the world. Decadence in art was the product of 'a generation revelling in jazz, jitterbugging, the elevation of the dress-model to stardom, the transformation by artifice of women into broadshouldered narrow-hipped, bottomless beings committed to ungainly attitudes; the exalting of the discordant and the ugly'.[2] Lionel Lindsay, a trustee of the National Gallery of N.S.W., was in full agreement:

Modernism in art is a freak, not a natural evolutional growth. Its causes lie in the spirit of the age that separates this century from all others: the age of speed, sensationalism, jazz, and the insensate adoration of money.[3]

For all the bitter personal animosity between Norman and Lionel Lindsay by this time, they were at one on this point. In a tribute to Julian Ashton, written in 1940, Norman Lindsay looked down from Springwood in the Blue Mountains and saw a barbarian mob intent on the destruction of a cultural system he prized. At some time since the 1890s, Australian society had fallen from grace. By 1940 the whole world appeared to have been driven from the Garden of Eden. Lindsay wrote:

[Art destroys when] it revolts against all those traditions and form images in art by which the human mind has been built, as it has done for the last twenty years under the label Modern Art. But that is only one facet that is at present turning Europe into a jungle. Europe invented modernism in art and now Europe must pay the penalty for its relapse into primitivism and moral imbecility.[4]

Primitivism had been a powerful force in European modes of art as it was to be in Australia. On this issue high conservatives and Stalinist communists were, ironically, at one; primitivism was synonymous with irrationality, self-indulgence, and the powers of darkness. These were the results of a moral turpitude in modern society. For conservatives

J. S. MacDonald: art critic and gallery director, the most outspoken and powerful champion of the conservative pastoral tradition

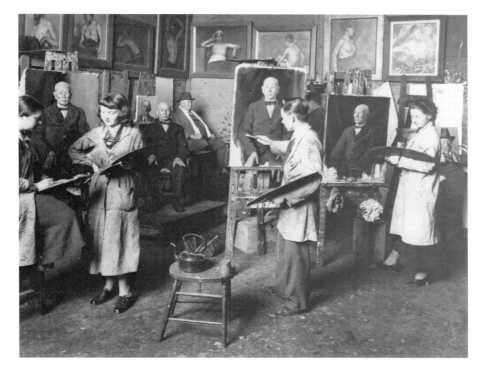

The life class room of the Melbourne National Gallery School in 1935, with students Phyl Waterhouse, Alannah Coleman, Charles Bush, Jean McInnes and a Miss Eastwood. The walls of the room are lined with life studies by such past stars of the school as Hugh Ramsay, John Longstaff, Max Meldrum, James Quinn, Isaac Cohen and Charles Wheeler. In this artfully posed photograph, taken for the magazine *Table Talk*, the students are *not* in front of their own canvases

R. H. Croll: as a writer and public figure, Croll was an active supporter of conservative values in art

'decadence' was a key word encapsulating everything that threatened the timeless virtues and verities which appeared to be found for all time in the canvases of Arthur Streeton and Hans Heysen. The extent of the crisis in conservative circles is exemplified by the response of R. H. Croll. A tireless bushwalker as well as man of letters, Croll had extolled the vision of the Heidelberg School through his writings on Australian artists and his publication of the edited correspondence between Streeton and Roberts in *From Smike to Bulldog*. As a writer he was a spokesman for public taste, and he was also a key figure, as its secretary, in the Australian Academy of Art. Writing to Lionel Lindsay in 1942, he declared that the decadence found in the work of young art students was ubiquitous:

the bright young things of the studios boast that their works reflect their minds. By God they do! ... they blaspheme the Olympians — the Streetons and the Lamberts, and sacrifice filth upon the altars of the new gods they serve.[5]

This kind of repugnance eventually compelled Norman and Lionel Lindsay to resign from the Sydney Society of Artists. They felt with deep disgust that the disease of modernism was affecting the whole world, as well as their beloved Society. J. S. MacDonald described modernism to the public as 'gangrened stuff [which] attracts the human blowflies of the world who thrive on putrid fare'.[6]

Notions of decadence were buttressed by a belief that those throwing off the academic tradition and the press barons who catered for public taste were linked in a conspiracy with Jewish art dealers, art collectors and writers. One political dimension of this was the idea of *kultur-bolschewismus*, which had an international currency amongst conservatives. The most repugnant dimension of this conspiracy theory was anti-semitism. In *Addled Art* Lionel Lindsay insisted, for example, that modernism was not an art movement that had won its way by 'honest' fighting but was instead the product of propaganda peddled by 'hireling critics', who had in turn been corrupted by Jewish art dealers.[7] MacDonald agreed.

However distasteful the invective and anti-semitism that issued, it ought not to be dismissed as a foaming at the mouth by a few disgruntled conservatives. The White Australia Policy, with its restricted immigration, was all too often exercised against refugees from fascism in Europe. And there was a similar tone behind the pastoral tradition of such as Arthur Streeton. As early as 1931, MacDonald had written that Streeton's work pointed to 'the way life should be lived in Australia, with a maximum of flocks and the minimum of factories … If we so choose we can yet be the elect of the world, the last of the pastoralists, the thoroughbred Aryans in all their nobility'.[8] As late as 1940, Julian Ashton declared:

We are beginning to wake up to the fact that if we are to take our place amongst the nations of the world our vast areas must be peopled. We should encourage the assimilation of people preferably the Nordic races, who on account of the rigor of their climate have greater energy and endurance than southern races.[9]

Allied to this notion of racial purity were assumptions about good art and good artists. The good artist was one who served a lengthy apprenticeship in the groves of academe and whose development of skills, both diagnostic and executive, resembled those of the surgeon. Only after such an apprenticeship could the elevated subject matter of 'good art' be approached. Most of these ideas were longstanding ones and the only element that was new was a sense of impending crisis. In 1923 Lionel Lindsay had argued that on balance the isolation of Australia was beneficial in that it guaranteed the Australian artist freedom from the contamination of modernism.[10] By 1941 he had no such illusions. Whereas in the early 1920s he had spoken for a conservatism that was aggressively confident, two decades later his words reflected a state of demoralized retreat. Lindsay declared that he had written *Addled Art* because he saw Australian art threatened by the same corrupting forces that had caused the loss of identity in the national character of French painting after the death of Degas. In the final chapter he made an impassioned plea for a return to 'Subject'. In essence this was a last desperate rallying cry for a return to the Australian pastoral in art where such high subject matter included harmonies between nature and man,

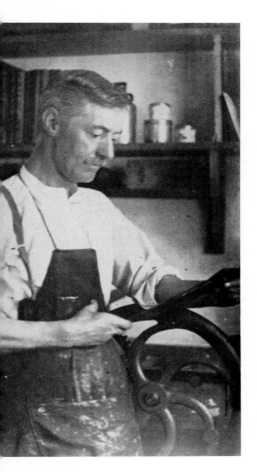

Lionel Lindsay at work print-making in his studio in the Sydney suburb of Wahroonga. An artist, craftsman and critic, Lindsay saw the values of his profession and craft under attack from modernism

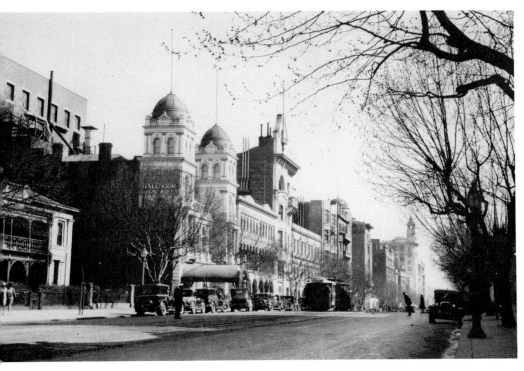

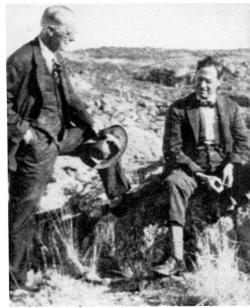

The top end of Melbourne's Collins Street in 1932: the lamps, iron lacework and noble facades of this elegant tree-lined boulevard, with its clubs and its studios of established artists, contrasted starkly with the adjacent back streets and alleys that contained the boltholes of innumerable young art students and struggling writers

Lionel Lindsay and the English equestrian painter Alfred Munnings in Castile, 1926

and between labour and the land. Lindsay warned that once the fundamental truth of that vision was lost, and once artists and their audiences were content to 'substitute abstract fantasies for reality and the sum of human experience . . . you descend to chaos and Old Night'.[11]

For the Australian artist of this temper only the sumptuous spread of Heysen's gums or Streeton's golden life-enhancing light offered a subject appropriate to the high seriousness which a national vision demanded. Such art could in Lindsay's eyes be undermined either by the anarchist modernist or the *petit-bourgeois* popularizer. He was as hostile to artists like Ernest Buckmaster and William Rowell, who reduced art to sitting room decoration, as he was towards Salvador Dali's surrealism. For Lindsay, both were undermining the standards of the artist's craft and calling, since the second quality of great art was genuine craftsmanship. The full realization of a worthy subject rested on a solid grounding in the painter's craft. This was jeopardized by both modernist and hack alike. If the modernist appeared to reject the principles of craftsmanship, the popularizer could not even recognize where its true virtue lay. Lindsay's plea was for a return to the discipline of art as craft and to the traditions of the Olympians: Streeton, Heysen, Lambert and Gruner. Modernistic concern for pretentious theory which resulted merely in surface decoration must give way to what he called in *Addled Art* 'high seriousness and the recovery of traditional means of expression'.

Similarly, MacDonald rejected all notions of modern art theory as mere indulgence in 'isms'. Conservatives reassured one another that modernism was just a fad. It followed, therefore, that for conservatives modernism was part of a cultural conspiracy by artists who had failed to master their medium and who had therefore become 'vindictively disgruntled'.[12] Such concerns were not restricted to Australia in this period. An interesting exchange developed between the president of the Royal Academy in London and Winston Churchill on this subject. Sir Alfred Munnings had proclaimed Lindsay's views in *Addled Art* as the essence of 'pure gold'.[13] As late as 1949, in maintaining this conservative argument against modernism, Munnings invoked the authority of Churchill's canvases.[14] To his credit, Churchill objected.

For conservatives, society and culture might change but not progress. As Lionel Lindsay put it, there could be change and variation, but if 'art progresses then it must be doing better than Rembrandt and Vermeer — for progress implies advance and betterment. It's a word for politicians to lie with'.[15] Writing to his brother Daryl late in 1943, he lamented the death of Streeton and in so doing offered a private eulogy for the art and the age which Streeton represented:

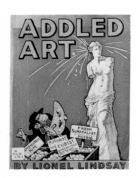

When it appeared in 1942, Lionel Lindsay's book *Addled Art* seemed to reveal the true face of conservative reaction

only in the Greek Anthology and the Greek stories can I find anything so simply natural as Streeton's ease and happiness in his painting and his extraordinary powers of selection in the Australian scene. His followers failed miserably, they caught only his dexterity with clumsy fingers, thinking that exterior touch will pass for style when style is implicit in vision and the humour, the very gratitude of the eye, for discovered beauty. That golden period is lost to the world, perhaps forever, for it was founded on no perplexities, nor formulae, no damnable and exhausting theories. Sic Transit![16]

William and John Rowell or W. B. McInnes were not in the league of Heysen and Streeton, but their values were the same and their teaching at the National Gallery School, along with that of Charles Wheeler, was stamped by the same character. On William Rowell's death in 1946, the sculptor W. L. Bowles lamented to MacDonald: 'Oh for the days when art was not the stamping ground for political stooges and egotistical gasbags and theorists. Bill was an artist by sheer hard work and guts and whatever his failings it was not laziness or theorizing.'[17] The critic Paul Haefliger was no friend of conservatives, but he did pay John Rowell grudging tribute in writing of his art in 1946 that it was 'the sort of craft which smokes a pipe and gets on with the job, rather in the manner of one who rolls up his sleeves and spits on his hands to chop wood'.[18] Lindsay and MacDonald might not have cavilled at this description of the job of painting, but their sense of the historic mission of Australian art was not met by the criterion of craft alone. Lindsay was a remorseless critic of the teaching practice of the Gallery School. As art critic for the *Herald* in the early 1930s he had damned the Gallery School, as he did the painting of its art masters, as the 'School of Smudge'.

Arthur Streeton, *The Land of the Golden Fleece*, 1926

Yet such words must be read within the context of the conservative reaction to change on the Australian scene. Opponents were not deceived one iota by the rhetoric or the sanctity of conservative artists. Writing of the Streeton memorial exhibition in April 1945, an unsympathetic Paul Haefliger saw in Streeton's canvases 'the symbol of a coterie which saw in his virtuoso technique an ascendancy of Australian nationality [and which] felt that here was an exponent who could meet his English contemporaries on a more or less equal footing'.[19] Lionel Lindsay had claimed as early as 1919 that Streeton was a superior painter to the leading French impressionists since Streeton had 'never succumbed to the worship of fact'.[20]

There was also a sense of peril from another quarter. At the very time when Lindsay and MacDonald were attacking modernists, they were also aware that the high landscape tradition in Australian art was being debauched by *petit-bourgeois* imitators. The National Gallery School came in for criticism, but the most notorious enemy were artists such as Ernest Buckmaster. Perhaps even more serious than modernism was the danger of the enemy from below: Buckmaster was one of the most popular and best-bought painters of the 1930s. On this score progressive and conservative were one.

Max Meldrum and his disciples

The identification of art students with the values of particular groups and their masters was intense. Any young man walking down Melbourne's Collins Street wearing a George V beard, for example, was unquestionably a Meldrum student, and it was said that one could tell how long he had been so by its length. One of the appeals of Max Meldrum's teaching was that it rejected the high-sounding nationalism that seemed to be ossified in a continued worship of the Australia of the 1890s. Meldrumites belonged to no country other than that of the rational intellect. Such a claim may sound strange given Meldrum's extraordinarily narrow and closed conception of painting. In this view, progress (apart from Meldrum's own contribution) had ceased with the nineteenth century painter Corot. What Meldrum stood for, above all, was a rejection of mysticism and mystification, whether of a national landscape tradition or of modernist abstraction. It was this that made Meldrum's students feel that they were modern rather than conservative.

Meldrum's painting based on tone was, as Bernard Smith notes, 'probably the last of those attempts, so characteristic of the nineteenth century, to deduce a rationalistic theory of painting from scientific or pseudo-scientific presuppositions'.[21] To quote Meldrum: 'the great masters have understood that, physiologically, colour relationships are recorded by the eye in a certain order and their aim has been to place tonal proportional and chromatic impressions in their fixed order.'[22] In shifting the impressionist accent of a Streeton from colour to tone, Meldrum gave students something concrete to grasp. In his attacks on

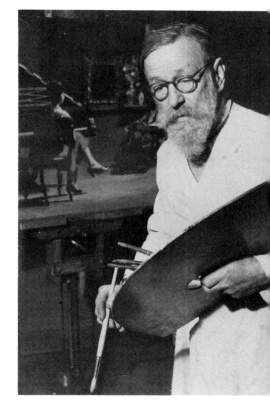

Few Australian artists inspired a more devoted following among their students than Max Meldrum. A rationalist in all things, Meldrum stood for a different kind of artistic conservatism

the work of the myriads of Meldrum students in the 1930s, the critic Basil Burdett accurately identified one of the main appeals of the Meldrum method as its reliance on a principle of putting down strokes of tone in a direct manner. By so doing it overcame that 'awkward hiatus between drawing and painting'.[23] The result of this method was a sketchy painting technique which for Burdett was utterly lacking in either formal construction or any imaginative dimension. And yet, for Meldrum, art was not a craft but a 'scientifically' based discipline in which the subject and the mode of painting were identified wholly with the optical analysis of tonal relationships.

Max Meldrum, *My Lady's Table*, c. 1927

Meldrum was not an artistic conservative in the sense in which the term has so far been discussed. His art related directly to his views of society, and therein lay much of its appeal to his more intelligent students. Meldrum's political liberalism had made him an outspoken pacifist during 1914-18. Meldrum was a paradox, and the nearest thing in Australian cultural history to a nineteenth century positivist in his absolute faith in rational principles. These he applied in equal measure to both art and life. Painting was a scientific practice in which there was nothing that could not be rationally articulated in words. Because he saw the painter as a professional master of certain skills, Meldrum also liked to use the metaphor of the surgeon. The master earned his status and respect through scientifically based knowledge and the skills essential to it. Painting progressed in accordance with the sciences, and as one student recalls, 'The stars in our firmament were Darwin, Marx, Freud and Meldrum. They were the four cornerstones of our edifice, absolutely.' Whatever the contribution of Meldrumism, young painters were often puzzled by the response of others: 'We looked upon ourselves as trail blazers and we fell between the two schools. The modernists looked upon us as old fogies and the conservatives upon us as a mob doing unfinished paintings — doctrinaire, soulless, godless paintings.'[24]

In retrospect, it is easy to see why Lionel Lindsay would call Meldrum the 'mad mullah'. It is equally clear why painters of liberal sensibility would see Lindsay as 'Colonel Blimp'. In simplistic terms, the painting of the conservatives had been frozen in the golden nineties; it was equally clear that Meldrum's art was frozen in the mid-nineteenth century. The notions of art, culture and life displayed by more progressive artists and their followers were part of an attempt to push as far forward in the French and European traditions as at least the end of the nineteenth century and the work of the post-impressionist masters. It is only in this context that painters like George Bell, Arnold Shore, William Frater, Daryl Lindsay and Adrian Lawlor can be properly understood. It is also only in this context that the impact of the *Herald* Exhibition of French and British Contemporary Art sponsored by Sir Keith Murdoch in 1939 can be fully appreciated. That exhibition largely consisted of canvases by the French post-impressionists and their English counterparts. To

grasp the full dimensions of this we need to trace the course of a liberal tradition in art through the 1930s.

A key figure in the attempt to clear away the effects of nationalism in Australian art was Gino Nibbi. For Nibbi, as for Adrian Lawlor and George Bell, the intellectual and aesthetic élite of the spirit knew no national boundaries. Lawlor described Nibbi as an 'enlightened "agent provocateur"' in the culturally backward community of Australia.[25] As the proprietor of the Leonardo Bookshop in Little Collins Street, Nibbi's role was as educational as it was entrepreneurial. A whole generation of artists, students and interested laymen quickly became avid buyers of the reproductions he imported. These ranged from postcards to magnificent and expensive Piper prints from Munich. As Lawlor observed, a curious situation soon developed where many non-artists knew more about modernism than did artists. In the absence of any other means of contact the opportunity to buy, or simply look at, reproductions of quality and books and magazines dealing with art was enormously important. Nibbi's shop was the main source, but others also began to cater for the small but intense demand.

Nibbi arrived in Australia in 1928;[26] two years later, after a Pacific journey, he returned and opened the Leonardo Bookshop. His reasons for migrating were to do with both politics and art. Mussolini's accession to power was a factor in prompting the move, since Nibbi had been a fervent supporter of the Italian Republican Party, with its strong liberal tradition of anti-clericalism, anti-monarchism and anti-fascism. Australia, however, was also a staging-point for Nibbi's pilgrimage to Tahiti and the Society Islands in pursuit of material on Gauguin's years in the South Pacific. He was looking, he said, for 'memories surviving among the people'.[27] No doubt this project accounted for the two-year gap between Nibbi's first arrival and his establishment of the Leonardo Bookshop. Nibbi brought with him a small but valuable collection of modern paintings, which included works by Giorgio de Chirico, Gino Severini and Moïse Kisling. The de Chirico, *Horses on the Beach*, was not a good picture and was from his later period, but it had been a personal gift from the artist. Nibbi's eye was acute and he has been credited with having recognized the talent of Ian Fairweather, whose first recorded appearance in Australia was at the bookshop in 1934.[28]

This elegant, fat, mystical Italian plunged into artistic controversy immediately on his arrival in Melbourne. His tough comments on Australian painting published in a letter to the *Herald* in 1931 were followed by regular contributions to *Art in Australia*. While his writings were never doctrinaire and always showed receptivity to a wide range of styles in art, on one point he remained adamant: his utter rejection of nationalism in art. Nibbi attacked the notion of an intrinsically national tradition of art in 1931 and stated his position again in 1939 in a review of the first Contemporary Art Society exhibition. The C.A.S.

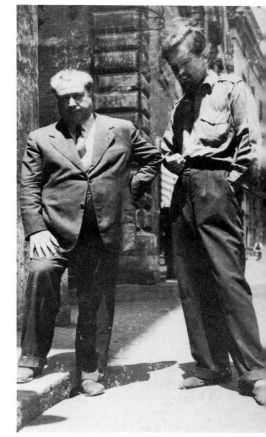

Gino Nibbi, with Alister Kershaw in Rome in the 1950s: as a writer, art critic and bookseller, this Italian expatriate helped educate two generations of Melbourne artists

stood for an open attitude towards art; art at its best could only be based and judged on ideas and values that bore no relationship to national boundaries. Nibbi rejected the claim that by looking to some mystical soul, it was possible to lay the foundations for an art typically Australian. The visual arts dealt more properly with universal values stated in international terms: 'we must believe in Australian artists rather than in a mythical Australian art.' Nationalism had no place in modernism because the ultimate aim of art, in Nibbi's terms, was purely aesthetic. As Nibbi so accurately saw it, the dilemma of young Australian artists was the great and difficult task of connecting with 'the atmosphere of their time'.[29]

During the inter-war years Australian culture lost contact with the central tradition in European art emanating chiefly from Paris. Australians, it seemed, had culturally slipped a gear. The central problem of the 1930s was, as it continued to be in the 1940s, one of identifying the nature of the values upon which an art purporting to be part of an authentic twentieth century culture might be based. One of the chief stumbling-blocks was the whole contradictory and complicated movement which modernism itself represented. Artists in Australia did not have any direct contact with actual modernist works on any scale until the *Herald* exhibition. Even the few fortunate students who had studied abroad during the 1930s were at a loss to know where and at what to look. For the most part this first generation of modernists, naturally enough, found early twentieth century English painting more immediately accessible than the French tradition which influenced it. In any case there had been negligible contact with the work of the French masters. According to Arnold Shore, in 1931 George Bell's understanding of early modernism was even less than his own, despite Bell's long period of residence abroad.[30] Indeed, the Bell-Shore 'School of Creative Art', which opened in Melbourne in February 1932, was based more on faith in modernism than on direct response and sophisticated awareness.

The Bell-Shore School
Shore's own teaching was, as he later put it, 'based on observing fundamentals of shape and local colour. From these one could develop to consideration of three dimensional problems, colour scales, study of plane surface organization and the like'.[31] This suggests an advance on Gallery School procedures but is hardly a radical approach to art. Despite his own interest in Van Gogh, Shore's cautious painting displayed essentially nothing more than bravura brushwork and greater freedom in a more independent use of colour.

George Bell was effectively the senior partner in the school and, as the more forceful personality, gave the school's teaching its particular character. In July 1934 he went abroad to seek, he declared, the 'golden key of modernism'. He returned in November 1935 possessed, it seemed, of insights denied his more provincial colleagues. While away he had

visited galleries in Paris and Spain, but spent most of the period studying under Iain McNab at the Westminster School in London. In essence, Bell's teaching also laid great stress on the formal aspects of painting; that is, it displayed a concern with pictorial structure by employing relationships between ground and picture planes and their interaction with the more dynamic planes. By the 1930s such a concern for formal organization in painting was common among teachers in London and Paris such as McNab and André Lhote. The simplification of forms based on those in nature, the reduction of a composition to essential planes, and the use of formal rhythms were the basis of a rather academic approach to painting on the part of these masters. It was, in fact, a sterile academicism derived originally from the post-impressionist and cubist experiments. The experience of 1935 gave Bell

George Bell's Melbourne studio and school, as photographed by one of its most promising students, Russell Drysdale, c. 1936. This school, on the corner of Bourke and Queen Streets, was one of the two most progressive in Australia; here any student was able to work from the nude model. The young artist David Strachan is seen here at work on the extreme right

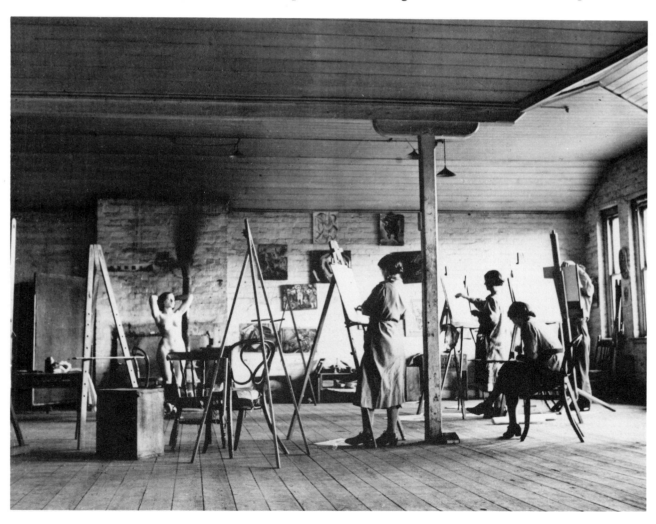

a basis for teaching methods and principles not unlike those of the Westminster School.

That teaching, and especially the use of life models, was far in advance of anything that students found at the Gallery School in Melbourne. The result could be, and often was, a liberating experience for many of those students affluent enough to attend. However, the degree of Bell's sophistication should not be overestimated. Before his return to Australia in 1920, he had been an active member of the Chelsea Arts Club and with his two close friends, George Lambert and Fred Leist, was friendly with Walter Russell, Philip Wilson Steer and Philip Connard. Connard, especially, was a powerful influence on Bell's painting style. This is borne out by Bell's picture *Lulworth Cove* (1911), with its simple construction and stress on colour. After the early years before 1914, Bell's work became progressively broader in handling and reflects something of the ideas on which his teaching was founded after 1935. That it was a circumscribed development is indicated by a later work such as *Toinette* (1934), which possesses a degree of abstraction beyond which he never ventured. Its simplified forms and muted colours recall the style of Moïse Kisling rather than Cézanne, let alone rigorous cubism. Bell tended to look more towards Kisling and Modigliani than to earlier and more thorough-going aesthetic revolutionaries like Braque, Picasso or Matisse. Indeed, William Frater has claimed that Bell considered Kisling a greater artist than Cézanne.[32] Certainly, if the influences evident in the work of Bell's star pupils are to be trusted, it was towards that distinctive group of expatriate painters, which also included Chagall and Pascin, that Bell directed his students. Often referred to in a narrow sense as the 'School of Paris', in contrast to the sharp challenge of surrealism, the work of these artists achieved a fashionable acceptance during the twenties and thirties through their use of cubist and expressionist-derived modes.

The two art schools founded in 1932 in Australia on 'modern' principles, the Bell-Shore School in Melbourne and the Crowley-Fizelle School in Sydney, reflected their respective English and French models. In Sydney the teaching rested heavily on the theoretical foundations laid in Paris by Lhote.[33] The school formed a nucleus for a group which became known as the George Street Painters. Their work, more abstract than that of their Melbourne counterparts, nonetheless never strayed from a tasteful semi-figurative style, an elegant derivation of cubism far removed from its original impulses. Besides Rah Fizelle and Grace Crowley, the group included Eleonore Lange, Frank and Margel Hinder, Ralph Balson, Dorrit Black and Mary Alice Evatt. Of this group only Balson did not study overseas; and it was Balson who proved by the 1950s to be the most enterprising abstractionist and most able to sustain a rich development.

Their first major exhibition as a group, Exhibition I, was meant to begin a series of annual shows. The fact that Exhibition II did not eventu-

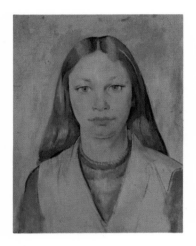

George Bell, *Portrait of Toinette*, 1934

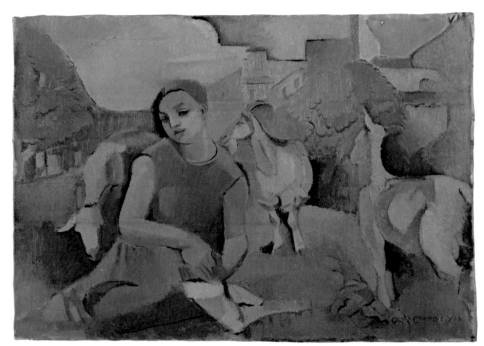

Grace Crowley, *Girl with Goats*, 1928.
This work by one of Sydney's foremost
modernist painters and teachers
epitomizes the well-tailored and
cautious quasi-cubist style of early
Australian modernism

ate and that the Contemporary Art Society took the lead as a force for
modernism brings us to the consideration of far more radical impulses
in the Australian artistic world of the 1930s. The experience of younger
students of the 1930s and their friends determined the character of
Australian modernism in ways incomprehensible to artists thus far
considered. For these students the world was an infinitely more complex
and disordered place in moral and aesthetic terms than it was for those
like Bell who sought little more than to throw off the constrictions of
Australian naturalism and nationalism.

It will be recalled that artists had a fourth option — to go it alone. In
the face of the adulation of Meldrumites and the aggressive certainty
of conservatives and even cautious modernists, this option was based on
individualism and a different kind of courage.

Going it alone
The creation of a branch of the Contemporary Art Society in each of
the three capital cities was an attempt to give sustenance to artists who
had decided in their various ways to forge their own separate paths into
the twentieth century against all conventional wisdom in Australian art
circles. Nevertheless, until 1938, it was an exceedingly difficult path to
follow.

Most often during the day, young students such as Sidney Nolan,
Albert Tucker, John Sinclair, Yosl Bergner and others were forced to
eke out a living by various short-term means. For some it meant working

for commercial advertising firms or for printers, designing for manufacturers, or producing freelance illustrations for newspapers and popular magazines. For others it meant manning stalls in the Victoria Market. Their studios were shared lofts in Little Collins Street, condemned city buildings, or poky rooms and dilapidated garages in Carlton and Princes Hill. Young students of radical tendencies were seldom found in the drawing classes of the National Gallery School where Wheeler and McInnes held sway, or in the expensive day classes of the George Bell School. One was more likely to find them in the life classes of the Victorian Artists Society, among the shelves of Gino Nibbi's Leonardo Bookshop, in Ristie's coffee shop and the incipient jazz clubs, on the fringes of the Eureka Youth League and, especially, deep in the bowels of the Public Library. It was at Nibbi's, in the art room of the Public Library, and sometimes in private libraries, that the key books and reproductions of modernist art, literature and philosophy were to be found.

Many of these young students had begun their formal training in the context of the Gallery School, where the overwhelming majority of students were either young girls waiting for their debutante ball or middle-aged women concerned as much with permanent waves as with art. Among this crowd could be found embattled groups of young intellectuals in search of a communion of the intellect and the spirit. During the 1930s such groups constituted no more than half a dozen enthusiasts at any one time. The intellectual and social environment they created for themselves was intense, restless and adventurous — even violent. At various times they included Sam Atyeo, Clifford Bayliss, Howard Mathews, Laurence Pendlebury, Roger Kemp, Sidney Nolan, Gordon Daniels, Noel Blaubaum, John Sinclair and Charles Bush.

George Johnston had belonged to just such a group and describes them in familiar terms:

they would dress extravagantly, as if initiation into the esoteric world of art carried with it the right to wear a uniform; they would be forever flinging their prejudices and beliefs and opinions at one another: they would plagiarise their own gods and defile the gods of anyone else. They lived according to some constantly changing creed of noisy controversy.

In short, they were typical art students found everywhere. But in Melbourne they were also, as Johnston saw, more than that; they were a tough 'intellectual *avant-garde*'.[34] What Johnston did not recall, however, was that this intellectual toughness was invariably linked with a self-destructive and demonic larrikinism that was equally a feature of this Melbourne cultural 'push'. One illustration will suffice. On one occasion a drunken, destructive and not entirely unfriendly fracas between Blaubaum and Mathews, which took place in the attic above Tucker's studio, culminated in a window frame being torn out of its casement and hurled with spectacular effect onto the cobblestones of Little Collins Street three storeys below.

Howard Mathews with fellow Melbourne National Gallery School student Joan Currie: Mathews was one of the more dynamic members of an intellectual core of Gallery School students in the late 1930s

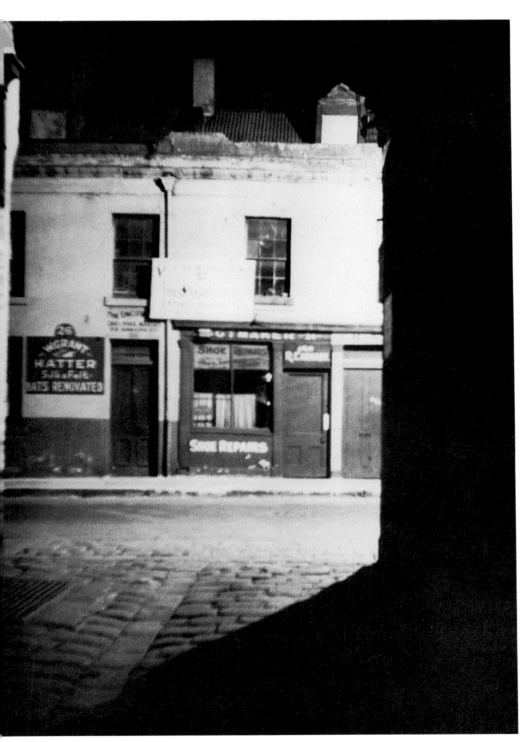

Albert Tucker's early studio, situated at the top end of Little Collins Street above a hatter and cobbler's premises, c. 1940. This narrow cobble-stoned lane was the hub of Melbourne bohemia at the time

Rebellious, violent and aggressive, these young artists and their followers were not only in pursuit of new ideas but were also in flight from the web of Australian suburbia; a world of the *petite-bourgeoisie* with all the potential hollowness and flat philistinism that Melbourne's suburbs could sustain. As a young man surveying his surroundings from the roof of a suburban bungalow, Johnston perceived a world which justified all forms of flight and commitment:

there was nothing all around me as far as I could see, but a plain of dull red rooftops in their three forms of pitching and closer to hand the green squares and rectangles of lawns intersected by ribbons of asphalt and cement . . . In the slums, I reflected, they had a fetish about keeping front door-knobs polished, but here in the 'grand' respectable suburbs the fetish was applied to cars and to gardens, and there were fixed rituals about this, so that hedges were clipped and lawns trimmed and herbs weeded, and the lobelia and the mignonette were tidy in their borders, and the people would see that these things were so no matter what desolation or fear was in their hearts.[35]

Galaxy of Talent

Throughout the 1930s there was, then, a procession of brilliant students at the Melbourne National Gallery School who set the intellectual tone and pace for the group that surrounded them. The milieu of the school was unprepossessing in the extreme, for all the grandeur of the facade and the majestic dome of the library. Buried beneath lay another world described by Johnston:

The National Gallery School, for all its high-sounding name, was really only an enormously long tin shed, heavily rafted under a roof of corrugated iron, which was a kind of shabby annexe to both the Art Gallery and the National Museum. Three-quarters of its length was used as the Antique School, a bizarre tunnel-like recession of intimidating chiaroscuro, filled with innumerable chalk-white plaster casts of antique Greek, Graeco-Roman and Roman nude statuary posed under bare electric bulbs against the blackness of the shadows. It was an unnerving, jolting sort of place, because nothing agreed with anything else, and one had no sense of harmony or of proportion or of perspective.[36]

The reality of the art establishment for young students was a shabby, dislocated and ugly world encapsulated in the school and extending even to the objects of art displayed there.

First-year students began by drawing with charcoal on paper. Choosing subjects from the casts, they would 'look and put', progressing slowly from 'acanthus-leaf to sandled foot, to bust, to stele, to standing figure, working always closer to the Life Class door'. Ultimately, entry would be gained to the painting school supervised by W. E. McInnes, who had taken over in 1935 after the death of Bernard Hall. Here students worked

Sam Atyeo: rebellious art student and pioneering modernist in the early 1930s, whose painting scandalized Melbourne

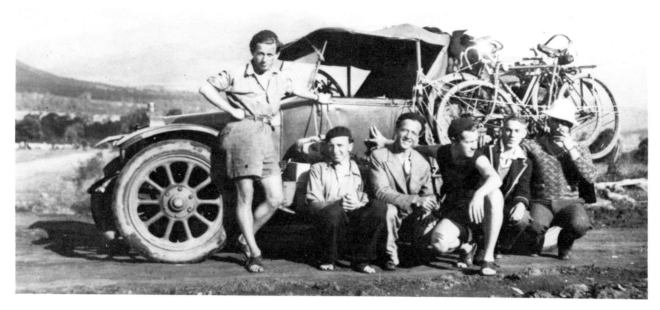

Art students at large, 1938: John Sinclair, Gordon Daniels, Laurence Pendlebury, Sidney Nolan and friends outside the Tawonga pub in the Kiewa Valley. The racing cycles strapped to the tray of this 1910 Talbot attest to Nolan and Sinclair's passion for long-distance bike-riding

from nude models; first in charcoal and finally in oils, progressing from sepia monochrome to full palette in their final year. Although McInnes was of a retiring nature, he was considerably more inspiring than the even more diffident Charles Wheeler, who succeeded him in 1936. It was said of Wheeler's teaching that he never mentioned the name of any artist. It is hardly surprising, all other impulses aside, that students should have turned towards what outsiders judged as cultural bolshevism.

The first of the prodigious talents was Sam Atyeo. Atyeo attended the school from 1927 to 1932 and studied under the ageing but still crusty disciplinarian Bernard Hall. As the star pupil, Atyeo won in succession the still-life, the monochrome and the Grace Joel prizes; he was the first male student to win an important prize at the school for twenty-six years, and seemed set to take off the prestigious travelling scholarship in 1932. However, the volatile Atyeo had become increasingly unhappy with the strictness of Hall's tonal realism and narrow teaching methods. Instead of a conventional entry Atyeo submitted a picture entitled *A Gentle Admonition*, on the theme of Lot scolding his fictitious daughters. The picture was distressing to Hall in its subject as much as in its style. Rather in the manner of the British vorticist William Roberts, Atyeo depicted the puppet-like figures of two nude female fellow students standing alongside the caricatured and unmistakably stern figure of Bernard Hall dressed in a nightshirt.[37] Understandably, Hall refused even to hang the work (which in normal circumstances he was required to do), giving as his reason that its style contravened entry regulations. Not only was it an affront to Gallery School teaching — more importantly, it was a

personal insult. The picture was subsequently displayed in a shop window in Collins Street, where it is said to have stopped the traffic. In the wake of the publicity that followed, Atyeo held his first one-man show in a modern design and furniture shop owned by Cynthia Reed.

During this exhibition Atyeo first met H. V. Evatt and was introduced by Cynthia Reed to her brother and sister-in-law John and Sunday Reed. For Reed, Atyeo was an extraordinarily 'brilliant boy, very vital, very alert, a very quick brain and a mind darting everywhere'.[38] As he also recalls, Atyeo and Evatt 'struck sparks off each other'. The deep affinities between establishment radical and student rebel are inescapably caught in the story of the transformation of the external person of Herbert Vere Evatt. As the story goes, Evatt appeared at Atyeo's exhibition in buttoned-up boots, lavender waistcoat and cut-away top coat, winged collar and derby hat. A horrified Atyeo hauled the High Court judge out to Henry Buck's, where he invested Evatt in Scotch brogues, sports shirt, woollen tie, a Harris tweed jacket and a stetson hat — to the subsequent delight of Mary Alice Evatt.

Sam Atyeo, *Organised Line to Yellow*, c. 1933

Between 1932 and 1936 Atyeo experimented with a wide range of stylistic ideas ranging from a cautious emulation of Cézanne to the more radical-looking mode of the Klee-like *Organized Line to Yellow* (c. 1933). His intellectual restlessness was, nonetheless, a barrier to consistent development. Because of the poverty of available visual sources, Atyeo's painting relied heavily on the ideas of philosophers like Hegel. Together with a fellow student, Moya Dyring (whom Atyeo later married), he experimented freely with pictorial ideas derived from the work of Van Gogh, Cézanne and Picasso. Dyring herself has been credited with being the first artist in Melbourne to experiment with cubism. Such an assertion is difficult to substantiate and it would not be accurate to assume an undue degree of sophistication in much of this early work. *Organized Line to Yellow*, Atyeo's best work, may resemble the style of Paul Klee, but Atyeo had never heard of that artist. The work is an abstract realization of Bach's Double Concerto in D Minor, and the lines in the painting are an attempt to reproduce the interweaving rhythms of the solo instruments. Atyeo was aware of Walter Pater's dictum that all art constantly aspires to the condition of music, and worked out a theoretical understanding of modernism on the basis of the writings of Roger Fry and Clive Bell in conjunction with German aesthetic philosophy. These theoretical ideas were presented both in Atyeo's paintings and in a series of private lectures — delivered at his studio in Little Bourke Street and in the South Yarra home of his wealthy patron, the elegant and intellectual financier and stockbroker E. C. Dyason.

Atyeo was the most dynamic force among the younger painters in Melbourne during the early 1930s. His activities ranged from painting to design and architecture, in addition to the intellectual discussions on modernism which he orchestrated. As an *enfant terrible*, the voluble Atyeo set himself firmly on the side of all that was new, in complete rejection

of fusty modes and values. What he found most frustrating, however, was the almost complete absence of any informed intellectual discussion on art and ideas. The friendship of Dyason, Evatt and the Reeds helped fill the vacuum; but even that group of potential crusaders and patrons suffered a similar sense of loneliness and frustration. Other artists and critics who professed advanced ideas and a liberal outlook he also found to be limited by a blinkered awareness of what was happening elsewhere. Discussion with the architect and historian Hardy Wilson invariably came around to Chinese and Japanese art; with George Bell, to the Slade School; with William Frater, to Cézanne. Adrian Lawlor he found erratic; even Basil Burdett professed little personal sympathy for painters beyond the French post-impressionists or those of the English school such as Sickert or John. As a questing artist and intellectual, Atyeo felt absolutely alone. His condition was by no means singular except that he was able to leave Australia for Paris in 1936 on the proceeds of his redesigning of the facade of Regency House in Flinders Lane for Dyason.

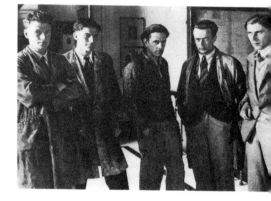

Students of the Melbourne National Gallery School, 1935: Colvin Smith, Roger Kemp, Clifford Bayliss, T. Challin and Edward Heffernan. Through his intellectual power and his almost legendary abilities as a draughtsman, Bayliss dominated the school and directed the thinking of his younger contemporaries

From the mid-thirties the intellectual group that developed among Gallery School students offered its members something of that stimulation and mutual support that Atyeo had missed so acutely. After Atyeo had left the school his place as star pupil was filled by Clifford Bayliss, who was enrolled between 1933 and 1935. Bayliss professed (at least on an intellectual level) to be a Marxist and was intensely interested in modernism. Unlike his predecessor, he employed his masterly skills as a painter and draughtsman to carry off the travelling scholarship in 1935, and left for London in the following year.[39] Bayliss was a powerful presence among students and although he left comparatively early, his influence was considerable on younger pupils at the school: John Sinclair, Sidney Nolan, Oswald Hall, Charles Bush and Howard Mathews.

Nolan first met Bayliss and Sinclair while on a cycling trip to Sydney in 1935. It was through Bayliss that, while attending night classes at the Gallery School, Sinclair was introduced to the world of painting in an intellectual sense as well as to that of literature, philosophy and the world of ideas generally. Since the Gallery School, as such, taught nothing beyond the craft of painting and drawing, students such as Sinclair or Nolan found their real mentors in intellectuals like Bayliss and, later, Howard Mathews. Like Bayliss, Mathews had grasped something of French modernism and had wide-ranging intellectual interests. Mathews was also tipped to take off the travelling scholarship for 1938. In the event, it was won by Oswald Hall. Without question, Mathews had been the finest draughtsman at the Gallery and, ironically perhaps, missed out for that very reason. The rather less talented Hall sent in a painting in a semi-abstract style that recalled the work of Wyndham Lewis. The judges, Max Meldrum, James Quinn and Harold Herbert, may have felt constrained to make a gesture towards modern

art given the controversy surrounding the foundation of the Contemporary Art Society some months previously.

Albert Tucker was never a Gallery student because the straitened circumstances of his family made it impossible to afford either the nominal fees or the time demanded of a full-time student. He bitterly resented the fact, as he did also his inability to attend the altogether much more expensive Melbourne University. Like some of his friends from the Gallery, he attended some classes at the Bell school; however, he soon found that neither Bell nor Shore was able to offer what he sought, although he did exhibit with 'The New Group', which consisted mainly of Bell students. But as Basil Burdett stressed, the 'turbulent and romantic outlook' of Tucker's work sat ill with the 'classic repose' of the principles and style of George Bell.[40]

His family had been hit particularly hard by the depression and he was required, therefore, to live at home so that his income could supplement that of his father and help sustain a precarious middle-class existence in Malvern. Tucker's father worked as an under-gear repairer for the Victorian Railways, but the family background and his mother's values were firmly middle-class. She refused resolutely to live in North Melbourne as his father wished. For a time the family subsisted on a diet of white bread, semolina and sausage meat. In 1933 and 1934 Tucker worked as a house painter, after which he moved on to jobs with various commercial advertising agencies and retailing businesses. The demeaning nature of the work, and a consciousness of exploitation by unscrupulous employers, finally made him resolve never again to suffer the humiliations of a hireling. From the mid-thirties he relied on freelance illustration and cartooning for papers and magazines such as the *Bulletin, New Idea, Table Talk*, the *Herald* and the *Sun*. The income was small but sufficient to enable him to survive and still find time to draw and paint. Tucker did not receive a regular income until he entered the army at the beginning of 1942. It must be said, however, that this did involve an element of choice. Burdett had commended him to Sir Keith Murdoch as a prospective illustrator on the staff of the Herald and Weekly Times. Tucker duly reported, and after a long wait was ushered into the panelled sanctum where Murdoch sat in splendour. The offer of 12 gns a week staggered the impecunious artist, who immediately countered with the suggestion that he should work on a half-time basis, thus ensuring also time to work at his own art. Murdoch's brow darkened and, hurling the portfolio of work onto a bench, dismissed the artist with a thunderous, 'See you later, Tucker!' One did not negotiate with God.

Whatever education in art and the world of ideas that young art students of Tucker's generation were able to acquire came almost wholly from their own resources. Books and reproductions were bought or scrounged wherever possible and fellow students were pressed into the role of sounding-board or devil's advocate. Without doubt, the single most valuable resource remained the Public Library with its specialized

art room. Atyeo had been one of the first to discover its riches when driven upstairs by the dearth of intellectual discussion in the Gallery School. Albert Tucker and Sidney Nolan followed and in turn introduced it to others. When not playing table tennis or cycling, Nolan was invariably also found there. Here he read Schopenhauer, Kierkegaard and French symbolist literature and, through Howard Mathews, was first introduced to the writings of Rimbaud and Verlaine.[41] As with Tucker, Nolan's real education began after ceasing formal schooling in 1932.[42] If anything, it was an even less ordered effort. After leaving school Nolan attended art classes on a part-time basis at Prahran Technical School in 1932. He then studied briefly with an art correspondence school while working for a company making illuminated signs. He also worked as a designer of men's hats and advertisements.

Nolan's attendance at the Gallery School was a token one only. John Sinclair remembers Nolan as having done no real work in the sense expected by Wheeler: he 'did not even pretend to study in the approved manner and I still smile at the recollection of a pallid, misshapen drawing

The reading room of the Public Library of Victoria: modelled on that of the British Museum, this vast room under its great dome held the most important resources available to young art students in search of education and enlightenment

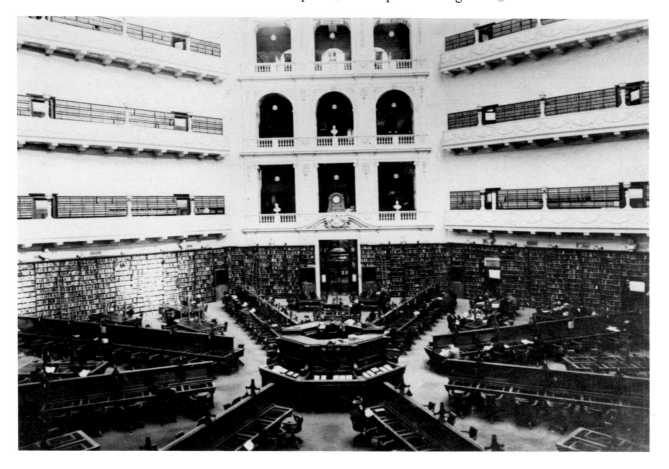

Verve, 1938. French art magazines, lavish and sophisticated, did much to erode Australian cultural isolation before the outbreak of World War II

of a plaster foot that stood neglected on his easel for months. It was the only drawing he did under official guidance and it was awful'.[43]

In Sydney something of a similar sense of frustration was apparent among the more enterprising students. After 1938 the East Sydney Technical School grew into one of the most progressive in Australia, but this was not the case in the mid-thirties under the English sculptor Rayner Hoff. James Gleeson studied there from 1934 to 1936 and found unsympathetic teaching designed around a strict academic curriculum. The only library available to students (and, one suspects, staff) contained mostly back numbers of *Studio* and old catalogues of the Royal Academy. It was all hopelessly out of date and offered no encouragement to any student who rejected an academic outlook. The sense of wasted time and effort was utterly demoralizing. As a consequence Gleeson enrolled at Sydney Teachers College, and there two pieces of good fortune instantly served to rekindle an enthusiasm for art. The first was contact with the head of the art department, May Marsden. Marsden's approach to art teaching was creative and imaginative and for the first time Gleeson was made aware that art possessed dimensions beyond academic exercises. Bernard Smith, too, had found great stimulus in the richness and range of Marsden's ideas when he had attended the college earlier. The second piece of fortune was Gleeson's discovery that the college possessed an extensive art library, the consequence of a Carnegie grant which provided one of the finest collections of art books and reproductions in Australia. As in Melbourne, the discovery of such resources provided students with their first introduction to art in a real sense 'by showing the absolute richness of art, the range and compass of it'.[44]

Unless fortunate enough to win one of the coveted travelling scholarships awarded by the National Gallery School or the Society of Artists, few students of this generation had any prospect of overseas study. They were also encouraged to do so less than in the past, when the principal art masters were European-born.[45] The complacency of Australian teachers was reinforced by their response to the unimpressive results of those who had gone and returned. Far from direct access to the canvases of European masters, artists had to rely on books, magazines and reproductions to fill the gap. This was not as great a handicap as might be supposed. Gleeson, for example, was able to subscribe to French art magazines such as *L'Oeil, Verve, Minotaure, Vingtième Siècle* and *Cahiers d'Art*. All were impressive publications. In Melbourne Peter Bellew could also import these journals through the Hill of Content bookshop. Carl Plate returned to Sydney in 1940 and established the Notanda Gallery and bookshop, which likewise stocked such publications. They were occasionally available too through Gino Nibbi. Most students, however, had to rely on public libraries or those of wealthier friends. That of John Reed, for example, was a key source for artists from the 1930s onwards. One of Tucker's important early discoveries

in the Public Library was a copy of *Die Kunst Des 20 Jahrhunderts,* the volume by Carl Einstein on modern painting in the *Propylaen Kunstgeschichte.* Despite having a German text this 1926 publication was of great value because of its extensive illustrations, albeit in black and white. In English, the main texts were Herbert Read's *Art Now* (first published in 1933) and R. H. Wilenski's *The Modern Movement in Art* (the revised edition of which was published in 1935) and *Modern French Painting* (1940). Their ideas soon supplanted the views of Fry and Bell that had excited an older generation.

Friendship between Gallery School students in Melbourne formed the basis of supportive enclaves and groups which coalesced in the late 1930s and early 1940s. During 1938 and 1939 Sidney Nolan, John Sinclair, Laurence Pendlebury and Gordon Daniels shared rooms in Russell Street. But Little Collins Street was the centre of their world. Along this axis could be found the Café Petrushka, the Leonardo Bookshop, Ristie's, and Cynthia Reed's shop; in addition there were the Primrose Pottery Shop and the studios of Albert Tucker and Joy Hester. Noel Counihan shared a studio nearby for a time with Roy Dalgarno and Nutter Buzacott. Fiesoli's café was close.

Melbourne in the 1930s was both — in one sense — a cultural wilderness and also a tremendously stimulating environment in its particular mix of character and spirit. Nowhere was this sense of milieu more evident than in the cosmopolitan company of the Café Petrushka. There artists and camp followers of all persuasions gathered. Hal Porter listed as habitués in 1937 Loudon Sainthill, James Flett with 'a portfolio of water colour pirates and self portraits', John Dale and Max Meldrum, William Dargie, Hayward Veal, Helene Kirsova 'with her hair in pale braids, with pale eyes and flaming cheeks', Albert Tucker, George Bell and his students, and a chauffeur-driven Theodore Fink 'weighed down by wealth and a hundredweight of rich overcoat'.

The square mile of the city still offered numerous cheap studios and lodgings as it had done in the 1890s. Porter describes it as both a refuge from the suburbs and as a theatre of entertainment and action:

Vingtième Siècle, 1938, and *Cahiers d'Art*, 1936

Within the inner city there are still nineteenth-century cottages, terraces of attics, old warehouses, ex-shops, hay lofts, and delicensed pubs, all to be rented. The buildings at the eastern end of Bourke Street have innumerable fishy one-room enterprises ... The attics and back rooms of Little Collins Street are rented by young artists of every sort who use the places as studios, love-nests, pieds-à-terre away from mum and dad, or merely settings for booze-ups.[46]

Within this arena, the meeting-places and boltholes of particular artistic and intellectual coteries and groups were well defined. Justus Jorgensen and his group of dissident ex-Meldrum students favoured the Mitre Tavern in Little Collins Street. Meldrum himself held court with his students alongside left-wing artists, intellectuals and fellow travellers in the Swanston Family Hotel. From there the left-wingers would repair to

The Swanston Family Hotel 'troops' as reviewed in this 1939 drawing by Noel Counihan. Back: Theo Moody, Noel Counihan, Judah Waten, Dr Ken Bretherton, Phillip Lasgourgues, Pat Stanley (smoking), William Dolphin, Nutter Buzacott, Bert Jennings. Front: Brian Fitzpatrick, Norman Porter, David Aronson, Les Kelly, Dr Albie Phillips, Rafael Wysokier, John Gordon, Sam Samson. The hotel was for long much favoured not only by this left-wing group but also by Meldrumites and other art students

Ristie's coffee shop in Little Collins Street: a favourite haunt of artists and Melbourne's young intelligentsia for two decades

Bill Dolphin's violin shop just around the corner. The 'troops' of the left, as Noel Counihan called them, numbered among their ranks Brian Fitzpatrick, Noel Counihan, Judah Waten, Nutter Buzacott and Dolphin himself. Attached to this core were various radical members of the professions who can be identified in Counihan's drawing of 1939. For other progressives in the late 1930s and the war years, the place to talk on a single cup of coffee from afternoon to night was Ristie's coffee house in Little Collins Street. Ristie's was later especially favoured by artists and writers of the *Angry Penguins* group: Albert Tucker, Max Harris, Harry Roskolenko, Neil Douglas, John Yule, Tony Underhill, Max Dunn and many more. Gino Nibbi's Leonardo Bookshop too was a favoured *salon*, as also earlier was George Bell's studio upstairs on the corner of Bourke and Queen Streets. Basil Burdett was to be seen at Bell's studio as frequently as were the painters. The city was both a place to work and to live for artists and *cognoscenti* alike. Burdett, urbane of sensibility and urban by temperament, had quarters in Spring Street within sound of the *Herald* printing presses.

Yet while Melbourne and the inner suburbs remained important for shelter and for the stimulus of its meeting-places and a sense of milieu, a significant shift was taking place elsewhere during the 1930s. This was a move from inner city studios and South Yarra flats on the part of artists and their friends to Eltham and Warrandyte along the upper reaches of

the Yarra. Long a favoured painting spot for artists travelling out of the city by train, this area fifteen miles out became increasingly a place to live and work. In the early 1920s Penleigh Boyd had established a studio at Warrandyte by converting an old wattle and daub barn into living and working quarters. A decade later the picturesque cottage-cum-studio with its exposed beams and rustic charm was bought by Connie Smith, who began also to buy paintings from young artists. In 1935 Justus Jorgensen, who had earlier broken from Meldrum, moved his extended family to Eltham. There they began construction of a group of pseudo-medieval buildings that Jorgensen called 'Montsalvat', using *pisé-de-terre* and local stone. This was the first of a number of artist colonies in the Warrandyte area. Danila Vassilieff, having returned to Australia in 1936, lived for a short period in Fitzroy. In 1937 he too moved to Warrandyte,

The Russian expatriate artist Danila Vassilieff at work building his house, appropriately named 'Stonygrad', near Warrandyte in the early 1940s. Many other artists and writers had moved out into this semi-rural area

Two contrasting examples of architecture: Danila Vassilieff's 'Stonygrad' nearing completion — homespun expressionism in a bushland setting (*above*); 'Montsalvat' under construction — mock-medievalism inspired and directed by the dissident ex-Meldrumite Justus Jorgensen

where he had been invited by Clive and Janet Nield to join the staff of 'Koornong', an experimental school devoted to progressive ideas in education. Near the school Vassilieff built 'Stonygrad', an idiosyncratic piece of domestic architecture in an expressionist manner, from local timber and from stone which he had blasted out of the steep hillside.

Not all who moved out were as eccentric as Jorgensen or Vassilieff. Nutter Buzacott and a fellow commercial artist, Harry Hudson, settled there after the depression, sharing the Penleigh Boyd studio. The writer Alan Marshall also belonged to this burgeoning community of artists and intellectuals. Adrian Lawlor lived in Warrandyte at 'Broom Warren' from the early 1930s. Lawlor's house was strategically close to that of Connie Smith, his mistress for many years. Both Lawlor's house and the Boyd studio were gutted on Black Friday, 13 January 1939, when devastating fires swept through the area. Lawlor built a new house overlooking the Yarra valley, basing the design upon constructionist principles similar to those that Walter Gropius had employed for the residences of the *Bauhaus* masters in Dessau. In 1935 John and Sunday Reed moved from South Yarra to an old weatherboard farmhouse situated on fifteen acres of hillside and river flats near Heidelberg. This area still largely consisted of orchards and dairy farms in the 1930s and 1940s. The Reed property, 'Heide', close to the area favoured by the early Heidelberg painters, was to become one of the liveliest centres for talk and art during the following decades.

That Warrandyte had become an art locus as distinct from the city of Melbourne was announced in May 1938 by a major exhibition of paintings from progressive artists arranged by Connie Smith at the Boyd studio. She had by then become something of a discriminating collector and was particularly sympathetic towards the work of young or as yet unrecognized artists. The large exhibition opened by John Reed contained work both by students and by more established moderns; among them were Bell, Shore, Frater, Tucker, Buzacott and Harry de Hartog.[47] The Warrandyte exhibition was in the nature of a curtain-raiser for the first Contemporary Art Society exhibition held at the National Gallery of Victoria later in 1939.

The move away from Melbourne was not from the city as such. Just as the inner city areas of Carlton and South Melbourne were a refuge and working-place for students and young artists from the outer ring of suburbia, others sought a comparable refuge from the closed world of bourgeois values. This geographical mobility was an expression of at least two common factors that lay beneath the immense diversity of personality, styles and artistic inclination. The flight either to inner or outer Melbourne represented a desire for a flexible, permissive and creative sense of community. And, perhaps more importantly if less consciously, it signified the recognition that within the suburbia that girdled the city of Melbourne lay an even greater danger to freedom, creativity and progress than in high conservatism. That danger was in

'Heide', the old weatherboard farmhouse built in the 1880s and bought by John and Sunday Reed in 1935. Behind the house the open paddocks of what were then still dairy farms extend to the tree-lined banks of the Yarra near Heidelberg. The house and its environs soon became a focus for many of Australia's most radical artists, writers and jazz musicians

the suburban mentality of *petit-bourgeois* values, which no celebration of the Australian democratic tradition and mateship could disguise.

The Radical View

Radicalism enveloped all for whom art signified something more than craftsmanship and national verities. Art, and specifically something called 'modern art', was a touchstone for everything in life that was open and dynamic; and the hope was that its vitalism would change a society that had become ossified, conservative, reactionary and potentially fascist. The Contemporary Art Society stood for a culture and sensibility that had to be contemporaneous; these things were also to be humanist in the tradition of the Enlightenment. To be modern was to be anti-fascist. In pursuing both lonely and collective courses young radicals were the most open to any signs of innovation in European art. Not surprisingly then, the radicals within the C.A.S. responded directly to the modes and motifs of Picasso, Chagall, Dali, de Chirico and others; and precisely because of the events of World War II they were able to weave these cultural threads into the observable and recognizable Australian milieu, whether urban or rural. Of course, this complex process was to take time and was accompanied by the fury of polemical exchange as the radicals found differing ideologies appropriate to their personal temperaments and senses of art.

Nevertheless, for all these differences there was one common factor that high conservatives, liberals and radicals were reacting against: the vulgarizing and corrupting power of the *petite-bourgeoisie* and the prevalence of what a recent historian has called the *Spiesser* mentality.[48] Norman Lindsay had recognized the phenomenon in the horror and censorship with which wowsers met his wry social observations and exotic *divertissements*. Lindsay's comment on Australian life and manners, *Red Heap*, was banned in Australia when published in 1930. Conservatives during the 1930s perceived it in the hack painting of a Buckmaster, who took the most superficial features of the poorest paintings of Streeton and Heysen and pandered to popular taste. Others saw that the principal danger lay in the denial of the vitality of art by a rejection of new painting modes. Incipient radicals were instinctively aware that both *haut-bourgeois* and *petit-bourgeois* taste were challenged in even more fundamental ways by primitivism, surrealism and German painting of the early 1920s.

Adrian Lawlor

In all this the position of Adrian Lawlor was crucial. He put it clearly in the introduction to his book *Arquebus*, in 1937:

It is not that one wishes in the least to be taken for a rebel; indeed, one may look upon the common ensigns of rebellion with a positive distaste. One may be driven into nostalgia, a personal neurosis, even, by one's increasing awareness of the gulf that divides one's own opinion from that of the 'plain man' where aesthetic values are concerned.[49]

Whereas George Bell was an artist first and a reluctant polemicist second, Lawlor was less an artist than one whose primary mode of expression was words. His joy in polemical exchange was unbounded. Even in relation to his one-time friends Lawlor was an intellectual maverick, and it is not surprising that he broke with Bell in 1940. In the 1930s the writings of Lawlor and Basil Burdett alone give articulate expression to the values of the diverse vanguard of radical and liberal-minded rebels.

Adrian Lawlor: painter, novelist, art critic, polemicist, broadcaster, brilliant conversationalist, and the most outspoken champion of new art and new ideas in the 1930s

After an early period of uncertainty, Lawlor's life was dedicated to the pursuit of art in all its forms. Fortunately he was able to exercise his aesthetic enthusiasms without restraint because he was freed from having to make art pay or having to work in order to paint or write. Born in London, self-educated and with Fabian socialist leanings, he arrived in Australia in 1910.[50] Before embarking for France with the first A.I.F. he married Eva Nodrun, a woman twenty years his senior and possessed of a comfortable income from a family tanning business. After the war Lawlor tried working for a time as a clerk in the tannery but was unable to endure such routine work for long. His first writings were published

in the early 1920s in *Vision* and his first piece for *Art in Australia* appeared in 1927.

By the end of the 1920s Lawlor had discovered his true vocation: that of artist, critic and polemicist. While often verbose and sometimes inconsistent, Lawlor was never dull. If one were to single out one personality on whom he modelled himself, it was unquestionably Wyndham Lewis. As far as ideas were concerned, they were taken with an even hand from both Lewis and Roger Fry, in itself no mean achievement. These were linked in turn with ideas from Herbert Read. All these influences can be found in *Arquebus*, with its mixture of rumbustious humour, mordant wit, irony and sarcasm. In this it reflected the blast and bombast of vorticist pronouncements. Yet behind the mask Lawlor also offered a clear statement of values that bore upon the aesthetics of art and life.

Alister Kershaw, a young friend and protege during the 1940s, recalls Lawlor's extraordinary impact:

Adrian always struck me as the most authentic genius I ever met; not necessarily in anything he ever wrote or painted, but he could never say anything commonplace or uninteresting; he just couldn't do it. His mind didn't work like other people's minds; he always saw things from an unexpected angle; he always interpreted things in a fantastic way.[51]

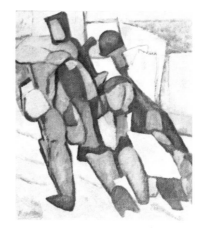

Although not everyone was quite so impressed, what was certain was that Lawlor's vital approach to life embodied utter rejection of an institutionalized mediocrity such as an Australian Academy.

Throughout his ten years as a painter Lawlor remained an eclectic. During the 1920s he had studied drawing briefly at the Melbourne National Gallery School and later under the Meldrumite teacher A. D. Colquhoun. He did not begin painting seriously, however, until 1930 and then only after having been cajoled into it by William Frater. Typically, he immediately presented a one-man show of his work in that same year. Ten years later an anonymous writer described its impact: Lawlor's first exhibition burst 'like a high explosive shell in the midst of Melbourne's slumbering art world'.[52] His very early works were painted in a loose and expressive style reminiscent of Christopher Wood. Thereafter, he continued to explore all manner of modernistic styles as he exhibited year by year throughout the 1930s. Burdett commented on Lawlor's last exhibition at the Athenaeum Gallery in 1940 that, although he was now more in command, the work remained eclectic, the product of a *pasticheur*: 'abstract one minute, surrealist the next'.[53] Burdett listed the most obvious influences: Cézanne, Bonnard, de Chirico, Matisse, Picasso, Dali. For Burdett it remained, nonetheless, a record of the experience of one of the liveliest minds in the Australian art world.

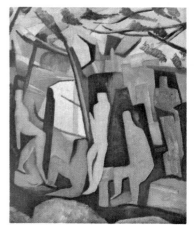

Adrian Lawlor, *On the Road*, 1939 (top); *Quintet*, 1940

From 1940 Lawlor ceased painting and exhibiting. He continued, however, to write criticism for the *Sun* and art and literary magazines, and in 1949 his novel *Horned Capon* was published with private help. The novel was a disaster, but a further key contribution to cultural life

beyond the Bergsonian vitalism of his exhibitions continued in his critical and polemical writings as well as his weekly A.B.C. broadcasts on the arts. Nonetheless, his substantial retirement from an active engagement with art was confirmed by his withdrawing at this time from the affairs of the Contemporary Art Society. The reasons are complex and were only partly a consequence of adverse critical reception of his work and the fact that his last show, like all the others, was a financial disaster. Part of the problem was that he painted as he spoke and wrote, quickly and with confidence and verve; the impromptu performance of a dynamic and uneven character. Some of his paintings were indeed very fine, but Burdett's incisive judgement must stand: 'this many-faceted art, as a whole seems to me, at least, to lack the personal conviction of style which is a quality of survival.'[54] Unlike most Australian painters he explored every conceivable mode of contemporary art; excellence was less important than dynamic exploration of the new genres.

An unrepentant dilettante, Lawlor adopted a stimulating set of artistic personae which found expression through his incisive and eccentric wit. The imaginative literary artists he most prized were, understandably, Wyndham Lewis, Richard Aldington, D. H. Lawrence and Roy Campbell. In common with these he argued for an élite of the creative spirit and sensibility. 'Creative art', Lawlor wrote in 1936, 'is the art of men who are alive in every normal faculty, and whose prepotent energy informs those faculties with a power of exuberance in expression beyond the power of men who are merely normal.'[55] On the left he may have been caricatured as a crypto-fascist, but this is to miss the essential point. Art, vitalism and life had to be asserted in the face of the deadening grip of a *petit-bourgeois* mentality.

Lawlor's rejection of mediocrity and *petit-bourgeois* philistinism differed fundamentally in character from the approach of conservatives like Lionel Lindsay who sought solutions in the values of the past. Lawlor saw that this rejection demanded also the rejection of the high tradition of Australian landscape painting which it contaminated. Unlike the conservatives, he did not see in twentieth century society and values a decline from a state of earlier moral certitude. However, in one sense he was at one with such men. In a reorientation of values away from mediocrity of intellect, he was opposed to the notion of democratic politics with which he believed it to be involved. Radical democracy was 'a dirty milieu'.[56]

In the last resort, Lawlor may not have been quite able to define the nature of modernism, but he saw more clearly than George Bell where stultification lay. The Australian Academy of Art was the outward face and imposing facade of the enemy from below, raised to the spurious level of officialdom. The real enemy consisted of the legions of 'solid citizens, artless policemen, lymphatic water-colourists, retrograde parsons (and their ladies), brigadiers, staff sergeants, brewers, strong silent men — the great sub-mental Australian "art loving" public ... with

Adrian Lawlor's house with its simple geometrical forms and spare elegance, designed by the artist on constructivist principles, was as unrepentantly non-conformist as Lawlor himself

their expensive Heysens and Powers, their priceless Streetons and their honest-to-goodness Max Meldrums all cluttering the pillow'.[57]

In a talk given to the Melbourne Contemporary Group in the mid-thirties, Lawlor scornfully dismissed the pretensions of both Meldrumites and debased conservatives.[58] The best that he could say of the 'photographic' painting of the Meldrumite pseudo-science of optical illusion was that at least it possessed a fully worked out *raison d'être*. Its practitioners knew what they were doing and why. However, nothing could redeem the popular academic 'naturalists':

[the] amorphous and slithery seeker after the 'poetry' of the Bush, your lover of plush-and-odorous rose-petals, your chocolate-boxy concocter of palpitant and undreamt of marvels of nuance in a woman's flesh, your contriver of that romantic gloom that invariably surrounds the head of a wealthy merchant when he sits for his presentation portrait.[59]

The principal purveyors of such *kitsch* in Australia were, Lawlor stated, Henry Aloysius Hanke, Charles Wheeler and Ernest Buckmaster. It might be noted that Hanke had won the Archibald Prize in 1934 and the Sulman in 1936; Wheeler had won the Archibald in 1933 and the Crouch Prize twice; Buckmaster had won the Archibald in 1932 and in 1941 *The Jolly Swagman* won £500 awarded by the National Gallery of Victoria for an 'Australian Subject Picture'.

Ernest Buckmaster, *The Jolly Swagman*, 1941. One of the most popular landscape painters of the 1930s, Buckmaster had an unerring instinct for sentiment and painterly swagger that was well rewarded. But it was paintings such as this that demonstrated to modernists and high conservatives alike the depths to which the Australian pastoral tradition had descended

Lawlor had hit upon an essential characteristic of the artist in the Australian scene. The potential buying public, which on populist argument would understand the best of a national art, was in fact little different from the *bourgeoisie* of London or Paris. That fact was realized with awful clarity when Robert Menzies declared complacently: 'with all my individual defects, I represent a class of people which will, in the next one hundred years determine the permanent place to be occupied in the world of art by those painting today.'[60] Basil Burdett responded ironically: 'People like Mr Menzies, of course, have the advantage over those who have patiently tried to unravel the still unsolved riddle of what art is.'[61]

Lawlor's principal point was that the strength of modernism in the twentieth century and the affirmation of every venture in art relied on a constant set of irreconcilable tensions: classicism and romanticism; formalism and expressionism; truth and appearance; rational mentality and the violence of emotion; the nobility of toil and its degradation; the need for an aristocracy and the inevitable decay that accompanied it. If any one aspect of these states was pre-eminent and there was no conflict or questioning involved in the creative art for either artist or audience, then the result was non-art. Worse, the consequence was all too often a debasement of the tradition which great European philosophers and artists had passed on to their successors. Significantly, the

A student revel at the Melbourne National Gallery School, c. 1940: the full diversity of character, skill and ambition of such students is suggested here. Few, however, would respond to the challenge thrown out by Adrian Lawlor, Gino Nibbi and Basil Burdett, or the example set by fellow students Sam Atyeo, Clifford Bayliss and Sidney Nolan

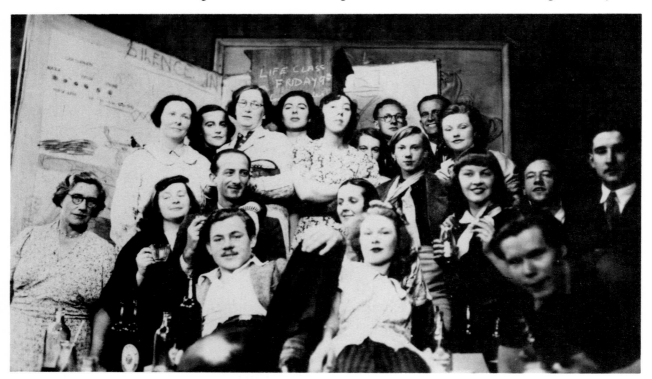

musical works Lawlor enjoyed most were the last quartets of Beethoven and Irving Berlin's 'Dancing Cheek to Cheek'. The two could happily co-exist. Contradictions and irresolutions, as every vitalist, symbolist and surrealist knew, were held in a state of inconstant balance, and life was a series of problems irresolvable without sweat and the ever-present threat of failure. As Lawlor saw, the new 'post-Freudian art' was different in a fundamental sense from all that had gone before: 'the cosmos is no longer tied up in a neat parcel: we have undone it.'[62]

For Lawlor, if life was to be art and art was to be life there could be no easy reconciliation of opposing human attributes. Those attributes had constantly to be synthesized to create a full and vital existence. Precisely where such a humanism was to be identified and how it was to be practised in an Australian context was the problem. Artists and intellectuals would differ in degree, but in the 1930s they were united in identifying precisely the forces and figures which opposed it. Lawlor spoke for them all when he stated that: 'Compared with your academic painter, whose whole experience consists in a vague, synthetic and essentially sentimental condition of reminiscent pastiche, your modern artist is passionately alive, here and now, to all modes of apprehension.' The *real* artist could not choose to be modern; it was 'innate and inevitable in . . . every creative gesture of twentieth century creative man'.[63]

The key word in Lawlor's rhetoric, which resounds with a sense of evil, is 'slithering'. For Lawlor, to 'slither' in paint and in life was the very essence of the avoidance of tension, a denial of the fundamental need to affirm the human spirit in the face of adversity, a refusal to seek good in the face of evil and to achieve new forms of expression in the face of convention — all things which Lawlor believed bore on the relation between life and art. While Lawlor had hit upon the single common concern of all art groups in Australia, the problem in the art conflicts of the late 1930s and during the turmoil of the war years was *how* artist-radicals were going to view art, culture and the people.

THE POLITICS IN PAINTING
The Australian Academy of Art and
the early Contemporary Art Society

Our painters today seem to have lifted up their eyes to the hills, and to have permanently focussed them there.

Basil Burdett (1938)

Whatever the signs of change in the courageous actions of isolated individuals and coteries, the 1930s remained a 'wilderness'. In a world without grace, its features were marked by poverty. The weight of Australian society lay like a sodden grey blanket over the efforts of anyone who refused to conform politically, socially or culturally. And there was no aristocracy to correct bourgeois prejudice and counterbalance the lumpishness of that great majority. Radicals were on their own. Even if Robert Menzies had not set out to enshrine nineteenth century values in an Australian academy of art, the damming up of a deep frustration would have had far-reaching consequences.

Legacies of the Depression

The economic reality until the very end of the decade remained the Great Depression: its legacy for many was fear, hardship and conformity. As producers of expensive commodities artists were hit especially hard, whether established or novice, conservative or modern. Even powerful and august bodies such as the Society of Artists in Sydney could offer scant protection. Under the progressive and open leadership of Sydney Ure Smith, who had been its president since 1921, this art society had grown to prominence in the 1920s and gave the work of members, whatever their artistic persuasion, a public standing that in good times usually ensured sales. Under its aegis early modernists such as Roland Wakelin found support and encouragement. Yet Wakelin wrote to Ure Smith in 1938 despairing of the predicament of the artist:

No one seriously interested in art can regard the situation with complacence [*sic*] and as far as I am concerned . . . I simply cannot incur the expense of exhibiting pictures where I don't even sell enough to pay the framing bill [and this from an] exhibiting member of the Academy and the Society of Artists . . . would

Opposite The foundation members and movers of the Australian Academy of Art, photographed at its brave launching in Canberra in June 1937: Daphne Mayo, W. B. McInnes, Norman Carter, Hans Heysen, Sydney Ure Smith, R. H. Croll, R. G. Menzies, Harold Herbert, Rayner Hoff, William Rowell and J. R. Eldershaw

you be satisfied with such a result of 35 years of work? . . . there will have to be many radical changes in art before I am satisfied.[1]

The lot of Australian artists during the 1930s was more difficult than at any time since the depression of the 1890s. Not only the pioneering modernists but also painters of an older generation such as Rupert Bunny and James Quinn found the going hard. Both had returned to Australia in the 1930s with established overseas reputations and a standing there that was the envy of many artists in Australia. In 1938 Rupert Bunny wrote to Sydney Ure Smith, telling him that he was unable to send work to the Society of Artists while there was the faintest chance of the National Gallery of Victoria buying any of his paintings. 'You see,' Bunny confided, 'between us (& with my excuses for touching on the subject) I am just "stony broke" and haven't even the necessary to pay the expenses of my show . . . I am really in a very great dilemma.'[2]

Experimental painters such as Bunny or Wakelin might not have sold easily at the best of times, but the extent of the crisis can be gauged from the experience of artists in the national landscape tradition. Its most recent, and for many its greatest exemplar, Hans Heysen, sold less and less as the depression worsened. His income in 1931, he declared, was 'practically nil' — 'one doesn't like to think of Money matters at all, but one is now forced to and I hate it'.[3] In a climate of financial struggle it is possible to think of the established painters, and those aspiring to Olympian status, banding together to preserve a monopoly of Australian art patronage. The move to establish an academy of art in the mid-thirties could easily be seen as an attempt to set up such a cultural cartel through a body that would act as an official arbiter of taste in Australia. The Australian Academy of Art cannot be so neatly characterized. The paradoxical alliances of artists within it, and of those who joined together to oppose it in the Contemporary Art Society, present contradictions that have been too easily glossed over. The reference to Wakelin's membership in itself suggests something of its heterogeneous nature. The changing and often contradictory relationships between conservative and more liberal artists and their supporters during the 1930s reflect fundamental cultural patterns in Australian society that demand explication if the art of the more radical artists is to be fully understood.

While conservatism can be fairly easily defined, the modernist movement in Australia from the 1920s to the 1940s is complex and paradoxical. Within the Contemporary Art Society there was as little unanimity over the nature of modern art as there was over the role of the contemporary artist or of the Society itself. There were times, for example, when some of the C.A.S. members found more common ground with leaders of the Academy than with their own fellow members. The Academy itself was not always what it appeared to be to those who opposed it. Nor did the polemical fury of either conservatives or radicals

James Quinn: a successful portrait painter in London, on his return Quinn was one of the few members of an older generation of academic artists to champion the cause of young radical modernists

always accurately reflect the real positions. It is important to see each clearly and to recognize the real nature of the conflict.

The intellectual and cultural movement that bore fruit in the 1940s, for all the divisions on political and aesthetic lines, had its centre in the C.A.S. — more a movement than an artists' exhibiting society of the traditional kind. It brought together painter, writer and patron under the banner of a fighting organization for new values in Australian culture. Thus the history of the C.A.S. between 1938 and 1947 is also the history of cultural change within Australia at that time. The C.A.S. made known the new art for the first time, acted as a forum for the most intense and committed intellectual debate in Australian cultural history, and enabled the groups it embraced to speak with a common voice in national terms — groups for whom radicalism often meant quite different things. There were those like George Bell or Rah Fizelle, early in its history, for whom radicalism meant the expression of formal qualities in art. These leaders were soon supplanted by artists and laymen whose radical conception of culture involved questions of social change, and change in the nature of the creative experience itself. This required a commitment to surrealism and expressionism; conceptions of art and attitudes towards life, as much as definable styles.

Modernism had first gained a hold on Australian art and life in the 1920s despite the overall predominance of conservative taste in painting. Bernard Smith labelled the period 'Leviticus', because 'it was then that the old men of the tribe, their years of exile over, began to lay down the law for the guidance of the young' and the air hung 'heavy with the arrogance and respectability of old men'.[4] Although the 1930s were marked by a resurgence of life, something of that decrepitude of the spirit and manners had flowed on. Even in Sydney the earlier interest in post-impressionism seemed enfeebled in the 1930s, a mere decorative adjunct compared with the high seriousness of the landscape painter or portraitist.[5] By contrast, however, the 1930s also saw new forms of modernism for which nothing in Melbourne, unlike Sydney, had helped prepare the way. Given also the greater strength of conservatism in Melbourne, the clash there between the old guard and newly emerging forces was a bitter one.

The Australian Academy of Art, which was established in Canberra in 1937, was modelled on the British Royal Academy and the nineteenth century official French *Salon*. Half a century before, the New English Art Club in London had served notice to the Royal Academy that the latter could no longer lay claim to pontifical authority or control patronage. As late as 1910, Walter Sickert, one of the Club's founders, confidently asserted that it 'sets the standard of painting in England'.[6] In retrospect it appears extraordinary that the Royal Academy should have been the model for a national Australian body of artists; it had long since ceased to number among its members those men whom many of the more conservative Australian artists professed to admire above all others.

The explanation of this apparent paradox lies as much in the geographical situation of Australian artists as it does in the conservative temperament of many of its prime movers. As was the case earlier with Canadian artists, Australians were on a cultural periphery in relation to European centres of art and also lacked a cultural centre within their own country. The two countries also had comparable colonial status; the Academy could be seen in part as one of the last brave attempts to uphold the ideals of an Anglo-Australian movement.

Founding the Academy

The idea of an academy was first mooted by Robert Menzies as early as 1932 when he was Attorney-General in the Victorian state government. By 1935, with enhanced authority as the new federal Attorney-General, Menzies sounded out artists in Melbourne and began tentative inquiries in London concerning the possibility of obtaining a Royal Charter. At a general meeting of the Sydney Society of Artists early in 1936, Sydney Ure Smith stated that artists would be foolish not to take advantage of the efforts on their behalf, and concern for their welfare, by a politician of such high standing; it might be many years before another such opportunity occurred for uniting Australian artists.[7]

Robert Menzies' aim was not only to secure a Royal Charter, but also to commit patronage of the arts to the commonwealth government. This would enable the building of a new and genuinely 'national' gallery in Canberra and, through the help of an academy, a great collection. The Academy's main job would be to organize annual exhibitions from which a national collection would be drawn. The whole scheme would thus achieve a cultural bridge over longstanding artistic and geographical rivalries.

In 1935 the members of Sydney's Society of Artists pledged unanimous support for the Academy. For these artists it represented the principle of a unified Australian culture in art. Yet beyond that ideal, many artists privately felt deep reservations. Doubts raised as early as 1935 led Sydney Ure Smith to write to Hans Heysen deploring the bitter words that had been uttered over the issue. The raising of the standard of Australian art, Ure Smith argued, would only be achieved if it had the unanimous support of all established artists of worth.[8] Without that there would be no Royal Charter and the Academy would be merely another art society, no better, and probably worse, than were existing ones.

Support for the Australian Academy idea came from two positions. The first was a conservative one for which Menzies was chief spokesman. The second was a more liberal position exemplified by Ure Smith. The differences between these two men represented broad and fundamental differences in Australian culture and politics; differences in

values and in a sense of Australian nationality deeply rooted in the colonial experience of Australians in the late nineteenth century. In immediate terms, Menzies saw the Academy as institutionalizing a native tradition of landscape painting epitomized by the canvases of Arthur Streeton and Hans Heysen and the early work of Elioth Gruner: a vision of the Australian pastorale. The more moderate Ure Smith believed that the proposed Academy should be seen in other terms: a Society of Artists writ large, allowing for a catholic taste in art that would embrace Australian responses to modernism.

The debate over the Australian Academy has strong echoes of earlier debates over federation between imperialist Anglo-Australians and men like Alfred Deakin of a liberal persuasion. Menzies held to the principle that unified and unifying institutions must prevail over diversity. The principle of the 'rule of law' was, for Menzies, easily transferable from a political principle to one of aesthetics. As he put it in 1937, 'Experiment is necessary in establishing an Academy, but certain principles must apply to this business of art as to any other business which affects the artistic sense of the community. Great art speaks a language which every intelligent person can understand. The people who call themselves modernists talk a different language.'[9]

Tom Roberts's early 'labour' paintings notwithstanding, by the 1920s nothing that Roberts, Streeton or Heysen painted constituted any challenge to an Anglo-Australian establishment. In a more fundamental sense than any aesthetic one, Streeton's painting remained fixed within the pastoral framework of values represented by *The Purple Noon's Transparent Might*. It was on the basis of such a sustaining imagery that Menzies sought cultural unity.

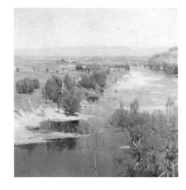

Arthur Streeton, *The Purple Noon's Transparent Might*, 1896. The expansive vision of an Australia Felix: proclaimed so triumphantly at the end of the nineteenth century, Streeton's image of the Australian pastorale meant little to a generation of art students coming of age in the political and economic climate of the 1930s

By contrast Ure Smith argued for the Academy that it could equally be a force for diversity. This 'statesman of the Australian art world', as the pioneering Australian art historian William Moore described him, was prepared to support the idea of an academy as long as that cultural unity which it was designed to encourage did not inhibit openness or an enriching difference in art. It could be called a Royal Academy, but it must remain both catholic and Australian. If it failed either test, an academy would become a force for reaction and parochialism. Ure Smith's position might be compared with that of the early liberal nationalists who accepted an imperial framework for the Commonwealth. His doubts and fears stemmed from a full realization of the degree of balance necessary if the enterprise was to create a progressive culture instead of enshrining past precepts.

Cutting across these two key positions was a range of personal ambition and antipathy as well as the longstanding rivalry between Sydney and Melbourne artists. From its inception, a combination of these factors produced a degree of conflict around the question of the Academy not seen before or since in Australian art. But the fears, doubts and anguish the Academy occasioned cannot be dismissed as mere

squabbling or internecine warfare between art societies. What was at issue was the future of an Australian art; the degree of hostility, as well as the sense of disillusionment at the Academy's ultimate failure, was directly proportional to the knowledge of what was at stake.

For artists the most immediate and prickly question was that of status. Who would be fellows and who the associates? After much difficulty seventeen names were proposed as 'RAs'. Five immediately refused the dubious honour of a fellowship: Arthur Streeton, Max Meldrum, Will Ashton, Norman Lindsay and Sidney Long.[10] Some, like Sidney Long, rejected the Academy because as members of the Sydney Royal Art Society they feared that Ure Smith would 'stack' it with his own favoured painters, their rivals in the Society of Artists.[11] For Norman Lindsay, in 'a crude country like this an officially established Art Centre would give Art generally a standing [that] would make intrusion by policemen and politicians a trifle more difficult'. But he refused to join because he also believed in 'the fixed law that all official and aldermanic institutions in Art tend to establish mediocrity'. What was needed, Lindsay held, was a change in the calibre of Australian artists and no art society, however imposing, would make artists out of 'flunking tradesmen'.[12] Rupert Bunny's refusal, on the face of it, had less lofty motives: his feet were bad, his wife ill, and he was preparing for a show in Sydney.[13] The reference to his wife is odd, to say the least, in view of her death four years previously. Streeton had earlier been favourably disposed but he changed his mind, preferring, one supposes, to remain apart from and perhaps above the noisy altercation.[14]

In the face of this response, even the most ardent supporters of the Academy had doubts. Norman Carter, an established portrait painter and leading member of the Society of Artists, wrote to Ure Smith in July 1937 shortly after its launching, expressing deep fears for its future:

There is a blind sectarian spirit abroad & we are losing all sense of the universal outlook, the true catholicity which searches for the truth wherever it may be found … We can degenerate into being conscious members of a cult or an aristocracy, grow snobbish & so die forgetting only to be buried.[15]

Soon even Ure Smith's remaining optimisms evaporated as he himself became one of its chief doubters. He lamented to Carter:

The poor old Academy! It almost seems doomed to failure — members resign, some die, others doubt it and all are restless. It's all wrong because in starting such an important Society all should be equally interested, sympathetic and enthusiastic — but who is? — the best of our men doubt it.

Ure Smith spoke for many when he stated that what was being created was a monument to Edwardian pomposity. Menzies was besotted by 'pomp & ceremony, by the outward, by "names" and "labels" as such … an annual dinner, with all the nobs of the land invited, the Church, the

Norman Lindsay in his studio at Springwood in the Blue Mountains: a romantic maverick and a rebel among his peers, Lindsay was one of the most prominent of established figures to reject the whole idea of an Australian Academy of Art

Navy, the Army, the G.G., etc. etc. on the lines of the Royal Academy dinner'.[16] It was as wrong as it was absurd.

That the Academy was launched at all on 19 June 1937 was due wholly to the sympathetic support of leading members of Sydney's Society of Artists. But beyond the coterie which met in Canberra, few other artists were to be quite so amenable to Menzies' powers of persuasion. Menzies himself did not help matters by arrogant pronouncements regarding the nature of the enterprise. In April 1937 in an opening speech for the autumn exhibition of the Victorian Artists Society, he declared:

You all know of the proposal to form an Academy of Art in Australia. I must admit that I was the prime mover of this idea. I feel definitely that some authority or body should be formed here as in other countries. Every great country has its art academy. They have set certain standards of art and have served a great purpose in raising the standards of public taste by directing attention to good work. This exhibition indicates that the Victorian Artists Society is encouraging every type of painting.[17]

Adrian Lawlor's *Arquebus*, published in 1937, held up the whole of Australia's art establishment to ridicule

More specifically, Menzies made it clear that whatever the Victorian Artists Society might encourage, as far as he was concerned, modernism would find scant acceptance on the walls of the Academy. His critical remarks showed as much diplomacy on this occasion as did his comments on foreign policy at that time. They were directed in this case at the work of some Melbourne artists whom James Quinn had invited to participate in the show and for whose paintings one entire wall was set aside: the group included George Bell, William Frater, Arnold Shore and Adrian Lawlor. It was before this wall that Menzies made his declaration as a direct challenge to George Bell, a formidable force in Melbourne art circles. Menzies' lack of tact may have stemmed from the fact that his ire had already been aroused by criticism from these men and the fact that Bell had already declined Academy membership.[18] Whatever the cause, his remarks started a violent controversy that quite eclipsed any preceding exchanges, a dispute fully documented in Adrian Lawlor's splendidly irreverent *Arquebus*. Whatever hopes the Academy might have had of success perished in the virulence of the emotion that flared in the exchanges of late 1937 and early 1938. The response of opponents was the immediate stimulus for the formation in 1938 of the Contemporary Art Society.

In Sydney, artists had been divided principally over questions of the nature of the new Academy. In Melbourne it became a question of whether the Academy had a right to exist at all. Its values were seen from one Melbourne perspective as wholly negative and reactionary. For Adrian Lawlor the issue was simple: reaction or progress. Those who supported the Academy in Melbourne, though, were even more conservative in painting, taste and politics than their Sydney counterparts. Lawlor felt that men like Will Rowell, W. B. McInnes, Harold

Arnold Shore, one of Melbourne's pioneering modernist painters and teachers, who accepted membership of the Australian Academy of Art

Herbert and Ernest Buckmaster could only conceive the world in 'slush and stockholm tar' and that an 'R.A.' was the apotheosis of their ambitions.[19]

George Bell's most savage attack was published in the *Australian Quarterly* in June 1938. For Bell, the Academy was guilty of 'the sanctification of banality and the strict preservation of mediocrity'. But even more pernicious was the power over public money which a small clique was attempting to arrogate to itself. This would ensure a dictatorship over the dispensation of patronage and thus 'the acquisition of absolute power in the sole interest of Academy members'.[20] Bell supported his attack by organizing opposition in the Victorian Artists Society. In March 1937 a proposal passed by members stated that 'the formation of a Royal Australian Academy would hinder the development of art in this country, and we therefore pray that a Royal Charter be not granted and that this be conveyed to the Governor-General'. Five days later Bunny, Daryl Lindsay and Bell publicly refused membership of the Academy — although in all justice it must be added that they had only been offered associate membership, not fellowships.[21]

There is a sense, then, in which the issue of the Academy and the establishment of the Contemporary Art Society can be seen as a continuing concern with the fundamental questions of national identity that were a legacy of colonialism and the federal movement. The Academy was an answer to the perennial problem of distance, both geographical and cultural: whether between Australia and Europe or between the two social, commercial and cultural centres that formed the small Australian art market. That fact of distance had seemed to deny the Australian artist a sense of milieu that Paris, London or Munich had offered European artists. However, any positive consequence was negated by the conservatives who very soon gave the Academy its character; reaction prevailed over progress and Melbourne over Sydney.

The president of the Academy from 1937 to 1941 was Sir John Longstaff, a friend and intimate of Menzies and J. S. MacDonald, a man described as 'the hearty and complaisant embodiment of art officialdom in Australia'.[22] Ure Smith was its vice-president and soon became the representative of a minor faction. He was less fearful of change than were the conservatives, but did want the Academy controlled by those with skill and wisdom in art matters.

The Sydney-based Society of Artists which Ure Smith led had long followed a policy of cautious acceptance of the new. William Moore had described it in 1934 as 'the salon of Australia, inspiring confidence in the work of younger artists coming on, who may be trusted to face new problems and give a fresh impetus to the art of our country'.[23] Like the Academy, and in the manner of other established art societies like the Victorian Artists Society formed in the nineteenth century, it elected its new members. Unlike the Royal Art Society, from which its original members had rebelled in 1895, it did not divide them in terms of status

as the Academy proposed. But Ure Smith felt that a federally based Academy might further break down the petty rivalries that attached to the established art societies. The irony was that it not only exacerbated such feelings, but opened up new divisions among artists and so provoked the uncontrolled change that he feared.

The principal opponents of the Academy were Melbourne-based modernists who had formed a coherent group as early as 1932 when the Contemporary Group held its first exhibition. That exhibition included work by Bell, Frater, Shore, Lawlor, Daryl Lindsay, Eric Thake, Isobel Tweddle, Ada Plante and Eveline Sime. Led by Bell, Frater and Shore, the group sprang from the impetus provided by an exhibition sponsored by Sir Keith Murdoch in the *Herald* building in December 1931. This contained canvases by Matisse, Utrillo, Dufy and Modigliani on loan from private collections in Australia; Bell, Frater and Shore provided accompanying public lectures. The Bell-Shore school was established soon after — prompted in part by the financial straits in which Frater and Shore found themselves.

Although the most trenchant criticism of the Academy came from members of this group, they were themselves bitterly divided over the issue — a division that resulted in irreconcilable splits between one-time friends. In the end Frater and Shore accepted the blandishment of Academy membership while Bell and Lawlor rejected it. Even before this, however, Shore had begun to resent Bell's proprietorial attitude towards the school. This additional factor may have helped Shore decide to join the Academy, but no doubt a greater force was the promise which membership of the Academy held for recognition of his painting at a time when he was achieving some measure of official success. Bell never forgave either of his two former friends and associates. Shore wrote sadly to Lionel Lindsay that the Academy had 'put a nail in the coffin of the friendship between George Bell and myself. I have held, from the first mention of the idea, that it was best for us to go in with the scheme, & make it worth while. G.B. has accused me of all the trickery he can think of, for holding such an idea'.[24]

When the Academy held its first annual exhibition in 1938, it claimed that the event marked 'a definite move towards the co-ordination of the artistic activities in a true Federal spirit'.[25] This declaration showed a brave face in view of the setbacks suffered by the Academy in that same year. In 1937 Menzies had felt completely confident that a Royal Charter would be forthcoming.[26] But by 1938 he was forced to admit that he had been unable to muster sufficient support in Canberra to make an official submission for a charter. The Lyons government, it soon became apparent, was not prepared to put such a request before the Crown while any sizable group of established artists made their opposition known. In response to the news, Ure Smith wrote to Norman Carter expressing regret over the whole sorry venture: 'I can't feel the slightest bit enthusiastic ... and I almost wish we'd had the sense to leave it alone.'[27] Ure

George Bell, who as a cautious modernist and as one of Australia's most influential teachers, spearheaded the attack upon the Australian Academy of Art

Smith's doubts were confirmed by that first Academy exhibition in Sydney. The general standard failed, in his eyes, to reach that of a Society of Artists show. Other members shared his disappointment and feeling that something had gone sadly wrong. Nonetheless, as late as 1940 Ure Smith still hoped that the situation might be saved if he could weld Will Ashton, Louis McCubbin and himself into a trio strong enough to preserve standards of selection.[28] But by then it was too late.

The foundation of the Academy had been an attempt to proclaim the pre-eminence of a unified culture. But when it held its second exhibition at the National Gallery of Victoria in 1939, it faced a direct challenge from the Contemporary Art Society, which followed the show with its own massive exhibition at the Gallery. Any continued claim that the Academy, by virtue of its federal character, could speak with 'a single authoritative voice' never rang so hollow. The inclusion of modernists like Shore and Frater likewise failed to enhance its claim to a catholic and open character. Commenting on the Academy's third annual exhibition in Sydney in 1940, the critic and co-founder of the important Macquarie Galleries, John Young, stated that 'like the first and the second, [it] remained sectional and exclusive, rather than national'.[29]

Founding the Contemporary Art Society

The emergence of the C.A.S. was not solely a reaction against the Academy: informal discussions concerning the idea had earlier taken place in Bell's studio in Queen Street. The generally illiberal atmosphere in Melbourne and the growing frustrations and response of young artists and sympathetic lay supporters led to talk, even before the idea of the Academy became public, about the need to establish a society of progressives whose aim was to help promote new ideas in art. The discussions, which included Frater and Shore, took place in 1937 in Gino Nibbi's Leonardo Bookshop, where Adrian Lawlor invited John Reed to take the lead and form a society of which Reed would be president.[30] Other active participants included Peter Bellew, then a junior reporter on the *Herald*; Vivian Ebbott, a dentist; Guy Reynolds, a psychiatrist of advanced views; and Allan Henderson, a solicitor who had offices near Reed's own in Collins House.

George Bell took the decisive step in July 1938 when he distributed a leaflet called *To All Artists*, anticipating a meeting at the Victorian Artists Society. Although in Bell's name, the statement was drafted in Nibbi's bookshop and was a composite effort. The call to arms warned that the Academy represented 'an attempt by a handful of artists to dominate the rest of the artists and the public and force the acceptance of its own standard of art'. It was a threat to the many through the acquisition of power by the few and had to be countered quickly. The statement proposed a society which would unite all artists and laymen 'in

Vivian Ebbott, a dentist and one of the small band of professional people who supported modernism in the 1930s. On Ebbott's wall hangs an early Cézanne-like painting by Sam Atyeo

favour of encouraging the growth of a living art'. To this end a meeting was called on 13 July. The *Argus* reported that 170 members were signed up and a constitution formally adopted. George Bell was elected president and Adrian Lawlor secretary.[31] At the meeting Bell announced that this was not going to be an aggressive society but a defensive one, showing the work of contemporary Australian artists both young and more established. This modest view of its character prevailed initially over more radical ideas. Through Bell and Lawlor the Contemporary Art Society appeared, on the surface at least, to reflect the values of the earlier Melbourne Contemporary Group.

In its original aims, the C.A.S. differed in no fundamental respect from a body such as the Society of Artists. Its objectives were the promotion of the free development of art unhampered by any denomination; the stimulus of public interest in a living art; the removal of customs duties on imported works of art and a more enlightened attitude towards censorship; and an educational role through lectures to members and the public.[32] Similar too was its aim of encouraging embryonic work by young artists, and a broader policy of national art patronage to ensure the purchase of contemporary work. In these terms, such aims fail to convey the radical nature of the Society as conceived by a group of leading members; the difference lay in the spirit and content, not in the form. The degree of this difference was not even apparent to George Bell until policy had to be implemented in the organizing of the first annual C.A.S. exhibition.

From the outset the leadership was evenly divided, two groups holding irreconcilable conceptions of the Society. On the one hand stood George Bell, Norman MacGeorge, Marjorie North, Clive Stephen, Isobel Tweddle, and a legion of Bell's students. Also supporting Bell were Rupert Bunny as vice-president and, initially at least, Adrian Lawlor. The more radical leadership comprised John Reed as lay vice-president; the artists Albert Tucker and Nutter Buzacott; and the lay council members, Peter Bellew, Vivian Ebbott, Allan Henderson, Gino Nibbi and Guy Reynolds. The first group saw the C.A.S. as a craft guild which accorded respect only to those who had won esteem from their peers and which extended patronage with due discretion to new and promising apprentice artists. 'My idea', Bell later lamented, 'was based entirely on an Artists' Society.'[33] The opposing group was imbued with a belief in the proselytizing function of modern art. This aim could be furthered by any enthusiast, whether painter, poet or critic. Exhibitions were to be open to all talent within the ambience of a modernist spirit.

Despite the primary role of lay members in forming the Society, Bell was opposed to their having any appreciable influence. For Bell, the role of the Society in relation to the Australian Academy was to be like that between the British Royal Academy and the New English Art Club or the Camden Town Group, which had formed exhibiting societies in opposition to the Royal Academy. Interference by lay members would

be as bad, Bell feared, as the Academy's imposition of false standards and ideas. For radicals like John Reed, there was no appreciable difference between an academy on nineteenth century lines and any other body that laid down standards and formal rules. However advanced these might appear, both were abhorrent.

The nature of the proposed inaugural exhibition in 1939 raised fundamental questions. Was it to be a huge unselected show along the lines of the French *Salon des Indépendants* or the later English Allied Artists Association exhibitions? Or was it to be a more restricted exhibition along the lines of the French *Salon d'Automne?* Bell preferred the second option. For Bell, there existed in art a clear set of formal principles, and to these he committed himself as one of Melbourne's foremost artists and art teachers. An art based on these principles had to be defended on the grounds that its standards were at least as high as those of naturalism. Bell and others of this temper considered that artists, by virtue of their special aesthetic sensibilities and artistic awareness, were the only legitimate guardians of quality in painting, modernist or otherwise.

As John Reed saw this tendency, it was one in which lay members in the Contemporary Art Society would be relegated to the position of privileged onlookers and supporters. In the radical vision of a new movement the role of lay members was crucial: they were the custodians of that quality of participation that would alone ensure the free, open and dynamic association of varied artistic temperaments. Reed had therefore seen to it that in all executive decisions lay members would be on an equal footing with artists.

In practical terms, it was a question of who could exhibit and who could not. Beyond this concern lay a commitment to the idea of a democratic art society, one which, by its fundamental nature, guaranteed through a constitution that it would remain open and receptive to new forms and conceptions of the visual arts. Even at the risk of endangering excellence, the basis of the radical case was the right of all young artists to exhibit freely. As John Reed has put it more recently, the principle was that 'if a man was an artist, well that was his business and nobody else's'.[34] This principle of artistic and creative freedom was an absolute one, since the creative art of the future was at stake. That art could be found in no other place than in the embryonic work of every young artist.

The very first exhibition in 1939 brought this ideological and cultural conflict to a head. It also challenged the closed-shop and fixed-standard principle of the Academy at the most profound levels. The radicals did not, however, have complete victory this time. They failed to rally the numbers to ensure the principle of non-selectivity and they failed to open positions for the laity on the selection committee in which so much authority resided. Lay members had the right to challenge the selection of the jury only in the event of their seeing that some grave injustice had been perpetrated by commission or omission. It was by virtue of this provision alone that the radicals succeeded in having included Nolan's

Dr H. V. Evatt, Judge of the High Court of Australia, opened the first exhibition of the Contemporary Art Society in 1939. Evatt's progressive views opposed those of R. G. Menzies as vehemently here as in the arena of Australian party politics

first exhibited work, *Rimbaud*. The result was that in 1939 only a narrow selection from a vast range of talent was exposed to public view. The domination of the moderates did, however, result in the C.A.S. gaining access to the walls of the National Gallery of Victoria. It is doubtful whether the Board of Trustees would have acceded to the request without Bell's standing with individual trustees, especially Sir Keith Murdoch, the recently appointed chairman. Murdoch was no friend of either the Academy or of Robert Menzies — nor, as it soon appeared, of the radicals in the C.A.S. The exhibition was opened in June by another of Menzies' opponents, H. V. Evatt, who used the opportunity of the opening speech to attack the Academy and its supporters for their 'unwarranted assumption of pontifical authority'.[35]

Basil Burdett was unfortunately unable to review the exhibition because he was in Europe preparing for the *Herald* exhibition of contemporary art. Posterity has had to rely upon a rather lame review of this historic exhibition by his replacement. That reviewer did, however, express the feeling that somehow the paintings revealed 'the huge restlessness of their time'.[36] On show to a large public for the first time were works of Noel Counihan, Vic O'Connor, Joy Hester, Harry de Hartog, Sidney Nolan, Albert Tucker, James Gleeson, Peter Purves

John Reed: a Melbourne solicitor of advanced views in art and politics, Reed was the chief spokesman for the more radical wing of the early Contemporary Art Society

Smith, David Strachan, Sali Herman, Rah Fizelle, Frank Hinder and Russell Drysdale. Their work, together with that of an older generation of artists, made the point without equivocation that modernism had at last come to Australia. John Reed made the bold claim that the exhibition and its art could speak to the future with one voice,[37] a claim which cannot be dismissed as mere rhetoric. True, it might appear that Reed was trying to paper over many differences. At a more profound level, however, he was expressing the feeling of many elements from both Sydney and Melbourne that had responded to the promise of liberation.

In this situation, where were the conservatives supporting the positions struck by J. S. MacDonald, Lionel Lindsay and Robert Menzies? The crumpled suits in contemporary photographs would suggest an unconscious acceptance of defeat. The Academy continued to exhibit until 1946 with an ever-predictable set of canvases and subjects. It lost dynamism, not least through losing the support of the Sydney artists. For public purposes, Ure Smith announced in 1941 that, owing to the stringencies of war, the Sydney-based northern division would 'go into abeyance'.[38] The reality was the desire by members of the Society of Artists to wash their hands of the whole frustrating and sorry affair.

Profound, then, was the surprise of radicals when in March 1945 the federal Minister of the Interior stated that the Academy would be the sole arbiter for the appointment of war artists. Consequently many artists, irrespective of their values and, in some cases, merit, were given membership of the Academy. Official war artists who thus exhibited with the Academy included Ivor Hele, William Dargie, Sali Herman, Donald Friend and Charles Bush. This move was made in 1944 when C. E. W. Bean, himself no mean water-colourist, decided that the selection of artists to capture Australia at war had to be broadened, since informal recommendation had been the basis to that point. As a consequence, the War Memorial Board set up an Artists Advisory Panel in July 1944 consisting of four representatives from the Academy: Daphne Mayo and Frank Medworth for Sydney and the northern states; Will Rowell and architect Percy Meldrum for Melbourne and the south.[39] Not surprisingly, some artists who captured important aspects of Australia at war were not even considered by the Academy for official positions. Wartime exigencies breathed life into an Academy that had become little more than a shell, but after this brief resurfacing, it sank without trace and was finally wound up in 1949, when its remaining funds were handed over to the Victorian Artists Society.[40]

It was understandable that John Reed, Albert Tucker and their contemporaries should have deplored the final intrusion of the conservative establishment upon the artist in a time of national crisis. As we shall see, Reed felt that young artists like Albert Tucker and Sidney Nolan were depicting Australia at war in ways incomprehensible to a Harold Herbert or a Julian Ashton, who had sought to preserve the heroic pastoral tradition that the Academy appeared to embody. While right

Cover designed by Eric Thake for the catalogue of the first C.A.S. exhibition, which opened in June 1939 at the National Gallery of Victoria

in this, radicals misread events in the early 1940s. By 1945 the Academy, with all the powers given it by a wartime government, no longer represented the Australian art establishment.

The Cultural Liberals

In 1941 Menzies fell from office and entered a period of eight years political eclipse. The counterpart to this in the art world was the realization in the same year that a centralized Academy could never revivify Australian art. It is in this context that the role of Sydney Ure Smith and Sir Keith Murdoch in the late 1930s and early 1940s can be properly understood. Writing to Ure Smith in March 1937, Murdoch observed:

The Academy idea I fear greatly and distrust — we must differ upon it. A little group of Melbourne artists, greatly strengthened by J. S. MacDonald, sets itself up as internationally supreme, & is far too widely accepted as such. We are seriously told that 'Herbert has no equal in the world!' We get a lot of trash thrust upon the public & with an RAA there will be more authority behind this than before. We have so few keen artists & so much dead rot. You are different in Sydney with your more liberal point of view, & higher standards in some directions.[41]

In Melbourne Murdoch had been appointed a trustee of the National Gallery of Victoria in 1933, long before the beginning of the fiery

Sir Keith Murdoch in the seat of power: chairman of the Herald and Weekly Times empire and a trustee of the National Gallery of Victoria, Murdoch was determined to end old-fashioned conservative control of art and taste in Australia

debates dealt with here. Murdoch's concern throughout the 1930s was to revitalize society and culture on a local level, as opposed to moves which depended upon over-bridging of local differences. Entrenched conservative interests at a state level were represented by the directors and their supportive trustees in the National Galleries of Victoria and New South Wales. In either case they maintained a parochial, limited and restricted view of the role and form of acceptable artistic expression.

In all this, Murdoch's *bête noire* between 1936 and 1941 was the director of the National Gallery of Victoria, J. S. MacDonald. As we saw, MacDonald was the most outspoken champion of conservative nationalism in Australian art in the 1930s, and his appointment as director in 1936 had imposed, in Murdoch's eyes, the dead hand of an increasingly discredited establishment. If a high point might be ascribed to conservatism in Australian culture, it was less that of the formation of the Academy in 1937 than of MacDonald's appointment to the directorship of Australia's premier art institution. MacDonald himself was ineligible for membership of the Academy because he had ceased to paint after 1918. But like his friend and confidant Robert Menzies he identified closely with the values of its more conservative southern wing. His association with academies had indeed been a long one: he had exhibited with the old official *Salon* in Paris, with the Academy of Arts in New York and with the British Royal Academy.[42] Within the Melbourne scene, large issues were now at stake in the conflict between Murdoch and reactionary interests represented by MacDonald. The events of this battle are worth telling in some detail.

Murdoch hoped that a regeneration of interest in the arts would be achieved by administrative changes and the acquisition of new paintings at the National Gallery of Victoria. Early in the thirties he had appointed Basil Burdett to the staff of his influential paper the *Herald*. Until then, Burdett had worked in Sydney as an art entrepreneur and as an associate editor with Ure Smith of *Art in Australia*, a magazine to which he was also a frequent contributor. Murdoch's close and intimate association with Burdett dated from 1931 when Murdoch had bought into *Art in Australia*. Although Burdett was on the *Herald* staff from this point he did not become its art critic until 1936. In the intervening period he was away in Europe for a further two years. Burdett, multi-lingual and much-travelled, was a man who had been intensely responsive to developments in the art world in London and Paris. In the columns of the *Herald* Burdett was thus able to launch trenchant criticisms of exhibitions by Australian artists, not only on their own scale of values, but also from an international perspective.

In 1936 the appointment of a head for the National Gallery of Victoria became a matter not only of competition between interest groups, but also of intense ideological dispute. The death of Bernard Hall in 1935 left the jobs of both director and Felton Bequest adviser vacant. The

directorship was a 'plum' job with a salary of £1000 per annum. In the ensuing wrangle, certain issues became clear. Conservative cultural interests were represented on the one hand by political forces of the right in the Victorian Country Party, and on the other by certain artists who had already received longstanding patronage from the National Gallery or who had been honoured by a trusteeship. In this fashion links existed between R. D. Elliott (whose country newspaper chain opposed Murdoch's city newspaper interests), H. S. Bailey (Chief Secretary and Attorney-General in the Country Party-led state government of Albert Dunstan), Robert Menzies and Sir John Longstaff. Such men supported MacDonald's application, taking the view that Australian art should move no further forward in time, nature and sensibility than the work of Heysen or Streeton. These were the 'connections' against which Murdoch felt the major battle had to be fought — a conflict in which the modernism of the 'cultural bolsheviks' was irrelevant.

The struggle was a protracted one. Longstaff lobbied on MacDonald's behalf among artists and trustees while Menzies exerted his considerable influence among politicians.[43]. In March 1936 Longstaff assured MacDonald of his support and that of many artists, but warned that opposition was to be expected from Murdoch, who had backed Burdett.[44] Faced with the forces of conservatism, Murdoch felt that Burdett, combining the functions of columnist in the *Herald* and director of the National Gallery or Felton Bequest adviser could help move Australian art into the twentieth century. As *Herald* critic, his wide aesthetic interests would be given free rein; as director, he could enable the Gallery to show examples of twentieth century art; and as Felton Bequest adviser he could make effective decisions on purchases under a bequest that everyone knew was one of the richest given to any gallery. With such resources Burdett could choose canvases in 1936 as advanced as Braque's cubist or Picasso's post-cubist works.

But Burdett failed to win either of the two more ambitious positions, a failure that is one of the little-known tragedies of Australian art. He seems to have been unable to decide whether to go all out for the directorship or for the position of adviser. Certainly the latter held far greater appeal for a man whose closest cultural ties were European. In August 1936 it was clear to Daryl Lindsay that Burdett would not get the directorship. As Lindsay lamented to his brother Lionel, 'I worked like a beaver to get Basil the job ... if he had started to go for it in earnest 3 months ago, as I suggested to him, I think he might have got it — I simply can't make him out at times.'[45] And, despite testimonials for Burdett from eminent figures in London such as Henry Tonks, Randolph Schwabe and Frank Rinder, the advisership went to the Englishman Sir Sidney Cockerell. The appointment of Cockerell, a medievalist, was actively opposed by Murdoch, who wrote that although he was the best in Britain he was 'not better than the best in Australia'.[46]

The trustees had become deadlocked over the directorship of the

J. S. MacDonald, savouring a moment of triumph, with congratulatory telegrams received after his appointment as director of the National Gallery of Victoria

Gallery, and as a compromise had opted for the architect and architectural historian Hardy Wilson. The recommendation was overturned by the Chief Secretary and, to the utter consternation of his opponents, MacDonald was given the job. One might add that Hardy Wilson, who did not dispute the decision, was unlikely to have followed a more enlightened policy towards modernism than MacDonald. This position, which MacDonald held until 1941, made him one of the most powerful figures in the Australian art world, despite the bad blood between the director and the majority of the trustees that resulted from the inauspicious beginning of his reign.

Of all the many features of this complex affair, the most important in determining Burdett's failure was the interest of the Victorian Country Party and the right wing of the United Australia Party as epitomized by Robert Menzies. Also significant is the degree to which this incident reveals the powerful hold of conservatism on the state galleries at that time. In Melbourne, at least, the National Gallery ultimately determined which artists' work was acceptable and which not. In short, although the Australian Academy very rapidly revealed the sham behind its facade, the forces of conservatism retained their hold on the more important local institutions until the beginning of the 1940s.

It is conventional wisdom that radicals pursue their crusades to the finish. What is too rarely recognized by historians — political and cultural — is that liberals can fight as long as radicals or conservatives. In this particular instance Murdoch, from 1936 faced with the dominance of conservatism in the form of J. S. MacDonald as director of the National Gallery, and with yet another form of academicism in Max Meldrum as a fellow trustee, orchestrated a sustained and ultimately successful attack on the art establishment in Melbourne.

Burdett was in the vanguard of this attack. In 1937 he described the National Gallery of Victoria as having 'the air of a cultural backwater — an air as chilling as those waxy marbles of royalties which greet one in the vestibule and seem to sound the keynote of the whole institution'. Its general air of decay did not stop there but extended to the unpainted railings outside and the patchy lawn bounded on either side by sad and scraggy Moreton Bay figs. In front of the facade, dirty bronze statuary seemed to anticipate the melancholy mausoleum within. For Burdett, the National Gallery had no obvious buying policy of discernment or sympathy towards either European or Australian painters. 'Has it', he asked, 'effectively laid the foundations of a collection which will tell the story of Australia's artistic pilgrimage and development to the future?' The answer, it may easily be guessed, was a resounding no. The Gallery had simply not touched the lives of ordinary men and women in any deep sense. Their chief reason for making a pilgrimage to the building was, all too often, to stand entranced before Phar Lap in the adjoining museum.

In 1938 Burdett took the Gallery to task for using the provincial

galleries as dumping grounds for those works rejected for hanging in the National Gallery. As he put it, 'If we cannot do something to educate taste there at least we should do nothing to debase it.'[47] But the position of Burdett and Murdoch was far from negative; both were active in putting forward suggestions to improve the Gallery's aesthetic, educational and supportive function as the key art institution for the community. It was a campaign which continued throughout the late 1930s and into the war years.

Burdett's position as a journalist on the *Herald* staff was a favoured one. It is said that he was the only member of the staff invited to dine when Murdoch entertained important guests in the *Herald* building. Murdoch bought works of art on Burdett's advice, and his collection of early English moderns was as much a reflection of his mentor's predilections as it was of Murdoch's own taste. By 1941 Burdett might seem to have earned the directorship that again fell vacant; but he went to war, and was killed at Sourabaya when the aircraft on which he was a passenger crashed.

In Burdett's place, Daryl Lindsay was made director. At the time it seemed to be a victory in one local scene for the liberal forces in Australian art. Murdoch had become chairman of the board of trustees in 1939 and Daryl Lindsay had been appointed keeper of prints. Their powerful alliance very quickly determined the character the Gallery would assume and the art which would be acceptable for the following two decades.

The overall result of these events in Melbourne was far-reaching. The

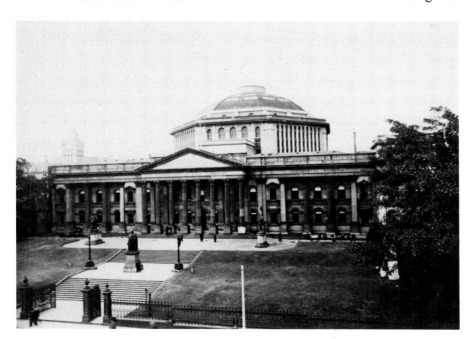

The imposing classical edifice of the Public Library, Museum and National Gallery of Victoria as it appeared in the 1930s

appointment of Daryl Lindsay as director cleared away a great deal of the influence exercised by conservative forces. The doors were opened to the rather cautious modernists who until 1940 had been faced with a choice between official and strongly conservative institutions and an increasingly radical C.A.S. These artists could now find their way to a new home of patronage and support. A further consequence was a sweeping of the stables, equivalent to Murdoch's in Victoria, by Sydney Ure Smith in New South Wales.

At the beginning of the 1930s, cultural conservatism in Australia had looked to have an almost unshakable grip on art and art institutions. This was the case even in Sydney, where in general a somewhat more open and liberal climate had prevailed. By the end of the decade the old guard had succumbed to an unrelenting attack and possessed no effective control or appreciable influence in either of the Melbourne or Sydney galleries or major art societies. This view is far from the conventional account in which an unregenerate conservatism was vanquished in one decisive battle, the 'Dobell case' in 1944. Those who ·defeated the Academy and who moved into positions of enhanced authority were far from being rebels but, in a series of skirmishes between 1936 and 1941, these cautious dissenters routed the upholders of myopic and insular national values. When the main manifestos of cultural conservatism, by J. S. MacDonald and Lionel Lindsay, were written at the beginning of the 1940s, they represented the views of those already defeated and passed over. They were a desperate rearguard action by old, tired and dispirited men. In 1942 Lionel Lindsay wrote to MacDonald in a mood of complete despair:

What a pair of fools we are to have troubled so much about decadence. I spent 8 months on 'Addled Art', because I hate the fustian, and I might have been better employed and happier at a job of engraving. There is no intelligence in Australia. The battering and 50 years of A.L.P. wage dreaming have brought us mentally to the point of collapse.[48]

There was, of course, more than one brand of powerful artistic conservatism and academicism in Australia between the two wars. Meldrumism remained forceful through its enormous appeal to young students and through Meldrum's own considerable influence in official art circles. Meldrum was no friend of Murdoch, but he too harried the conservatives. The attempt by Bernard Hall in 1931 to remove Meldrum's *Peasant of Pacé* from the walls of the National Gallery of Victoria produced an outraged howl of protest from Meldrum's legions of supporters.[49] In 1937 Meldrum was himself appointed a trustee and he was as strongly opposed to Murdoch as he was to MacDonald. With a characteristic flair for dramatic timing, Meldrum announced his utter rejection of Academy membership on the eve of the election for the controlling executive in December 1937.[50] His first reason for rejecting the Australian Academy of Art was aesthetic. Meldrum's system of tonal

impressionism was opposed to that based on colour as it had evolved in its nationalistic guise and which, from a Melbourne perspective, the Academy was seeking to enshrine. The second reason was that, like other opponents, he believed that the Academy was also a shrine to mediocrity. Bell had argued that it was falsely élitist; Meldrum argued along similar lines. He specifically rejected the election of twenty-five members by ballot because this demonstrated the false use of democratic principles in an area where democracy had no place. For Meldrum, then, the Academy was not 'the aristocratic body that it should have been ... It was lending its prestige to men who had not reached a necessary standard of craftsmanship'.[51]

Few of the first generation of Australian modernists in either Sydney or Melbourne had not been touched by Meldrum's messianic teaching.

But by the 1930s it appeared to more enterprising artists to be stultifying and as much a cultural *cul-de-sac* as was the national landscape tradition. For Burdett the doctrine of Meldrum and his worshippers formed the 'artistic Calvinism' of Melbourne; a sect or cult in which heresy was inexorably punished by excommunication.[52] The greatest sin of such academicians for liberals was the persistent belief that Australian artists had nothing to learn outside Australia. As Adrian Lawlor declared in *Arquebus*: 'Australian art is a negligible quality in the serious art of today, its practitioners for the most part feeble and vitiated in intention, its values poverty-stricken, its products mere essays in academic convention.'[53] In 1937 Lawlor published his trenchant *Eliminations*, which was directed specifically at the iniquities of Meldrumism.

An academician has been defined in the widest terms as one who 'wants to stop certain things from happening in art and he believes that society ought to help him accomplish that aim. He is an embattled idealist, a believer, potentially militant, in a set of values capable of surmounting the "decadence" of the times ... the academician like the priest, holds the keys to eternal life, to a grandeur above history'.[54] There was more than one kind of academicism. Lionel Lindsay, Max Meldrum, George Bell and even Noel Counihan had more in common than each realized. The elimination of one mode of academicism did not necessarily mean that the Australian artist had been set free in either aesthetic or political terms. Radical artists were forced to go on fighting for a new art and a new culture throughout the 1940s and the 1950s, as hard as they had fought in the thirties — and what added to the difficulty was that the issues would never again be as straightforward as they had been before 1940.

While we have been concerned here with the institutionalization of conservative values, such values were diffused throughout the community. Reactions to a figure such as John Reed indicate aspects of this repressed and repressive society. Reed's background was that of the wealthy Australian *haute-bourgeoisie*; as members of the Tasmanian squattocracy the family was as close to landed gentry as Australia could produce. Educated at a British public school and a graduate in law from Cambridge, Reed came to espouse values and opinions in the 1930s that were received with the same degree of horror by fellow lawyers as were his long hair and coloured ties in Collins Street. For Reed, the atmosphere was 'reactionary and oppressive in the extreme'. It was less a case of outright repression than of ostracism for anyone who expressed views concerning either radical art or radical politics. As Reed has put it:

You couldn't hold down any normal sort of routine job in the city and at that time be connected with anything remotely advanced either artistically or politically. You just had your head chopped off and that was that — you were out. To be out in those days meant more or less that you starved.[55]

The economic reality of the thirties remained the Great Depression.

Harold Herbert at work: a skilful water-colourist, renowned *bon vivant*, and intemperate conservative. Herbert's art criticism written for Melbourne newspapers was as immoderate as his political views

Reed himself was hardly in danger of starvation, but he did relinquish an uncomfortable partnership for a private legal practice. Another casualty of this repressiveness was his early lively friendship with the conservative water-colourist Harold Herbert. As Herbert said, 'there are two things in this world I cannot stand . . . one is modern art and the other is communism; you stand for both.'[56] The question of precisely what John Reed and the radical artists of the Contemporary Art Society did stand for in relation to liberal and conservative concepts of culture was less easily defined than Herbert could suppose.

Two things are clear about the position of radicals at this time. The first is that conservative forces in the arts had their counterparts in right-wing political parties: often the two areas were linked either to prevent or to control change by dominating institutional and thus establishment taste. The second is that artists and art *cognoscenti* of apparently more advanced and liberal views were just as unlikely to countenance a complete liberalization of the arts in Australia as were old-fashioned conservatives. Yet in all this flux, artists of a radical persuasion were possibly best served. The events that resulted in the creation of the C.A.S. in Melbourne in 1938 brought with them many an internal and apparently internecine struggle. What was at the time and in retrospect abundantly clear was that the radicals, who stretched from communist social realists like Noel Counihan and an apostate left-wing painter like Albert Tucker to Jewish painters like Yosl Bergner, and even to the esoteric, questing Sidney Nolan, found their home in the various warring sects within the general aegis of the C.A.S. and a community of the spirit, however disparate, which it fostered.

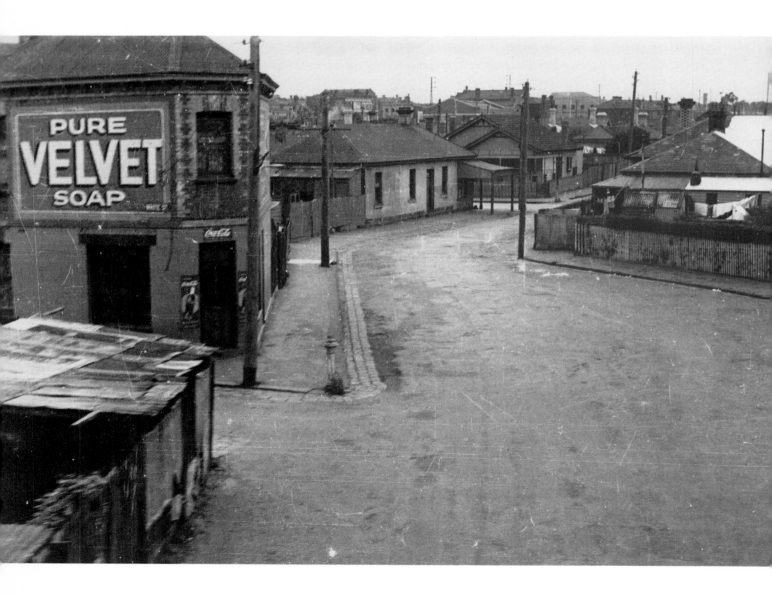

CHAPTER THREE
DEMOCRACY AND MODERNISM
The Contemporary Art Society
and the Popular Front 1939-1942

Everything remains to be done, every means must be worth trying, to lay waste to the concepts of the family, nation, religion`. . .` We combat, in whatever form they may appear, poetic indifference, the distraction of art, scholarly research, pure speculation.

André Breton (1929)

Virginia Woolf observed that in or about 1910 'the world changed'. That was the year of the first of the great post-impressionist exhibitions arranged by Roger Fry in London at the Grafton Galleries in 1910 and 1912. Something similar could be said of creative artists in Australia between 1939 and 1942. In 1939, the *Herald* Exhibition of French and British Contemporary Art gathered together in the Melbourne Town Hall canvases that included many from the most advanced of modernist painters in France and Britain. It was a triumph for liberals and radicals, in that order. Then in 1941 the Contemporary Art Society held its most notorious exhibition, which brought together works testifying to the dynamic changes that had taken place in Australian painting since the 1930s. And this too was a triumph — for modernist radicals and for all those committed to the political left.

The *Herald* Exhibition of 1939

The *Herald* exhibition was intended for a larger and more general audience than the restricted public normally drawn to art shows; with a vast array of paintings and sculpture ranging from Cézanne and Gauguin to Dali and Ernst, it represented a major assault on popular and academic taste.[1] The exhibition seemed, indeed, to bolster the cause of leading Australian modernists.

Australian artists were not involved in selecting work for the show, sponsored by Sir Keith Murdoch and arranged by his colleague Basil Burdett. Nonetheless, for Australians it was without precedent. True, earlier loan exhibitions had been organized during the 1930s, in particular that held at the National Gallery of Victoria in October 1937 and arranged jointly by George Bell and Sydney Ure Smith. Its British and

Opposite Australian suburbia: vast reaches of bitumen and bluestone, weatherboard and red brick, galvanized iron and terra-cotta tiles; this was the world that stood in stark contrast to the life-force of the inner city or outer bushland communities for young artists and intellectuals

Catalogue of the *Herald* Exhibition of French and British Contemporary Art that went on show in Australia in 1939

European paintings were drawn from local collections and the overwhelming bias in the fifty-two works was towards British art. But already in 1937 the idea of a more imposing international show was in the air.

In September of the following year, with a brief to assemble canvases for a truly modern exhibition, Burdett arrived in London shortly after the Munich crisis. While the resulting exhibition reflected something of Burdett's own taste, it was also moulded by the political exigencies of 1938-39. The feeling of imminent war made many owners apprehensive about lending works, but in other areas Burdett found the climate to his advantage. The enterprise could be projected as a cultural protest against militarism and fascism. Hitler's huge Munich exhibitions (700 confiscated works had been shown in 1937 and a show of officially sponsored and approved work was held in 1938) had been intended to reveal the disparity between the health and vigour of the new German art and the diseased condition of modernism and non-Aryan art. In 1938 the British Council and the French Association for Action through Art had also held exhibitions in several European capitals.[2] From this point of view, Burdett arrived at precisely the right psychological moment. He was able to take works directly from projects already containing canvases from the Tate Gallery and the *Jeu de Paume*. The Museum of Modern Art in New York also offered its services by lending, among others, fine paintings by Gauguin and Matisse. In general, the quality of the selection was extraordinarily high. In the process of assembling it Burdett visited the studios of artists as prominent as Maurice de Vlaminck, Fernand Léger and Picasso.

Burdett's efforts resulted in a remarkable show, but he himself was as luckless as ever. On the boat trip back to Australia he fell ill with jaundice, and to his chagrin a younger colleague, Peter Bellew, took over the actual running of the exhibition. John Reed describes the degree of 'flair' Bellew showed: 'He made Adrian Lawlor a master of ceremonies and had a chariot built in which Adrian propelled himself around and harangued the crowds.'[3] While Burdett languished in bed, Bellew bathed in reflected glory at the Melbourne Town Hall. It was too much for Burdett, who dragged himself out for a reckoning at the site of the crime. A friend, Michael Keon, witnessed the extraordinary sight of Burdett's tall figure loping down Little Collins Street, his prominent jaw set and face sulphurous, as much with ill-concealed rage as with jaundice; dressed in a blue double-breasted pencil-striped suit, grey Homburg and, to match the colour of his eyes, bright yellow patent leather shoes. Muttering darkly, 'You know where I'm going, don't you!', Burdett forged onwards to confront his rival.

Whatever the personal frustration, Burdett's exhibition represented the first wholesale and direct contact that most Australians, whether artist or laity, had with modernism and its perspective of the twentieth century. It was accompanied by a large-scale public relations and adver-

tising exercise through the Adelaide *Advertiser*, the Melbourne *Herald* and *Sun*, the *Sydney Morning Herald* and the Brisbane *Daily Mail*. By design and by accident the selection of paintings was bound to excite response, but that selection avoided almost all inclusion of and reference to the radical face of the modern movement. The glimpse, important as it was, revealed to artists what were already familiar features. It is not now easy to reconstruct the exhibition given the poorly illustrated and inadequately documented catalogue and the absence of first-rate critical comment.[4] But by being restricted to the Anglo-French tradition, it contained no examples of German or northern European expressionism, or works by the German new-objectivity movement of the 1920s. There was no Russian painting and no Italian futurism. Nor were there examples of vorticism, dadaism, the more radical canvases and collages of Picasso's cubist work, or the abstracted fauvism of Matisse. There was some surrealism; but the movement was thinly represented, with one work each by Chagall, Ernst, Dali and de Chirico. This meagre ration was supplemented by the milder work of British artists who had been influenced by surrealism and expressionism: Sutherland, Wood and Wadsworth. The exclusion of such long-recognized high points of modernism can be explained by the political climate and by Burdett and Murdoch's feeling that modernism had generated a lunatic fringe; such art was as alien to the refined aesthetic sensibility of the *haute-bourgeoisie* in Paris as it was to Melbourne.

The exhibition provided a shock of the new, but by its nature it could also be sold as respectable and patriotic. It was not mere rhetoric, therefore, when the exhibition was opened in Melbourne following the outbreak of war and the French Consul-General declared: 'We could not wish for a more effective and better form of propaganda than this fine show.' In a general sense, the selection of works was safe and acceptable. For example, all the nine canvases by Picasso except one still life from 1914 avoided the high cubist phase of the artist's work. The same can be said of the four works by Braque, which excluded the analytic cubist period of 1907-12. The main emphasis was on post-impressionism and later examples of the 'School of Paris': there were seven important canvases by Cézanne; eight each by Gauguin, Matisse, Seurat, Van Gogh and Bonnard; works by Vuillard, Modigliani, Gris, Léger, Signac, Derain and Vlaminck. The sizable British section was dominated by the stalwarts of the New English Art Club: Walter Sickert, Philip Wilson Steer, Henry Tonks and Augustus John. As Burdett's friend John D. Moore pointed out with approval in Sydney, the work was 'very traditional and not revolutionary as some people claim'. [5]

The anti-establishment campaign of which the exhibition was a crucial part culminated in a *Herald* editorial on 28 October 1939, in which Murdoch blasted the conservative and insular buying policies of Australia's principal national galleries. This was a counter-attack to views already expressed by Will Ashton, director of the National Gallery

of N.S.W., and by J. S. MacDonald in Melbourne. MacDonald, especially, had opposed any purchases from the show in the most vitriolic terms imaginable. 'As owners of a great van Eyck,' MacDonald declared, 'if we take a part in refusing to pollute our gallery with this filth we shall render a service to Art.'[6] By attacking the exhibition, MacDonald was aiming a direct blow at Murdoch as the newly elected chairman of the board of trustees of the Gallery. In the event, what was bought in Australia was of low quality and in minor key. The National Gallery of Victoria bought two small works, by Van Gogh and Félix Vallotton; the National Gallery of N.S.W. four, by Wilson Steer, Tonks, Derain and Gauguin (this last, *La Cabaretière*, was later successfully claimed by Camoin to have been one of his early pictures).[7] Members of the Contemporary Art Society had lobbied for major acquisitions but even their presentation of a painting to the Melbourne Gallery was unadventurous — a minor Derain, *Roses in a Blue Vase*. In a direct material sense, Australia gained little.

The degree to which the exhibition leavened local sensibilities is more difficult to assess. There is no doubt that it generated enormous excitement and enthusiasm. John Reed recalls that 'one always had the feeling that ... things were never the same — that combined with the formation of the C.A.S. and the C.A.S.'s first exhibition'.[8] Certainly, the connection between the two events is important. The timing of the exhibition created a wave of support for the Society, one upon which branches were successfully launched in Sydney and Adelaide. The *Herald* exhibition gave legitimacy to the C.A.S. in intellectual circles, thereby boosting its prestige and respectability in the eyes of the public.

In general the response by artists was enthusiasm for art works with which they were already familiar. The exhibition confirmed and consolidated much of what Bell and the Fizelle-Crowley schools had been teaching. However, it had little to offer artists who were beginning to discover a more radical modernism in surrealism and expressionism. Albert Tucker's reaction sums up the collective response: 'Tremendous revelation, absolutely tremendous — mind you, I was already familiar with a lot of it by courtesy of Gino Nibbi.'[9]

In creating a groundswell of enthusiasm for modernism the really significant effect of the *Herald* exhibition was its impact on the non-art-student intelligentsia also coming of age in the late 1930s. The extent of this impact might be difficult to assess but impact there was. Ian Turner, in 1939 soon to be a student of arts and law at Melbourne University, has testified that it was in the Melbourne Town Hall that he caught his 'first glimpse of the world through new ideas'.[10] It is almost certain that this experience was shared by many others. The Contemporary Art Society had also begun to convince this public that art mattered and that radical art was a touchstone for contemporary thought. The success of the *Herald* exhibition at once confirmed that belief and extended it into new quarters. A description by Herbert Read of the

effects of the first great international surrealist exhibition held in London in 1936 might have equally applied to the *Herald* exhibition:

in the outcome people, mostly young people, came in their hundreds and thousands not to sneer, but to learn, to find enlightenment, to live. When the foam and froth of society and the press had subsided, we were left with a serious public of scientists, artists, philosophers and socialists.[11]

The *Herald* exhibition helped, then, to inform students where modernism had been in the late nineteenth century and where safe enclaves existed in the twentieth, but it offered little that might indicate where the modern artist ought to stand in 1940. Despite this symbol of contact with modern European culture, the Australian artist remained comparatively isolated from the more radical movements overseas. The outbreak of war served to increase the isolation of Australian artists — in contrast, for example, to their American counterparts. American artists in New York had had continuous access to some of the greatest and most comprehensive collections of modern art ever assembled. With the fall of Paris, the entire surrealist movement, as well as the foremost abstract artists of the era, ended their wholesale exodus in New York. American artists felt charged therefore with a sense of responsibility for sustaining a European tradition and civilization.

 Australians, facing a world in crisis, felt as deeply as any others a need to sustain art and civilization but, unlike the Americans, possessed few immediate and tangible models. The German occupation of Western Europe prevented the flow of publications from the major art centres to Australia and, to fill the gap, Peter Bellew, having moved to Sydney in 1940, in 1941 refurbished Sydney Ure Smith's one-time property *Art in Australia*. Bellew, with the help of talented expatriates, transformed that old and rather fusty magazine into a lavish production that would not have disgraced its internationalist model, *Cahiers d'Art*. The editorial of the first issue declared in 1941 that 'Art cannot die, and we in Australia can preserve, encourage and foster the culture our enemies would destroy.'[12]

Peter Bellew: a journalist and a man of great entrepreneurial flair, Bellew was committed to a belief that Australian artists should maintain contact with the best of European cultural values even at a time of global conflict

The Radical Defence of Culture

Such a declaration had a special meaning for radicals early in 1941. To defend culture meant to promote revolutionary political aims by strengthening all those forces opposing fascism and reaction in a broad alliance. True, communists outside Soviet Russia maintained a difficult and equivocating attitude towards the 'imperialist' Allied war effort against the Axis powers while the Nazi-Soviet Pact remained in force. Cynical exercise though it might appear to outsiders, every communist knew that only tactical necessities dictated the temporary suspension of policy embodied in the popular front against fascism which the 7th

Congress of the Comintern had laid down in 1935 as binding on national communist parties. The united front policy adopted by communists everywhere joined progressive forces and individuals in an unremitting campaign against a fascist evil that was seen as being both local and immediate as well as international and long-term. The tactic was nominally suspended after August 1939 and was not resumed until 22 June 1941 when the German army launched operation Barbarossa.

Whatever the political difficulties faced by communists in 1939-41, it remains true that during this period the extreme left impressed its values upon the character of cultural bodies like the Contemporary Art Society in Australia, as it did upon radical-minded individuals and groups in most western nations at this time of crisis. Many of the leaders of the Contemporary Art Society between 1938 and 1942 were either members of the Communist Party or had seriously entertained the idea of membership. The list of card-carrying members includes Noel Counihan, Vic O'Connor, Yosl Bergner, Harry de Hartog, Malcolm Good, Danila Vassilieff, Herbert McClintock, James Cant, Roy Dalgarno, Bernard Smith and Max Harris. Some had been longstanding Party members. Harry de Hartog, for example, had been active on the left as a youth in Holland before coming to Australia in 1923 and joining the Party in 1924.

Harry de Hartog: this Dutch expatriate artist and member of the Communist Party succeeded George Bell as president of the C.A.S. in 1940

The point must be established immediately that membership of the Communist Party by many of these artists and intellectuals could often mean quite widely varying moral outlooks as well as practical concerns. In the case of men like Cant or Harris, membership of the Communist Party involved at most an alliance with those of a more extreme view who opposed the same enemies; in no way did their membership involve subservience to the vast array of Stalinist proclamations, programmes and injunctions. Indeed there were many who, though feeling a broad sympathy with the ideals of the political left, found themselves saddled with an ambiguous and at best obscure relationship with the Party. Many of the numerous front organizations in the late 1930s did not clearly define the responsibilities of members either to the organizations themselves, or between a so-called 'branch' and the central Party. As a case in point, Albert Tucker's anguished personal experiences of social realities in the 1930s led him to join an 'artists branch' of the Communist Party. In an acrimonious dispute with communists in 1944, Tucker stated the nature of his connection thus:

I was a member for about three years. I developed theoretical conflicts with them over cultural matters. After being subjected to bureaucratic gagging and inquisitions . . . I ceased attending meetings or paying dues. A few months later I was asked to clarify my position. I did so to a special meeting led by Counihan . . . and refused to return to the fold.[13]

As far as Tucker was concerned he was more a member of an intellectual *salon* than of the Party in the sense in which Counihan would have under-

stood it. The 'artists branch' itself remains an obscure body. It was formed probably by de Hartog and Counihan and seems to have been a comparatively small group whose activities included conducting art classes, painting banners and producing sets for the New Theatre.

Beyond hard-core Party members, most artists, even where affiliated in various ways with the Party, can more accurately be described as 'fellow travellers'. John Reed, for example, felt a general sympathy for Party aims as did so many advanced thinkers. There was talk among Reed's friends of joining, but most retained, as he did, their fellow-travelling status. Later, in a similar frame of mind to Albert Tucker's, Reed also described the extent of his involvement with Party affairs.[14] Both he and Sunday Reed gave financial support to Party campaigns out of a sense of shared ideals and personal friendship with communists who often had links with the C.A.S. Reed had contributed money to support the state secretary of the Communist Party in Victoria, Jack Blake, when he was ill with tuberculosis. The extent of other radicals' sympathies is harder to ascertain. The group of young artists and students that included Sidney Nolan, Lawrence Pendlebury, Gordon Daniels and John Sinclair had a cautious left-wing outlook. Sinclair recalls that Nolan especially, although of the left, was strongly anti-Stalinist and utterly rejected socialist-realist aesthetics.[15]

Among such radicals the Contemporary Art Society was increasingly seen as a fighting organization for the defence of democratic and progressive values in opposition to all that was conservative, reactionary, potentially fascist, and morally iniquitous. It was, at the same time, envisaged as having a catalytic and nurturing role for a new art and a new sense of professionalism for the Australian artist. These two roles, which happily co-existed and mutually reinforced one another in the early 1940s, proved totally incompatible by the middle of the decade.

The early radical conception of the Contemporary Art Society had from the beginning conflicted sharply with George Bell's views. The uneasy alliance between moderates and radicals under his presidency began to disintegrate within months of the first annual exhibition in 1939. The first blows were struck at a general meeting in September called to discuss changes to the constitution. Unhappy about Bell's attitude, Lawlor wrote confidentially to Tucker inviting him to an unofficial war-council at which it would be discussed 'whether we want to be [an] anti-academic (in the narrow local sense of the word) society, or whether we wish to be part of the modern movement in art'.[16] Four days before the official meeting this group circulated the results of its deliberations in the form of a signed notice to all members warning of the dangers which alterations to the constitution would involve.[17] The health of the Society in carrying through its progressive role of revitalizing Australian cultural life was in danger of being 'entirely nullified, and the Society ... completely wrecked by the actions of one group'. If successful that group would 'turn laymen into mere appendages of the

Malcolm Good: member of the C.A.S. and the Communist Party and a quixotic candidate in the federal and state parliamentary elections of 1940 and 1943

Society, increase the division of opinion among artists, and create a dangerous undemocratic inequality ... which would seriously weaken our opposition to reaction in art, as well as our own progressive movement'. This opposition party was led by Reed, Lawlor, Tucker and de Hartog. Not all were radicals but all were determined to save the Society by ensuring that lay members could not be removed from the council and their influence destroyed.

At the general meeting this group defeated Bell and his friends by only one vote. (Appropriately enough, Albert Tucker gave the meeting a talk entitled 'Politics and Art'.) Although no split occurred that time, any notion that a united front could include everybody was undermined. As Bell later stated, from that point 'the atmosphere always unpleasant became downright nasty'.[18] This must have been the case for both parties.

Bell finally resigned as president of the C.A.S. in June 1940, shortly before the scheduled annual general meeting that finally brought everything to a head.[19] As Reed recalls, 'I consistently tried to work with George ... I sought a mediator in the person of Clive Stephen ... and asked if he would help bring us together. Unfortunately he proved as intransigent as George.'[20] The annual general meeting itself, despite efforts at mediation, was as stormy as everyone had feared and, in the face of personal accusations, Reed walked out. He was soon followed by Bell and a large group of the latter's supporters, who resigned from the Society *en masse*.

Bell had believed that in the months leading up to this event 'the Society had been infiltrated and captured by communists in the Stalin style'.[21] And no doubt he had become, as Reed put it, 'increasingly opposed to any form of activity which tended to widen the scope of the Society'.[22] As a consequence, Bell played his last card: before storming out of the hall, he proposed that the Contemporary Art Society be terminated. Once over the initial shock, his opponents remembered that the Society could not be wound up without the calling of a special meeting for this specific purpose, and Bell was forced to withdraw the motion.

The Contemporary Art Society had survived, but at great cost. The exodus of the liberals ended the possibility of further patronage by powerful men of the stamp of Murdoch and Daryl Lindsay. It also lost the use of the studio which Bell had promised for life classes and social gatherings. Henceforth radical artists found no favour with the powerful leaders of the emerging cultural establishment.

Despite Reed's efforts to hold the alliance together, a split of some kind was inevitable given the utterly divergent conceptions of the role of the C.A.S. and the art it should champion. Conspiratorial accusations aside, Bell was right in seeing an aggressively radical left-wing movement within its ranks. Those who triumphed in 1940 were either communists or sympathizers or, like Lawlor, men wishing to give full effect to the idealism that had helped create the C.A.S. The only way

of maintaining a broad base with community links, and ensuring that all artists had a right to exhibit, was through a democratic institution protected from the whims of individual members. The shift in leadership reflected the new dominance of the radical values that stamped the 1941 annual C.A.S. exhibition. Markedly different from the preceding exhibitions of 1939 and 1940 (which were lent a sense of gravity by the venue, the National Gallery of Victoria), the exhibition in 1941 embodied in full measure the values members now embraced; the world had certainly changed in 1940.

The first show in 1939 had reflected the heterogeneous nature of the original C.A.S., containing as it did selected work from almost every serious artist in Melbourne and Sydney not within the ambit of the Academy. The annual exhibition of 1940 was held in August after the split with George Bell, which had two consequences. The first was the absence of Bell's supporters and friends, such as Drysdale, who left Melbourne for Sydney at this time, much embittered by Melbourne art politics. The second was that it was an unselected exhibition and therefore contained a wider range of work, both good and bad. The latter proved troublesome when the exhibition was shown in Sydney later in 1940 at the David Jones Gallery; the early success of a cautious modernism in that city seemed imperilled.

The C.A.S. in Sydney

Following Peter Bellew's move in 1940 to Sydney, where he had accepted a job on the *Daily Telegraph*, John Reed, who had taken over as secretary of the C.A.S. from Bellew in Melbourne, suggested that Bellew should try to form a new branch in Sydney. The initial meeting took place at H. V. Evatt's house in Mosman and was attended by Rah Fizelle, Paul Haefliger, Frank Hinder and other leading Sydney modernists. A formal meeting of artists was held at the Teachers' Federation Building on 13 August 1940 and a committee was elected with Fizelle as chairman and Bellew as secretary. From the start, however, things were not as smooth as this short recital of events might suggest.

In commenting on recent events in Melbourne at this time, the critic Kenneth Wilkinson concluded that 'blazing controversy seems to be essential, after all, if art is to remain a living force'. Sydney was to experience it in full measure. As a friend of Bell, Fizelle shared with other Sydney modernists deep doubts concerning Bellew's idea of a radical and democratic society. Such doubts on the part of the few were overridden, however, by the enthusiasm of the many. It was an enthusiasm in part engendered by the excitement of the recent showing in Sydney of the *Herald* exhibition. The Sydney exhibition of the C.A.S., which opened in September 1940, soon revealed the limits of this enthusiasm. In his review of the exhibition in *Art in Australia*, Wilkinson wrote that Sydney artists were, on the whole, more amiable and reasonable than their Melbourne counterparts.[23] 'They do not', Wilkinson noted, 'publicly fight

Sydney artist Frank Hinder and his American-born wife, the sculptress Margel Hinder: the two artists were leading Sydney modernists and belonged to a circle strongly influenced by European and American cubist-based constructivism. The beliefs of these highly articulate abstractionists contrasted and conflicted strongly with the more intuitive and emotional art of young Melbourne artists

to the death.' 'Publicly' was the operative word. In private, the dispute over the question of 'standards' was intense, and demonstrated that many Sydney artists felt, no less strongly than Bell, that artists had to ensure the right kind of professionalism.

Sidney Nolan's painting *Boy and the Moon* (see p. 151) tested the limits of this sense of professionalism and served to polarize opinion. Wilkinson listed it as being among the minority of works that failed to reach accepted standards. 'Few spectators', he maintained, 'will be able to take seriously Sidney Nolan's "Boy in the Moon" [*sic*].'[24] For Wilkinson, it was the work of a non-artist — and others agreed. Frank Hinder recalls that he 'was one of several who wanted it thrown out because we saw it as such a fraud'.[25] It appeared to be a gimmick; some called it the 'lavatory seat', and for many it seemed to devalue their own works, alongside

which it was hung. Hinder went so far as to resign from the C.A.S. committee in protest at Peter Bellew's high-handed insistence on its inclusion. Paul Haefliger was opposed to it, and in Melbourne Adrian Lawlor had been unable to accept it as art. In a debate with Nolan, Lawlor had been reduced to a paroxysm of frustration when forced into the impossible position of having to demonstrate what was *not* a work of art.

Despite the widely differing character of the canvases of Fizelle, Hinder, Haefliger and Lawlor, such men were united on the question of what it was to be an artist. Their principles differed little from the views of a man like Sydney Ure Smith. Having seen the C.A.S. show which had been opened by John D. Moore, Ure Smith felt compelled to reply to its attack on the ideals he valued. 'An art society composed of laymen and practising artists', he declared, 'can never be regarded seriously. Art is not different from any other profession . . . let us progress cautiously, but also do not let us lose our sense of the fitness of things.'[26] As with Bell in Melbourne, Ure Smith rejected the C.A.S. as a venue for acceptable forms of artistic modernism: for both men, democratic culture was a contradiction in terms.

The C.A.S. in Melbourne
In 1941 the Society applied once again for National Gallery space in Melbourne and was met with a flat rejection. This finally demonstrated that neither Murdoch nor the new director, Daryl Lindsay, had any desire to offer encouragement to this new and troublesome group. Whatever the openness of Burdett to the work of radicals, it was apparent that his friends had no sympathy whatsoever for the work of artists like Nolan, Tucker or Vassilieff.

If the events of 1940 heralded the shape of things to come, the annual exhibition of 1941 stated the values of the new Contemporary Art Society in unequivocal terms. The catalogue set forth the following principles:

The Contemporary Art Society offers absolute freedom to the Australian artist, imposes no limitations and refuses no work, except that which has no aim other than representation. It is essential that opportunities be provided for showing the work of artists trying to break new ground. No jury has sat upon these pictures, nor do they represent the theories of any particular group. The paramount object of the Society is the encouragement of a creative contemporary art. To do this, the Society realises it must show work at all stages of experiment and discovery.[27]

Representational paintings only were excluded; in effect, this barred all who, however sympathetic otherwise, were not prepared to be as experimental as modernists — a clause which was used later to political effect. The 1941 exhibition was an attempt to implement democratic principles

and ensure that the new art would evolve freely, unhampered by extraneous controls. In 1940-41 the C.A.S. also began a vigorous programme of public lectures, and although these soon faded their significance to us now is that they indicate the intense intellectual interest in surrealism at this time. That interest was also strongly evident in the paintings of the 1940 and 1941 exhibitions, as was a preoccupation with expressive social realism.

The 1941 exhibition included fine examples of work from the most promising young artists of Melbourne and Sydney: some leant towards abstraction, but the majority of the more important paintings were exercises in surrealism and social realism. Among the more significant were two paintings by Danila Vassilieff of Fitzroy street scenes; a piece of sculpture by Sidney Nolan, *Woman and Bird*, together with five paintings, including *Luna Park*; two paintings by Noel Counihan, *Pregnant Woman* and *Consumptive* (his first exhibited works); six surrealist paintings by James Gleeson; a large anti-war painting by James Cant, *The Merchants of Death*; and four works by Albert Tucker, which included the important *Spring in Fitzroy* and *Setting Sun*. Among the most exciting on show were four pictures by the young Yosl Bergner: *Russell Street, City Lane, Pie Eaters* and *Refugees* — their first exposure to a large audience.

In terms of size alone (310 works — far more than the *Herald* exhibition), this show was a massive assault on all assumptions about art in Australia. Its dramatic character, both in quality and quantity, was enhanced by the nature of the venue and the events which surrounded its presentation in October 1941. The refusal of the National Gallery to provide hanging space saw a desperate search for premises. Few commercial galleries were large enough to accommodate the vast array of work, an exhibition almost twice the size of the previous year's. Finally the idea was sold to the management of the new Hotel Australia in Collins Street (in itself a shining symbol of cosmopolitanism), which agreed to provide the space on the promise that the exhibition would draw not only large art crowds, but thirsty ones. The exhibition that resulted from all this labour was a landmark in Australian art and in its own way as important as the *Herald* exhibition.

It was intended to display various facets of the modern creative spirit and set these against 'retrogressive' culture. A central feature of the exhibition therefore was two evenings of modern music: one 'serious' and 'classical', the other a performance of 'hot jazz'. The response of local classical composers and performers was disappointing, but Don Banks and the Graeme Bell jazz band helped make the night of 28 October a heady experience.

Of the papers, only the Melbourne *Truth* could capture the new atmosphere of the occasion:

The show on Tuesday brought together the strangest combination seen in Melbourne for a long time. Long haired intellectuals, swing fiends, hot mommas

Albert Tucker, *Spring in Fitzroy*, 1941

Danila Vassilieff, *Nocturne No. 3 (Commonwealth Lane)*, 1936

and truckin' jazz boys rubbed shoulders on friendly terms. While swingsters hollered 'Go to Town' and jittered in the aisles, the intelligentsia learnedly discussed differences between rhythms of hot jazz and pigment of Picasso.[28]

Amid the noise and elation, other C.A.S. members were getting signatures together on a petition to the Chief Secretary attacking the trustees of the National Gallery of Victoria for failing to represent or to accept the values of the contemporary movement in art; this movement, the petition pointed out, was universally accepted everywhere in Europe except in Germany. The last clause annoyed two naval officers, who snatched the petition and fled with it into the nearby lavatories. *Truth* reported that John Reed called for 'six moderately sober volunteers' to rescue it from these uniformed representatives of the establishment. In spite of cries of 'Hands off the King's uniform!', the fracas surged out into Collins Street. By then much of the petition had vanished down one of the lavatories. The manager of the exhibition ('flowing-haired and yellow-tied Michael Keon') told reporters, 'This puerile, barbaric and intolerant destruction of the petition is typical of just that attitude we are attempting to control.' As Reed later concluded, 'one could only get the rather rueful satisfaction of handing them to the police'.[29]

The catalogue of the 1941 C.A.S. exhibition, the largest and most notorious of such events

The ill-fated petition had been part of a general campaign against 'authoritarian' control of art in Australia. In New South Wales this was prosecuted zealously by Peter Bellew, who had had a professional interest in the *Herald* exhibition. The trustees of the National Gallery of N.S.W., to whom many canvases from that exhibition had been entrusted during the war, had decided to store them in the Gallery cellars. This particular grievance later led to a broad movement of protest in Sydney against the administration of the National Gallery, and to far-reaching changes. But at this stage a further protest was sparked off by the issue of the American Loan Exhibition of Australian and New Zealand Art, being organized in 1941 by Professor Sizer of Yale University. As with the annual exhibition of 1940, the Sydney branch of the C.A.S. split again on the question of selection. In the end, the C.A.S. refused an invitation to submit work for consideration by the conservative selection committee. On this occasion, Frank Hinder resigned altogether from the C.A.S.[30] Although the exhibition contained work by artists such as Russell Drysdale and Peter Purves Smith (the New York Museum of Modern Art bought Purves Smith's *Kangaroo Hunt*), the image Americans received was the time-honoured one of the pastoral. The central canvases expressing this vision for Americans were David Davies' *Golden Summer*, Tom Roberts's *Shearing the Rams*, Walter Withers' *By Tranquil Waters* and Arthur Streeton's *The Purple Noon's Transparent Might*.[31]

In terms of size and the inclusion of the foremost talent in Australian art, the C.A.S. reached its zenith in 1942. In that year it was extended to include a third branch in Adelaide, bringing on to the cultural scene new and dynamic radical figures such as Max Harris.

Ivor Francis, *Schizophrenia*, 1943.
South Australian artists like Francis,
while anxious to link up with
progressive movements in Melbourne,
were considerably less radical than
their contemporaries elsewhere

The C.A.S in Adelaide

Until 1942, Adelaide art had been controlled more or less completely by the conservative-led Royal South Australian Society of Arts. The body was housed, as it still is, in impressive premises on North Terrace; as an organization it was largely directed by the conservative values of its secretary, the art critic for the Adelaide *Advertiser*, Henry Fuller. During the 1930s there grew up in its ranks, whether as fellows or associates in the Royal Academy style, a number of more liberal-minded members who formed themselves into a separate exhibiting body called 'Group 9'. Two leading members were Dorrit Black, who had studied under Lhote in Paris, and Lisette Kohlhagen, once a pupil of George Bell.[32] The younger artists and students who were to form the nucleus of the Adelaide branch of the C.A.S. were mostly associate or junior members of the Adelaide Society of Arts: Ivor Francis, David Dallwitz, Douglas Roberts, Jacqueline Hick, Jeffrey Smart and Ruth Tuck; they were a lively group but they knew little about modernism. By 1941 Max Harris and Francis especially had begun to read about and to experiment with surrealism and symbolism. Among artists Ivor Francis, by virtue of his senior status, found himself cast as spokesman and leader for a group that had studied together at the South Australian School of Art. There they had discovered the imaginative dimensions of art through the teaching of art history and appreciation by Mary Harris, a Scottish Quaker and mystic with an enthusiasm for the work of Blake and the romantic movement in art and poetry. Her teaching also embraced the works of Van Gogh and other post-impressionists, although in a highly idiosyncratic way. The awareness of students was further quickened by Bellew's new *Art in Australia* and little magazines such as *A Comment* from Melbourne and Adelaide's own *Angry Penguins*, which had first appeared in 1940.

Towards the end of 1941 the more radical associates of the Society of Arts conceived the idea of staging an exhibition of contemporary Australian art under the auspices of the C.A.S.[33] This was in part a protest against the restriction imposed upon them by the Society, which had refused to hang many of their works in its spring and autumn shows. But the council of the Society of Arts agreed to allow the associates to organize their own show, and to accept interstate work. There was a degree of double-dealing by the moderns in this: they did not reveal to many of the other associates or to their supporters among the fellows, such as Dorrit Black, that the proposed exhibition involved the C.A.S. A committee met on 19 March 1942 to organize the exhibition, but at this point there was no intention to break from the Society of Arts; the aim was to save it from itself through reform. However, John Reed was not prepared to lend the support of the C.A.S on such a restricted basis, and a compromise was made: that Sydney and Melbourne artists would contribute works on a voluntary basis. The exhibition opened on 9 July

to the dismay and shock of the older members of the Society of Arts. Fuller expressed their feelings of betrayal: 'It's been threatened for a long time and it's come at last. Art has passed through many phases, and has come to a stage which perhaps defies adequate words for description.' The Society of Arts vowed that never again would it be cheated into sponsoring another such outrageous show. Questions were asked in state parliament, and the *South Australian Teachers' Journal* published a special number devoted to the show.

The South Australian branch of the C.A.S. was established on 23 June 1942 before the exhibition opened. An early discussion had taken place at the home of the artist and jazzman Dave Dallwitz, where Max Harris, his arms full of magazines, argued that the committee that had been set up to arrange the exhibition should not stop there. Adelaide artists, Harris had argued for some time, should form a branch of the C.A.S. and link up with the progressive current in Australian culture elsewhere.[34] When the branch was finally formed, Dallwitz was elected chairman, Dorrit Black vice-chairman, and Harris secretary.[35] For all the initial rebelliousness of the Adelaide artists, the decision was taken reluctantly and only in the face of continued obstruction from the Society of Arts, as well as much cajoling from Harris.

The Adelaide members of the C.A.S. shared with many Sydney colleagues a distaste for radical experiment in art, however. Reed continued to pressure Francis to attack the acquisition policy of the South Australian Gallery under its director, Louis McCubbin, but Francis resisted. South Australians were also sceptical of the idea of non-selection because they were anxious to dissociate themselves from amateur Sunday painters of the Society of Arts. C.A.S. shows had to *look* professional. One consequence was that membership in Adelaide was more exclusive: two people were required to vouch for a member's 'contemporaneity' (in Melbourne anyone could join by merely paying a subscription of 2s 6d). But in spite of the differences, Reed declared to Mary Alice Evatt that 'the exhibition in Adelaide has been a tremendous success and seems to have had a dynamic effect on that rather dreary city'.[36]

The year 1942 saw, then, a high watermark in the history of the C.A.S. Established in the three largest cities, it could justifiably claim to be a national body representing the most advanced intellectual and artistic elements in the Australian community. The one shadow was that neither the Sydney nor the Adelaide branch was united over principles which by 1942 formed the keystone of the executive branch in Melbourne. Nevertheless, the radical leadership prevailed at this time in the three groups and the C.A.S. was nominally united on the principle of cultural democracy.

Although the Communist Party remained illegal until the end of 1942, communists worked openly after June 1941 in support of the Allied war

effort on the basis of the united front policy.[37] The Party had been declared illegal by the Menzies U.A.P. Government on 15 June 1940, but after June 1941 its growing popularity combined with a whole-hearted support of the war meant that no government action was taken against it. The spirit that prevailed in the C.A.S. early in 1942 reflected a policy of active co-operation by Communist Party members with all causes and individuals that might help further the destruction of fascism at home and abroad.

It was on the basis of this crusade against fascism that Noel Counihan was prepared to work with John Reed and Albert Tucker and to accept experimentation. The fact that Counihan was successful in forging links outside the C.A.S. between communists and conservatives such as Harold Herbert or liberals such as Sydney Ure Smith was looked upon with disquiet by Reed and Tucker. They felt that the C.A.S. owed its birth to the rebellion against reaction and survived because of its resistance to attempts at dictatorship. Despite rumblings, the front held until the end of 1942, a year in which, in the face of the Japanese advance, Australia's very survival seemed to demand the repression of finer points of cultural principle.

Noel Counihan, a founding member who became prominent in the C.A.S. in 1942, had not, in fact, been involved in the earlier fight for survival. In 1940 he had been in New Zealand with Judah Waten and in early 1941 was still recovering from the tuberculosis to which he had succumbed while away. Later in 1941, with some degree of health restored, he finally committed himself to painting. This, plus the change in party tactics after June 1941, led Counihan to join Tucker and Reed as the leading spokesmen of the Contemporary Art Society. In 1941 Tucker was elected president and Reed was re-elected secretary. In the following year Reed relinquished his legal practice to work wholly for the C.A.S. and to set about launching a publishing venture with his wife Sunday and with Max Harris. Vic O'Connor and Yosl Bergner also became leading members of the Melbourne C.A.S. council at this time, as well as being recruited into the ranks of the Communist Party.

The C.A.S. had come a long way from 1938. What began as an act of opposition to local conservatism in Australian art had expanded into a national body of artists and intellectuals whose opposition to reaction and fascism was conceived in international political and cultural terms. The fight against reaction at home had become linked by the exigencies of war with the revolutionary crusade of the 1930s against fascist oppression everywhere. Reflecting this, the annual exhibition of the C.A.S. in 1942 was held, it was stated, at a time when 'battles are being fought which will decide the very future of the human race and its cultural achievements'.[38] The foreword to the catalogue went on to state:

We fight for the fundamental liberty to express ourselves as we think fit. The fight must be aggressively fought on every front . . . The fact that in the midst

Noel Counihan, artist and committed revolutionary, photographed in the Melbourne offices of the magazine *Table Talk* in 1937

of the most terrible crisis in our history our artists contrive to create freely and plentifully is the best test of our national health.

This exhibition of art, representative of the contemporary artists of New South Wales, South Australia and Victoria, most of them in the armed forces or performing national service, is a further demonstration that we Australians are a free, virile and creative people, believing in our cause.

In contrast to the ignominy and sterility of art under Fascism, we present the freedom of our democratic art.

In opposition to the art of conservative reaction, the C.A.S claimed to promote an art which in its vigour and criticism had historically ranged itself on the side of liberty and life. There were, however, many worms in the bud.

Two Faces of Modernism

One of the biggest was the question of 'democratic modernism'. Two main options as to its nature seemed open in 1941 and 1942: surrealism and expressive realism. In contrast to the apparent blandness of much abstract painting, these modes appeared to offer a way of painting that was radical in both style and content. Surrealism, it was known, had waged a longstanding battle against the tastes of the *bourgeoisie* by challenging every convention in art as well as regimentation in life. Expressive realism (by contrast with imitative naturalism) had its roots in the nineteenth century art of Daumier and Van Gogh and in the twentieth looked to the pre-cubist work of Picasso. Represented later by work such as that of the German graphic artists George Grosz and Käthe Kollwitz and the Americans William Gropper and Philip Evergood, it too could claim to be modernist.

In one respect, the *Herald* exhibition had pointed the way for those alert enough to pick it up. Exciting as it was, it contained only one painting that was in any real sense controversial: Salvador Dali's *L'Homme Fleur*. In a review of the exhibition in *Art in Australia*, an anonymous critic described how the crowd had congregated and raged around 'the solitary nightmare of Salvador Dali'.[39] That fact alone gave an answer to the question posed by the critic: 'Is the authority of the triumphant captains of the [modern] movement about to be challenged and diminished by the disorderly advance of surrealism? Is there a writing on the wall of this exhibition?' The writing was on the walls of the C.A.S. exhibition in the ensuing three years. While no artist except James Gleeson sought to emulate Dali, a concern for content gave a powerful incentive to radical artists, whose work revealed an increasing and accelerated interest in surrealism. In opposing authoritarianism in art, surrealism appealed right across the radical spectrum from anarchist to Trotskyite. In the world of painting, it affirmed the right of any artist, in Australian terms, to go it alone.

By the 1930s surrealists in Europe and America found themselves deeply divided from those who accepted the directives of the international communist movement. How was it that Australian artists attracted to radical art on the one hand and radical politics on the other were able to co-exist in 1941 and 1942? The explanation lies in the youth of most of the artists and the lack of political sophistication of Max Harris, Albert Tucker and others before 1942, as much as in the political exigencies of 1941, which demanded tolerance by communists. In the global people's war against fascism the use of every instrument in the humanitarian arsenal was needed and could be justified. The result was that for a short period radical artists felt free to explore modes of art in either area.

The anger and alienation which drew young artists towards radical politics and an art of social protest has been explained away by reference to their supposed working-class origins. This is a gross misrepresentation. Most were not of working-class background, which would in any case have made less likely a leap into membership of the radical intelligentsia. If anything can be said about the social background of radical artists, it is this. They understood the *petit-bourgeois* culture because that was the world of their parents. They knew where the enemy was. Albert Tucker's middle-class origins have been mentioned. Sidney Nolan's father drove trams but he was also an 'S.P.' bookmaker. Vic O'Connor's mother was impoverished after the death of her husband and during the 1930s maintained a precarious middle-class existence by making slippers to be sold at the Victoria Market. She was an amateur pianist with an intense love of the theatre. Noel Counihan's father had begun work as a shop assistant, and rose eventually to the status of commercial traveller.[40] Counihan's mother had been a milliner and possessed strong social aspirations for her family. In one way or another, all of these families had been hit hard by the Great Depression. The deep fear of losing middle-class status intensified its value.

The artists were outsiders as students in a far deeper sense than in their being merely unable to pay fees for tuition from George Bell. They were alienated from the middle-class culture that at once attracted and repelled them: this by no means unusual form of alienation was important in Australian art, because upon it common bonds could be forged within the united front and the C.A.S. That Sidney Nolan and Arthur Boyd were products of a more *laissez-aller* social ambience is reflected in the refusal of both to share the anger of their friends.

Two outsiders must be recognized as important influences on the young Australian radicals: Yosl Bergner and Danila Vassilieff. Although Bergner and Vassilieff are often linked, their respective positions were quite different, despite the fact that both were exiles and had become members of the Communist Party in the early 1940s. The much older Vassilieff was unquestionably a central figure in helping to free young artists from the strictures of art as craft. When he arrived in Melbourne

in 1937 Vassilieff had been painting professionally for over a decade.[41] Born in the Don region of Russia in 1897, he first arrived in Australia in 1923, and between 1929 and 1936 travelled and painted widely in the Americas and Europe, before returning to Australia. By contrast, Bergner had not painted seriously when he arrived in the same year as Vassilieff, just before his seventeenth birthday. Bergner remained, as a Jew and as a painter, an outsider socially and aesthetically until 1941. Vassilieff, on the other hand, very quickly found friends and supporters. John Reed opened the first of his regular exhibitions in 1937, and became one of his most constant champions. Vassilieff's early Melbourne work in the Fitzroy and Collingwood area continued to reflect the images of inner-urban life that he had first painted in Sydney around Woolloomooloo and Surry Hills. These were among the first paintings Melbourne saw of the untidy poverty-stricken streets that embraced the central city.

Yosl Bergner and Adrian Lawlor in Lawlor's house at Warrandyte, c. 1941. The young Jewish painter was a powerful influence on his Australian contemporaries

The back streets and lanes of Carlton and Fitzroy (*top*) offered cheap quarters for impecunious artists and immigrant refugees from the late 1930s onwards — and a wealth of subject matter for the Russian expatriate artist Danila Vassilieff. Many works based upon such scenes appeared in Vassilieff's regular Melbourne exhibitions. The show depicted here was at the Riddell Gallery in Little Collins Street

Basil Burdett became another of Vassilieff's most influential supporters. In a review of the artist's work in 1938, Burdett made the point that Vassilieff might have been a poor painter from an academic point of view but, perhaps because of this, his vision was a liberating influence.[42] This un-Australian freebooting Cossack was able to see the richness of material which lay in urban rather than suburban life. It was a milieu which Burdett understood, choosing to live in the city itself rather than even nearby in East Melbourne or South Yarra. The humanism that activated Vassilieff, and in which Burdett saw the epic vision of life as C. J. Dennis had portrayed it, was underscored by the calligraphic directness of his style.

Vassilieff consciously rejected French formal abstraction, calling such painting 'ghastly good taste' and fashionable academicism. In its place he looked to the more expressive style of Van Gogh, Maurice Vlaminck, Chaim Soutine and Marc Chagall and evolved an aggressive, graphic painting style, drawing directly with the brush. For artists like Tucker, Nolan and later Boyd and Perceval, Vassilieff had two lessons: first, a wholly professional notion of an artist as one committed to art irrespective of financial return, since art was life; and second, a belief in painting as expression without any gesture to the idea of art as craft in an academic sense. He often spoke contemptuously of academic skills, dismissing them as mere tradesmanship. Real craftsmanship lay in the use of either established or newly invented techniques which corresponded to the imaginative vision of the individual artist. In the last resort, what mattered to Vassilieff was the capacity of the individual artist to respond with immediacy to the world of social and imaginative experience.[43]

The implications of Vassilieff's *genre* scenes far outweighed their aesthetic worth as such. The choice of subject and the directness of expression produced an art which, as Burdett saw, did not flatter our knowledge of the familiar but increased a sympathetic understanding of life by expanding social horizons and widening aesthetic sympathies.[44] In other words, the richness of life in Vassilieff's vital art pointed to a deep humanism and set it in opposition to the academicism of Meldrum, the vacuousness of the derivative pastoral tradition, and the bland modernism of Bell.

Vassilieff had had considerable contact with European art while travelling in America and Europe in the early 1930s. But it is Bergner who has been lauded as the artist who brought with him to Australia some awareness of northern expressionism. What he certainly did possess and was able to draw upon was an extraordinarily rich cultural heritage. Born in Vienna in 1920, Bergner grew up and was educated in Warsaw, a member of a highly and diversely cultured family of Galician Jews. Bergner's mother, Fanya, was a fine mezzo-soprano and his sister, Ruth, a dancer. Bergner's father, Hannan Zacharios, better known by his literary pseudonym Melech Ravitch, was a Yiddish writer, journalist and

Danila Vassilieff, c. 1940. To young artists of Albert Tucker's generation 'he was a rich and sombre presence who carried with him the odour of Byzantium and the Caucasian Steppes'

Danila Vassilieff, *Fitzroy Children*, 1937 (*top*); *Nudes in Collins Street*, 1945

essayist. A tireless campaigner in the cause of Yiddish language and culture, Ravitch was a member of the Yiddish literary circle that included the writers Sholem Asch and Isaac Bashevis Singer. This group held progressive liberal views and in the heady years immediately following the 1917 revolution Ravitch named his son, Vladimir Jossif, after Lenin and Stalin. Ravitch had been in Germany in 1933 and that experience made him realize that the Jews must escape the evils of

Europe. As a member of the Steinberg Group he visited Australia in 1934 to raise funds for Yiddish schools in Warsaw. He visited Alice Springs and the Kimberleys, and later South Africa, in search of possible territories for Jewish settlement.

Ravitch returned to Australia in 1936 bringing with him his daughter Ruth. Yosl Bergner was sent for in the following year and travelled via Paris, where he stayed for several days. Brother and sister were settled in a Parkville tenement, and Bergner was immediately put to work in a knitting factory. His father, having paid for a year's supply of milk, left for America one month after Bergner arrived; they did not meet again until 1950. His mother was dispatched to Australia in 1939, arriving three months before war was declared. His uncle, the writer Herz Bergner, was also brought out at this time, on the very eve of war. During the war Bergner's paternal grandmother, Hinda Bergner, was to die in an unknown German concentration camp.

As with no other painter, Bergner's background was to inform, enrich and deepen his canvases. On this ground alone it is no wonder that he spoke so directly and powerfully to his contemporaries in Australia. Bergner's first three years in Melbourne were lonely and difficult. He was always hungry, despite support from sympathetic Jewish friends, and was forced to work for survival at a seemingly endless series of menial jobs in Carlton sweat-shops. Yet out of this experience in 1938 and 1939 came some of the most important and some of the least-known paintings in Australian art.

The decision to become a painter was made while Bergner was still a boy in Warsaw: an uncle, Moishe Bergner, had been an artist and had gone to Palestine in 1910, leaving behind the legacy of a romantic figure dying by his own hand in the wilderness. Painting did not come easily, and in 1939 Bergner attended classes briefly at the National Gallery School. There he met George Luke, a fine draughtsman with whom he came to share a studio in Little Collins Street. Later in 1939 Bergner moved to a studio-loft above a garage in Princes Hill. Gradually, through left-wing Jewish contacts, Bergner's circle of friends, both Australian and Jewish, widened. Among Jews he became friendly with Judah Waten and Winslow Pinchas Goldhar and through them made contact with the Jewish communist group the *Gesert*, also known as the 'Young Kadimah Set'. This association had connections with the Eureka Youth League and the Jewish branch of the Communist Party as well as with the Kadimah cultural centre in Lygon Street. Among Australian friends were George Luke's family; Arthur Boyd, whom he met through Max Nicholson; and Noel Counihan, through whom Bergner was introduced to the Swanston Family circle.

It is fair to say that in spite of his early enthusiasm for art, Bergner knew as little about modernism in any sophisticated sense as did his Australian contemporaries. But his sympathies and his sense of the darker, more expressive stream in painting had been stimulated by

access to his father's extensive library in Warsaw. He was acquainted with post-impressionism and reproductions of central European symbolists and expressionists such as Munch, Kubin and Kokoschka. In Paris he recalls having looked at work by Daumier, Van Gogh, Cézanne and Rouault. That was the limit, however, and after 1937 Bergner struggled, along with his Australian friends, to discover the threads of modernism through reproductions.

His first exhibition was a group show with Arthur Boyd and Noel Counihan at the Rowden White Library of Melbourne University. One critic dismissed the work of Boyd and Counihan out of hand but found that in 'Bergner's work there is a broad pity and sympathy for mankind that is worthy of his artistic talent'.[45] George Bell also noted the expressiveness of Bergner's style but, not surprisingly, disliked the dimension of social concern: 'The use of an exaggerated tonal range gives a dramatic effect of some power [but] the sociological comment in the work was an interpolation rather than an integral force.'[46] The energy, verve and directness of expression that characterize the early works have been lost on later commentators, since the best seem only to have survived as photographs. In spite of his prolific output, and unlike Vassilieff, Bergner did not exhibit again until 1941. The period of his life between 1938 and 1941, when he entered the army, was an unsettled and transient one involving surreptitious moves from one studio to another. His influence on other artists, especially on Boyd and Tucker, was a consequence of direct personal contact rather than public exposure.

Yosl Bergner, *Princes Hill*, c. 1938. This work, like many Bergner paintings, has been variously titled and dated

Between 1938 and 1941 Bergner's art exhibits an intense search for a style capable of expressing his social concerns. One early group of works demonstrates an exploration of Cézanne's concern for the organization of visual planes. The urban architecture of the inner city areas of Parkville, Princes Hill and Carlton was the subject of another group of works which are more loosely handled; their painterly style, with a thick impasto technique, indicates the presence of Daumier, as does the rhythmic flow of city roof-lines. The heavy and form-defining swathes of paint suggest also the expressive mode of Soutine, although colour is subdued and often sombre as in *Princes Hill* (1938). The immediate architectural milieu of the painter is rendered in such works without social comment. They are thus distinguished sharply from other paintings of the same period in which the artist was moved by contact with the 'low life' of the city, and especially areas around the Victoria Market, to produce a group of paintings that must occupy a unique place in Australian art.

Bergner responded directly to the humanism of Daumier and the early pre-cubist Picasso in their sensitive and compassionate portrayals of the lives of mountebanks and the dispossessed poor. The strange gypsy-like character of the Luke household in Richmond recalled for Bergner the haunting images of Picasso's work between 1901 and 1905 and the very

Yosl Bergner, *Pumpkins*, c. 1940

early paintings of Dutch peasantry by Van Gogh. In 1938 and 1939
Bergner sold socks for a Jewish stall-holder in the Victoria Market.
There the sight of metho drinkers, beggars, hawkers and the unemployed,
scavenging for vegetables around the deserted stalls, cross-connected
with the pathetic images of Daumier, Van Gogh and Picasso, and with
recollections of life in the Warsaw Ghetto of his youth.

Few paintings have survived or are now accessible from this series
of 'social realist' works. Of the more notable, the so-called *Pumpkin Eaters*
(1940), was originally bought by John Reed from the 1942 C.A.S. annual
exhibition. Until now Bergner's standing as an artist has been based
solely on one or two works, in particular *Pumpkins* (its proper name),
which is one of his most derivative, although it cannot be dismissed
lightly. The original title serves to indicate the point of the painting: the
counterposing of the image of pumpkins, which alone in the work are
given touches of vivid orange and green, against the clumsy, shaven-
headed, sightless, spiritless, ineffectual family.[47] The visual references
to Daumier and Picasso are direct, but the important point is the contrast
between the rank fructification of these vegetables and the human
hopelessness and lifelessness depicted.

Pumpkins is neither the best nor the most representative of Bergner's
works in the 1938-40 period. Among the first of his social commentaries

were portraits and scenes from the Victoria Market in 1938. Their heavily built-up surfaces and bold forms with strong linear bounding contours recall the early work of Van Gogh. These were followed later in 1938 by works which drew their forms from Picasso, while employing the more sombre earth colours of Daumier: *The Toy Seller*, *Salvation Army* and *Unemployed at the Warm Wall*. By 1939 and 1940, in works such as *Municipal Rat Catchers* and *Pumpkins*, the style suggests an even-handed debt to the two masters: figures directly quoted from Picasso are set against a flat backdrop of city buildings and tenements which recall the background of Daumier's *The Laundress*.

Bergner was painfully aware that his lack of draughtsmanship all too often lent to his works a clumsy eclecticism, but the openness of space and the lighter note of *joie de vivre* found in Vassilieff's pictures had, in any case, no place in Bergner's world view. By 1939 the intensity of Bergner's approach had transcended debts to other artists to produce two exceptional paintings: *Man in Warsaw* (1939) and *City Lane* (1939).[48] The style of both is direct and scabrous; an expressionism that makes no concession to taste or to academic skills. In *City Lane*, space is created by the tunnel-like recession of the street, whereas *Man in Warsaw* exploits an exaggerated perspective of a road off to one side. The latter recalls Edvard Munch's road which leads to nothing, just as the lonely figure of the man with a twisted mask-like death's head instead of a face also strongly suggests Munch's *The Scream* (1893). The agoraphobia of *Man in Warsaw* is replaced by a claustrophobic sense of menace in *City Lane*, where the perspective creates a *cul-de-sac* ending in a wall below a lowering sky. In either case, whether the figure is exposed or trapped, he stands as a disturbing metaphor for emptiness and despair.

These were the paintings which spoke directly to artists such as Arthur Boyd and Albert Tucker and others of their generation. Bergner's term for such paintings was 'social humanism', one which he always preferred to 'social realism' with its political overtones. They are the first paintings in Australian art which confronted the poverty and despair that were the legacy for so many of the Great Depression. The outcasts and victims who people Bergner's canvases are members of an Australian *lumpen-proletariat*; in Bergner's vision they are related, at times clumsily but sometimes with adroitness, to the dispossessed that know no nation. His capacity for identification was a product of his inheritance and personal experience. The inheritance, through Ravitch and Singer, was a liberal-progressive one that was at once selfconsciously Jewish and self-consciously European: the sense of being a member of a cosmopolitan culture yet being apart from it. In personal terms, Bergner knew precisely what outsidership meant.

The artist who responded first and with greatest immediacy to Bergner's work was Arthur Boyd. In the late 1930s Boyd's work showed a sharp departure in subject and in style from the earlier landscape paintings. Boyd's new paintings of heads and grinning masks were among

Yosl Bergner, *Man in Warsaw*, 1939 (top); *City Lane*, 1939. Bergner's paintings at this time reflected his concern for the social realities of urban poverty and psychological states of anxiety and dispossession

those he exhibited together with works by Bergner and Counihan in 1939. Franz Philipp describes the abrupt change of style that accompanied the new subjects: 'the brushstroke becomes more varied, uneven in ductus and pressure; sweeping and stabbing it creates more violent contrasts of flat and impastoed areas. The opposition of sombre, muddy and violent colours heightens the expression of compulsion and anguish.'[49] Boyd here was emulating Bergner's style and use of colour, though his paintings contain little of Bergner's social comment, and the subject stemmed from an interest in psychological states occasioned by a reading of Dostoyevsky's *The Brothers Karamazov.*

Bergner was instrumental in Noel Counihan's final decision to tackle painting. Despite early rather sporadic and tentative efforts, until 1941 Counihan had largely confined himself to cartooning and black and white illustration. In 1941, however, while recovering from tuberculosis in the Gresswell Sanatorium, he determined to take up painting. Bergner had been encouraged in his mission to get Counihan working by Judah Waten, and brought along a number of paintings. Counihan found in Bergner a kindred spirit whose work was a great stimulus. His first works, too, portrayed victims of society: the wretched patients of the nearby Mont Park mental asylum whom he sometimes saw strait-jacketed and whose pitiful cries he was forced to endure.

Arthur Boyd, *Laughing Head,* 1938

These early efforts were crude and all were destroyed. Counihan did not respond, as Boyd had done, to Bergner's more painterly expressionist essays; he dismissed them as 'froth and bubble'.[50] For Counihan the monumental and formal design of *Pumpkins* was more exciting. He began to follow Bergner's example in a tentative exploration of the ideas of early French modernism when he moved with Nutter Buzacott to a studio in Dudley Chambers in Collins Street. After that Counihan rented his own studio in Russell Street behind the National Gallery, in the condemned building where Nolan also worked. The result of his work in these places was the two paintings he exhibited in the 1941 C.A.S. exhibition. With its ill-digested debt to Picasso and its Cézanne-like colours and planes, *Pregnant Woman* is something of a student's work. Not until 1942 did Counihan begin to arrive at a more personal style.

The chief attraction of painting for Counihan was colour, as well as the opportunity of making more major statements than graphic art seemed to allow. It was a difficult transition: 'I had to work out for myself a language in which I could say what I wanted to say in terms of colours — in which the form and the graphic elements were expressed in terms of colour.'[51] Albert Tucker probably helped in this by introducing Counihan, as he later did Boyd and Perceval, to Max Doerner's treatise *The Materials of the Artist and their Use in Painting.*[52] This gave Counihan, as it did others, a more sophisticated knowledge of painting techniques when, as he recalls, 'I set out to diligently teach myself to master the traditional methods of painting.'[53]

For reasons of health Counihan did not go into the army. However,

by 1942 his close friends Yosl Bergner and Vic O'Connor had both done so. Bergner's alien status meant that he had to join the Army Labour Company. He had already been recruited as a member of the Communist Party — a commitment natural for a Jew of liberal-progressive sympathies at a time when the war being fought on the eastern front seemed to hold out the only hope of halting fascism and liberating European Jewry. He was sent to Tocumwal on the border of Victoria and New South Wales, where the Labour Company had the job of reloading railway trucks at the change of gauge.

Vic O'Connor first met Bergner and Counihan in 1941 through their common membership of the Contemporary Art Society. In the late 1930s O'Connor had become friendly with Gino Nibbi and through Nibbi and David Strachan had made his first real contact with the progressive Melbourne art world. Until then he had only been a young outsider visiting exhibitions of painting by Lawlor, Shore and Vassilieff. Strachan persuaded O'Connor to join the Contemporary Art Society and to enter two small pictures, a landscape and a still life, in the 1939 exhibition; he also attended George Bell's Sunday art classes where he met fellow students Russell Drysdale, Sali Herman and Wolfgang Cardamatis. The split between Bell and the radicals in the C.A.S. forced O'Connor to take a stand, and his association with these artists ended after six months. In any case, he had become increasingly unhappy with Bell's Slade School views. O'Connor's romantic temperament responded more to the metaphysical painting of de Chirico, whom Nibbi had known and admired. In 1940 O'Connor exhibited, alongside his more conventional paintings, two works in the C.A.S. that reflected this influence: *Composition on Time* and *Interior.* At this time he was doing law at Melbourne University and, on completion of his degree at the end of 1941, O'Connor was posted to a machine-gun company based at Tocumwal. In 1942 he was transferred to Brunswick, where he remained in the army until 1944. His willing participation in war service cannot be dissociated from the duty then required of every loyal communist. Such a sense of duty contrasts with the attitude towards war of those who came to be associated with the *Angry Penguins* venture.

Noel Counihan, *Pregnant Woman*, 1941

The year 1941 was one of experimentation for O'Connor as he became increasingly aware of a deeply felt need to express in a personal way the crisis of the times. O'Connor was conscious of a prevailing sense of unease in the early war years and his most important painting of 1941, *The Acrobats*, was produced in this atmosphere. Exhibited in the C.A.S, this work with its air of fantasy and foreboding shared a prize of £50 with a work by Donald Friend. For O'Connor it was a highly symbolic picture: against the backdrop of a large circus tent, figures are grouped on a flat foreground plane around a large ball and a trapeze. It is at once a lyrical and menacing image, creating a sense of silence and arrested motion. At the end of 1941, largely, it would seem, from seeing Bergner's work, O'Connor's style and subject matter changed dramatically. After

the manner of Bergner, he began a series of drawings and paintings based on the familiar world of the Victoria Market, where he sold footwear from his mother's small cottage industry. His custom was to rise at four in the morning to sketch the bustling early life of the market. Apart from these sketches, one of his finest late 1941 paintings is *The Refugees*. Its sombre earth colours and painterly style look directly to Bergner's expressive work of 1939. The bowed figures, supposedly pathetic victims of war, seem wrapped in a limbo of paint which ebbs and flows about them.

When O'Connor met Bergner and Counihan in 1941 he felt an immediate affinity with their outlook and sense of art. The contact not only transformed his painting and gave it a direction hitherto absent, but changed his life by channelling personal alienation into political commitment. Nonetheless O'Connor's impulse to join the Communist Party stemmed from an awareness of shared cultural values, rather than from deeply felt political convictions, as held by Counihan. In this O'Connor was closer in spirit to Bergner than to Counihan. Even so, for radicals like O'Connor or Bergner, joining the Communist Party in 1942 or 1943 provoked no emotional crisis. At a time when the Battle of Stalingrad seemed likely to determine whether European humanism would survive or go under, they felt a link with the 'enlightened' forces of history. This can be contrasted with Counihan's conversion at the height of the social and economic crisis of the depression, where evil and the root cause of society's ills were experienced in an immediate and personal way. The sense of commitment of a Noel Counihan, who had received a Catholic education, was moreover far greater by virtue of the emotional crisis that must have accompanied his conversion. Could an apostate Catholic ever doubt the faith which George Orwell described as that of a new Church?

Other leading radical artists to emerge were Albert Tucker and Sidney Nolan. Although both were prepared in 1941 and 1942 to share leadership within the C.A.S. with communists whose allegiance belonged outside the Society, the evidence of their art during this period — an art which, in turn, communists tolerated for a time — suggested that their respective senses of humanism and the radicalism that flowed from it differed in fundamental ways from that of the extreme left. That, and the sympathetic support of John Reed, was about the only thing which these two extraordinary individuals had in common at this time.

Between 1939 and 1941, Albert Tucker ranged more widely through the tangled skeins of modernism, from nineteenth century post-impressionism to surrealism, than any other Australian modernist before or since. Whereas Sidney Nolan very early found an aesthetic and intellectual sympathy with the highly personal and involuted world of symbolist poetry, Tucker did not recognize his own world until 1940-41. His early post-impressionist works of the late 1930s end in 1939 with the immediacy and powerful authority of his first major painting statement, *Portrait of Adrian Lawlor*. At the time of its completion Tucker could

Albert Tucker, *Portrait of Adrian Lawlor*, 1939

Opposite The day after Black Friday, 13 January 1939: Albert Tucker, Alan Warren and Adrian Lawlor seated on the remnants of Lawlor's furniture after his first house had been destroyed by the bushfire

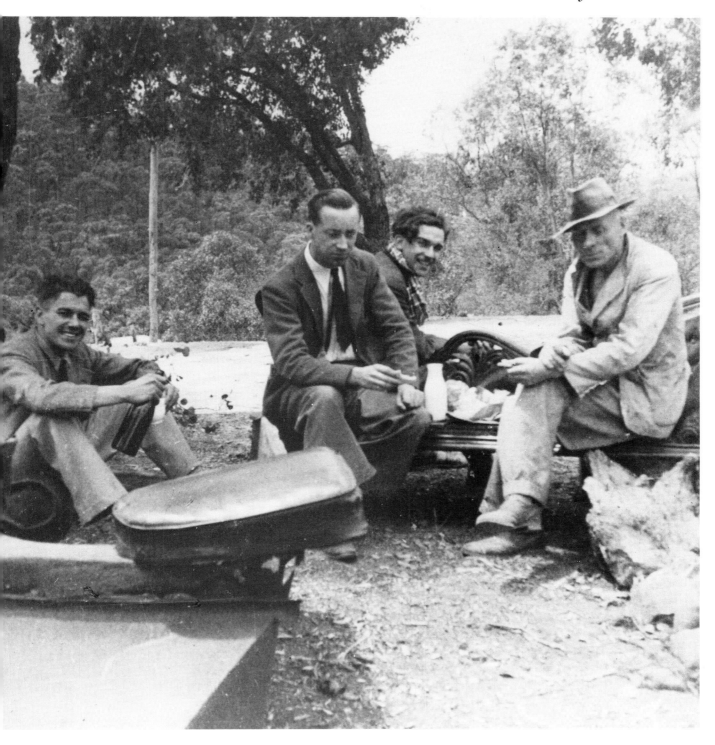

not know the degree to which Lawlor's particular brand of individualism would later parallel his own. The portrait is an expressive and monumental image, the form being carved out in a series of bold planes suggestive of Picasso's early cubist 'negroid' phase, reinforced by the mask-like character of the head. Colour is largely monochrome but has heavy accents of complementary reds and greens.

It is almost certain that Tucker met Yosl Bergner before 1940, but there is no evidence of an artistic connection before Bergner exhibited with the C.A.S. in 1941, after which Tucker looked very closely at the work of the younger artist. Before then, Tucker's chief interest was surrealism and the work of the German painters George Grosz, Otto Dix and Max Beckmann. He thus explored both surrealist and expressive social realist modes. The first C.A.S. exhibition in 1939 saw surrealist work by James Gleeson as well as Tucker's first tentative essay in this mode, *The Philosopher*. The monumental figure that occupies the foreground of this mysterious moonlit landscape is derived from Picasso's *Young Acrobat on a Ball* (1905). In general the feeling of the work owes more to the metaphysical mystery of de Chirico than to the more meretricious veristic illusionism of Dali, which Gleeson preferred. Tucker's single effort in the latter manner was *The Futile City* (1940), the symbolic images of this Dali-like composition being derived largely from the word images of T. S. Eliot's *The Waste Land*. In the background a blighted city, recognizably Melbourne, occupies a landscape barren of life; in the foreground stand a leafless tree, skeletal bones and a symbolic key; overhead, blood runs from vermilion clouds. Despite all these surrealist clichés and literary rhetoric, it remains an arresting work. *We Are the Dead Men* is even more highly theatrical; it shows the influence of the savage caricaturing of society by Grosz while still reflecting Tucker's preoccupation with Eliot's view of the facade of contemporary culture. The title refers to the sense of futility and the utterly bleak view of humanity found in Eliot's 'The Hollow Men'.

The work of 1940-41 represents a search by Tucker for ways to project the city as a stage for suffering and oppression. Tucker's use of surrealist devices contains little of the psycho-symbolic equivocation of a Dali or an Ernst. Surrealistic devices and the savage satirical art of the German 'new objectivity' painters were more useful. His attitude towards surrealism was given in a paper delivered to the Contemporary Art Society in Sydney in 1940 at a seminar whose topic was 'What is Surrealism?'. For Tucker, surrealism would 'make its contribution when, paradoxically enough, it commences to exercise judgement and reason, when it subjects the new material it has found for us, to a critical analysis. And then it will cease to be Surrealism'.[54] In other words, the value of surrealism was in the degree to which it extended the repertoire of symbolic devices at the artist's disposal. If symbols were to add up to a coherent statement they had to be intelligible and accessible much in the manner of the symbolic poetry of Eliot or Pound.

Albert Tucker, *The Futile City*, 1940 (*top*); *Wasteland*, 1941

Tucker's discovery of the novels of George Orwell seems to have coincided with his closer friendship with Yosl Bergner early in 1941. In the C.A.S. exhibition of 1941 at the Hotel Australia, Tucker exhibited four paintings that show evidence of contact with Bergner's work: *Portrait, Fisherman's Bend, Spring in Fitzroy* and *Setting Sun. Fisherman's Bend* reflects Bergner's expressive style, by taking a corresponding subject of urban poverty from this down-at-heel side of Melbourne. *Spring in Fitzroy*, with its sombre colour, once again makes use of the brooding, seated, Picasso-based figure, now staring out into the seedy back streets of that inner-urban area. Here Tucker was inspired directly by Orwell's powerful critique of suburban mentality in *Keep the Aspidistra Flying*, first published in 1936. The inclusion of that wilted plant beloved of the Edwardian middle classes makes the point of the work clear. Orwell's words describing bourgeois mass vulgarity and cultural vacuousness resound in Tucker's image:

He gazed out at the graceless street. At this moment it seemed to him that in a street like this, in a town like this every life that is lived must be meaningless and intolerable. The sense of disintegration, of decay, that is endemic in our time, was strong upon him.[55]

Tucker was at one with Orwell's unhappy refugee from *petit-bourgeois* English society, who saw middle-class philistinism along the mean streets of suburbia and behind the vulgarity of every advertising bill-board. For Orwell, as for Tucker, it spelt 'desolation, emptiness, prophecies of doom'. 'For can you not see, if you know where to look,' Orwell asked, 'that behind that slick self-satisfaction, that tittering fat-bellied triviality, there is nothing but a frightful emptiness, a secret despair? The great death wish of the modern world.'[56] The concern for surrealism and expressionism conjoined in what is, perhaps, Tucker's most important painting of 1941: *Setting Sun*, later to be titled *Wasteland* in homage to Eliot's epic poem. It is a small work but an impressive and powerful one. The expressionist style, aggressive and violent — even gauche — gives a great intensity to the small and rather vulnerable figure silhouetted against the sunlight, which illuminates city buildings and a dark, forbidding landscape. The raw expressionistic mode of painting Tucker adapted from Bergner and Vassilieff helped free his work from the direct influence of literature, conventional perspective, and traditional notions of craftsmanship.

Herbert McClintock, *Dawnbreakers*, 1939 (*top*). Surrealist work by McClintock, shown painting here on the rooftop of his Sydney studio, was produced under the pseudonym 'Max Ebert'

The attraction of surrealism was so pervasive in the early 1940s that few modernists could resist it. Even fewer could grasp the substance behind the shadow. It was Sydney that produced a passable pastiche of the highly illusionistic late phase that everybody identified with Dali. James Gleeson could use it to express a powerful personal vision; Herbert McClintock (who signed his surrealist work 'Max Ebert') could not. McClintock's early experiments in surrealism such as *Dawnbreakers*, while accomplished, are of passing interest only.

During 1940 and 1941 Gleeson published a number of pieces in *Art in Australia* and *A Comment*, which demonstrate a sophisticated grasp of surrealist aims and precepts. His real discovery of surrealism occurred in 1939 when a friend, Frank Brown, returned to Sydney bringing with him a book of reproductions of work by Salvador Dali. Brown also possessed a collection of paintings by de Chirico which he left in Gleeson's care during the war. Gleeson saw his first Dali, *L'Homme Fleur*, at the *Herald* exhibition and recognized an accord with his own natural artistic and philosophical bent. Although paintings shown in C.A.S. exhibitions in 1940-44 indicate a direct and overwhelming debt to the Spanish painter, more private and exploratory pen and water-colour sketches and drawings from this time suggest an awareness of the abstract and automatic aspects of the movement implicit in the work of Miro, Masson and Ernst. Gleeson was an aesthetic conservative; surrealism's appeal lay more in its capacity to extend the range and scope of the subject matter of art than in the challenge to the conception of picture-making and the role of the artist that André Breton envisaged.

Surrealism is not a movement that can be neatly defined, nor can its art be easily categorized. Surrealist devices play a considerable part in the work of Albert Tucker, Arthur Boyd, Russell Drysdale and Peter Purves Smith, just as a surrealist outlook is present also in the early work of Sidney Nolan. At the same time, none of these artists should be thought of as a programmatic surrealist, which was more the case with James Gleeson.

Nolan's relationship with surrealism is the least clear of any in this group, just as his early work is the most idiosyncratic and challenging of any from the aesthetically radical artists in the early forties.[57] His egocentricity was unique. John Sinclair recalls that what excited Nolan most in the C.A.S. shows were the Nolans. The course he charted was the most highly personal and self-assured of them all — a fact evident in his first exhibition, which John Reed opened on 11 June 1940 in Nolan's studio in the condemned building above a greengrocer's shop in Russell Street. The walls were painted 'shocking' pink and on these were hung some of the most extraordinary works yet seen in Australian art. Many were monoprints — small and apparently ephemeral abstract images dashed off with a casual insouciance. Others were either drawings, collages or montages constructed from reproductions of steel engravings of classical paintings by Raphael and Poussin. These were cut into squares and rearranged to produce a disorientating juxtaposition of images.

Critics rose bravely to the occasion of this experience, although neither George Bell nor Basil Burdett made much headway with the work. Bell attempted to use formalist precepts in discussing the exhibition. Nolan, he wrote, was experimenting with 'line, colour, mass and surface texture, significant in themselves as elements of a design discarding all extraneous association of ideas'.[58] Once beyond this

An example of Sidney Nolan's early experimental art: *Untitled Monotype*, c. 1940

formalist platitude, Bell ended on a lame note: 'Whether or not this aim at the absolute in art will be found wanting eventually in its relation to life, these experiments in the basic elements of painting will lay a foundation for the future of this young artist.' Burdett found that the overruling note of the exhibition was one of 'austerity': 'Mr. Nolan reduces his expression to such simple terms that all previous local essays in abstractions seem tentative. At times he almost abstracts himself out of existence, leaving only a snail's trace of hairy line upon the paper.'[59] More aware than Bell, Burdett saw in many of the works the character of Chinese ideographs and a suggestion of automatic drawing; perhaps also Klee or Kandinsky. Burdett tried every combination of influences, concluding finally that in painting 'Mr. Nolan suggests a cross between Picasso and Rouault'. In the end, he too admitted, but with more frankness, that 'what Mr. Nolan is really after eludes me, I must confess. I failed to find any key to his highly esoteric art'.

Whatever their difficulties, both critics recognized that Nolan's work could not be dismissed. However, their own view of art provided no conceptual means of handling the sophisticated work of this 23-year-old artist. Nolan's friends were aware of a 'colossal' degree of intellectual arrogance and sense of complete inner certainty, which enabled him to pursue a lonely path giving obeisance to no other artist or teacher, whether European or Australian. Nolan was apparently a completely inner-directed man. As John Sinclair recalled, 'From the time he became

interested in art he rejected absolutely any form of teaching that didn't seem to him to be valuable — which, in fact, meant that he rejected *all* teaching'.[60] Even his contemporaries, Albert Tucker, Arthur Boyd and John Perceval, were as mystified by him as Bell and Burdett had been.

When Nolan finally gave up the pretence of being a National Gallery School student in 1938, he moved to Ocean Grove, where he lived for a time with Elizabeth Paterson whom he had married that year. Later the couple moved back to Russell Street where they ran a not very successful pie shop. Even before this venture, envious of a stipend John Sinclair received from Sir Keith Murdoch, Nolan had approached Murdoch seeking similar sponsorship. An utterly nonplussed Murdoch passed Nolan over to Burdett, who in turn recommended that he study under Bell. Nolan demurred at this suggestion, so Burdett proposed a visit to John Reed. The meeting was a success and Nolan returned jubilant from Heidelberg. Nolan had found in John and Sunday Reed the two people who would champion his art and help direct his energies over the following nine years. These events were followed by other changes in Nolan's life. In 1940 he separated from his wife and their newly born daughter.

Sidney Nolan, *Montage*, 1940

From 1940 Nolan's development proceeded without a break, as did his insatiable thirst for ideas. John Reed described the young Nolan as never being without a book under his arm.[61] His favourite authors were Blake, Rimbaud, Verlaine, Nietzsche, Kierkegaard, D. H. Lawrence, James Joyce and William Faulkner. Others recall that he was never without a pad for sketching or for writing poetry; or without a camera around his neck. In his artistic life as with his physical feats of diving, cycling or fighting, Nolan was 'like a man possessed'.[62] As late as 1939 he seems to have been undecided whether to be painter or poet; in the end, he remained both. There are, of course, many references in Nolan's art to the work of early European modernists, but Nolan's overriding aim was to be original in the sense of using the direct experience of the senses as the basis of art. It was this conscious desire, in emulation of the practice of Arthur Rimbaud in literature, that distinguished Nolan from other contemporaries who accepted the need for apprenticeship, however self-directed.

Nolan's work between 1938 and 1941 has often been described in the abstract terms in which Bell and Burdett saw it. His shift in 1942 to a more figurative mode might be seen as reversing the more usual pattern of development. Certainly, very early works with their swinging and looping lines and interpenetrating planes are abstract in a way reminiscent of Atyeo's earlier linear abstractions. But Nolan's work of 1939-40, especially the montages, were created more in the spirit of Rimbaud where the viewer is invited to participate in the poet's disordering of the senses, whereas the early formal experiments are highly symbolic in an intensely private and personal manner.[63] In essence, Nolan's early work can be seen as a creative play with materials and

modes of art: oils, ripolin, paint on slate or blotting paper, collage, elementary print-making, a free play looking more to the practice of Paul Klee (whose work the surrealists reproduced freely in the 1920s), as well as of Joan Miro, André Masson and Max Ernst.

The 'automatic' realization of forms and symbols was a mode of surrealism widely practised in the 1920s as a more authentic way of setting down images and ideas stemming from the dictates of the subconscious. The initial impulse for *Boy and the Moon* was thus a glimpse Nolan had of John Sinclair's head silhouetted against a full moon. The image of a yellow disc on a stalk-like neck against a deep blue-black ground is less an abstract design than a distillation of sensory illusion.

Along with *Boy and the Moon*, Nolan exhibited *The Eternals Closed The Tent* in the 1940 C.A.S. exhibition. This was probably painted earlier in 1939, because it was on the basis of this work, inspired by lines from Blake's *First Book of Urizen*, that Nolan was offered the commission to devise sets and costumes for Serge Lifar's ballet *Icare* early in 1940.[64] The ballet had its Australian premiere with the de Basil Company at the Theatre Royal in Sydney, 16 February 1940. As with the painting and an earlier work, *Selby* (1938), the sets were stark and austere in their use of heavy black bars.

The appearance of the de Basil ballet in Australia in the later 1930s and early 1940s, combined with the *Herald* exhibition, gave young artists like Nolan, as well as an older generation, a feeling of enormous exhilaration. The presence of *haut-bourgeois* French culture confirmed the end

Serge Lifar and Sidney Nolan, watched over by Colonel W. de Basil, discussing the designs for the ballet *Icare* in Sydney, 1940

A performance of *Icare* at Sydney's Theatre Royal

Basil Burdett (second from right) picnicking with members of the de Basil Monte Carlo ballet company. As well as being art critic for the *Herald*, Burdett wrote about his other love, the ballet, for that paper

of Australia's cultural insularity and anglophilia. As Nolan has put it, 'When de Basil came out with his Company I think this just stunned Melbourne. You see I think it had certain fixed ideas about itself. It thought it was the centre of culture perhaps in the Southern Hemisphere.' The magnetic presence of the dancers and their entourage — graceful, artistically and politically sophisticated — seemed the very embodiment of the European tradition of culture: 'Melbourne was just overwhelmed first of all by the beauty of the performances and then by the beauty of the people themselves.'

The spread of war, the fall of Paris in 1940, the expansion of that conflict into a people's war against fascism in 1941, and a fight for survival by Australia in 1942, all brought to an end that French phase. As we have seen, these events helped change the character of the Contemporary Art Society and were now, in 1942, to induce far-reaching and radical changes in the work of its foremost artists. One example will serve at this point to illustrate the transformation. By 1942 Nolan, stationed at Dimboola in a Supply Company, recalls the shift in his sense of place and culture:

I went [into the army] as a kind of abstract painter with my thoughts on Paris but I gradually changed right over to being completely identified with what I was looking at and I forgot all about Picasso, Klee and Paris and Lifar and

everything else and became attached to light . . . the agitated state . . . [in which]
I went into the army gradually subsided into a relationship with the landscape.[65]

Sidney Nolan, Yosl Bergner, Vic O'Connor, Albert Tucker, Arthur Boyd
and John Perceval all went to war. In one or two cases they did so
willingly; for the most part, however, they donned uniforms only under
duress, and that experience, together with their sense of what the war
represented, was to change them all in fundamental ways. The experi-
ence of war for those half-dozen artists was also to transform the nature
of Australian art.

Signs of these changes were present in the annual exhibition of the
Contemporary Art Society in 1942, shown in Melbourne, Sydney and
Adelaide, and in the Anti-Fascist exhibition at the end of 1942 in
Melbourne and Adelaide. On one level these exhibitions appeared to be
a triumph for the united front in Australian culture, but the art itself bore
witness that any unity of political purpose had by then ceased to exist.
What, after all had Nolan's *Dream of a Latrine Sitter*, or Tucker's anguished
Army Shower Room to do with Counihan's *Tribute to Stalingrad* or *The New
Order*? Between them lay deep differences of temperament and values:
the differences between symbolism and surrealism, on the one hand, and
socialism and social realism on the other; between a sense of art as a
personal testament and art as a political weapon; between the liberaliz-
ing force of anarchism and individualism, and the unifying thrust of
communism and populism. The differences led to bitter in-fighting and
a second split in the Contemporary Art Society in 1944, and became a
factor in its eventual demise in Melbourne in 1947. The ultimate result
of this conflict was the evolution of a new tradition in Australian art and
culture. A full understanding of the values and modes of that tradition
demands close study of the events within the Contemporary Art Society
during these years and also the wellsprings of the art of opposing groups.
The starting-point for this exploration must be a deeper examination of
the nature of the liberal tradition in Australian culture. The reader will
be aware that the term 'liberal' has thus far been employed to embrace
the values of men as different as Sydney Ure Smith, Sir Keith Murdoch,
Daryl Lindsay, Adrian Lawlor and Basil Burdett. In dwelling on the links
between such men we have necessarily neglected the differences, differ-
ences which were to be profoundly important for the future of Australian
art. But beyond that, the true spirit of liberalism, taking as it often did
strange and bizarre forms, was one of the major forces in the creation
of a new humanism in Australian culture — just as its perversion acted
against that humanism by all too often failing to recognize where it truly
lay.

CHAPTER FOUR
LIBERALISM AND ANARCHISM
Art Criticism and
Intellectual Life, 1940-1946

If I am an Anarchist — So what? *Max Harris (1939)*

The debate over Australian cultural values which resulted in deep intel-
lectual and aesthetic division between writers, artists and intellectuals
during the 1930s and 1940s has repeatedly been characterized in terms
of 'Australianists' and 'Internationalists'. This distinction is not nearly as
clear-cut as many would have it, and ignores ideological differences. In
opposing conservative nationalism the liberal tradition stood in the
1930s, as we have seen, for cultural internationalism. In the 1940s
communists were faced with the problem of reconciling a nationalist
tradition embodied in the values of the labour movement with the aims
of the international communist movement. This identity problem,
however, was an immensely more painful and difficult one for those in
the centre than it was for those either on the extreme right or left.

The essence of liberalism is the value of the individual in relation to
his times and milieu. The consequences can be confusing. For, as Hugh
Stretton has observed, the liberal's responses in valuing individual lib-
erties will depend upon the character of that society and its culture.[1] In
other words, where illiberalism seems dominant, as in the 1930s, the
liberal will behave as a radical. Where society seems more radical,
the liberal will often feel forced to adopt what appear to be more con-
servative values. The search is for the authentic and the 'natural' —
whether this is expressed in social relationships or in the cultural
outflowing of a community based on such relationships: hence the
importance attached to those dangerous qualities originality and
creativity. Not unexpectedly, liberals will often differ about the language
used to define natural values and the ways in which such values are
expressed. A Lawlor, a Tucker, a Burdett, a Harris and a John Reed
found much in common, but much also that led to discord and misunder-
standing in the arguments about the nature of Australian culture and the
creative life.

The dichotomy between nationalism and internationalism, parochial-
ism and cosmopolitanism, makes for a complex problem. For an
Australian like Basil Burdett, as for his younger contemporaries, the

nationalist versus internationalist debate was culturally bankrupt. For these men both positions had been reduced by their respective proponents to a level which promoted art that was academic, escapist, even *kitsch*. In undertaking a search for richer directions in Australian culture we must examine Burdett's life more closely.

A Non-doctrinaire Liberal

Basil Burdett rarely spoke of his early life in Brisbane, even to his most intimate friends. His arrival in Sydney in 1921 represented his escape from Australian *petit-bourgeois* philistinism at its meanest level. Not for nothing did he refuse ever to disclose that he had been an illegitimate child, born in Ipswich in 1897.[2] His abandoned mother was forced to raise her son in the rigidly puritanical and narrow-minded atmosphere of her parents' house in the Brisbane suburb of Enoggera, where Burdett's two unmarried aunts also lived. Burdett escaped from this environment by enlisting in 1915 at the age of eighteen as a stretcher-bearer in the First Field Ambulance of the A.I.F. The experiences of those who carried and tended the wounded were usually more traumatic than those of the active combatants, and although Burdett did not return to Australia until late 1919, the shock was still apparent. His grand-father's welcome home was shattering: 'Well, I thought that at least it would make you a gentleman.'[3] Burdett neither forgot nor forgave; after leaving Brisbane, it is doubtful whether he ever returned.

Burdett's peripatetic career, and an urban lifestyle in which he developed his sensibilities as an art collector and entrepreneur, represented in themselves a complete rejection of a world that had made his early life miserable. In Sydney he became involved in art journalism and art-dealing, and in 1925 established, in partnership with John Young, the Macquarie Galleries in Bligh Street, which rapidly became one of Australia's most important exhibiting venues. In December 1925 he married Edith Birks, the daughter of an established Adelaide family, and there seems no doubt that his wife's considerable financial resources laid the basis for the gallery partnership. The marriage failed after three years and Burdett, further embittered, left Australia for Europe, where he travelled extensively in Britain, Italy, France and Spain. He returned in 1931 for the divorce proceedings and settlement. His association with the Macquarie Galleries also ended in 1931, a casualty of the divorce, as was his valuable collection of old English glass, china, furniture, books and paintings. In 1931 Burdett, as we saw, moved on to Melbourne where he joined the staff of the *Herald* as a senior reporter. Between 1933 and 1935 he was again in Europe, now fluent in French, Spanish and Italian.

Between 1936 and 1940 Burdett brought to art criticism in Australia a unique combination of aesthetic sensibility, intellectual awareness and

open-minded sympathy for the work of young artists, however radical. Burdett's sympathies were broader than those of any other critics writing in the 1930s except, perhaps, Adrian Lawlor. In part this might be attributed to his unique status as a layman in the world of art criticism at a time when the qualification for employment as a critic, as for the directorship of a national gallery, was usually that a man was, or had been at some time, a practising artist. But Burdett's sympathies, unfettered as they were by attachment to a particular artistic style, still had their limits — and they were drawn precisely where Lawlor's were. He was unhappy in 1940 about the absence of a selection jury for the C.A.S. annual exhibition and could find no reason for the inclusion of Nolan's *Boy and the Moon*, a work he described as an 'embryonic canvas which seems mere impertinence and posturing'.

Burdett's conception of art comes closest in many ways to that of Roger Fry. He firmly believed, like Fry, in formal values in art but was not prepared to dispense with the essential imaginative experience of art. For Burdett, art was 'the record of spiritual and visual adventures — misadventures if you like — the report in various media of the things the modern artist has seen and felt — particularly the things felt'. For Burdett, art had two functions: the first was to civilize men by the creation of a more harmonious living, that is, human, environment; the second was to report the experiences of a particular social milieu. The former was the province of aesthetics, the latter the world of imaginative experience. Art failed when it neglected the one at the expense of the other. Only the best art achieved this difficult but essential harmony. Burdett refused to make a distinction between aesthetics and imagination when writing on aspects of the Australian visual environment as varied as stamp-designing, glass manufacture, posters, road-building, architecture and town planning, and he fought the debasement of taste in all these areas and more. Writing of the generally low standard of Australian glass-designing in 1940, he attacked its vulgar excess of decoration and other unsatisfactory features. Burdett compared the wretched state of the craft in Australia to that in nineteenth century England, which Ruskin had attacked as 'an artistic abomination'. Australians badly needed, Burdett felt, another Ruskin to demonstrate the eternal truths of harmonious form. Burdett, in his own way, aspired to be the Ruskin of Australian culture — a ruthless critic for whom nothing was outside his ambit. Writing about the new Acheron highway in the Victorian Alps, opened in 1936, Burdett noted, for example, that road construction had aesthetics of its own and commended the road engineer as 'an artist with a soul' for creating work which, 'like all good art, contains the element of surprise'. Indeed, he declared, the greatest tribute to the engineer's vision had been paid by those drivers who had piloted their cars off the hillside in their fascination with the view. In personal terms Burdett had the courage of his own aesthetic convictions. At a time when the rest of Australia wore black swimsuits, Bur-

Basil Burdett on the roof of Alcaston House, on the corner of Spring and Collins Streets, where he had his flat

dett appeared on a Melbourne beach arrayed in splendid turquoise.

As Burdett saw it, the central problem of Australian art was the preoccupation with the pastoral vision of the past enshrined in the landscape tradition. As he defined the problem in 1938:

The landscape setting of our life absorbs ... [our painters]. The life itself is neglected. Our painting is like a novel without any characters. Landscape pervades our exhibitions like a recurring decimal monotonously repeated ad infinitum.

Is there nothing in our life worth depicting on canvas?

For Burdett, indeed there was, and it had nothing to do with the pastoral life. The most exciting new subject matter lay in the city. This was the potential source for a vigorous new humanism in Australian art which Burdett called for — but with the caveat that the artist 'who tackles it must be able to turn his hand to the human figure as well as to architecture, for it is the life of Fitzroy as much or even more than its setting that Vassilieff has expressed'. Australian artists had to overcome their fear of subject painting by lowering their gaze to the streets of the city and extend in this way that other tradition of early Australian impressionism which Roberts and Streeton had begun in *Bourke Street, Melbourne* (c.1886) and *Redfern Station* (1895). For Burdett there was symbolic significance in Sir Arthur Streeton's last one-man exhibition in 1940. Streeton had told him that this was intended to be his last show: 'I've done enough work', he said simply. For Burdett, Streeton had been a founder, his life the embodiment of 'the only real school Australia has yet had', one which, for Australians, 'will always have a peculiar significance'. The exhibition in May, then, was more than a swan-song for Streeton; it was an elegiac end to the conservative tradition of the pastoral, which had begun with the spacious panorama the young artists of the Heidelberg School had beheld from Eaglemont.

Burdett turned to the teeming cosmopolitan world of the city which, with its inner urban areas, provided the humanizing milieu of a Chelsea, Montmartre or Montparnasse. Burdett's love affair with the city is evident in his support of artists such as Vassilieff, in his bitter condemnation of the destruction of Sydney's Georgian buildings, and his accounts of personal ramblings around Melbourne. In 'A Jolimont Ramble', Burdett describes the quiet of a morning where on that charming hill 'a few minutes from the city's heart, a dog was sleeping in an open doorway. A cat was climbing over a green paling fence, and a woman was digging the garden plot which separated an ancient bluestone cottage from the footpath'. By way of contrast, in 'Melbourne Nocturne' Burdett describes how the magical character of the city gradually changed, starting with 'the swift fall of winter darkness' over the boulevards and ending in the early morning emptiness of Collins Street with the 'silence beneath the elm trees and the planes ... Only the muffled echo of my footsteps in the foggy darkness ... Melbourne has

been left to darkness, to fog and to me'.[4] In between, there was the life of light, of lovers' meetings, of crowds at a concert or perhaps a ballet, and inevitably the sub-culture of the coffee shop: 'Some of us have taken refuge in the coffee shops, gone underground like rabbits. We sip our coffee with cream and munch raisin-bread toast and talk of Garbo and the Budapest Quartette and the latest book we have read.' Somewhere a deep-throated voice sang: 'It's a sin to tell a lie'.

Burdett was more than an aesthete or boulevardier, although he was both of these things. Neither was he simply a weapon for Murdoch to launch against the old establishment, although he did that job impressively. Burdett's outlook helped inform and direct Murdoch and, however much others later distorted them, his values underpinned those of a newly emerging liberal establishment. The tragedy is that his death in 1942 prevented his ensuring that that establishment retained his own openness and humanism. What Burdett brought to Australian art-writing and intellectual life was a sense of the possibility of a current in Australian life and culture that connected with the humanism of modern European culture while retaining values intrinsic to the Australian experience. It was a position he had stated as early as 1929.[5]

The story of Burdett's public career, for all the gain, is one of lost opportunities for Australian culture. In personal terms the tragedy was of a different dimension. Whereas Adrian Lawlor saw life and art in terms of the vital consequences of irresolvable contradictions, Burdett's life was a search for wholeness and harmonious relationships whether in art or society. It was this sense of culture and tradition that drew him irresistibly and continuously to France, and, most of all, to Spain. Nettie Palmer, as astute and sympathetic an observer of men and manners as she was literary critic, saw that despite a degree of Australian patriotic sentiment, a man like Burdett could never really be at home in Australia — one might add, in the Australia of the 1930s, at least. Nettie Palmer also saw Burdett as suffering the 'unhappy plight of a man who lives for Art yet can't find full release in any art'.[6] He could appear even to friends as distant and aloof, sometimes arrogant, and one may guess that this was largely a shield for a natural diffidence and, perhaps too, a disappointment with his own creative efforts. The artist Lloyd Rees described it as a 'protective armour with which he surrounded his softer senses'.[7] In personal terms the harmony Burdett sought, in the face of the Australian *petit-bourgeois* philistinism from which he had fled and against which he never ceased to fight, was out of the reach of a man whom one of his closest friends, Daryl Lindsay, described as 'the strangest mixture of afflictions and inferiority complexes that ever was'.[8] Indeed his emotionalism was compounded for Lindsay by another flaw: 'a certain weakness of character that I don't like'.[9] That 'weakness' was homosexuality, which Daryl Lindsay abhorred to the same degree as his brother Norman. Indeed Burdett's love of Spain was in part, he said, 'because there men kissed naturally and nobody looked askance'.[10]

In philosophical terms, Burdett's values resemble those of the Basque liberal reformist writer Miguel de Unamuno, whom he admired. The emotional and romantic Unamuno strove likewise for a vision of human unity in a country which in the early years of the twentieth century was in some ways even more conservative and myopic than Australia.[11]

Burdett's favoured artists by the late 1930s were those of the emotional and romantic character of Vlaminck rather than those in the classical mould of modernism like Léger. Vlaminck, as a representative of the romantic tradition of French art, was indeed for Burdett 'something very like Unamuno's "whole man"'.[12] The Australian needed to feel at one with Spaniard or Frenchman and realize the wholeness of culture, a wholeness which would relate the past to the present and the best of disparate cultures to each other for greater enrichment of Australian art and life.

Liberals of the generation of Burdett and Lawlor, whether they pursued a harmony of values through faith, or found that life-force in contradictions between values, were neither able nor prepared to accept that art could be given a radical political face in the fight against illiberalism at home and abroad. Having parted company with the younger progressives in the C.A.S., by 1942 Lawlor was appalled at the prospect of modernism being enlisted in an anti-fascist crusade. No doubt Burdett would have greeted the prospect that art could be regimented, as men were being regimented, with equal alarm. Although the younger progressives were not yet aware of the logic of their position, Lawlor and Burdett knew that liberalism in art, as in life, demanded distinctions of values, both moral and aesthetic, and risked ultimate élitism. Any alternative meant dragging art and the life of the spirit back into that narrow and barren mould of bourgeois mediocrity against which they had set themselves so resolutely. Eventually the artists and intellectuals who coalesced around the magazine *Angry Penguins* had to acknowledge the same logic. The route this liberalism traversed between 1940 and 1945 was a tortuous one, conditioned as it was by wartime exigencies and influenced by newer forms of liberalism which took their cue from the promptings of Herbert Read. The central figures in this were Max Harris, Albert Tucker and John Reed. Their intellectual development provides the key, therefore, to an understanding of the spirit which paved the way for the development of the second authentic school of Australian painting — one that Burdett would not witness.

Angry Penguins

The years 1940-43 represent a cultural watershed in Australian art and intellectual history. By 1943, attitudes had been formed that would characterize the rest of the decade. During these years the Contemporary Art Society not only became the premier art institution in Australia,

but it also helped create a more sophisticated intellectual milieu than had hitherto existed. In 1943 the magazine *Angry Penguins* moved from Adelaide to Melbourne following the formation of the Reed & Harris publishing firm. By so doing it gave a public mouthpiece to the radical artists and intellectuals within the Society, who by 1943 had little truck with Stalinist communism. *Angry Penguins* began in 1940 as a literary magazine but by 1943 was also a forum for intellectual debate, publishing many key statements by radicals within the C.A.S. In the absence of any other art journal, it reproduced many of the important paintings by the artists in sympathy with its ideals: Sidney Nolan, Albert Tucker, Arthur Boyd and John Perceval, Danila Vassilieff and Joy Hester.

In this respect *Angry Penguins* was unique, but the early 1940s saw the growth of other little magazines that reflected the intensity of the intellectual life in this period. Whereas in August 1939 there were only two (the Jindyworobak *Venture* and the more conservative *Bohemia*), by the end of 1939 three more had appeared: *Western Writing, Southerly* and the *People's Poetry*.[13] The year 1940 saw the founding of *A Comment* (Melbourne), *Meanjin Papers* (Brisbane) and *Angry Penguins* (Adelaide). All of these except *Meanjin* and *Angry Penguins* retained their initial small scope and character, remaining limited vehicles for publishing verse and literary prose without laying claim to any clear-cut editorial policy or ambitious cultural programmes. *A Comment* did publish art-polemical material but its aim remained a modest one: to 'extract from the surrounding gloom a few people who will be really interested in our efforts to put into print the newest ideas in writing and design'.[14] The brightest star, however, until its demise in 1942 remained *Art in Australia.* Under the editorship of Peter Bellew, who took over in 1941, it became

A Comment, July 1941: one of the more lively and unpretentious of Australia's little magazines, it offered a forum for art and literary polemics

Rex Ingamells and Flexmore Hudson, Adelaide poets and Australianists, 1945

for two years one of the most ambitious publications in Australia. Much of this remarkable activity was due to the war, which restricted the importation of overseas journals and forced Australian writers to face issues which might seem less urgent in peacetime.[15]

At the centre of this quickening of the intellectual pulse was Max Harris. Born in 1921 in Adelaide, Harris grew up in the South Australian country town of Mount Gambier, the son of a commercial traveller for a grocery company.[16] By winning a three-year scholarship Harris was able to attend St Peter's College, one of Adelaide's most august private schools. He then worked for a time as an office and copy-boy for the evening tabloid paper the Adelaide *News*, before studying for a degree in English and Economics at Adelaide University. Described at this time by Hal Porter as being as 'slender and handsome as Flecker's Hassan or a Syrian sweetmeats-vendor',[17] Harris cut an extraordinarily precocious figure on the small Adelaide literary scene. By 1939, at the age of seventeen, he had already had poems published by the Jindyworobak Club (for which he acted as secretary) and *Bohemia*. He was also preparing his first book of poetry for publication. *The Gift of Blood* appeared in 1940, its publication partly assisted by the Jindyworobak group under its tribal elder Rex Ingamells.

Beyond the confines of Adelaide University, this group of 'Australianist' poets embodied the literary life of that provincial centre. The main avenue for Jindyworobak publication in the 1940s was *Poetry Australia*; under the editorship of Flexmore Hudson it was for a while a vigorous rival to *Angry Penguins* and *Meanjin*. Well before this, however, Harris had begun to chafe at the Jindyworobaks' narrow conception of Australian literature based on local idioms and rural and aboriginal themes.[18] In April 1939 he set out his frustrations at this limited and limiting vision of poetry in a long letter to E. J. Turner, the secretary of the Melbourne Bread and Cheese Club, which published *Bohemia*. This Melbourne group of book lovers, journalists and writers was led by J. K. Moir, an indefatigable collector of Australiana and a man who, it is said, never wrote a literate word in his life. The group took a similar view of Australian literature to the Jindyworobaks, but the short-lived *Bohemia* published a wider range of lively poetry and included work by Max Harris, Harry Hooton and Gavin Casey as well as of men like Rex Ingamells. The Bread and Cheese Club, like the Jindyworobaks, was especially opposed to the use of names and idioms derived from Anglo-Saxon literature. The literary sources for the Jindyworobaks included D. H. Lawrence's *Kangaroo* and P. R. Stephensen's pungent essay *The Foundations of Australian Culture*, published in 1936. As a movement the Jindyworobaks claimed to speak for timeless verities which expressed an essence, 'Alcheringa', the spirit of the place. Nowhere else has Australianism been advanced more energetically, or sometimes more naively, than in the magazines of the group, *Venture* and *Poetry Australia*,

Bohemia, October 1939: a monthly 'all Australian literary magazine', its bias was openly acknowledged in its slogan, 'Mateship, Art, Letters'

or in the anthology *Conditional Culture* (1938), in which Ingamells reissued his manifesto 'Concerning Environmental Values'.

Harris's letter to E. J. Turner in April 1939 was an attempt, as he put it, to make contact with other 'kindred spirits'. Comparing himself to the young Dylan Thomas in England, Harris made it clear that he profoundly disagreed with the Australianism of the Jindyworobaks. Whereas Ingamells was convinced that the Australian writer should limit himself to his immediate Australian environment as an essential prerequisite for the flowering of Australian culture, Harris argued that this myopia ignored the ever-changing notion of reality in the consciousness of artists.

This letter by Harris warrants quoting at some length because it represents a personal credo and statement of cultural values which, for all its precocious excess, formed the basis for the first issue of *Angry Penguins* and continued to represent the values that magazine espoused later in a more mature form. Harris confessed to faith in a new romanticism:

P. R. Stephensen: an unlikely *Führer*, but political authority saw him as a threat to Australian security

I believe that this new attitude can be brilliantly expressed thru [*sic*] the Australian environment — if the [Australian] poet could get a real essential cognisance of the intuitive change of attitude in the poet and painter today there is a great chance of a real lasting efflorescence of [Australian] culture . . . I want to come into real and vital contact with the essential nature of a world wide movement intellectually. Each moment of isolationism is a nail in the coffin of [Australian] culture.[19]

Harris concluded that there was a great need in Australia for a new *Weltanschauung*. Unfortunately, as he complained in a *Bulletin*-like metaphoric flourish, 'we buck from the effort of it — the accusations of imitativeness, of sucking up all the latest foibles purely for mechanics sake — [which] pushes us back into the sliprails of the [old] romanticism'.

The old romanticism to which Harris refers had its origin in the *Bulletin* school of writers and its art-equivalent in the Heidelberg school and the pastoral landscape tradition. In painting the dominance of this tradition had never been seriously challenged, except by the Meldrumites, until the late 1930s. In Australian literature and letters the 'gum-top' school, the Jindyworobaks and the nationalism of P. R. Stephensen's the *Publicist*, had an enormous energy in the late 1930s deriving from an extremist restatement of conservative nationalism. The crypto-fascism of Stephensen's eventual position led to his internment along with others of the Australia First Movement.

P. R. Stephensen's *The Foundations of Culture in Australia: An Essay Towards National Self-Respect*, 1936, was fervently nationalistic

The wider literary movement that has been called 'Australianism' was a comprehensive one in the late thirties and early forties. It took in the chauvinist patriots of the extreme right, liberal-minded men like Clem Christesen of *Meanjin Papers*, and the cultural policies of the Communist Party. Given the political climate at the end of 1941, with the tide running

Meanjin Papers, spring 1943: an ambitious quarterly devoted mainly to literature and with a strong nationalist bias

against the isolationism which Australia First demanded, liberal-minded men had to tread warily and avoid the taint of guilt by association. Writing to Ingamells in December 1941, shortly after the appearance of the issue of *Meanjin Papers* in which Ingamells expounded the extreme nationalistic views of his Australianism, Christesen offered the following words of warning:

This is obviously a testing time for Australia generally. Movements sponsoring Australianism, national culture, cannot afford to make mistakes at this crucial period. Intelligent people interested in art and literature here and elsewhere, are looking about them and asking who are these chaps who are making a stand for the recognition and the development of a distinctively Australian national culture. They are referred to the Jindyworobaks, to yourself and Group and to Mudie and Stephensen and the Publicist group . . . and perhaps to some extent to the Meanjins.[20]

For Christesen, the authentic Australianists were fighting for democratic values and must be wary of ideologically dubious cultural bedfellows such as Stephensen, whose politics and unbalanced behaviour could greatly damage the movement. Nationalism was the central theme of *Meanjin Papers* and Christesen strove from the beginning to preserve it from the unsavouriness which the Australia First Movement had acquired for itself late in 1941 and early 1942. The consequence was that *Meanjin Papers* in March 1942 devoted a whole issue to the need for Australia to find cultural roots and thus a sustaining faith at a time of military crisis.

War intensified the debate concerning the nature of an Australian stand and appropriate values for it. War did not, however, precipitate the debate. In its many forms it had been the central intellectual and cultural issue of the 1930s. The views of a Max Harris had been well formed by early 1939; it was now a question of refinement and this took place, as it did for Albert Tucker and John Reed, amid the complex questions of morality and art which the united front brought to consciousness.

In an immediate sense, the problem Harris faced was one of patronage. It was this that brought him and Melbourne artists together intellectually. Initially Harris got support within Adelaide University from Professor J. I. M. Stewart, Jury Professor of English Literature, and Charles Jury, a classics scholar and poet. The first issue of *Angry Penguins* was published in 1940 under the auspices of the Adelaide University Arts Association and was jointly edited by Harris and Donald Bevis Kerr, who was killed in action in New Guinea in 1942. University support, Harris confided, was not all that he could wish for: 'Those who did give help and encouragement have their interest not so much on the work as it stands, but on the genuineness of my aims and ideals, [that is] on me. They cannot reconcile themselves to what comes from me in black and white.'[21] The second issue of *Angry Penguins*, which appeared

in 1941, contained reproductions of James Gleeson's surrealist *Images of Spring* and Sidney Nolan's Klee-like *Woman and Tree*. In its pages Harris publicly declared an alliance between the magazine and the Contemporary Art Society. He had visited Melbourne early in 1941 seeking to establish contact with other like-minded spirits and had been introduced to Reed and Nolan. It seems that there was instant rapport; all shared a common fascination with surrealism and radical politics.

In the 1940 and 1941 issues of *Angry Penguins*, the ideas of Herbert Read were prominent. In the second issue Harris appealed to Read's conception of surrealism in defending the explicit sexual references in his poem 'The Pelvic Rose', which he had dedicated to Salvador Dali.[22] While Harris shared this preoccupation with surrealism with Melbourne artists and intellectuals, his must have been a lonely voice in Adelaide in 1940-41. Nonetheless, by playing the role of an *enfant terrible*, Harris declared to Turner, he had managed to create quite a stir.[23] On one occasion Harris addressed the University Arts Association on the subject 'Philistines, You and Surrealism'. The result, he reported, was a 'near Dadaistic' uproar.[24] Even before 1940 and *Angry Penguins*, Harris had been associated with surrealist ideas. He offered 'Narcissus' as an example of surrealist poetry:

> I am Max Harris, fleeting and flesh-ile,
> vain, erudite and stupid, until
> words lesion the languor of pains
> shading probes and jarred rhymes,
> and the movement lashes as rain
> leaks bending to heath.[25]

To advocate surrealism (good or bad surrealism, nobody knew the difference) was to lay claim to being on the side of a radical and anarchistic future. In 1940 Harris argued that since France now lay under the heel of fascism, surrealism ought to be actively propagated as a political act.[26]

Of course, this was a time when to be both a surrealist *and* a communist was to feel absolutely on the side of history and those humanist values which were everywhere struggling to survive. In 1941 Harris described one of his most notorious early adventures, one which he has continued to celebrate and embroider:

I am in the shit over here at present and this week I'm plastered all over page one of the local 'Truth'. There are a gang of potential 'strike breakers' who have organized themselves to 'help the government in case of a strike' at the University — and I proceeded to break the strike-breakers in no uncertain fashion. The result was two armed camps and an ultimate riot which they brought about in which myself and half-a-dozen of the others were thrown into the river by the strike-breakers; but then my boys got to work, and threw the strike-breakers into the river.[27]

Without doubt the fact of belonging to a proscribed political party was an exciting experience and Harris has subsequently claimed to have been 'the founding force behind the first Communist Party Branch of the University of Adelaide when the Party was an illegal organization'.[28] Harris presented himself to left-wing artists in Melbourne in 1942 as a card-carrying member of the Party and argued that *Angry Penguins* should be a vehicle for left-wing political as well as advanced aesthetic ideas. As late as July 1943 Harris wrote to Bernard Smith making his political position clear: 'the essential truth of the matter is that I have been an active rank and file member of the C.P. since I was 17, and I still am at present.'[29]

For Australian intellectuals like Harris, Reed and Tucker, the allegiance to communism, though brief and transitory, was an important step in helping them break from Australian provincialism. Before 1940 this rebellion was a confused affair and natural allies were all too often identified with genuine enemies. In 1941, for example, Harris could see little difference between the crypto-fascism of the *Publicist*, the racist conservatism of Lionel Lindsay, the Australianism of the Bread and Cheese Club, and the aristocratic élitism of Adrian Lawlor.[30] The finer distinctions which Christesen called for were lost. Throughout 1941 Harris pressed home an attack on all cultural positions that he identified, rightly or wrongly, as undemocratic and regressive.

In the face of this vision of a general evil, the only moral attitude possible for men like Harris was one of revolutionary communism and its supposed equivalent in the arts. In the September issue of *A Comment* Harris declared that, although Lawlor had called for the elimination of forces denying creative art and life in Australian culture, Lawlor himself now needed 'eliminating'. Lawlor had become irrelevant:

Lawlor has been doing some work pitching into the carcase of a dead and castrated donkey ... Meldrumism, traditionalism, etc. This is all right. Most of us feel it to be unnecessary and use our energies more constructively, or to eliminate the dangerous elements within the modern movement as genuine labour elements are fighting the Curtin brand of opportunism.[31]

Adrian Lawlor could not be dismissed as easily as this. It should be recognized that it took considerable courage for Lawlor to declare publicly in *Art in Australia* in 1941 his absolute allegiance to the élitism of D. H. Lawrence and Friedrich Nietzsche in complete opposition to the authoritarianism and anti-humanist values of political *Führers*, whether of the political right or left.[32] Lawlor's spiritual world was not their world:

Where I belong there is no M.G. ambushed behind the reeds, no tank trap behind the hawthorn hedge. The Dive-bomber does not divide the horizon there, nor the Bren-gun split the shining upper air with its whining missile. Man, for all his innate and interosculating vices, is in fact less of a brute where I come from

than he is around here, where lust becomes lethal and desire straddles itself with death.

The artist's role was not to adopt a 'boy-scout' habit of mind and exhort others to do good deeds, or himself to administer 'the dreadful Daily Dozen' to fascism and other evils. That was not the world in which Lawrence or Nietzsche existed but the world of nationalism and chauvinism, a nightmarish world of 'Bottomleyism' which, as Lawrence described it in *Kangaroo*, was inimical to the creative liberal spirit. Lawrence knew full well from his experiences in England during the Great War how that spirit had been broken.

Lawlor, like Lawrence, could appear either as radical or conservative depending upon where he identified the presence of dehumanizing forces. In the 1930s it was in the Australian Academy and in the 'slithering' of art popularizers. In the early 1940s it was in the enlistment of culture in the service of war. For a man who had fought with the Anzac Corps in the bloody mess of Passchendaele in 1917, liberal life had to be asserted at all costs in the midst of a second war. And since for Lawlor art was life and life was art, when art was threatened so too was humanism and the value of the individual spirit.

Lawlor was prepared to state unpalatable truth even in the illiberal political climate of 1941. Submission to authority on the part of the artist, whether to military authority or to the communist-directed united front, was tantamount to creative suicide. Lawlor's closest friend at this time, the young poet Alister Kershaw, wrote to Rex Ingamells in November 1941 confessing an affection for P. R. Stephensen, but stating that he rejected utterly Stephensen's politics: 'as I have frequently told him ... all my being revolts against the idea of taking part in any war for any purpose.'[33]

It should occasion no surprise that members of the Communist Party saw in Lawlor and Kershaw an incipient, if not an outright, fascism. Bernard Smith made the association explicit in an attack on their views in the *Australian Quarterly* in March 1943.[34] In 1944 and 1945 Tucker and Reed were to find themselves similarly accused by Melbourne communist artists in the pages of *Angry Penguins* and the *Communist Review*. In the case of Lawlor and Kershaw, it must be said that both took great delight in provoking such responses. There was, for example, the well-remembered occasion of Kershaw's performance at Melbourne University when he fastidiously donned a pair of white gloves before deigning to take a copy of the *Worker's Voice* out of a briefcase and proceeding to berate Marxism. On that occasion Kershaw also read two surrealist poems by James Gleeson backwards. Kershaw and Lawlor were prepared to debunk pretension and preciousness wherever it might be ferreted out. Kershaw's epic poem 'The Denunciad', part of which was published in *Angry Penguins* in September 1943, spared no one and no group on the artistic or literary scene. Kershaw's sallies raised a great

Alister Kershaw, c. 1944: poet and provocateur

deal of laughter, but what raised the hackles of the left most of all were, as with Lawlor, his serious statements of belief. It must be said that both in temper and character Kershaw's were more extreme than those of Lawlor. Kershaw derived much from the attitudes of the flamboyant South African poet Roy Campbell, who had fought for the Nationalists in Spain.

Kershaw's poetry in the early 1940s, especially 'Lands in Force', was as widely admired as his social values were reviled by those of his generation whose liberalism took more radical forms. Kershaw's most important and provocative statement of values, 'Salute to an Aristocracy', appeared in the January 1942 issue of *A Comment*. It was a defence of the poet and artist as a natural aristocrat.[35] Creative men denied the individual spirit of their creativity by closing ranks and forming groups — whether aesthetic or political or both. The agent of change in culture was not political movements, but the actions of the truly creative artist, by nature an aristocrat of the spirit whose striving helps transform the quality of life. In Australia, for Kershaw, life was all too often reduced to the bourgeois values of the golf club, on the one hand, or the proletarian values of trade unions and Marxist study groups on the other. Whether bourgeois or proletarian, both spelt mediocrity, philistinism, and death in life. Kershaw felt, as strongly as Lionel Lindsay or Lawlor, that the greatest danger to culture lay in popularization; and beyond that in dilettantes who professed to 'love' art but were in reality its parasites, a dangerous philistine public to which the mediocre artist pandered and which thereby distorted the value of art.

Neither Kershaw nor Lawlor was close enough to see that the group that had begun to coalesce around the *Angry Penguins* magazine valued the natural integrity of the individual and the creative artist just as intensely as they. In December 1942 Lawlor described the canvases of the annual C.A.S. exhibition of that year as 'violent psychological retching and belching'.[36] They were symptomatic of the intrusion of politics into the realm of art.

In the defence of liberal values Lawlor found himself forced into a position that had little positive to offer younger artists except 'aristocratic' élitism. Artists and writers like Harris and Tucker were not prepared to accept the retrogressive aesthetics of either crass élitism or populist Stalinism. In seeking alternatives in surrealism their response was sharpened by the very real threat of authoritarianism. In their own ways both were as resolutely against serving the war effort as Kershaw. In Tucker's case his conscription in 1942 not only exacerbated a personal *angst* but also brought home in the most direct way possible the truth of Lawlor's contention that authority and creativity could never co-exist. He was, for example, appalled when told the lengths communists were prepared to go in the event of a take-over of power — if the Japanese actually invaded Australia. By the end of 1942 Tucker had come to believe as firmly as Lawlor that the individualist values of the artist had

to be guarded at all costs from tyranny and authority, whatever its source.

Harris was more successful than his artist friends in avoiding military conscription, spending only a short period in the army as a non-combatant acting corporal before obtaining work in an exempt category as a research statistician. Before then, in 1941, Harris played the role of conscientious objector, an attitude he celebrated in a poem published in *Angry Penguins* in 1943 entitled 'Love Story of the Bourgeoisie who got out of step with time'. This prompted the rather more patriotic A. D. Hope to reply with the line, 'Corporal Phyllis's tits are quite out of step with mine'.[37] Certainly Harris's energies were mainly directed towards war on the intellectual front in 1942 and 1943. Besides being the prime mover in starting an Adelaide branch of the C.A.S., at this time he assisted Mary Martin in establishing a bookshop. Early in 1943 the first issue of *Angry Penguins* edited by Max Harris and John Reed appeared; in June 1943 the Reed & Harris publishing firm was formed.[38]

The new *Angry Penguins* was intended to be Marxist in tone and content, but it was obvious from the first joint issue that this was not to be its character. Harris announced that, whereas *Angry Penguins* had begun in 1940 as a narrow literary anthology, it now aspired to be a journal supporting all advanced literature and art. Its connections with the Contemporary Art Society would underwrite this aim. In effect, *Angry Penguins* took up in a more radical fashion the role of *Art in Australia*, which had ceased publication in 1942. A comparison between Peter Bellew's *Art in Australia* during 1941 and 1942 and the later *Angry Penguins* is highly revealing. It is a comparison between the liberal spirit as exemplified by a Burdett and a Lawlor and that inspired by values of a more radical kind.

Art in Australia

Until its demise *Art in Australia* remained the foremost journal for art criticism and comment. The enterprise brought together a number of fine talents. Through Bellew's entrepreneurial ability it employed such skills as those of the recently arrived English designer Richard Haughton James. Lawlor was a regular contributor, as were also Paul Haefliger and his wife, Jean Bellette, recently returned from Europe in 1937. The editorial of the first issue early in 1941 declared with some sincerity that the magazine had 'no favours to bestow — only a sincere desire to serve Art'.[39]

The result more than measured up to expectations although the means were often questionable, if excusable in the circumstances of war. Many of the reproductions were simply pirated in complete contravention of all copyright restrictions. Important drawings and paintings were reproduced in this way from work by Picasso, Masson, Ernst, Braque, Tanguy

ANGRY PENGUINS
NO. 4

Edited by MAX HARRIS

Angry Penguins, no. 4, 1943 (*top*): the first issue of the magazine produced by Reed & Harris in Melbourne. The surrealist painting on the cover is by James Gleeson; the contents were to infuriate both the right and the left

Max Harris's only novel, *The Vegetative Eye*, had its cover designed by Sidney Nolan. Few literary efforts can have been demolished with the gusto that A. D. Hope brought to the task in *Meanjin* in autumn 1944

and Matta. But what was significant for an Australian production was the assumption that local writers should be published cheek by jowl with pieces by the foremost artists and intellectuals of the times: Herbert Read, André Breton, Paul Rosenberg and André Masson. Many were commissioned especially for *Art in Australia* and it is hardly an exaggeration to claim that the magazine was one of the most important publishing ventures on the international scene at that time — a phenomenon too few people appreciated.

This achievement accorded not only with Bellew's own conception of culture but also with the aims of Warwick Fairfax who, like Murdoch in Melbourne, wanted a change in the Australian art scene. Accordingly, the new *Art in Australia* had an international and progressive outlook. Not everybody was sympathetic. Ure Smith naturally resented any change to 'his' magazine and, like many others, thought that Australian artists were being sold short by the new emphasis. Many conservatives resented its use as a platform to attack the policies of the trustees of the National Gallery of N.S.W.: it is said that six members of the Australian Academy demanded the return of their subscriptions. From this time Bellew, whom J. S. MacDonald described as 'that oiled and curled Assyrian bull, smelling of musk and insolence',[40] became the *bête noire* of conservatives and older liberals alike. Robert Menzies objected to its emphasis on French art and told Bellew, 'I never liked French art, it was always decadent and the fall of France proved it.'[41] Even fellow members in the Contemporary Art Society feared that Australian art was in danger of being sacrificed on the altar of internationalism. The beginning of an estrangement between Peter Bellew and his one-time supporter and friend John Reed seems to have had its origin in this thorny question of balance. It was a fight to have work by leading members of the C.A.S. reproduced. Although paintings by Nolan, Tucker and O'Connor were featured, there was always the fear that they would be relegated to an inferior status.

Yet however impressive and accomplished the new *Art in Australia* appeared, it was a hot-house bloom. Only the conditions of war enabled its flagrant disregard of copyright to go unnoticed or to be accepted by European intellectuals in exile or under siege. The problem was not financial; knowing full well that *Art in Australia* always lost money, Fairfax had gone on subsidizing the venture. Series 4 ended after only six issues despite the fact that every issue had sold out. The principal reasons for its demise were that Bellew was conscripted into the navy in the middle of 1942, and that paper and other materials were becoming increasingly scarce. Only Warwick Fairfax among the management of the *Sydney Morning Herald* had been enthusiastic, and with Bellew's departure production was suspended. It was never renewed.

In the second half of 1942 it looked as if Australian artists would be totally without a magazine of quality dedicated to serious art-comment and criticism as well as to reproducing work. The fourth issue of *Angry Penguins*, however, served notice that it aspired to fill the vacuum by

Art in Australia 1941: the old quarterly was transformed briefly by Peter Bellew into this lavish and outward-looking production that rivalled its French models

becoming 'a literary and art journal proper'. Indeed, its precocious title would be dispensed with as the magazine moved 'in terms of the social and cultural movements of our age'. But the name (originally derived from a line in a poem by Harris, 'as drunks, the angry penguins of the night') stuck and, for want of any alternative, was accepted as not inappropriate for an avant-garde venture.

Angry Penguins became, with *Art in Australia*, the most important cultural magazine of the early 1940s. Its publishers argued similarly that the modern movement in Australia stood in the front rank of twentieth century progress in the arts; in their case they discerned kindred spirits in Dylan Thomas, Herbert Read and other advanced artists and writers in Europe and America. In reflecting this international movement, it came to represent in local terms the values and ideas of a key group of artists and intellectuals who had been among the most radical members of the student intelligentsia and their supporters in the 1930s. As such, it became a rallying-point for men of such diverse temperaments as Max Harris, John Reed, Sidney Nolan, Albert Tucker, Arthur Boyd, John Perceval and Peter Cowan, as well as visiting American intellectuals like Harry Roskolenko. It resembled less an antipodean *Cahiers d'Art* than coterie magazines such as the British Penguin *New Writing* or the American *New Directions*, in presenting not only advanced art and writing but standing for a defined cultural position. This fact must be recognized from the start, whatever the claim of the editors that it sought to place

The American poet and writer Harry Roskolenko, who arrived in Australia with the Army Transport Service in 1943: Roskolenko had by then moved from Stalinism and Trotskyism to values akin to those of the *Angry Penguins* circle

itself above party by standing for 'no brand of culture — neither pseudo-modernistic nor retrogressive. It will be purely a forum for the highest literary and art level emerging for this country'.[42]

The 'transition' fourth issue of early 1943 was, however, something like the catholic-minded enterprise Harris and Reed claimed it to be. It presented a cross-section of opinion and thought which, despite the provocative character of Albert Tucker's piece 'Art, Myth and Society', seemed wholly in keeping with the programme of the united front. John Reed was playing safe within the rhetoric of the left when he added in the editorial that 'if from time to time it reveals inconsistencies, it may be anticipated that these in turn will lead to a more vital and creative synthesis'. Reed's account of the Anti-Fascist exhibition of the previous December contained, furthermore, nothing to disturb the outward face of this radical unity.

The New Liberalism

All that had vanished by the time the fifth issue appeared in September 1943. The tone of *Angry Penguins* was now set by polemical attacks on leading members of the C.A.S. from communist artists, and the equally vehement rejoinders. It included a piece by Noel Counihan entitled 'How Albert Tucker misrepresents Marxism' and one by Harry de Hartog, 'Fascism in the Making'. The clash between communists and their one-time fellow travellers is dealt with later: suffice to say at this point that the division of values and attitudes, both artistic and political, was clear and unequivocal by 1943; evident too was the growing consciousness of a group best identified by the term 'Angry Penguins'. Harris now rejected a united front position in the belief that the time had come to make a stand and define where he, his associates and *Angry Penguins* stood politically and artistically. On the one hand, he wanted to distinguish the position of the magazine from the continuing thrust of Australianism as exemplified by *Meanjin Papers*. On the other, he wanted to make it clear that *Angry Penguins* did not share the values of Stalinist socialist realism which had found a voice outside the official communist press in the newly established *Australian New Writing* edited by Bernard Smith, George Farwell and Katharine Susannah Prichard.

Thus in an editorial written in the September 1943 issue, Harris and Reed set out the policy of *Angry Penguins* in terms of a new cultural rhetoric. It would not encourage blatant nationalism because that would be inherently artificial. Of its own accord Australian art, the editors argued, would inevitably 'mature into a form of expression which will be unique and in the truest sense of the word indigenous'.[43] In the same year Harris had attacked *Meanjin*'s particular brand of 'Australian Kulchewer' from within the pages of that journal itself in a piece entitled

George Farwell, left-wing writer and activist, on a visit to Central Australia

'Dance Little Wombat'.[44] Neither were the *Angry Penguins* editors prepared to accept communist injunctions that artists avoid personal and subjective themes and face political reality squarely, painting or writing on the basis of social experience alone. There were other realities equally if not more important to artists. As Reed and Harris put it in the September editorial, 'We are happy to find that our poets *are* sometimes concerned with love, one of the deepest and most fundamental forces in human nature, and with the landscape, the influence of which has a profound bearing on the life of man.'[45]

The decision of the editors of *Angry Penguins* to devote much space to polemical and art-political material was a reflection, it was declared, of 'the complex situation which confronts the artist today'. And indeed, things were complicated. The Australian artist of radical-liberal sensibilities was struggling, at a time when the united front was failing, to find answers to the fundamental questions of art and life: where ought the artist stand on questions of national versus international values; if the war was being fought as a war against evil, how could that evil be defined and where was it located; if evil existed, where did good reside and in what terms could life-enhancing values be identified? In 1943 the Angry Penguins were sure of only one thing in answering these vital questions: Stalinism and united front policies had not only failed to provide convincing answers but were themselves suspected of dangers comparable to those of fascism. Certainly the consciousness of war and the life struggle involved could not be avoided by the artist. The perplexing problem now was that of determining the relationship to the struggle of both the individual and the artist. The answer could be found only in a new ideological stance, one concomitant with individual liberty and thus underpinning a social and cultural milieu that would guarantee freedom and progress in the face of reaction, whether from the right or the left.

Like Burdett and Lawlor, the Angry Penguins refused to think of different aspects of the arts as distinct from one another. In speaking of the group that produced *Angry Penguins* John Reed has said: 'We regarded art as a total phenomenon which was involved with society as a whole and that it was relevant to explore other areas as well as the areas of the fine·arts.'[46] In this sense they followed in the footsteps of André Breton and Herbert Read, for whom life was a total and organic whole. *Angry Penguins* was therefore equally ready to pronounce on any subject — cinema, jazz, literature, the visual arts, economics, society or politics. Sidney Nolan was involved not only as an artist, for layout and design, but also as one of the poetry editors. Later Albert Tucker was given an 'official' position as editor of the 'sociological section' of the magazine. The magazine's early smokescreen of openness should not, however, be allowed to obscure the core of values from which its forays were conducted. In their own ways and in their various modes, Harris,

Katharine Susannah Prichard, who established *Australian New Writing* with George Farwell and Bernard Smith in 1943. Although not a product of the Party press, like its three editors the journal stood for an uncompromising Marxist view on art and literature

Tucker, Reed, Nolan, Boyd and Perceval all articulated the values of a radically *new* liberalism. The outstanding theorists at this early stage were Tucker and Harris.

In 'Art, Myth and Society', in the fourth issue of *Angry Penguins*, Tucker set out his views on the tasks facing the new art.[47] The argument is not always consistent or even coherent, but what is important is the courage with which Tucker expressed the point of view of artists no longer prepared to accede to communist injunctions on art. To this end, his words appeared alongside the text of the address by J. D. Blake on the occasion of the opening of the Anti-Fascist exhibition. Blake had restated on that occasion the Stalinist line on art as represented in the 1930s and 1940s by Andrei Zhdanov's socialist realist demands upon the creative artist. In complete contradistinction to these views Tucker, like Lawlor before him, pointed to the inevitability of a gap between the creative artist and society. Unlike Lawlor, Tucker argued for this inevitable 'contradiction' in the language of anarchism and surrealism and Jungian psychology rather than in terms of the romantic-liberal tradition of Nietzsche and D. H. Lawrence. Although the charge of anarchism was not made explicitly by Noel Counihan in an attack on Tucker's ideas later in 1943, he may have been more astute than he realized when he likened Tucker's style to that of the great French anarchist philosopher Pierre Proudhon.[48]

In October 1941 Tucker had still shared a sense of common purpose with other left-wing painters. By the end of 1942 he had come to the same stand as Lawlor in the previous year. His conclusion in 'Art, Myth and Society' was that 'full creative freedom is absolutely essential for the reciprocal growth of the individual and society . . . [the artist] must be assured of creative freedom at all times'.[49] Tucker joined his own personal convictions on this point with the views and values of Herbert Read, who argued that only the creative imagination with its myth-making potential could reconcile the contradictions of human experience and consciousness.

Where Tucker differed from Lawlor was in his belief that an 'organic' art demanded a return to an art of content. Great art could never be without a significant human content. This was a legacy from Tucker's association with the radical left, but it was also the legacy of Burdett's particular brand of liberalism. Burdett may have baulked at Nolan's early 'abstractions' but one feels sure that he would have found much to his humanist taste in the work of the men and women around *Angry Penguins* between 1943 and 1947. Tucker's call for a new humanistic art based on psychological and social realities as experienced and perceived by the creative individual was echoed by Max Harris in 'Art and Social Integration', published about the same time in the *Australian Quarterly*.

Society was, Harris wrote, like 'an organism: perpetually undergoing mutation, integration and disintegration; and the field of art changes very

Albert Tucker, c. 1942: an artist and intellectual whose fierce individualism in art and in life was matched only by that of Sidney Nolan

often because environment is a fluid thing'. Similarly, Lawlor had held
that the artist worked always from a position in which nothing was stable,
predictable or certain. But whereas Lawlor, fully aware of the danger
of social change, was wary of anything that threatened individual libert-
ies, Harris was still radical enough in 1943 to believe in the necessity
for such changes. On this basis he called for revolutionary action on the
part of those cultural groups in Australia and overseas which had grown
out of 'the imperative search for a new positive pattern of community
life'. The truly creative artist had the potential to act as a protagonist
and an agent of radical social change. The character of the art that would
help precipitate such community-based changes could not yet be known.
The only predictable thing about this art, for Harris, was that, being
'unpretentious, subjectively true, immediate, and essentially sane [it] may
be the great art of our generation'.[50]

The ideas expressed here by Tucker and Harris demonstrate a radical
liberalism that underwrote and helped direct the most experimental art
of the 1940s. It is an informed and selfconscious humanism in the
tradition of the earlier art criticism of Lawlor and Burdett in the 1930s.
The exposition of these ideas precipitated, as we shall see, a second
crisis and split in the C.A.S.

Between 1943 and 1946 Harris was in contact with the two men upon
whose efforts the revival of the anarchist movement in Britain in the
1930s and 1940s rested: Herbert Read and George Woodcock. Also
belonging to this movement were Dylan Thomas (a self-professed
anarchist), Alex Comfort, Denise Levertov, John Cowper Powys and
Ethel Mannin.[51] If Herbert Read's views were influential in moulding the
ideas expressed by Tucker and Harris, they continued to be canvassed
and quoted with approval in *Angry Penguins*. The Australian Angry
Penguins (Tucker, Harris and John Reed) found in the writing and
anarchist theories of Read a fertile source of ideas, which offered at
once a language and a framework for radical liberal values centred on
individual experience and freedom. In 1942-43 those values appeared
to be threatened more than ever — and now from their one-time allies.
Although they never called themselves anarchists in the cultural and
political sense that Read and Woodcock acknowledged, they were
nonetheless profoundly affected by these ideas that gave their own
thought its particular cast.

For Read, as for his Australian followers, it was through the endeav-
ours of the individual artist that culture progressed. Aesthetic experience
was equated with an awareness of psychological and social realities. The
Canadian-born George Woodcock argued precisely this point in the
pages of *Angry Penguins Broadsheet* in April 1946. In 'The Writer and
Politics', Woodcock stated that individual intellectualism was as radical
a force for change as direct political action:

The really independent writer, by the very exercise of his function, represents
revolutionary forces. The conscientious writer, the sincere artist, the true intel-

Angry Penguins Broadsheet, 1946: this
issue illustrates vividly the role that jazz
played in the lives of the *Angry
Penguins* group. The cover photograph
shows the Harlem trumpet player
Morris Goode and the Australian Roger
Bell on cornet playing the blues

lectual, are all capable of acting in a revolutionary manner so long as they are allowed to think and speak without compulsion or restriction . . . As long as they work according to an internally valid creed, their work will have real significance.[52]

Woodcock stated the case for anarchism in its 'classical' form and emphasized the supreme value of the individual over and above that of the social organism. The primary aim of the modern anarchist was 'the resolution by the individual of his own nature'.[53]

In reply to communist criticism, Woodcock made the specific point, one on which the Angry Penguins were by 1944 in full agreement, that the artist should refuse to support all programmatic political theories and membership of political parties. Woodcock concluded by spelling out what anarchism involves in practice:

Anarchism . . . is based on the concepts of freedom and justice, justice being that reciprocity of freedom without which no real individual freedom is possible. The social principles which follow from these concepts are mutual aid, and co-operation, and communism or common ownership of the means of production.[54]

Of course the Angry Penguins were never active in the clear political sense that Woodcock defines here. Nor were they prepared to involve themselves in the sort of governmental and semi-official activities which brought Herbert Read an eventual knighthood (for an anarchist a somewhat dubious honour). The English movement did through its links with advanced social and artistic movements, however, provide an alternative radical model. As such, it helped open the way to new modes of artistic expression conceived in terms of a humanist critique of Australian society. It was, as the reader will now be well aware, a case of 'old wine in new bottles'.

While individual anarchists, by the very nature of their philosophy, differ widely over particular issues and over the nature of anarchism itself, on one point all were unanimous. For the anarchist, as for the liberal, there can never be any direct relationship between art and political action. Art ceases to be art when it becomes political propaganda, since the intrusion of active politics is inimical to creative expression. Liberal and anarchist alike accepted the fact, however regretfully, that the masses inevitably lacked the capacity for an immediate access to progressive art. John Reed argued similarly in *Australian New Writing* in 1944 that a gap between the work of the aesthetically advanced artist and the bulk of the population was unavoidable.[55]

The link between the *Angry Penguins* coterie and a set of values identified with anarchism was clear by 1944 — a very critical year for Australian art politics. In 1944 Albert Tucker spelled out the new values in uncompromising terms in an article in *Angry Penguins* entitled 'The Flea and the Elephant'. This was Tucker's bitterest attack on communism and

the Melbourne social realist artists led by Counihan and O'Connor, and it was a paean to individualism. Cultural achievement, he held, was ultimately a product of 'the interaction between a particular man and his particular context'. Within that context, Tucker demanded for the artist 'a margin of freedom, leisure and privacy' to achieve a truly radical art. 'And that', Tucker declared, 'provides us with a political ethic — the continuous extension of personal freedom.' If society was to be socialist, it had to be socialism with a sense of genuine community and a human face. Communism for Tucker meant Stalinism and Stalinism could never accept relationships between 'clearly self-conscious and other-conscious individuals bound together in mutual respect and mutual responsibility'. Against this ideal stood the Stalinist command: 'Comrades of the intelligentsia! ... Unite! You have nothing to lose but your brains!'.[56]

Angry Penguins as it appeared in 1945 with a cover by Albert Tucker

For Albert Tucker a sense of community had always to allow for a sense of individual liberty. In practice, as the Angry Penguins group developed around the institution of *Angry Penguins*, he discovered how difficult it was to achieve. Alienation occurred even within its ranks. Not everybody's individuality was granted equal respect and not all painting was given the stamp of critical approbation. By 1946 Tucker found himself an outsider even from the group on whose behalf he had spoken so forcibly. At the same time, Arthur Boyd and John Perceval found that the new direction their painting was taking in 1945 and 1946 was considered a betrayal of the values which all had appeared to espouse and express between 1943 and 1945.

In 1944 *Angry Penguins* announced that Sidney Nolan was now a formal partner of the Reed & Harris firm. There were also other critical new developments in *Angry Penguins* from this time. Despite the battering that Max Harris and John Reed had been given over the Ern Malley affair in the previous year, *Angry Penguins* appeared in 1945 in an even more ambitious format. With a cover illustration by Albert Tucker depicting a returned digger cast like a broken doll among the refuse of society, it announced a brave new role concomitant with its extended scope. The language of the editorial in which this was couched had a now-familiar ring:

The growth of *Angry Penguins* has been, we believe, of an organic character. To start with, an eclectic anthology of verse, then including prose, subsequently widening its scope to cover the field of painting, and latterly music, the film, and finally sociology. We do not feel that this growth has been forced, but rather has come about by a natural process indicated by a deepening awareness of the wider integration of art and society to provide an over-all cultural organ for the artists of this country.[57]

The long editorial was less a coherent statement than a series of separate pronouncements: a manifesto for a new radical liberalism based on anarchist forms. The ideas expressed, consistent with a conception of culture and society that Herbert Read and George Woodcock stood for,

Mo's Memoirs, reminiscences by the Australian comedian Roy Rene, and Henry Miller's *Murder the Murderer* were the two most notable coups of the Reed & Harris publishing firm. Sidney Nolan designed these and other Reed & Harris books

were open-ended, humanistic and 'organic'. So open-ended were they that the only selection principle which the editors were prepared to acknowledge was that of work thought 'creatively valuable'. There was no indication who would decide what was valuable and what was not, or how this would be done. But perhaps the most important point made was a reaffirmation of the *Angry Penguins* conception of where the Australian artist stood in the world. Wherever it was, he was not alone: 'We must remember that the whole world is interrelated as never before, yet each country, each community has its own individual function and can contribute its full value to the world only if it is conscious of its separate identity.' What was true for the individual artist, then, was also true for an individual people or nation.

The position thus stated is not the same thing as 'internationalism'. Harris's poetry might be connected in the minds of the Angry Penguins with that of a Dylan Thomas, the paintings of Tucker or Nolan with those of an André Masson or a Paul Klee, but regional and individual differences of society and temperament were regarded as being equally important as the universality of creative endeavour. The task of the Australian artist was to address himself to an Australian audience, however universal the truth of his cultural message. Geoffrey Serle in his analysis of this 'national problem' notes the difficulty and the extraordinary sophistication demanded by 'the relaxed upright stance'.[58] For the Angry Penguins the solution was worked out in terms of the ideological values identified here. Both *Angry Penguins* and the C.A.S. were intended to help artists contribute to the wider stream of culture by drawing upon internal and external resources, and on national and international traditions.

The expansion of *Angry Penguins* in 1945, in line with this historic mission, involved a move to larger premises at 48 Queen Street and, in addition to the magazine (which was fortunate if it came out once a year), the publication of a monthly *Broadsheet*. An American connection was established through the poet Harry Roskolenko and contributions came from American writers. The list of Reed & Harris books published, planned, or for which they acted as agents at this time is impressive. Authors included Arthur Calwell, Reg Ellery, Bruce Williams, Peter Cowan, Dal Stivens, Alister Kershaw, Geoffrey Dutton, Roy Rene and Harry Roskolenko, as well as Max Harris and Cynthia Reed. Henry Miller's *Murder the Murderer* was published in Australia by Reed & Harris at a time when it remained banned in America. The list of names in itself testifies to the magnitude of an achievement rarely recognized in Australia's cultural and intellectual history.

The whole enterprise of *Angry Penguins* and Reed & Harris had become more outward-looking, and the changes reflected very much the new connections made with American writers. In particular, the values of Harry Roskolenko reinforced the intellectual and ideological bent of the Angry Penguins. American culture was an immediate thing in 1944, given

an American military presence since 1942. *Meanjin Papers* and *A Comment* also published work by American poets — especially the American Jewish writers Roskolenko and Karl Shapiro. Shapiro arrived with the American Navy and Roskolenko with the Army Transport Service. While Shapiro remained closer to the group around *A Comment*, Roskolenko embraced a wider Australian literary and artistic scene. Back in America in 1945 and 1946, he acted as the *Angry Penguins* representative, gathered material for publication from such figures as Kenneth Rexroth and Harold Rosenberg, and contributed a 'Letter from America'.

The appearance of the *Angry Penguins Broadsheet* marked the end of wartime restrictions. It proved enormously popular; unlike the magazine, it made money. Intended to act as a vehicle for polemics and comment on topical issues, in practice it differed little in character from the magazine. Nonetheless, in the second issue the editors singled out the targets they intended to attack and declared its aim of opposing 'bad social judgment of art and literature [and] the bad culture that the social milieu evokes'.[59] In other words *Angry Penguins* intended to oppose *petit-bourgeois* culture in Australia in all its forms, whether masquerading as the populist values of communism or the debased values of suburban mentality.

The character of the Angry Penguins group needs careful analysis because it was not always either homogeneous or harmonious. Although there existed a general consensus, there was an inner and outer group. The nucleus consisted of the four partners of the publishing firm: John Reed, Sunday Reed, Harris and, from 1944, Sidney Nolan. An outer ring

Max Harris and Joy Hester in the Tarax milk bar in Melbourne's Swanston Street, c. 1944

included Albert Tucker, his wife Joy Hester, John Perceval and a host of satellites who came and went at Heide.[60] John Perceval and Arthur Boyd stood to one side of the central group since both were held by strong communal bonds of family and friendship to the Boyd encampment in Murrumbeena, with its attraction for young university intellectuals and craftsmen.

If the more public figures of the groups were men, the importance of the feminine component should be recognized. In particular, the roles played by Sunday Reed and Joy Hester were central, despite the intensely private character of their lives. Sunday Reed's thoughts were not published; Joy Hester's paintings and drawings were exhibited only rarely. Hester's work, mostly drawings using Chinese ink and wash, is highly personal — evocations of relationships, with individuals or with an unsettling external world. Sunday Reed's intuitive and acute eye for art was matched by a deep feeling for personal relationships — a source of strength and a source of vulnerability. If the C.A.S. revolved around the leadership of John Reed and Albert Tucker, Sunday Reed provided much of the leadership that characterized not only Heide but also Reed & Harris. Harris himself described her as the 'governing sensibility' of the whole venture.

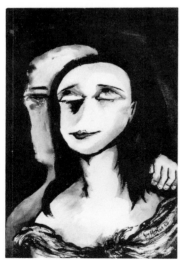

Joy Hester, *Face*, c. 1947 (*top*); *The Lovers*, 1956

Tucker, at heart the most individualistic of these figures, was attached through support from and friendship with the Reeds, through *Angry Penguins* (by employment), and by the sense of common cultural purpose expressed in its pages and through the C.A.S. Notwithstanding these links, the relationship frequently broke down and taxed the patience and diplomatic skills of both parties. At the end of 1945 Tucker wrote to the Reed & Harris partners protesting that he had been shut out of what he felt was an increasingly closed group.[61] In this highly revealing exchange he demanded full and equal partnership on the grounds of his contribution to *Angry Penguins* and his belief that until then the tie between himself and the others had been based on common interests in spite of disagreements in the past between himself and Max Harris — chiefly, it would seem, over Harris's refusal to break off all connections with communists. His complaint now was over the recent growth of the firm, concerning which he had not been consulted. Feeling even more of an outsider, Tucker demanded to know whether a consensus still existed and where he stood in the new scheme of things. John Reed replied on behalf of the partners:

In human terms what you say has shocked us very deeply. Over the past two years we had hoped we were working towards a feeling far removed from what you reveal. You have made your demand for partnership an absolute and final issue rather than an extension of our human relations.[62]

A sense of community between individuals clearly had its limits. As far as the firm was concerned, Reed wrote, partnership grew out of friendship and could not be demanded.

Joy Hester, c. 1943: primarily a graphic artist, she produced works that, though rarely shown at the time, attest to an intense feeling for emotive and disturbing dimensions of human relationships

In the face of Tucker's demands, Reed felt constrained to define precisely what the group understood by 'partnership'. He and Harris felt that organic groups such as this were a product of two factors: firstly, of joint social action in pursuing specific cultural goals; secondly, of the need for 'human relationships' between particular individuals. The second need was, in other words, a product of intimacy and friendship, and was the most important reason leading to joint effort since genuine cultural values could be generated and sustained only by a group of individuals 'needing to work together'. Tucker had argued that *Angry Penguins* ought to represent an open 'pooling of cultural talent'.

The use of the term 'organic' by either Tucker or Reed can be taken as something approximating the word 'natural'. This is similar to the notion of an 'organic society' as used by both the political left and the right: that is, in the sense of a society in which the units of class exist ideally in a symbiotic relationship. Reed also uses 'organic' as an anarchist to suggest an ideal communal set of relationships between individuals. It is ironic that in not being prepared to sacrifice individual liberty as

an artist, Tucker should have this 'organic' theory of anarchism used to maintain his isolation.

For his part, Tucker remained unimpressed by claims to exclusivity. He wanted the magazine and the publishing firm, related as they were to common activities within the ambit of the Contemporary Art Society, to form a wider front of creative individuals, each of whom would be free to contribute in their own ways to a critique of Australian culture and by so doing assert new and more vital values through their art. In his reply to Reed, Tucker expressed profound regret over the rejection of his claims 'both in a personal and a cultural sense'.[63] He felt resentful that his actions, which as a writer and as an artist had occupied an important place in the cultural life of the Australian intellectual community, could be disregarded in so cavalier a fashion. Although support from the Reeds continued, it was conducted on a more formal and contractual basis. Within two years of this falling out the Angry Penguins movement, which had coalesced in 1942, disintegrated. While perhaps this was a consequence of 'organic' necessity, there were more precise reasons, and these are taken up in the final chapter.

Whatever the differences among the Angry Penguins, by the end of 1945 two things were clear. There was a selfconscious movement in the latter years of the war which, however bizarre its social forms and however new its rhetoric, was a radical extension, perhaps even a rediscovery, of liberal values in Australian culture. Its values were expressed in the style and content of particular canvases. It also found voice in the pages of *Angry Penguins*. The second point is that this involved a newly conscious sense of the role of the Australian artist in relation to his immediate environment and to the wider tradition of European modernist thought in art and ideas, an understanding of which had been foreshadowed in the writings of the art critic Basil Burdett. This movement, liberal and humanistic, had its origin in the frustrations of artists and intellectuals faced on the one hand with a complacent bourgeois mentality and on the other by authoritarian politics.

The personal and ideological origins of the new Australian cultural maturity and independence have all too often been disregarded in assessing the formative forces of the new art of the 1940s. For this reason we need to follow carefully the political, artistic and temperamental clashes that occurred within the C.A.S. and in the politics of art in Australia from 1942 to 1946: that is, from the break-up of the united front in the Australian art world to eventual realignment of anarchists and communists. By so doing, we shall see the extent to which politics influenced art, and art affected politics.

The values for which the Angry Penguins stood are more clearly seen in practice than in theory, such is the nature of the liberal philosophy. In this respect conservatives and more extreme radicals are easier to understand, just as their respect for and understanding of each other tends to be greater than for those in an ill-defined centre. It was easy

for men like Lawlor or Tucker to state that vital art has the capacity to transform the values of a society and a culture, but it was less easy for them than for their opponents to state how the transformation occurs. Yet the consequence of their art and their actions was just such a transformation: Australian life in the 1940s was very different from that in the 1930s. The art of men like Tucker, Nolan, Boyd, Perceval, Bergner, Drysdale and others helped to bring about that change through assertion of an Australian humanism that took its cue from the liberalizing values of European modernism.

The central problem for the Australian artist, however, was different from that of his European contemporary. In Europe — especially in France and Britain — artists and writers were able to fight for a reassertion of the 'natural' values of societies which were themselves products of centuries of intellectual and artistic development. Men as different as André Breton, Herbert Read and D. H. Lawrence called for a return to values based on a deeper understanding of human drives and behaviour which were suppressed and destroyed by political, social, cultural and artistic strait-jacketing. In each of these cases the experiences of the 1914-18 war created a sense of the imperative need to rediscover authentic values (values invariably related to nineteenth century romanticism) and to reactivate them in contemporary society.

John Reed, Joy Hester, Sunday Reed (with Sweeney, the son of Joy Hester and Albert Tucker) and Tucker on the beach at Sorrento, c. 1946

As John Reed later became intensely aware, the Australian artist was unable simply to accept European traditions. That would result, as it did all too often, in artificiality and eclecticism. The Australian artist had to forge his own tradition in the 1940s, in the context of Australia and Europe, out of both native and more universal values. This compounded the difficulty of discovering the values and modes of intellectual and artistic modernism. Here lay the appeal of anarchism. By attempting to steer clear of dogmatism, the Angry Penguins were at one with Herbert Read in feeling that 'social realism is but one more attempt to impose intellectual or dogmatic purpose on art'.[64] By contrast, anarchism possessed an open-ended conception of culture. It appeared to offer a more fruitful option precisely because of the openness of its politics and its aesthetics.

It has been said that all art criticism which is not formal criticism is moral criticism. Art criticism, if it goes deep enough, embraces a critique of social and cultural values, a fact which Burdett and Lawlor knew full well. Whereas Stalinist communism predetermined how the artist and art critic would interpret art and society and where evil would be located, anarchism left it to the individual. Everyman could be a Ruskin. Through Herbert Read's influence, Australian artists and intellectuals who could not respond to the certitudes of communism were able to adopt a notion of art as a vehicle for social criticism and an agent for social change — one stressing social and ethical values without sacrificing the idea of aesthetic autonomy and experiment.

CHAPTER FIVE
DISSENT AND DIVISION
War on the Cultural Front

War is the enemy of creative activity, and writers and painters are right and wise to ignore it.

Cyril Connolly (1940)

As has been shown, a profound shift took place in Australia's art and among Australian artists and intellectuals in the early 1940s. The Anti-Fascist exhibition of the Contemporary Art Society in 1942 demonstrated the political complexities and conflicts involved, while appearing to testify to the unanimity of the popular front against fascism. But although older artists like Adrian Lawlor saw here a denial of the liberal spirit in art, the situation within the C.A.S. was more complicated than Lawlor, now an outsider, could realize. By late 1942 a liberal spirit in Australia's art and culture had begun to re-emerge in new guise. The exhibition was, for the astute observer, a testimony to two radical traditions, that of the communist left and that of the radical liberal anarchist — traditions whose values were to be a source of continuous conflict within the Society, leading to a second schism before the end of the war.

The respective achievements of these two movements were registered in key exhibitions outside the ambit of the C.A.S., held in Melbourne in July 1946: the exhibition Three Realist Artists, by Counihan, O'Connor and Bergner at the Myer Gallery, and one at Melbourne University that included Tucker, Nolan and Boyd. These shows embodied quite different conceptions of the role of the artist and of the relationship between art and society. The clash they represented was sharpest in Melbourne, but was also apparent in Sydney. Pens as well as brushes were used in the fray — in Australia's art journals and literary magazines and in manoeuvres within the C.A.S. What is important is that, out of the fire and fury of battle, some of Australia's finest painting emerged.

A Show of Unity

The Anti-Fascist exhibition was not the first achievement of the left in re-establishing united front policies. Nor was it merely a C.A.S.

129

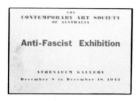

Catalogue for the Anti-Fascist
exhibition of the C.A.S. in December
1942

sideshow. It was one of the ways in which a small band of communist artists and fellow travellers in Melbourne and Sydney enlisted the support of artists of all kinds in the crusade against fascism after June 1941. This movement was closely related to similar ones elsewhere. Indeed, the small group of Melbourne artists whose members decided by 1944 to call themselves 'social realists' was not dissimilar in name or nature to the Euston Road School in London led by William Coldstream and Graham Bell.[1]

The movement among Australian artists against war and fascism can be seen, then, as part of a wider effort which in Britain involved the Artists International Association, founded in 1931. The A.I.A., as a unit of popular front politics in the 1930s, included communists, socialists and liberals, all standing for 'unity of artists against fascism and war and the suppression of culture'.[2] In 1941 it established an advisory committee that included Vanessa Bell, Misha Black, Duncan Grant, Augustus John, Henry Moore, Paul Nash and Lucien Pissarro. Sir Kenneth Clark was an active supporter. Australian artists of equally wide political and cultural sympathies were similarly brought together — artists whose views were as divergent as those of Harold Herbert, Max Meldrum, Charles Wheeler, Will Rowell, Vic O'Connor and Ernest Buckmaster — no mean achievement given the state of Australian art politics. As Counihan, the prime mover, recalls, 'I was concerned first and foremost with how we could mobilize the weight of artistic opinion and talent behind the war effort.'[3]

Backed by the Communist Party, Counihan began by contacting Herbert in 1941 and proposing that an artists' unity congress be held to get the campaign under way. Herbert was then one of three official war artists. In December, soon after Pearl Harbour, the *Herald* reported that a large number of artists from widely differing schools had agreed to co-operate in the name of the national war effort. The Congress of Artists was duly held at the Melbourne Town Hall and a manifesto was signed by all present, solemnly stating that they had come together in the face of the threat to Australia and its people 'to bear common testimony to their opposition to German fascism'.[4] The resulting organization, headed by Harold Herbert, claimed the support of fifty leading artists. Such names as Lawlor, Tucker and Nolan were, of course, conspicuous by their absence. For these men, not even the exigencies of war could induce association with the enemy at home.

In 1942 the Artists Unity Congress established an Artists Advisory Panel in Melbourne, which was soon followed by a counterpart in Sydney called the War Art Council. Both were intended to help put into practice an offer made to the federal government 'whereby every artist not already in uniform will devote himself to the fight'. Counihan was the Victorian secretary until tuberculosis again intervened and O'Connor took over the job.

The A.A.P. and the W.A.C. were imposing edifices. In October 1942

A Comment noted that the new body apparently 'really *does* stand for unity [and is] *the* most auspicious augury that has appeared on the cultural front in this country for many a long day'.[5] Thus, under the slogan 'For Victory and the Preservation of our National Culture', Australian artists marched forward on a wide front to join a crusade revived once again by the Comintern in June 1941.

The project made a brave start, but was a failure. Apart from arranging the 1945 Australia at War exhibition, in effect a more ambitious Anti-Fascist exhibition, and contributing to the establishment of the Council for the Encouragement of Music and the Arts, practically nothing was achieved. Even the Anti-Fascist exhibition has remained important only because it involved the work of leading members of the Contemporary Art Society: Bergner, Counihan, Nolan, O'Connor, Perceval, Tucker and James Wigley. The main aim of the movement was a national register of artists by means of which government and military authorities could utilize to the full the special talents of the artist, designer and craftsman in the fighting services and in government departments. The ambitious plan went to the Prime Minister in July 1942. Ure Smith summed up Curtin's reply for the organizers in Melbourne: 'Boiled down to a few words. No!'[6] A disappointed Ure Smith concluded, 'Everything went for nothing.'

Albert Tucker managed to avoid call-up for almost a year, playing a desperate game of cat and mouse with the military. His growing distaste for political action was now conjoined with the sure knowledge of the suffering to which it led. The crusade against fascism ended for Tucker, as for so many victims of the war, in the repatriation hospital at Heidelberg, together with other of the physically and psychologically disfigured and maimed. Having escaped from the alienation of a training camp at Wangaratta, he now had to endure the personal anguish of producing illustrations of wounds due for treatment by the plastic surgery unit. His contributions to the Anti-Fascist exhibition included works testifying to a different kind of evil from that which the Germans were perpetrating in Poland and Russia. Tucker was not discharged from the army, and released from his despair, until the end of October 1942.

The moral imperatives behind the art of Tucker, Nolan and Boyd in 1941-42 were very different from those of communist artists. Even Bergner's painting continued to differ in fundamental ways from that of fellow communists Counihan and O'Connor. Counihan, especially, continued to espouse the policies of the united front as they had been formulated and followed between 1934 and 1939. As laid down by the Comintern, these divided the world into two opposing camps — anti-fascist and fascist, humanist and anti-humanist, good and evil, that of progress and that of reaction. Communists should nevertheless unite with all those who opposed fascism — whether liberals, anarchists or members of the socialist labour movement. As in the case of the Spanish Civil War, communists were called upon to defeat fascism by defending

bourgeois democracy. The defence of democracy and 'national culture' by Australian communists reflected Comintern policy announced in 1935 that national parties should thenceforth decide policies on the basis of the respective national traditions and circumstances of each country.[7]

Whereas earlier Tucker was prepared to adopt the role of a left-wing radical for the greater good that communists predicted, by 1942 his experiences and increased intellectual sophistication brought certainty that ends can never justify means. But the world had changed in another way, and the idea of a popular or united front correspondingly changed its character. Before the war conservatism was identified as being, if not fascist, then crypto-fascist. Thus a Robert Menzies could be viewed as a man not dissimilar to Franco in Spain or even Hitler in Germany. The face of political reaction might vary but its underlying character did not. After 1941, with the change from a war of imperialism to a people's war against fascism and militarism, that identification was cast aside. Conscription, which all members of the left had once rejected, now became necessary and good, as was full co-operation with conservatives. Support of a government, any government, fighting the Axis powers was demanded by communists because 'the people' were now engaged in a total war on an international front against fascism.

It is little wonder that those of an essentially liberal spirit, who had once thought of themselves as left-wing, were now left behind because they still continued to insist — like Tucker, Nolan and Reed — that the only legitimate stance for the radical was an anti-fascism defined in terms of democratic anti-authoritarianism. These men watched with increasing unease the pragmatic (and for them cynical) development of an Artists Unity Congress movement, which seemed to deny the very values of democratic art over which the battles of 1938-40 had been fought. Nevertheless there was wary co-operation from both sides until the end of 1942.

The clash of values which in retrospect was evident makes the Anti-Fascist exhibition important in a way missed by one historian who has referred to it as 'that quaint contribution to the war effort on the Home Front'.[8] It revealed the differences between the values and attitudes of intellectuals flocking into the Communist Party in Australia between 1941 and 1945 and of those liberal-minded spirits who foresaw the dangers of authoritarian politics. The artists who became Angry Penguins were at this early stage aware of the dangers to a degree most fellow travellers did not appreciate until 1956.

Thousands of Australians were attracted into the Communist Party in the early 1940s because of its liberalized image following the invasion of Soviet Russia in 1941. Membership in 1940 has been estimated at 4000; by October 1942 it had grown to 15 000.[9] Indeed, for a time, its rigid democratic centralism relaxed, and a member was required only to accept the Party's programme, attend branch meetings regularly, pay dues, and engage in some form of activity. Only much later would intel-

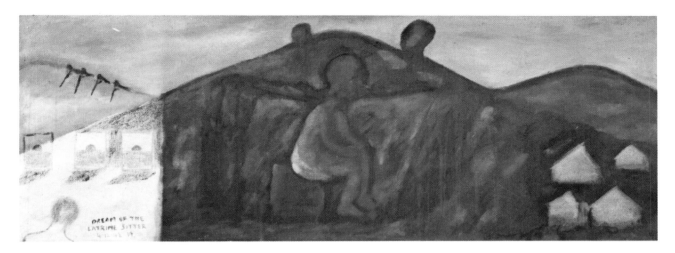

Sidney Nolan, *Dream of a Latrine Sitter*, 1942

lectuals of the calibre of the historian and labour activist Ian Turner, who came in at this time, realize in full measure a fact of which Tucker, Reed, Nolan and Harris were already painfully aware: that 'the individualism and anarchism of radical art are needed to temper the collectivism and authoritarianism of radical politics'.[10]

Diverse though their modes of painting and subjects were, none of the exhibitors at the Anti-Fascist exhibition would have demurred at one point in the anonymous foreword to the catalogue. This was that the present situation had created a new role for the artist and new directions for art: 'We are faced with a return of theme, subject, content ... for art requires a working faith.'[11] The exhibition was an attempt to crystallize this new tendency. But, as has been pointed out, two utterly disparate conceptions of art and culture, grounded in contrasting views of Australian society and politics, were apparent here: the autonomy of the individual as against the authority of the people; radical liberalism as against communism.

Before 1941, while the united front held, Nolan's *Dream of a Latrine Sitter* would have been tolerated by communists. But by 1942, with works such as this included in the Anti-Fascist exhibition, communists were as unhappy as were their opponents about the identification of individual dissent with communal action. To communists, *Dream* (as serious a work as had been *Boy and the Moon*) appeared to ridicule their aims. In *Death of an Aviator* and *Army Shower* Tucker also served notice, but in an apparently more serious manner, that his condemnation of authoritarianism and dehumanizing forces in society did not stop with the atrocities of fascists in eastern Europe and Russia. Nolan's painting now appeared less of an affront to professionalism than it had in 1940, but more of an attempt to deflate political pretensions. Tucker's work at least looked to have a serious political object, even if 'defeatist', whereas Nolan's daydreaming private seated on a 'privy' and his children meandering to

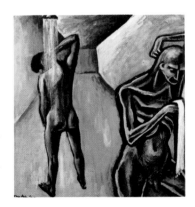

Albert Tucker, *Army Shower*, 1942

school appeared to be a complete abdication of political responsibility. Anything that failed to be positive in 1942 could not be neutral. It was by definition reactionary and defeatist because it was escapist. Counihan accused the Angry Penguins artists of promoting and spreading 'demoralization, pacifism, defeatism'. It is unlikely that any of the artists so charged would have objected to Counihan's closer observation that their canvases expressed nothing but 'the outlook of minds dominated by fear of pain, of psychological collapse and death'.[12] What else, indeed, could men of sensibility feel in 1942 and 1943? The question was whether it ought to be revealed; and that was a political question.

The mutual suspicions and anxieties did not flare into open public dispute until well into 1943. Until then Reed and Harris, as lay members of the C.A.S., strove to maintain a peace, however uneasy. In his review of the Anti-Fascist show in the fourth issue of *Angry Penguins* early in 1943, Reed attempted to reconcile the positions. As he observed, 'the immediate reaction of many people, both artists and non-artists, is that art has nothing to do with anti-Fascism'.[13] Reed argued that such a view was superficial in that it ignored the actualities of life in 1942, which demanded engagement on the part of the artist. However, those who came looking for political statements while forgetting to look also for art were bound to be nonplussed by many of the works. In attempting to reconcile the art and the politics of the exhibition, he was able to suggest little more than that, whether or not the paintings had an explicit political message, they were 'a legitimate and powerful reaction to the present-day world and [the artist's] establishment in his own sphere of anti-Fascist activity'. Reed's avoidance of the problem may reflect something of its difficulty, but it was also a gesture to united front

Politics on the Yarra bank, c. 1942: a large crowd being addressed by the tall, gaunt Jack Blake, secretary of the Victorian branch of the Communist Party. Ralph Gibson, who at about this time became the state president, is on the left. Note the police helmets prominent in the crowd, and sickles being held aloft on the right

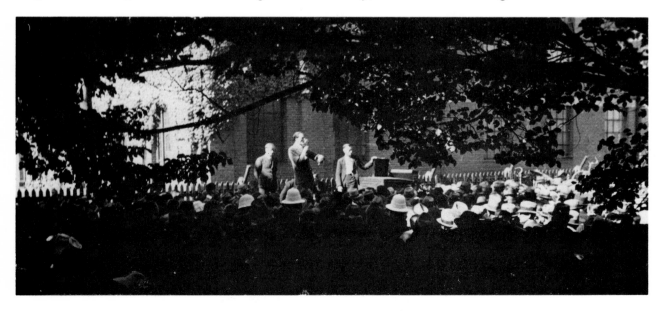

politics. As we have seen, Tucker and Harris were less reserved on the question. Their answer was that the artist must respond on the basis of his psychological sensibilities and a widening of awareness to immediate social realities.

In his piece 'Art and Social Integration', Harris was doing more than prescribing abstract goals for the artist. He was describing precisely the way in which Tucker, Nolan and Boyd were painting and living in 1942 when he declared that the job of the artist in a time of war was to 'record, accept, endure'.[14] He might have added 'protest', but he did not; that could too easily sound like a recipe for left-wing propaganda. In the issue of *Angry Penguins* in September 1943 the editors noted that, although consciousness of war was a powerful influence on artists, it was significant that, as the British writer Stephen Spender had observed, few poets actually wrote about it. They did not add, although the implication was there, that their work was no less relevant or radical in a political sense for all that.

The Cracks Widen

If the lines of conflict were clearly drawn up by the latter half of 1943, when it became a matter of public debate, the first real crack in the united front, as far as the C.A.S. was concerned, showed a year earlier. At a general meeting in September 1942 Reed put forward a motion to the effect that members involved in outside activities relating to art must have the approval of the C.A.S.[15] Reed and Tucker clearly viewed gravely the communist *rapprochement* with old enemies. For their part, neither Counihan, de Hartog nor O'Connor was prepared to accept direction from a body controlled by non-communists. O'Connor and de Hartog threatened to resign immediately and Counihan warned Reed that, if passed, the motion would split the C.A.S.[16] Reed gave way. This left the dilemma unresolved for both parties, and radical modernism was now as much under threat from the potential populism implied by the communist position as it had been earlier from the guild élitism of George Bell.

Until 1944 the Angry Penguins kept a firm hold on the C.A.S.: in Melbourne Reed remained secretary and Tucker president; in Adelaide, Max Harris was secretary and later chairman. In Sydney Peter Bellew remained a powerful influence until his resignation in June 1946, and fought to hold the branch to the democratic principles of the Melbourne group. But control in Melbourne remained vital since that branch could speak with the voice of a national society.[17] Nonetheless the Angry Penguins controlled rather than dominated the Melbourne branch because until 1945 the communist members maintained constant pressure on their leadership.

Between 1943 and 1946 the bitter in-fighting within the Contemporary

Art Society was accompanied by a furious clash in the pages of *Angry Penguins, Communist Review* and the *Guardian*. The exchange became enmeshed in the even more savage struggle for control of the C.A.S. in 1944. And yet, despite the public force of the Melbourne confrontation it is a mistake to conclude that all members of the Angry Penguins group were as hostile to communism as Tucker was. Like André Breton in the 1920s, Harris continued his overtures well beyond the point at which revolutionary politics could meet with revolutionary culture. Writing to Bernard Smith, by then the foremost non-artist apologist for communist views in art, Harris objected to the 'narrow and exclusive' claims being made by the most recent little magazine to appear, *Australian New Writing*. This was a reflection, Harris wrote, of adherence to 'an exclusive and dogmatic "line"' by those claiming to represent the only true art in Australia.[18] For Harris, 'it had done immeasurable harm by sabotaging any popular front among the intellectuals of the left'. In this and in a further letter, Harris was at pains to point out that he could still be counted in the communist ranks.[19] Harris argued for the acceptance by members of the Communist Party of 'intellectuals who hold a "pure" theory of art ... [and for whom art] is as subjective and non-social in function as stamp-collecting, or kissing a woman'.[20] It was a mistake, he insisted, to suppose that such intellectuals were opposed to an art expressing proletarian propaganda as such. Rather, by virtue of their respective natures, they were unable to be either John Steinbecks or contributors to *Australian New Writing*:

For their art they claim no more social validity than that it enriches sensitive human living and response under any epoch. But realizing that they are social animals and live on the terms of society, they place their services in the ranks of the Left. Either in the ranks of working class struggle; or integrating the most unorganized and inchoate of all classes — their own.

Harris stated that it was all the more unfortunate, then, that at a time when it was imperative that the intellectual class be united in the struggle against fascism, 'a noisy rhetorical line emerges, not to unite the intellectual class, but to coerce them into one type of activity, and to blindly destroy one another'.

Bernard Smith was less than sympathetic to the overture. Harris, stung by the rebuff, accused communists of engaging in a 'masquerade of word bickering'.[21] In the following month Reed admitted to Smith that Harris could be tactless and declared that, whatever the public pronouncements on dogma by *Australian New Writing*, there was much that they could surely agree upon: 'I have no quarrel with your argument in favour of a return to realism and indeed to my mind that trend has been apparent for some years.'[22] Further, he was ready to concede that there were undoubtedly many slick and unthinking painters within the C.A.S.; some, he agreed, might well be described as 'muddlers' and 'neurotics'. But for all that, in the re-evaluation of modernism that was leading to a revival

of realism, it was essential for a vital art that integrity of the individual be maintained.

It is clear from this correspondence (even allowing for the knowledge on the part of Reed and Harris that Smith was engaged in preparing the first scholarly history of Australian art, and one which would lay much emphasis on recent events) that public dispute between rival factions within the C.A.S. did not prevent reasoned discussion of the issues involved. But it is also clear that the leaders of the opposing camps were looking for *rapprochement* and understanding, not reunion. Perhaps because the issues were so important, no such mutual understanding was effected. In February 1944 Reed wrote again to Smith expressing regret that the Reed & Harris firm was not to publish Smith's forthcoming *Place, Taste and Tradition.* He made a further plea:

Whatever may be your own opinion of these artists [Tucker, Nolan and Boyd], it is impossible to escape from the fact that quite a number of us who are most closely associated with the modern movement, regard them as Australia's most significant painters. Nolan's work is, I believe, almost entirely disregarded in Sydney, but I do not hesitate to say that I think his painting is of the utmost importance and breaks altogether new ground, opening up a new era in Australian landscape painting.[23]

The plea was in vain. Although Smith respected the seriousness of Tucker's work and his capacities as a thinker, he was unable to respond

The first issue of *Australian New Writing*, 1943

to the more oblique art and thought of Nolan. As late as 1947 Smith was not prepared to concede that Nolan was one of Australia's more significant painters.[24]

Place, Taste and Tradition was not published until 1945, and is a document that belongs to an earlier phase of the history of ideas in Australia. The manuscript, completed in February 1944, originated as a series of lectures delivered by Smith between 1941 and 1943 for the Sydney branch of the C.A.S. It is not surprising, therefore, that it should be partly polemical and partly scholarly. In 1939 Smith, at the age of twenty-three, had joined the teachers' branch of the Communist Party and between 1939 and 1943 had read furiously and widely, using the resources of the Sydney Municipal Library and the Anvil Bookshop (a favoured meeting-place for left-wing intellectuals). The year 1943 was an active one for Smith. He continued to be a lay member of the C.A.S., though the 1940 exhibition had seen the one and only showing of a painting by him, a surrealistic work entitled *The Advance of Lot and his Brethren*. Thereafter he put his prodigious energies into poetry, art criticism and art history while also teaching full-time. Increasingly, however, he moved away from the narrower concerns of the C.A.S. to the point where he was a regular and vigorous contributor to the national debate on Australian culture being conducted in the *Australian Quarterly*, *Angry Penguins*, *Communist Review* and *Australian New Writing*.

Although having a greater literary bias than *Angry Penguins*, *Australian New Writing* presented the case for the communist conception of culture as vociferously as *Angry Penguins* opposed it. Based on John Lehmann's famous *New Writing* in England, *Australian New Writing* had the blessing of the Communist Party. The first editorial made no bones about its cultural values: it rejected completely 'national parochialism, academic narrowness and intellectualistic posturing'. In other words, it opposed the views of *Meanjin Papers*, *Southerly* and *Angry Penguins*. It claimed to stand for humanistic values of a more genuine stamp expressed in a new and uncompromising realism:

Art is a means of coming to grips with reality, of understanding the processes of society and the human heart and mind. By throwing a searchlight on everyday experience, revealing truthfully how people act and why, what is false in our way of living, what is constructive, the artist has as important a role to play as the scientist, teacher or the politician.

Whereas the Angry Penguins were unsure whether Australians possessed any tradition worth fighting for, let alone worth professing, *Australian New Writing* proclaimed that it stood without reservation for an Australianism that was 'essentially democratic'. Faced with the menace of fascism, the Australian people were finding a new awareness of their own cultural heritage. The result was a 'determination of the mass of the people to build a better social order when the war is won'.[25] While the turning towards an indigenous radical labour movement with its

expression in late nineteenth century art and literature — whether in the canvases of Roberts or the short stories of Lawson — was in line with local Communist Party policies, the early war years had seen a party more appropriate to the Australian temperament and needs begin to develop.[26] Even after the old Party bureaucrats took over in 1943 and reasserted control through a return to the old democratic centralism, the Australian bias was retained. It is against the growing emphasis on national traditions and tighter party control that one needs to see the views and the art of communists during the mid-1940s.

Bernard Smith's cultural convictions in 1943, like Counihan's, can be fairly described as 'socialist realist'. Neither hesitated to state his position in these terms in various magazines and journals. Surrealism was now written off by Smith as 'the culmination of that clandestine interest in the macabre and the morbid that is to be found throughout the course of nineteenth century literature'.[27] In March 1943 Smith described it as 'probably the most facile of the many distortions of Marxism'.[28] He later explained its resurgence in Australia in the 1940s as a response to the psychological stress of war. Its values were defeatist and pessimistic, values which world communism sought to eradicate. Instead of man being seen as victim, man ought to be celebrated in his power as 'maker and creator, as one who can come to grips with the present by his knowledge of the past, and to that extent fashion the future'. All neo-romantics were trapped in the fatalism and gloom of nineteenth century romanticism and were therefore part of a tradition led by T. S. Eliot, James Joyce, George Orwell and others who saw 'in the destruction of a system of social relations the destruction of civilization itself'.[29]

However splendid the rhetoric of the left sounded in 1943, it was painfully apparent that all too often it produced execrable painting. Examples were the work exhibited in the C.A.S. exhibition in 1943 by Herbert McClintock: *I Was a Shift Worker in a Munition Plant* and *C.C.C. Scherzo*. One fears that these were not intended as parodies of socialist realism. Whereas, in the war of words, it would be difficult (leaving aside one's own value judgements) to decide whose logic and whose evidence was stronger, the most radical painting on show undoubtedly belonged to the Angry Penguins. The exhibition contained some of the finest early work by Nolan, Tucker, Boyd and Perceval: Nolan exhibited two 'psychological' portraits in an expressive primitive style unprecedented in Australian art, and three outstanding examples of the Wimmera paintings: *Kiata, Railway Yards, Dimboola*, and *Morning Express, Dimboola*. Several paintings by Tucker from 1942 were also a comment on the psychological effects of the authoritarian aspect of war. In addition, Tucker exhibited *Spring in Fitzroy* and *Nostalgic Night*, paintings which mark the beginning of a series of pictures that remain among his best, the *Images of Modern Evil*. Boyd was represented by the first of the disturbing South Melbourne paintings: *The Kite Flyers, South Melbourne*

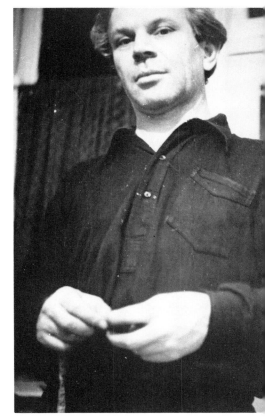

Herbert McClintock, 1940: by 1943 McClintock had abandoned his surrealist *alter ego* in favour of a more decidedly proletarian stance

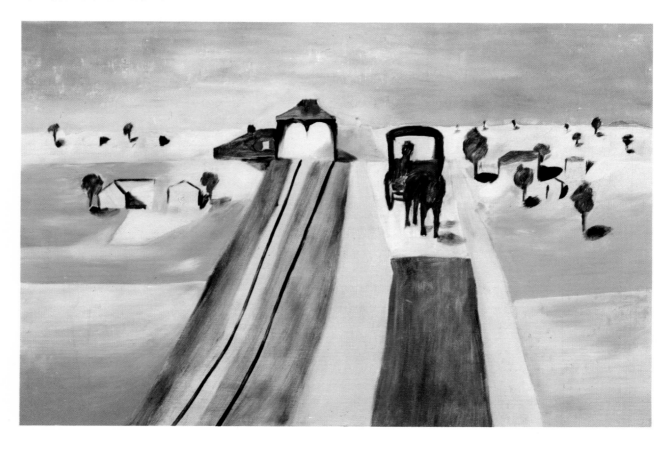

Sidney Nolan, *Kiata*, c. 1943

and *Three Girls Dancing with Lizard-Beast*. Perceval showed six works including *Boy with a Cat*, which were startling in their new sense of expressionist ferocity and anguish. The communist painters were by contrast thinly represented except for an impressive group of four works by Bergner; three of these on the Aboriginal theme continued a series begun two years earlier. In fairness it must be said that painting conditions were far more difficult in 1943 for Bergner, O'Connor and Counihan because of military obligations and illness. Politics is also apt to become a full-time occupation.

The exhibition was an exciting experience for modernist *cognoscenti*. Even Lawlor, who in 1942 had been so disenchanted with the Society, saw that a new note had been struck. With this exhibition the earlier 'intolerable tendency to preach and proselytise' was less pronounced.[30] Older liberals may have recognized the spirit of liberalism again in the ascendancy of the vigorous art now displayed by the Angry Penguins. However, Harold Herbert, although he had recently discovered that he could talk to communists, found many of the works so disgusting that he could not place them in his category of 'Art'.[31] He advised intending

visitors to study *Added Art* rather than risk a visit to the Velasquez Galleries. But whether the work on show was technically proficient or fumbling, mature or immature, to accept such painting, for Clive Turnbull, the *Herald*'s new critic, meant to be 'on the side of the living'.[32]

The ample evidence of a breakthrough by leading artists of the C.A.S. in 1943 corresponded to changes in its role as an art society. Under the direction of Tucker and Reed, the Society began to assume a more active entrepreneurial role by promoting the work of particular artists. This was made possible by its having acquired a studio in Collins Street which could be used as a meeting-place and a venue for life classes and exhibitions. Significantly, the first and only exhibition it succeeded in sponsoring there was of recent work by Nolan in August 1943.

By the September 1943 issue of *Angry Penguins*, it was clear that the magazine was wholly identified with C.A.S. leaders, and that only artists supported by John and Sunday Reed would be promoted in its pages. It contained an appreciative article by Reed on Perceval's art, as well as a shorter piece by Tucker on Danila Vassilieff and Nolan. Tucker's was a review of the one-man shows by these two artists in 1943. Vassilieff's work was commended for 'its profound yet simple direct vision [and] an ample humanist outlook with a rich imagery drawn from the life around him'.[33] Nolan's work he found more complex, even 'remote and esoteric'; but there was no denying that it possessed a unique quality of individual perception and originality 'in the steady growth of a rare lyrical talent'. Tucker restated the fundamental humanism which Basil Burdett had called for as the basis of a new working tradition of Australian art:

Here, as with Vassilieff, we glimpse for the first time since Roberts, McCubbin and the early Streeton, the return of an authentic national vision on a higher and more independent level.

In a series of courageous portraits and themes of disaster, where Nolan is approaching problems rich in human implications, he is wisely obeying history and pushing back towards the real sources of aesthetic experience — the world of living men.

Tucker was challenging any assumption on the part of communists that their 'people's art' could lay sole claim to a tradition of radical humanism in Australian culture.

The discontent within the C.A.S. simmered until early 1944, when it erupted into violent conflict. By the end of 1943 the triad of Counihan, O'Connor and Bergner was determined either to wrest control of the Society from the Angry Penguins or to force change onto it. The C.A.S., by virtue of the independent positions which Reed, Tucker and Harris insisted upon adopting, had ceased to operate as a united front body. There is no doubt that the social realists wanted to transform it into a more open organization amenable to front activities. But it must also be understood that as artists they still depended upon it, and therefore also

wanted a body more sympathetic to their kind of painting. In this respect the C.A.S. was always quite different from front organizations of the 1930s and 1940s such as the university labour clubs, in which a minority of communist representatives set the pace and directed the action from one or two key executive posts. The C.A.S. had begun, as it would end, as a body fighting for cultural change rather than political revolution.

In April 1944 O'Connor wrote to Bernard Smith informing him that a new dispute had arisen in the C.A.S. This revolved around the gentle figure of James Quinn, then a man of seventy-one struggling to survive as a portrait painter after an earlier successful career in London. Quinn had become friendly with Counihan and O'Connor, who felt that his present vicissitudes were the result of a campaign of victimization by the art establishment because of his courageous defence of progressive and enlightened attitudes. O'Connor and Bergner proposed a motion, therefore, that the Society should institute a campaign on Quinn's behalf and that, as a well-known academician, he be allowed to exhibit with it, thereby indicating the measure of the Society's concern for the situation of the artist in Australia. By extension the protest would also speak for all artists who failed to find favour with the establishment. The Quinn issue was a difficult one: on the one hand, all leading members accepted the need for a wide campaign of this kind; at the same time Quinn's style was academic, and he was a member of the Australian Academy. Clearly, the social realists were using the issue as a ploy to widen and change the character of the C.A.S., thus making it less identifiable in the public mind with avant-garde radicalism.

Following initial sympathy by the council, Tucker called for a special general meeting in April 1944 and by threat of resignation succeeded in having the motion rescinded.[34] His concern was that the artistic radical arm of the Society should be preserved at all costs. Support came from Harris, writing as chairman of the South Australian branch:

The Adelaide Branch will stand unreservedly against the motions and the aim of discretely enlightened institutions and art dictatorships such as the [Artists Advisory Panel] and Gallery Boards. I still maintain my opinion that it is an undialectical ... tactic. The aim of the society is not recognition but assertion, and given the history of contemporary art and the movements of world thought, the train of causation is not to assertion via recognition ... but assertion of such vitality that mediocrities are destroyed.[35]

Marxist rhetoric aside, Harris made the position of the Angry Penguins clear. The position of the radical artist, as George Woodcock had argued, was that culture and ultimately society are transformed less by political actions than by the assertion of the individual creative spirit through a vital and aesthetically radical art. As had happened before in the dispute with Bell, so now the fundamental *raison d'être* of the C.A.S. was being called into question. Now the issue was whether it was to be a front organization for communist politics in art or whether it was to

continue to be a forum for advanced ideas and a focus for avant-garde art. It became increasingly clear that communist politics, whatever the value of the art of individual social realists, was inimical to an art that challenged not only what was seen but ways of seeing. The schism was all too plain; a complete split was only a matter of time and circumstance.

Defeated on the Quinn issue, the social realists threatened to withdraw work from the forthcoming 1944 annual exhibition. O'Connor maintained that the Angry Penguins were only concerned with narrow and personal ambition and that the C.A.S. was reduced to an instrument to further this end. The crisis point was reached in June 1944 at the annual general meeting. Shortly before, O'Connor confided to Bernard Smith that the recent events had 'given rise to the position where we must decide whether we can continue to work and exhibit with the C.A.S., and if we do, on what conditions regarding policy'.[36] The event which by June eclipsed all former issues was the appearance of the Ern Malley edition of *Angry Penguins*. Even before the hoax had been sprung, social realists feared that the editors of *Angry Penguins* would continue to insist that it was sponsored by the C.A.S. Communists would be associated in the public mind with the obscurantist art and poetry which it was presenting in the name of the Society. Nobody could claim that Ern Malley's poems embodied working-class values, whatever other merits were subsequently argued for them. For O'Connor, the time had come for communists to take a stand and deny once and for all any recognition for the magazine from left-wing leaders and the rank and file of the C.A.S. The danger that the social realists foresaw was that continuing to exhibit with their opponents was tantamount to recognition of some value in their paintings and poems. What complicated the issue was that both groups claimed to be radical.

In Sydney the situation at least appeared more clear-cut; there the 'aesthetic' artists formed an opposition party to the left.[37] The situation in Melbourne and Adelaide was not only more complicated but also apparently more dangerous. Here, although communists knew that it was a spurious claim, the enemy claimed to possess radical sympathies and to be as socially critical in the character of their art as were communists. If the communists were to remain in the C.A.S. it was imperative that the distinction be made clear to the public.

One solution was to win control of the C.A.S. and drive out the Angry Penguins. The elections held at the annual general meeting, 30 June 1944, gave them a chance, and a hasty but intense campaign was launched. The resulting clash was equalled only in bitterness and fury by that with George Bell four years earlier. Because this election was not merely for the Melbourne branch but for the council of the C.A.S. as a national body, voting was on the basis of all three branches for the national executive of an art society with the largest membership in Australia. The stakes were high.

Concerned about the forthcoming election, Reed wrote to Harris in

Adelaide warning him that the 'party element' intended to contest all executive positions. He cautioned Harris that the Quinn issue was being revived and pressed as a *cause célèbre*. 'There are rumours', Reed confided, 'that O'Connor & Co. will make a determined effort to capture the meeting and it seems wise to be prepared for this and to get all the votes we can, both here and interstate'.[38] In like manner, O'Connor outlined the tactics of the left to Smith:

It is now positive that we must take some action, and it must be on the basis of popular support of the majority of the society. We had reached this decision and had decided that the first step was to cut the link between [*Angry Penguins*] and the society, and we thought that if we could oust Reed and Tucker from their official positions, we would make a sound step. Accordingly we have nominated candidates against all their supporters . . . It was necessary to do this on a popular basis, and to win the cooperation of all possible sections of the society.[39]

O'Connor had already telegraphed Smith in Sydney to arrange to have de Hartog nominated for president by the Sydney branch. In the event, Sydney members opted for the more neutral Peter Bellew. O'Connor had been nominated to stand against Reed for the position of secretary. He commented to Smith that he felt confident of winning 'if our organization plan works'.

O'Connor and Counihan had persuaded the Communist Party leadership to involve the Party in organizing support at branch level, but this ploy proved their undoing. In a dramatic last-minute revelation, Tucker announced that not only had the Communist Party actively campaigned on behalf of O'Connor, de Hartog and Bergner, but it had specifically directed hastily enrolled members how to vote.[40] It was Danila Vassilieff who had given the game away. Vassilieff was a member of the Warrandyte branch and, having received a notice instructing members to join the C.A.S. and vote Reed and Tucker out of office, promptly handed the evidence to Tucker.

The communists lost — a result all the more galling because it was by a single vote.[41] The vote that mattered was for Reed's position as secretary — and O'Connor was unsuccessful. Bellew was elected president and Tucker defeated Bergner for vice-presidency. The opportunity to control the C.A.S. never recurred. Yet while the Angry Penguins had won, life became no easier. The communists could claim a significant number of council seats and, although unable to exercise effective control, they were still a force to be reckoned with; they continued to harry their opponents for another year by mobilizing support from discontented and suspicious Sydney artists.

By 1944 victory in World War II was certain, and Australians now asked themselves what sort of society post-war reconstruction could achieve. Radicals of all persuasions knew how important it was to lay the foundations of a new society at this critical turning-point. Activity

by communists and sympathizers therefore intensified rather than waned. Control of, or at least power within, important national institutions, bodies and organizations — political, social, economic and cultural — became increasingly critical, since the future seemed to hinge upon those who aspired to give direction. It is in this context that the squabbles within a body such as the Contemporary Art Society acquire their real dimension.

The dissolution of the Comintern in 1943 affected communists primarily in two ways. The first was the return to the old style of democratic centralism by 1944; through it Party leaders maintained complete control over all activities of members. Communist artists were encouraged either to dominate the C.A.S., and therefore give direction to progressive art in the context of a wider Australian culture, or to replace it with art and cultural bodies which would ensure such direction. The fight for the C.A.S. must therefore be considered also in relation to the establishment of the breakaway Studio of Realist Art in Sydney in 1945 and the setting up of the Encouragement of Art Movement in July 1944 by the Artists Advisory Panel. In September the E.A.M. was reconstituted as the Council for the Encouragement of Music and the Arts. As far as the Communist Party was concerned, these groups were in their turn linked with other front organizations such as the National Theatre Movement, the Friendship of the Soviet Union Movement, the People's Cultural Council and the university labour clubs. Control was effected by means of the Central Arts and Sciences Committee, which was established in March 1943 at the 13th National Congress.[42] Whereas many of the political bodies were held under tight control, artists and art proved more intractable. Even when launched as a left-wing initiative, as the Studio of Realist Art was, this area of Australian culture was refractory.

The second way in which Communist Party politics affected artists whose allegiance it claimed, and through them the C.A.S., was in terms of nationalism. Until its dissolution the Comintern, acting largely as an agency of Soviet Russia's foreign policy, demanded of communists everywhere between 1941 and 1943 that the defence of Russia and the prosecution of the war take precedence over all other issues. While the disbanding of the Comintern brought about a tightening of Party control, it resulted also in each national party being allowed more freedom in determining policy. The intense feeling of nationalism which might, in any case, have been expected as military retreat turned into victory, was an emotion which could be put to good effect when Australians needed to look to the future. One of the central leitmotifs of radical left-wing thinking from 1944 onwards, then, was the recognition that the Australian labour movement, with its cultural cry of 'temper democratic, bias Australian', must provide the basis for contemporary political and cultural values.

The extent to which nationalism could act as a unifying force is

Communism in full flood: the newly appointed Soviet Ambassador to Australia, Vlasov, addresses the Soviet National Day rally by the Australia-Soviet Friendship League after a triumphant march through the city streets, 7 November 1943. The celebrations coincided with news that Kiev had been recaptured, and the crowd was estimated at 10 000. Seated at the table with hand to chin is the state Labor politician William Slater, who as the first Minister to the Soviet Union had just returned to Australia; in making this appearance Slater defied the central executive of the Victorian Labor Party

indicated by the success of the huge Australia at War exhibition held in Sydney and Melbourne in 1945. In size and scope, and in the range of artists of all persuasions and merit who participated, this was more like the exhibition the left would like to have mounted in 1942. In terms of its emphasis, it was precisely the sort of exhibition the social realists would have wanted the Contemporary Art Society to put on had they won control in 1944. In a sense it also echoed the aims of the early Australian Academy exhibitions by being an over-bridging exercise based on a belief in a nationalistic consensus of values derived from a notion of 'the people'. The title in itself, 'Australia at War', was as significant as 'Anti-Fascist exhibition'.

The Australia at War exhibition was initiated in February 1944 by communists working within the Artists Advisory Panel and the War Art Council. By 1945 these had become merged with C.E.M.A., under whose name the exhibition was held. Despite the conspicuousness of the activity of this front movement, communists themselves remained discreetly in the background. They did, however, scoop the main prizes with a series of fine paintings. Counihan's work *Miners Working in Wet Conditions* won the major prize of £100, as well as first prize in the Industrial Section. The show included canvases by official war artists as well as aspects of the war portrayed by a wide range of artists ranging from Grace Cossington Smith and James Quinn to Sali Herman and Donald Friend. It included works by professionals and amateurs alike. As O'Connor defined the aim of the exhibition, it was 'to get most of the [C.A.S.] artists, representatives of most art societies, and a good dash of social cream on this body'.[43] The 'social cream' was certainly evident: patrons included General Sir Thomas Blamey, Frank Packer, Sir Keith Murdoch, J. D. G. Medley, Daryl Lindsay and Louis McCubbin as well as the most important trustees of each of the national galleries.

James McAuley (*top*) and Harold Stewart, who in the guise of 'Ern Malley' carried through one of the most notorious of literary hoaxes in 1943 and 1944

Naturally the Angry Penguins boycotted the enterprise. A great deal of work by Tucker, Boyd and Perceval between 1943 and 1946 related directly or indirectly to the experience of war, but none of these paintings were in the spirit demanded by the organizers of the Australia at War exhibition. The ethical basis of works such as Tucker's *Victory Girls* (1943), Perceval's *Negroes at Night* (1944) or Boyd's *The Mockers* (1945) was utterly at variance with the work of Counihan or James Cant. By 1944 the gulf between communists and Angry Penguins was unbridgeable.

Following the C.A.S. defeat in mid-1944, Melbourne communists were able to exploit Sydney discontent in order to initiate changes. The Sydney branch had grown so rapidly that by 1944 it had overhauled the Melbourne branch, and dissatisfaction crystallized over the issue of a proposed exhibition at the Museum of Modern Art in New York. In September O'Connor resigned in protest over the narrowness of the Melbourne selection committee and was replaced by Arthur Boyd, thereby making it, in O'Connor's words, 'entirely a family affair'.[44]

John Reed justified the non-democratic actions of the Melbourne

council to Sydney on the basis that the Museum of Modern Art had only been interested in a small selective show of progressive, original and experimental work.[45] Accordingly, copies of *Angry Penguins* had been dispatched to give an indication of the quality and direction of Australian contemporary painting. Nothing could have been more provocative either to the left or to Sydney artists than such a gesture, following as it did close upon the heels of the Ern Malley hoax. Sydney artists were annoyed not only by their exclusion but by the close identification of the Society with *Angry Penguins* values. Aware of Sydney discontent, O'Connor, Bergner and Counihan withdrew their paintings. Reed counter-attacked by making the first official acknowledgement of the C.A.S. rift of the past two years:

a small pressure group which is obviously not confined to [Melbourne] is deliberately attempting to create dissension by forming a 'popular' issue with specious arguments; with the ultimate aim of subordinating the Society and its policy to an external political organisation to which they owe their allegiance. Their role in the Society is disruptive and inimical to the interests of the contemporary artist.[46]

At a general meeting of the Society in October 1944, O'Connor and Bergner put forward a motion opposing the M.O.M.A. exhibition selection committee on the basis that 'grave doubts as to their aesthetic judgments already existed in view of their participation in the launching of the poet Ern Malley'.[47] They did not have the numbers to support the motion of no confidence, but the gesture indicates the extent to which the Ern Malley episode provided a stick with which to beat avant-garde radicals. Amid a welter of mutual recrimination and abuse, the proposed American exhibition was simply dropped by Melbourne artists. What might have been an enriching connection was lost.

The exposure of the Ern Malley hoax in June 1944 had a shattering effect not only upon those at whom it was directed, but also upon many lesser satellites that had placed their faith in aesthetic radicalism. What Max Harris subsequently propagated as an Australian myth began with a carefully contrived prank in 1943 on the part of the Sydney poets James McAuley and Harold Stewart.[48] Harris was nothing less than ecstatic when he received a hand-written manuscript from Ern's sister, Ethel Malley, of poems and aphorisms by the young poet who had died tragically of Graves' disease. Harris declared to Reed: 'Whatever the circumstances I think these poems, architectural, unified in language treatment, are among the most outstanding poems I have ever come across ... It is unbelievable that a person going away to die could write poetry of this objectivity and power.'[49] John and Sunday Reed, Sidney Nolan and John Sinclair agreed, but there were doubts. Some words and phrases smacked, for example, of Alister Kershaw's style. Despite their reservations, Reed replied that since the poems were good, they should go ahead and publish and damn the risk.[50] The poems were published

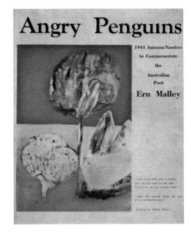

The special issue of *Angry Penguins* in autumn 1944 to commemorate the Australian poet Ern Malley: the cover features a painting by Sidney Nolan, *The Sole Arabian Tree*, inspired by one of Malley's poems

Dust jacket of Lawson Glassop's banned wartime novel *We Were the Rats*

Robert Close in Paris, c. 1956: the Australian novelist left Australia for Europe after the war, greatly embittered and vowing never to return. Close was imprisoned after his novel *Love Me Sailor* was prosecuted in Melbourne for obscenity; he was released early only because of his tubercular condition

without delay in a special issue of *Angry Penguins*, on the cover of which was reproduced a painting by Nolan, *The Sole Arabian Tree*, inspired by a line from 'Petit Testament'. The rest is history.

In one stroke the hoax demolished much of the standing of the Angry Penguins, in spite of their countering tactics. The following issue of *Angry Penguins* contained comments on the poems by artists and writers, the most eminent of whom was Herbert Read; Tucker contributed a satirical cartoon in the style of George Grosz, showing an innocent baby Max Harris oblivious of the squabbling of aged and juvenile academics. The case for the defence was that, by their own admission, Stewart and McAuley had used impeccable surrealist techniques to produce the poems. Nevertheless the authority of Max Harris as a poet and critic was undermined and the reputations of all associated with the magazine severely damaged.

The ripples spread to outposts as far afield culturally as Brisbane. There a small but vital group of young artists and writers had coalesced around the magazine *Barjai* and the Miya Studio art society. *Barjai* itself was a remarkable literary effort for the times — a kind of youthful *Angry Penguins* that was the creation of its 17-year-old editor Barrett Reid. Artists like Laurence Hope and Laurence Collinson and the writers Barrett Reid, Barbara Blackman and Thea Astley had been fired by *Angry Penguins* and the Contemporary Art Society. The Malley hoax left them shaken — and in some cases bewildered and lost. Thea Astley, a lapsed Catholic, returned straightway to the fold; Collinson, on the other hand, bolted for the Communist Party.

Catholicism or communism — these two poles offered refuge and certitude in the face of a hostile society. This was the year of the case contesting the award of the Archibald Prize to William Dobell; a threat of prosecution had been made in relation to the work of Donald Friend; in literature, Lawson Glassop's realistic *We Were the Rats* had been banned in Sydney and Robert Close's *Love Me Sailor* prosecuted in Melbourne; and, as a coda to the Ern Malley hoax, Harris had been successfully prosecuted in Adelaide in September for publishing indecency. In the last instance losing was probably preferable to winning, in that Harris could claim to be the victim of repressive authority — one example of what Harris called at the time 'the burning of the books'.[51] The fight against censorship was an important campaign, but rather less heroic for Harris was an earlier action against him for 'gross and malicious libel' in Adelaide in July of that year. In a drama review Harris had referred to an amateur actress (unfortunately one of skilled legal mind) as a 'demi-monde' without fully realizing what the phrase implied.[52] Proceedings by the plaintiff, Patricia Hackett, were discontinued, but Harris had to publish a full apology in Adelaide newspapers and pay costs.[53]

Whatever the legal vicissitudes of cultural radicals the real damage was to their cultural standing among peers. Communist and liberal alike

deplored the means but celebrated the end. The anonymous 'commentator' in *A Comment* (in all likelihood Adrian Lawlor) noted that the hoax had succeeded in 'exposing' the irresponsibility, the spiritual emptiness, the deplorable lack of critical sensibility of the Angry Penguins editorial group.[54] On the other hand the whole field of modernist writing and art had become vulnerable. Like others who were annoyed by the arrogance of *Angry Penguins*, the social realists found themselves in an awkward position: how to applaud without identifying themselves with the conservatism of the Sydney 'classicists'. It was necessary to revile the means as an example of cultural 'hooliganism' while at the same time commending and exploiting the consequences.

Writing to Bernard Smith in July 1944, O'Connor warned him of the potential harm the hoax could do to the C.A.S. and, by extension, communist members.[55] The Catholic *Advocate*, for example, had delivered a broadside at the whole radical modern movement in art and politics, using the Malley affair as its pretext. 'One thing is certain,' O'Connor wrote, 'we must defend ourselves — even if [*Angry Penguins*] have proved incapable of looking after their own defence.' O'Connor publicized the social realists' dissociation from *Angry Penguins* in an attack in the *Communist Review* in August.[56] He pointed out that the incident should not be construed in any sense as a weakness in the values of the C.A.S. as a whole. All it revealed was that the opinions and values of the group responsible for the magazine were ideologically and aesthetically bankrupt.

Barjai, 1946: a Brisbane-produced art and literary magazine that was a forum for young radicals

Sidney Nolan and John Reed in the Queen Street offices of the Reed & Harris publishing firm, c. 1945

The problem common to both parties was how to develop a free society and a free art that spoke to Australians of the contemporary Australian experience. By the end of 1944 and early 1945 both groups were attempting to take stock of their values and develop further concepts of the role of art in Australia. Should art offer a critique of society through the radical and innovative art supported by anarchists or through the rather less radical aesthetic of communist artists? The Angry Penguins pursued originality and individuality and as a means to this end favoured a decentralized institution. The C.A.S. was intended by them to be an open institution serving the needs of a divergent culture. The social realists favoured consensus and community and argued, in turn, that it could develop a national tradition based upon 'progressive' cultural values by means of a federal council. Thus O'Connor suggested to Bernard Smith that the whole structure and constitution should be overhauled.[57] Communist views were reinforced in Sydney by the attitudes of Carl Plate and Paul Haefliger, who resented the proprietorial attitude towards the Society of the new president, Peter Bellew. Bellew, ironically, continued to defend the original conception of the C.A.S. in its radical democratic form. Many Sydney artists had remained suspicious of Melbourne art ever since Nolan's *Boy and the Moon* first appeared and this dissatisfaction resurfaced in their refusal to send work to Melbourne exhibitions. The issue of non-selection also continued to fester. It was April 1945 before the Melbourne council of the C.A.S. was able to submit proposals for suggested changes — and then these were in the form of two irreconcilable drafts by Tucker and O'Connor.[58] O'Connor supported a unified art society based on centralized control over federal branches. Tucker opted for decentralization and individuality.

As early as November 1944 Tucker knew what sort of institution he wanted, and accordingly set his ideas down for Reed.[59] It is a revealing document, arguing as it does for change consistent with a coherent and clearly defined theory of culture, and may be taken as representing the views of his friends. Tucker listed three reasons for much-needed change: the unfortunate tension between Sydney and Melbourne artists; the destructive influence of the Communist Party; and the breaking up of the old cultural framework and consensus, upon which the C.A.S. had originally been based, because of the maturing of artists and their correspondingly greater sense of self-reliance.

For artists like Tucker, modernism in Australia could no longer be thought of as a single cultural mainstream. He objected to the assumption of a nationalist mantle, whether by the writers of *Meanjin Papers*, by the social realists and the editors of *Australian New Writing*, or by the conservative 'gum-tree' school. In place of a monolithic national culture, Tucker suggested that 'the diversity of conditions, the variety of influences, the social, cultural, geographical and climatic uniqueness of different areas of this continent provide the setting for the growth of

Sidney Nolan, *Boy and the Moon*,
c. 1939. This cryptic and
uncompromisingly severe image was
as mystifying to most of Nolan's
Melbourne contemporaries as it was to
their Sydney counterparts

distinctive State cultures'. The branches of the C.A.S. in the three main
cities should be devoted to the subjective art of their individual
members. There was absolutely no need even to consider a central
executive body.

The politics of confrontation was complicated by the evolution in
Sydney of a new art society — if such it can be called. Under the leader-
ship of the art critic of the *Sydney Morning Herald*, Paul Haefliger, the
Sydney Group was formed in 1945. Identified by Bernard Smith as 'neo-
romantic' in character, it was primarily a loose exhibiting association,
largely but not entirely made up of C.A.S. members. Its first exhibition
in August at the Macquarie Galleries contained works by Wolfgang
Cardamatis, Eric Wilson, Wallace Thornton, Justin O'Brien, Geoffrey
Graham, Gerald Lewers, Jean Bellette and Paul Haefliger. In his review
of the exhibition Haefliger pointed out that these were artists who had
little truck with ideology: 'Here few of the artists believe in the
overwhelming importance of theses and other extraneous matter.'[60] They
felt that they had absolutely nothing in common with either the Angry
Penguins or the communists. Prepared to support changes to the C.A.S.
constitution giving Sydney artists more autonomy, they rejected commu-
nist notions of a popular art. When Sydney left-wing artists James Cant,
Roy Dalgarno and John Oldham attempted to win control in the Sydney
general election of July 1945, they were resisted strongly by artists of
this temper. The communists were in fact beaten and, as outgoing chair-
man, James Gleeson expressed the hope that 'the present committee will

function without any of the clashes of personalities and interests that characterized the last committee'.[61] As in Melbourne in the previous year, it was a vain hope. Like the Sydney Group, the communists of the Studio of Realist Art chose to remain members of the C.A.S., and thus kept the art-political pot boiling.

In the face of these internecine disputes the Contemporary Art Society exhibitions in 1944 and 1945 presented to the public some of the finest work by Tucker, Nolan, Perceval, Boyd, Bergner, Counihan and O'Connor. There was little in the statements in either catalogue to suggest that behind works such as the first of Tucker's *Images of Modern Evil*, Bergner's Jewish paintings or Jean Bellette's *Orestes* was a protracted struggle for power and for the values which they embodied. It was left to Haefliger as a critic to make the distinctions for the public. He found in 1944 that 'the "wild men" of Melbourne are particularly violent in their clamour for a "vital" art'.[62] For his part, Haefliger doubted their claims. The only two exceptions showing clear talent were, he thought, the work of Nolan and O'Connor. The rest were 'ghetto' painters, 'artists whose tendentious paintings seek to stress the meaning of the slums'. Against so much apparently crude and confused painting Haefliger juxtaposed the work of the Sydney artists he preferred.

The 1944 annual exhibition was the last and smallest of the great all-encompassing C.A.S. exhibitions. The fracture between the two main

Jean Bellette, *Electra*, 1944. As this work by one of Sydney's foremost new painters demonstrates, acceptable Sydney modernism shared almost nothing of Melbourne restlessness or *angst*

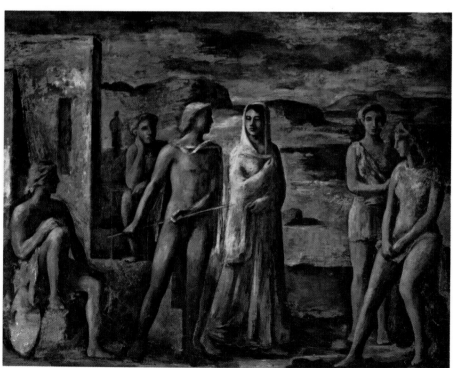

branches and the splits in Sydney resulted in Sydney artists having only a token presence in that year. The Sydney branch having decided to hold a separate state exhibition for local artists only, a number of artists simply ignored altogether the opportunity of exhibiting in Melbourne or Adelaide; James Gleeson's two important canvases *The Citadel* and *Landscape with Funeral Procession,* for example, were only to be seen in Sydney.

It was apparent to all that by 1945 the C.A.S.'s fortunes and its importance for artists had suffered a rapid and irreversible decline. To the factors listed by Tucker can be added the financial support artists found in the years of the 'art boom' after 1943; the increasing difficulty of managing large and unwieldy exhibitions interstate; the allegiance of artists to other art societies and groups; the ending of the war and the prospect of a new freedom of movement. But overshadowing them all was the emergence of a new establishment. As we shall see, the new set of relationships and power groupings in the institutions of Australian art by the mid-forties was very different in character from those of the old guard.

Cover for the catalogue of the C.A.S. annual exhibition in Melbourne's new Myer Gallery, August 1945

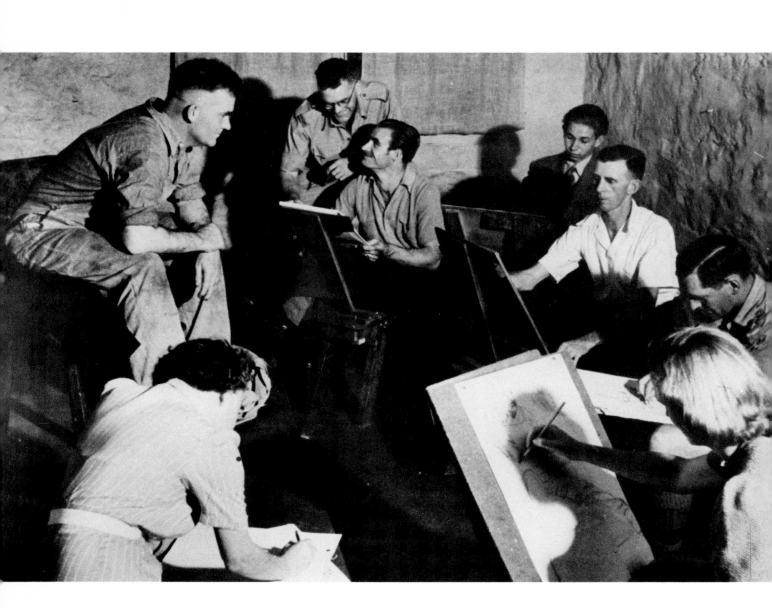

CHAPTER SIX
COMMUNISM AND CULTURE
Left-wing Art in Melbourne
and Sydney, 1942-1946

A national art requires more than the photographic rendering of certain national *symbols* ... A national tradition arises from a *people* as they struggle with their social and geographical environment.
Bernard Smith (1946)

The diversity and the individuality of the Angry Penguins artists have never been in doubt. By comparison, left-wing artists of the 1940s who embraced a different kind of radicalism have too often been viewed as an homogeneous bloc. Part of the explanation for this error lies in the selfconscious public face the left presented to the world: crusaders in a common cause know that they weaken it if disagreement is exposed within their ranks. In part the misapprehension can be explained by the genuine ignorance of the Sydney and Melbourne groups concerning their respective conceptions of art and culture. Mutual suspicion exacerbated misunderstanding but, for political reasons, differences were suppressed and cracks papered over. The result was a blurring of distinctions and a caricaturing of positions that has remained to this day.

The Melbourne-based artists called themselves 'social realists'; those in Sydney who established the Studio of Realist Art in 1945 used the label 'realists'. Realism in art meant, however, many different things to communist artists, as did political radicalism. While there was a consensus of sorts, membership of the Communist Party in Australia covered the widely varying degrees of political commitment that were characteristic of an era before the hardening of political arteries during the cold war. One could be a card-carrying member of the Party and still qualify for the title of 'fellow traveller'.[1] Assessing their degree of commitment is important if one is to ask how far Australian artists and intellectuals were prisoners of an ideology and under the direction of a 'sectarian' political party and how far they felt free to work from more independent aesthetic and ideological positions.

Such questions have not been asked. Fine paintings produced by artists of this camp have been lost or forgotten, and those that have been discussed have not been seen in their full political and cultural context. Few commentators have dissented from the conclusion that radical realists 'often begin as good artists and end as poor politicians; by

putting more energy into politics than into painting they burn themselves out'.[2] The evidence points to a more involved relationship than the sacrifice of aesthetic priorities to political and humanitarian ones, although that was indeed the case. Rather, it was the *nature* of the humanism to which communists responded that determined the respective aesthetic attitudes of Noel Counihan, Yosl Bergner and James Cant. In 1943, while the Angry Penguins refined an art concerned, through surrealism and expressionism, with the psychological realities of the life of the mind, the social realists were turning away from such matters.

Early Socialist Realism in Melbourne

To those who by 1944 had sloughed off their sympathy for Marxism-Leninism, Melbourne communist artists appeared to present a unified front. But that unity lasted only as long as the war and by the time of their major group exhibition, Three Realist Artists, in July 1946, it was crumbling.

The first indication of a coherent left-wing movement had been an exhibition by communist artists in 1942 at the Jewish cultural centre, the Kadimah Hall, in Carlton. This exhibition of over forty canvases contained work by Noel Counihan, Vic O'Connor, James Wigley, Nutter Buzacott, Yosl Bergner and others.[3] There had been, of course, a well-established left-wing movement in the arts in Melbourne and Sydney during the 1930s.[4] The Great Depression, which had propelled Counihan into the ranks of the Communist Party in 1931, produced in young radicals a sense of overwhelming need for social and cultural change. One early result was the appearance of the magazine *Strife* in 1930, edited by Judah Waten and Herbert McClintock. The early cartooning and caricaturing work of Noel Counihan in Melbourne and of George Finey in Sydney was also an important contribution to the left-wing press. The Workers' Art Clubs, established in 1932, offered ordinary people a chance to discover and participate in theatrical production, literary activity and the visual arts. Leading figures in this effort were Counihan, Finey, Jack Maughan, Judah Waten, Bill Dolphin and Nattie Seeligson. Always somewhat suspect as far as Party functionaries were concerned, the clubs took their cue from similar organizations in Europe and America. These were, in turn, founded on similar principles to those of the *Proletkult* movement in the Soviet Union during the 1920s. In this sense, they were forerunners of the later Studio of Realist Art in Sydney.

The populist movement in Russia was suppressed by Stalin's directives in the early 1930s. In Australia the Workers' Art Clubs and associated left-wing publications were ended in 1935 and united front activities took their place. By the 1940s the earlier specialist branches were wound up and in 1942 the Party adopted a policy of integrating specialist

The writer Judah Waten with Noel Counihan in Horsham, 1943: the relationship of both with Communist Party authority was difficult. While their loyalty was never in doubt, their refusal to toe the Party line made for trouble

Noel Counihan, *The New Order*, 1942

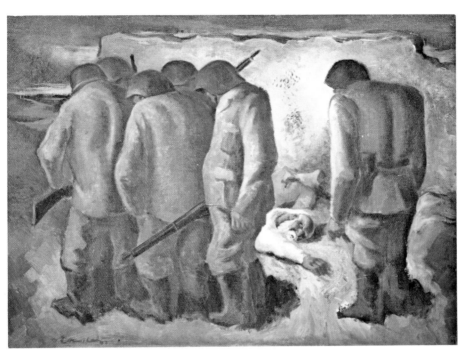

members with the ordinary rank and file in branches or of establishing more apparently independent 'front' organizations. The Artists Advisory Panel was a good example of such a body. In the great anti-fascist crusade artists of all persuasions were called upon to play their part in the common cause.

Although Counihan was in the forefront of this effort, it was a difficult time for the artist. The fight against tuberculosis was accompanied by running battles with the Party leadership over ideological issues and political tactics — on account of which both Counihan and Waten were expelled from the Party in 1942. Counihan was reinstated in 1943 but Waten stayed out for the duration of the war. Few of Counihan's early experiments from 1941 or the art-political works of 1942 have survived. *Heil Hitler, Tribute to Stalingrad*, and *They Shall be Avenged* were all destroyed without, one supposes, any enduring loss to Australian art. No doubt *The New Order*, which has survived, was a superior work. A small picture, it was inspired by Goya's monumental canvas *The Third of May*, and was the nearest that Australian painting got to socialist realist propaganda as exemplified in Russia by Alexander Gerasimov or Isaac Brodsky. Comparable painting in Australia would have demanded that the artist work in the *plein air* realist style of a Roberts or a McCubbin. The catch was that communists like Counihan were defending in Russian art a type of realism that was inimical to the aims of the Contemporary Art Society.

To the extent that Noel Counihan and Albert Tucker were both concerned with an art of communication, they shared a common problem: that of conveying, through convincing iconography and an appropriate style, ideas and values that were a response to personal social experience. Probably Counihan's most successful contribution to the Anti-Fascist exhibition and the 1943 C.A.S. exhibition was a drawing entitled *Pick-up*. Counihan depicts in straightforward terms the meeting between an American G.I. and a local girl. It is a natural, even sentimental, event which avoids the critical ire the subject would have drawn from Tucker. Apart from the more modest achievement of his graphic work, Counihan was, however, profoundly dissatisfied with his more ambitious early efforts. They were, he later held, 'too dominated by the idea element; they lacked the flesh and blood of intimate experience'.[5]

Noel Counihan, *Pick-up*, 1942

Vic O'Connor had a similar problem in painting a 'political picture'. Like Counihan, he felt unable satisfactorily to contrive an imaginative protest against German atrocities. Four such efforts were exhibited in the Anti-Fascist exhibition: *The Refugees, After the Raid, Nazi Culture* and *Pogrom* — the last three of which he subsequently destroyed. *The Departure* and *The Refugees* (1942), which looked to Bergner's style and personal experience, were different. Both paintings are based on vivid recollections of the eviction of O'Connor's family during the Great Depression. Only thus did O'Connor feel that he could achieve a convincing image of loss and desolation comparable to the sufferings of war refugees in eastern Europe. From this point, his style became more expressive and painterly, an unforced approach more in keeping with the temperament of this intuitive artist.

Late in 1941 Yosl Bergner joined an Army Labour Company and was sent to Tocumwal where, as we have seen, he was put to work with other aliens loading and unloading railway trucks. A painting from that year, *End of a Day's Work, Tocumwal,* is moving and disturbing testimony to the experience of alienation. Four civilian soldiers occupy the immediate foreground, the central figure being that of a fellow Jew. Their attitudes and expressions are those of men doubly dispossessed. Each figure is withdrawn and introspective, a point underscored by the reclining figure who shields his face with a hand. The night scene is lit by artificial light, the town in the background looking like a prison.

Two themes occupied Bergner from 1942 to 1946: the plight of Australian Aborigines and that of Polish Jewry. The connection between them was implied by the inclusion in the Anti-Fascist exhibition of two works from each theme. For Bergner the evidence of dispossession and alienation was everywhere — in the sight of an Aboriginal 'busker' on a city pavement playing a popular American song on a gum leaf, as much as in Carlton tenements. In Tocumwal Bergner discovered two Aboriginal families camped on each side of the town, to which they were forbidden entry. He reacted by producing two paintings entitled *The Aborigines Come to Town*, paintings that made a wholly ironic point.[6] In *Refugees*

(1942), Bergner depicts a group of pathetic figures against the background of a burning town. Whereas the Aboriginal pictures of this time have a monumentality of form, with the Jewish subjects Bergner employed a heavy painterly style more indebted to the early mode of Van Gogh.

By 1943 Bergner and O'Connor had joined Counihan as members of the Communist Party. Yet despite their fierce battle of words with the Angry Penguins, it was not a productive year. They were heavily committed to military and political tasks, and Counihan's health again collapsed. In May 1943 he wrote to Bernard Smith with the news that he was confined to bed and not painting.[7] Bergner, he said, was at camp in Tocumwal for months on end. Meanwhile, Vic O'Connor confided to Smith that he was far from happy with the painting he had exhibited with the C.A.S.[8] There were many frustrations and difficulties: 'I have a full time army job (work one stretch of five weeks without a day off — and about five nights a week).' What was a decisive and vigorous year for the Angry Penguins artists was a frustrating one for their opponents.

Vic O'Connor, *The Dispossessed*, 1942

Bernard Smith

Any public statement by communists at this time must be viewed in its military and political perspective. Thus Counihan declared in response to Tucker's attack on Zhdanov's conception of culture: 'Who is Zhdanov? He is one of the most brilliant leaders of the Russian Communist Party.'[9] It was the declaration of a political activist, a man for whom Zhdanov's military leadership in the epic defence of Leningrad was sufficient to brand anyone who questioned his cultural wisdom as a fascist. But we must also understand that there was a considerable difference between the toughness of this public stance and more private feelings concerning Marxism and conceptions of culture appropriate to socialism. Although many leading left-wing artists and intellectuals were prepared to accept the term 'socialist realism', many held private doubts about the Zhdanov prescription for art and literature that had been proclaimed as communist dogma in 1934. Naturally, it was unthinkable that such doubts should be aired. Yet the curious fact remains that both Sydney and Melbourne communist intellectuals accepted the public rhetoric of each other at its face value. In private, Counihan and O'Connor thought that *Australian New Writing* was excessively rigid and sectarian. At the same time they were aware that Bernard Smith saw their own position in much the same terms.

Yosl Bergner, *End of a Day's Work, Tocumwal*, 1941

For his part, Smith saw the virtue of maintaining a consistent ideological position in public while his real position was somewhat more pragmatic. How uncompromising that public stance could be is indicated by Smith's repudiation in July 1943 of the charge by Max Harris that *Australian New Writing* falsely claimed to represent the only truly

progressive art and culture in Australia.[10] The claims of *Australian New Writing* were not, Smith replied, based on claims for any new artistic tendency or impetus since this would suggest equally valid rival claims: 'There is no rival. It is.' The artist had one choice and one choice only: to be progressive or to be reactionary. In these terms, Smith dismissed as bogus any claims by Harris that a broad intellectual front of radical artists and writers was possible. There could only be one popular front and that was a front based on the working class. No 'pure' theory of art was possible: 'You can't unite the *intellectual class*, but you can unite intellectuals around the need for a better society, for alliance with the working class, for the defeat of Fascism.'

In less public terms, Smith was more flexible. Writing to a fellow communist whose piece of art criticism published by *Australian New Writing* would have done credit to Zhdanov himself, Smith counselled against appearing excessively narrow and sectarian. One must attack 'intellectualism', Smith stated, not 'intellectuals'. He went on to specify the immediate tactic within the long-term strategy of the revolutionary struggle. Such a clear statement by a man then writing the first analytical history of Australian art is worth quoting at length:

We have got to lay the essential scaffolding of a materialistic aesthetic in this country in the next few years. We will have to deal with these problems over and over again, applying our methods to Australian writers, to periods of Australian art, to detailed aspects of all the arts in this country; and we can only do it if we have our own position pretty clearly defined.
To do this I feel one of the main guiding principles must be the *necessary divisions* [italics added] that we must make between our convictions which arise from our socialist philosophy, our belief that art arises out of the social ethos, that is charged in content and form . . . by class struggle. We have to distinguish these convictions arising from our theoretical position from our own tactics in relation to modern artists, artist and writers clubs . . . We understand the position well enough in the realm of politics, the guiding policy of National front, united front . . . We must realise that there is a counterpart in the cultural world. All those artists who are willing to resist fascism have our support. We will not openly attack the forms of their art, even though we may believe that it arises from their misconception of social realities.[11]

The critic should confront cultural politics wherever this appeared reactionary (as in the case of the views of a Lionel Lindsay or an Alister Kershaw) because in such cases there was, for Smith, a clear link between aesthetic beliefs and politics. Elsewhere a more subtle strategy was required. Communists themselves had always to be on guard against sectarianism within their own ranks: 'Who are we to say what the best products of socialist realism are? Far better to say, here is a socialist, who is also an artist, look what he is doing.' Smith went on specifically to reject social prescriptions in art and culture and cautioned against ideas central to Stalinism — that art should be optimistic and that it

should employ the mode of academic naturalism. Such rules, Smith believed, were arbitrary and the communist critic should substitute a concern for art produced by all sincere anti-fascists and art that stressed a general tendency to return to realism.

In broad terms, this was the position Smith adopted as an art historian and critic in *Place, Taste and Tradition.* He was not prepared to dismiss modernism — he could not as an historian — but he employed criteria of political intention and the degree of realism to sort out progressive from reactionary artists. As he wrote in July 1943, however, any criticism of modernist ideas demanded careful handling:

> we will formulate our arrangements differently [from a sectarian stance], showing whenever possible the *positive* developments of the modernist movement ... On the other hand it is necessary to criticise those negative aspects of mysticism, subjectivism etc. which are so often present. In this way we would aim at keeping contemporary painters in touch with reality ... There is no rigid line in these matters. But the artist is an artist and as a man has a duty both to himself and to *his art* to appreciate and gather information from the political developments of his time.[12]

Bernard Smith's *Place, Taste and Tradition*, published in 1945, was not the first history of Australian art but it was the study that gave it form and shape

In practice, as *Place, Taste and Tradition* bears out, this open conception of art criticism was not easy to hold to, and Smith showed scant sympathy towards any of the Angry Penguins painters. The problem for communists was always the conflict between the demands of art and the demands of politics, between the role of the historian and the more judgmental role of the critic. So critical of other views was Smith in the original manuscript that the publisher, Sydney Ure Smith, refused to publish the section dealing with the Lindsays. This was subsequently published in two parts in the *Communist Review* under the pseudonym 'Goya' as 'The Fascist Mentality in Australian Art and Criticism'.[13] Despite the tone of this piece, by the time the book was published in 1945 Smith's views were being modified considerably by contact with Sydney Ure Smith and by his own growing doubts about the intrusion of politics into art. *Place, Taste and Tradition* is, in fact, two books: one is a sharp and incisive review of Australian art history from its beginnings to the twentieth century, based on much original research; the other is a book whose political rhetoric betrays its partisan aims. The second aspect must be accepted as a product of Australian art politics at a time when the Contemporary Art Society was being torn apart by an internecine struggle of which *Place, Taste and Tradition* was a part.

Smith did not hesitate to state that, in his opinion, Australian painting culminated in the politically conscious realism of Bergner, Counihan, O'Connor and Herbert McClintock. These were the artists who had 'reacted vigorously to the social and political upheavals of their own time'. Smith extended his favour also to the work of Russell Drysdale, Peter Purves Smith, William Dobell, Donald Friend and James Cant. The Angry Penguins artists, on the other hand, were linked with James

Gleeson, Max Harris and Ivor Francis to the spirit of 'war-time defeat-ism' manifesting itself in surrealism and apocalypticism. Perceval's rejection of socialist realism for an exploration of the world of the child was 'clear enough evidence that regression to a purely individualistic art has not resulted in the heightening of his artistic powers'. Nolan was mentioned only in passing and Boyd not at all. Tucker was dismissed on the basis of unsound political views and a pessimism 'linked spiri-tually with the world-weariness of the Eliot school'.

In the final analysis, Smith fell back upon that old socialist realist standby, the demand for an optimistic response to significant events. It was in this sense that he felt that the humanism inherent in the treatment of social and political events by the left-wing realists was superior to the work of other contemporary painters:

They have felt these issues, not as abstractions for the purpose of discussion, but as natural forces at the threshold of existence, moulding their lives. They have realized that Australia is a part ... of world movements: that it cannot be separated from these movements. But they have reacted no less vigorously to the social and political environment of their own country. Both these aspects of their work have arisen from their preparedness to record the urgencies of contemporary life, both at home and abroad.[14]

If Smith was not prepared to state outright that their vision was a more optimistic, and therefore a more progressive one than their opponents', it was because there was no need. Their contemporary rivals had already been found guilty of pessimism, world-weariness, intellectualizing, mystification, introversion and defeatism.

Two major arguments are woven into *Place, Taste and Tradition*. The first is that the important thrust of contemporary painting was towards a new realism. The second is that Australian art and culture possessed a native democratic tradition. These matters lie at the very heart of a longstanding and continuing debate in Australian cultural history over the fundamental question of an Australian identity and Australia's place in the world.

Smith devoted the final chapter of *Place, Taste and Tradition* to a plea for a new realism in art.[15] In answering the question, 'Where is contem-porary art going?', he addressed himself to what he saw as a crisis in twentieth century art and culture generally.[16] Since art and culture are tied to human history, they must progress. The claims of men like Adrian Lawlor and Albert Tucker for essential and unchanging verities in human experience were dismissed as spurious. The disputes in the C.A.S. which began in 1943 were evidence that many members had fallen out of step with history. As Smith put it, 'a Society like the Contemporary Art Society, by its very title, pledges itself to a kind of eternal youth, a sort of constitutional necessity to be always arriving'. If the C.A.S. was to survive it had to open its doors: abstractism and surrealism must give way to a new realism — a realism of a kind reflected in the recent work

of Jacob Epstein, Henry Moore, Diego Rivera, José Orozco and others. The obscurantist aestheticism and mysticism of expressionism and surrealism in Australia were merely another form of that anti-intellectualism which was also the central feature of the fascist flight from reason.[17] Romanticism in all its guises was the antithesis of reason and represented a flight from reality. In the 1930s Smith thought that many artists had turned their backs on political realities and accepted in a fatalistic way the destruction in Germany, Italy and Spain of European democratic culture. The surrealists had been hypnotized by the power that destroyed them. The time had come, Smith declared, for the artist to take whatever was of value in modernism and put it in the service of humanism.[18]

Much of the difficulty for communist artists of any nationality lay in the great confusion surrounding the Russian reaction against aestheticism. In taking their cue from Russian ideological precepts, both Bernard Smith and Noel Counihan were ready enough to favour proletarian content, but did not accept 'national form' if that meant academic naturalism. Both admired the early work of the Heidelberg School, which in 1943 and 1944 was being rediscovered by artists and young intellectuals. But it was inconceivable that they should either adopt or support the style of Ernest Buckmaster, precisely because of its popularity with the Australian public. Whereas the Studio of Realist Art in Sydney was based on ideas close to those of the proletarian movement in its support also of untutored art, Counihan committed himself to an art of high seriousness of subject and purpose. The alternative was the modernist tradition of social realism. There was no other option unless the artist were to slavishly accept Stalinist socialist realism as some Party members demanded. To experiment with proletarian art risked lowering professional standards; to risk tainting art by surrealistic adventures was to be politically suspect.

Nationalism

These were the problems and dilemmas upon which the incapacitated Counihan brooded in 1943. Beyond all else he knew that the best art was that which communicated an experience of the human struggle. To base art on personal experience of social realities (properly understood, of course) seemed to be the key. Thinking that Smith's views as expressed in *Australian New Writing* seemed to repudiate this conviction, Counihan wrote at length to him in December 1943 setting out a broader notion of socialist realism on which he, O'Connor and Bergner based their work. Counihan wanted no misrepresentation of their ideas in Smith's new book. The statement was a manifesto of the Melbourne communist group:

Our trend at present is to endeavour to record the most important, most comprehensive, most suggestive subject matter by digging into the depths of our own

intimate individual experience — that is, the indirect approach, to reveal the social relations involved in our most intimate experience. This approach to socialist realism, our objective, is the antithesis of the subjectivism of surrealism, and the sterility of all formalism. We are not concerned with examining our own 'stream of consciousness' ... we are not concerned with symbols of purely subjective significance or psychological symbols. Our subject matter is the material, tangible, visible world of nature and a [view] of human society — the human society of 1943, capitalist society with all its social, class relations, its conflicts.[19]

Edited by L. L. Sharkey, the *Communist Review* was the official mouthpiece of the Party, while often containing polemical material from its opponents

The values expressed in the statement were intended to distinguish Melbourne communist art from the apparently more doctrinaire views held in Sydney. By 1944 the group opted for the term 'social realism' to describe a humanistic art based on personal experience. Well before 1944 it was a term which, like 'socialist realism', had common currency among left-wing artists.

By 1943 Australian left-wing artists were less concerned with Moscow than with the indigenous national democratic tradition within which they felt they worked. There was a marked shift in this direction in the tenor and the subjects in left-wing publications such as the *Communist Review*. Miles Franklin, for example, contributed 'Joseph Furphy, Democrat and Australian Patriot' in September 1943. In October Max Brown, in a review of the Contemporary Art Society exhibition, wrote that the men of *Angry Penguins* 'will not go ahead until they turn their faces directly to their people and their country, bury themselves in the life about them, and learn to work with all their hearts and souls'.[20]

Bernard Smith's *Place, Taste and Tradition* can also be seen as part of this revival of left-wing Australianism. Above all else, Smith stated, he was concerned with the relationship between the course taken by Australian art and concurrent European tendencies from which Australian artists had drawn sustenance for an art of a national character. What were the characteristics of a genuinely national art? For Smith, 'A national art requires more than the photographic rendering of certain national *symbols* ... A national tradition arises from a *people* as they struggle with their social and geographical environment.'[21] That was seen as a legacy of the Heidelberg School, embodying as it did the aspirations of the democratic labour movement. It was a vision which had been lost by the subsequent distortion of the pastoral tradition in the conservative nationalism of the 'blood and soil' mystique of J. S. MacDonald. The logical consequence was (as Smith continued the argument in the *Communist Review*) the blatant anti-semitism and racism of a fascist Australianism:

there is a direct line of theoretical descent from the aestheticism which grew out of the Melbourne Bohemian circles of the nineties, and the increasing mysticism associated with the practice of landscape painting, to the development of

an arrogant nationalism ... and finally to an arrogant mysticism which takes on all the attributes of the fascist mentality.

Smith had no doubt about the danger and pervasiveness of this evil: 'the final common denominator of this "cultural" tendency is to be found in the concentration camps of Dachau and Belsen.'[22]

For communists the evil thus identified was contained within certain clearly definable class limits and ideological values. This was not the case for artists like Tucker and Boyd, or later for writers like George Johnston. The evil they identified could not be answered by an appeal to alternative virtues residing in 'the people' and realized in the heroic struggle of that people. For Smith, as for Counihan, the notion of 'the people' had a double loading: the people were an international proletariat but were also identified with an Australian working class that had in turn been moulded by specific social and geographical conditions.

Communists were attempting to found a new nationalism free of fascist contamination by locating its values in those of a native democratic labour movement based on the authentic values of an Australian people — values which also partook of a universal character. Smith pointed out the perils of this difficult but necessary dialectic:

A national tradition of Australian art should be sought for, not in the hopeless endeavour to create an *art-form* peculiar to this continent — as aboriginal art was — but an art the nature of which will grow from the features of a changing Australian society. Such an art, while maintaining many international connections and drawing from varied international sources, will reflect the life of the Australian people ... For a vital art can only grow out of its own time and its own place.

Like Counihan, Smith testified to a belief that there was an Australian way to socialism and an Australian art that might help show the way.

That national cultural tradition could only be produced 'from the gradual assimilation of many overseas tendencies as they react upon the local conditions of the country'.[23] It was a conception of culture which neither Burdett nor Reed would have disclaimed. On such a theoretical level of cultural aspirations, practically everybody was in agreement. The essential difference lay in the demand of left-wing radicals such as Smith and Counihan that the attitudes to be assimilated by artists, and the values to be discerned in a culture, be prescribed by Marxist-Leninist ideology. Whatever freedom artists or critics found for themselves within such strictures was severely circumscribed in the 1940s by the requirements of the united front. The irony for communists was that this not only alienated potential liberal allies, but ensured that the divisions within their own ranks were not bridged. Moreover artists like Bergner and O'Connor, though fundamentally 'fellow travellers', might have remained with the Party had they not been alienated by its demands in the post-war years.

Noel Counihan, *At the Start of the
March, 1932*, 1944

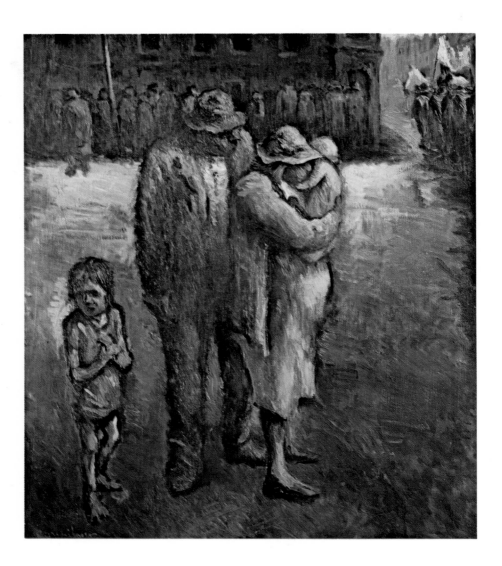

Noel Counihan

As Counihan slowly recovered from his debilitating illness late in 1943
he began to paint once again. In December he wrote to Smith: 'I am paint-
ing steadily, but my restricted time is broken into by various demands,
including political cartoons . . . However my painting is making progress
and I am working hard as circumstances permit.'[24] Always a slow worker,
Counihan produced even less than O'Connor and Bergner at this time.
Speaking on behalf of the three artists, Counihan pointed out to Smith
that their work could be divided into two categories: first, an imaginative
treatment of aspects of the war against fascism; second, work dealing

specifically with local Australian subject matter.[25] The first category
after 1942 belonged almost wholly to the work of Bergner and his series
The Jews. From December 1943 Counihan's work was, by contrast, wholly
local in its concerns.

Counihan's first paintings of an immediate milieu were of familiar
images around the working-class streets of St Kilda. The subject of *In
the Waiting Room* (1943) is an old and emaciated woman seated in a
doctor's waiting room. *At the Corner of Nightingale Street*, painted early in
1944, depicts a pregnant woman with two children hanging onto her
skirts gossiping with an old couple on a St Kilda street corner. They
express a sense of compassion for the poor and the lonely and are
painted with an energetic brush-stroke and vivid streaks of colour. The
subjects were the 'living material of real, profound experience' which
Counihan stated was derived from an intensely felt personal contact.
Counihan assessed his progress to Smith: 'aesthetically my own work is
developing as a result of the turn to very local subject matter, rich in
human and social content.'[26]

After this small group of works there was a gap in Counihan's output
until he began a group of paintings based on memories of the Great
Depression and produced in July and August 1944. The reason for the
break was that Counihan's health had collapsed again in March 1944.
During a further period of convalescence, he contemplated ways of
attempting a more ambitious painting statement. It is not uncommon for
artists with such an aim to turn to the exalted genre of history painting
— whether in relation to the distant mythical past or the heroism of
modern life. Counihan turned in 1944 to contemporary events in the
process of passing from history into myth, to what were perhaps the most
intensely felt experiences of his life: in 1933 he had risked prison by
haranguing crowds from behind the protective bars of an iron cage in
Sydney Road, Brunswick, as a protest against restrictions on free speech.
In 1944 Counihan painted *At the Start of the March, 1932*, *The Speaker, 1932*
and *At the Meeting, 1932*. *At the Start of the March, 1932* is stylistically close
to the work of 1943. However, *At the Meeting, 1932* is more sombre and,
like Bergner's earlier *End of a Day's Work*, looks to the early paintings
of Dutch peasantry by Van Gogh in its use of heavy accentuated forms
to express the stoical endurance and strength of the unemployed.

Yosl Bergner

In June 1943 Counihan wrote to Smith apropos of Bergner's Aboriginal
paintings: 'for the first time these abused people are being painted by
a painter with an understanding of their sufferings and exploitation. It
has taken a Polish Jew to interpret the aboriginal realistically, sympath-
etically, as a struggling people, without patronage or sentimentality.'[27]
By the end of the year Bergner was also working on a series based on

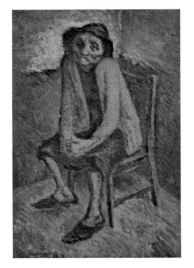

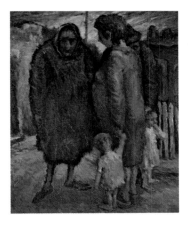

Noel Counihan, *In the Waiting Room*,
1943 (top); *At the Corner of
Nightingale Street*, 1943

the theme of the Warsaw Ghetto. The extermination of Jews, begun in Poland and eastern Europe in 1942, was by now in full operation. Little could be known outside or inside occupied Europe but certain events indicated the dimension of the tragedy. In April 1943 an unsuccessful but significant revolt took place in the Warsaw Ghetto, when for several weeks virtually unarmed Jews successfully held off German army battalions. Without doubt this event precipitated what are among his most important works: four key paintings from 1943, *Hanging Jews, Father and Sons, Looking Over the Ghetto Wall* and *Job*. Exhibited in 1944 with the C.A.S., they were not for sale. They are painted in a heavy manner with strongly built-up surfaces of pigment. The colours used exploit stark

Yosl Bergner, *Aborigines in Fitzroy*, 1941

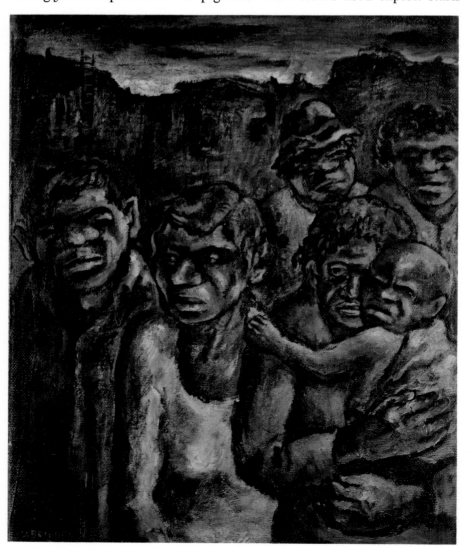

contrasts: black, white, greys, red and touches of blue-grey. The figures are unmistakably Jewish; men wear either cloth caps or skull caps and invariably a *talis kuten* or *tzitzith* jerkin.

The two figures in *Hanging Jews* are broken and emaciated corpses, sacrificial victims with bound hands and crossed feet. The landscape in which they hang is bleak and snow-covered. The figures in *Father and Sons*, a man and two naked children, stand within the ghetto against a red wall. Houses with dark windows take on the appearance of death's heads and the firmament above is dark and oppressive. Bergner was not religious in an orthodox Judaistic sense but the whole outward bearing of the figures suggests the withdrawal of celestial grace.

In *Looking Over the Ghetto Wall* the figure wears a cloth cap, suggesting not only Jewishness but also working-class status. This lone figure looks back over one shoulder at a high red wall topped with barbed wire. The wall emphasizes that a ghetto is a prison; the fiery sky behind that wall suggests, perhaps, an even worse hell beyond it. As with all ghettos, the wall that locks people in also serves to keep alien and hostile forces at bay.

Bergner continued the series in 1944 and one important work from this year is *Funeral in the Ghetto*. An emaciated woman and two youths push a cart upon which lies a skeletal corpse; in the centre of the picture stands the grief-stricken figure of a man who covers his face with a huge and helpless hand in a gesture of unutterable sorrow. In the background are the tenements of the Warsaw Ghetto, and above, the invariable burning sky. In specific terms, the painting appears to relate to the German policy in 1944 of deliberate starvation of the last survivors in the Warsaw Ghetto.

The advantage that Bergner had as an artist, if such it can be called, was the possession of a theme that became one of the greatest human tragedies. As a Pole, Bergner knew well the character of the Warsaw Ghetto and, as a Jew, he knew personally what it meant to be a member of a persecuted race. Moreover the complex Judaistic tradition offered the artist a set of symbolic references. His Australian colleagues, whatever their personal sympathies, were denied this identification and its symbolism. They had necessarily to turn to comparable themes within their own cultural traditions. It is significant, if unsurprising, that Bergner's paintings of Aborigines are less convincing and less moving on the whole than those dealing with the fate of his own race.

Vic O'Connor

Early in 1944, and now out of the army, Vic O'Connor began a series of street scenes based on images of life in the lanes and streets of West Melbourne. Two works, *The Woman with the Pram* and *The Woman with the Bow* were based on an old woman O'Connor often saw at the market.

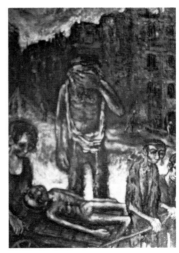

Yosl Bergner, *Looking Over the Ghetto Wall*, 1943 (top); *Funeral in the Ghetto*, 1944

Vic O'Connor, *Fitzroy Street*, c. 1943

After 1942 Vic O'Connor's art showed the least overt political content of any of the social realist group of Melbourne painters, despite the fact that his commitment to the left remained as intense as ever during the war years

The sight of this figure revived early memories and combined with an image of the artist's mother in a powerful way. It was a turning-point for the artist:

From that moment on . . . I was beginning to realise what activated my painting and the way to respond to it.
I wanted to paint autobiographical things. I wished to paint people around me, the reflection I had on what was happening in life, the judgements I made out of it — and I felt that people should be told and I moved to tell them about it.[28]

By 1944 Melbourne left-wing artists had a clear vision of the course of their art. In a statement published in the C.A.S. exhibition catalogue of that year, Bergner, Counihan and O'Connor reaffirmed that they represented a common point of view and worked together as a group 'to create a democratic art combining beauty of treatment with a realistic statement of man in his contemporary environment'. They concluded:

We three painters believe in a human, democratic art with its roots in the life and struggles of ordinary people, devoid of all obscure cliches and mannerism . . . an art intelligible and popular, expressing the deepest aspirations of the people.[29]

The Studio of Realist Art

In 1943 and 1944 the titles of many of the paintings exhibited in the C.A.S. exhibitions by Sydney left-wing artists such as Herbert McClin-

tock and Rod Shaw suggest comparable interest in the genre subjects of their Melbourne counterparts. Roy Dalgarno oscillated between paintings based on Aboriginal tribal images, which he had seen while on service in the Northern Territory working with an R.A.A.F. camouflage unit, and socialist realist works such as *Foundry Workers* (1945). In 1945 James Cant introduced for the first time a more selfconscious political dimension into his art in works such as *The Dole Days* and *Centre of the World, 1930*. As with Counihan's essays on the theme of the Great Depression, these were reconstructions of the experiences of the unemployed. But unlike Counihan, Cant adopted a simplified, rather naive mode of apparent artlessness in depicting the dehumanization of that experience.

The idea of the Studio of Realist Art originated with James Cant after his discharge from the army in 1944. Other early participants included Dalgarno, Shaw, Bernard Smith, John Oldham and Hal Missingham. All except Missingham, who might be ascribed a fellow-travelling status, were members of the Communist Party. These artists had become increasingly discontented with the C.A.S. in 1944-45 because of its general lack of sympathy in Sydney towards figurative art.[30] Yet despite apparent similarities in their art, the whole thrust of S.O.R.A. was quite different from that of the Melbourne social realists. To a large degree this can be attributed to Cant's wider experience with radical movements in England and Europe in the 1930s.

Cant had studied in Sydney under Dattilo Rubbo and then at the East Sydney Technical College and Julian Ashton's Sydney Art School before going overseas to study in 1934.[31] After attending the Central School of Arts and Crafts in London, he was invited to join the English surrealist group led by Roland Penrose. Typical of his early activity as an artist is his surrealist *Constructed Object*. In 1938 he withdrew from the surrealist movement to become a member of the Artists International Association and participated in several anti-fascist exhibitions. At the same time he maintained a concern for aesthetic radicalism and in 1939 was included in the exhibition British Surrealist and Abstract Paintings. At this time Cant's work, as *The Deserted City* (1939) indicates, owed much to de Chirico. In 1940 he was forced by the outbreak of war to return to Australia.

Cant's conception of a radical culture embodying both an aesthetic and a politically radical dimension set the tone for S.O.R.A. Although the group had the tacit support of the Communist Party, it must have been viewed with considerable misgivings. In its attempt to forge direct links with the trade union movement rather than the Party as such, S.O.R.A. was cast in the mould of the discredited Russian *Proletkult* movement. On the whole S.O.R.A. members did not contribute to Communist papers and magazines and were not as active generally in politics as their Melbourne counterparts. Members like Roy Dalgarno, Rod Shaw, Dora Chapman and Hal Missingham had been fully involved

James Cant, *Surrealist Drawing,* c. 1936 (*top*); *The Deserted City,* 1939

James Cant, *The Centre of the World,*
1945

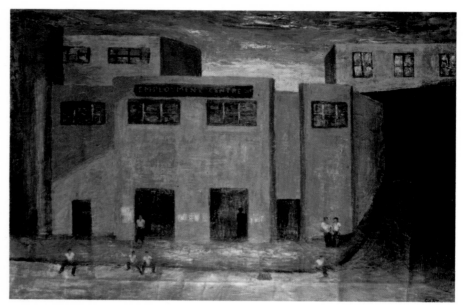

James Cant, c. 1945: the greater
openness of left-wing painting in
Sydney owed much to the breadth of
Cant's surrealist associations earlier in
Europe

during the war years with camouflage work for the armed forces or the
Civil Construction Corps, or had worked in Army Education. This
experience may partly explain why Cant's notion of a new and radical
art society having close ties with ordinary people evoked a receptive
response from artists closely involved with the war effort on this level.
The aim of S.O.R.A. was to achieve a cultural climate sympathetic to
radical action in society through creative activity.

S.O.R.A. was officially opened on 2 March 1945 in a three-roomed
basement backing onto the waterfront in Sussex Street.[32] In June the
group moved to Herbert McClintock's vast studio in the old George
Street *Bulletin* building. As James McGuire noted in the *Angry Penguins
Broadsheet,* Sydney militants were no longer found in such strength at the
C.A.S. The Sydney branch had suddenly become more genteel with the
departure of 'meerschaum pipes, chest warmers, velveteen coats and
trousers, beards, neckerchiefs, sandals (with socks), yellows and reds
and similar gear'.[33]

S.O.R.A. plunged into an energetic programme of lectures, art classes,
social events and plans for communal art projects. The first issue of its
Bulletin appeared in April 1945 and stated the reason for S.O.R.A.'s exist-
ence:

It is natural that such a group as ours should come into existence, in opposition
to the large amount of other-worldly, art-for-art's sake that fills the walls of
so many exhibitions — work that is an expression of decadence and puerility,
that is impossible to relate to the mass of Australian people.[34]

The days of élitism in Australian art were claimed to be numbered and the new *lingua franca* in art was realism and communal art. Architectural murals and print-making were to be the primary media and, as McGuire noted with some cynicism, 'Realism is in everything. Realism will out; it cannot be stopped. It has energy, drive, organization, initiative, raffles. Realism is in Art.'[35] If these ideas found scant sympathy in established Sydney art circles, they were no more readily accepted by the central Communist Party leadership. Cant's Party membership was tenuous, and typical of that of many wartime adherents. No doubt the Party hierarchy saw in S.O.R.A. a potentially fruitful extension of cultural front activity, but it soon realized that artists are rarely amenable to rule. For Cant, as for others, surrealism provided a lead into realism. Because of this legacy, he was reluctant to dispense with psychological realities in favour of social ones. S.O.R.A. leaders also continued to insist that workers should become artists, whatever roles artists might visualize for themselves. The activities of a body such as S.O.R.A. were intended to parallel Party political activity rather than serve it slavishly.

Rod Shaw, *The Cable Layers*, 1946

How did other communist artists regard this group? Bernard Smith did not exactly disapprove of S.O.R.A. but, even though a member, had doubts about artists isolating themselves from broader associations. Counihan was not prepared to accept the cubist and folk-art influenced work of an Orozco or a Rivera with its central strain of primitivism as an expression of the art of the people. He did not see art in open and experimental terms in the way that Cant, having been a member of the surrealist movement, did. For Counihan, the job of the artist was to educate the workers *up* to art, not to help bring out their natural express-ive capacities on their own terms, as the classes organized by S.O.R.A. attempted to do by relating art to the needs of ordinary men and women. The innocent eye received short shrift with Melbourne communists.

Much energy at S.O.R.A. went into organizing painting and drawing classes, public lectures and film nights, and a library of books and repro-ductions. S.O.R.A. organized an annual exhibition of the work of both artists and students, and more specialized exhibitions in conjunction with trade unions and the Party. Ambitious plans for murals were conceived but never carried out. One of the more radical ideas that fell through was a series of paintings to have been published in book form by Dalgarno and sponsored by four federal unions: the Miners, Seamen's, Wharf Labourers and Ironworkers unions. Paintings by Dalgarno such as *Foundry Workers* materialized but the publication did not. Dalgarno did not help matters by his arrogant and outspoken attitude, which alienated many. All too often, ambitious schemes launched by S.O.R.A. collapsed.

Roy Dalgarno, 1946: the drawing on Dalgarno's easel is one of a series on foundry workers at the Port Kembla steel works

There were other problems. The second exhibition held at the David Jones Gallery in 1946 was to be opened by Jessie Street, wife of the Supreme Court justice Sir Kenneth Street and long a leading spirit in the various front organizations of the time. Because of this communist

connection the management of the store objected to her presence. In protest, Rod Shaw officially opened the exhibition and then closed it in the one speech. In July 1947 a fire destroyed the George Street premises. This accident precipitated a series of moves from place to place that accelerated the decline. Never primarily an exhibiting society, S.O.R.A. had to have such facilities to be successful.

Then S.O.R.A.'s activities — intended to bridge the gap between artist and public — went awry. Unfortunately, as the artists came to realize, the bohemian attitudes and antics of artists and those on the fringe did not accord with a working-class sense of respectability. Parties intended as efforts to raise desperately needed funds often got completely out of hand — a result of the volatile mixture of alcohol, turpentine and aggression. For James and Dora Cant, the effect was to wear away the fine edge of their faith in the harmony and mutual tolerance on which S.O.R.A. was launched.

The decline of S.O.R.A. belongs to the story of the general radical

Noel Counihan, *Miners Working in Wet Conditions*, 1944

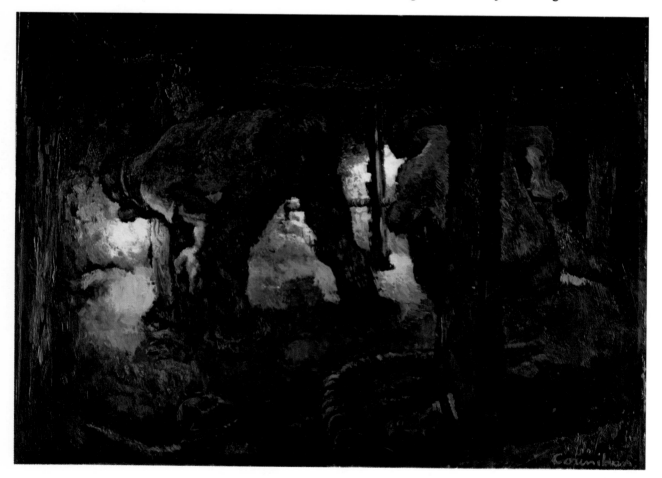

demise of the late 1940s. In 1946 it was still extremely active and appeared to be a strong force in Australian art. In the editorial of the ninth issue of *Angry Penguins*, Harris and Reed acknowledged that this communist 'cultural offshoot' attracted many of the younger and livelier Sydney artists.[36] However, the attitude of the Angry Penguins was that S.O.R.A. offered a coherent set of ideas on art and the role of the artist in society only by grossly simplifying the confused and confusing picture of modernism. It is a charge not lightly dismissed. As with Meldrumism and other forms of academicism which sought to lay down rules for the artist, social realism, even in its more open forms, had appeal but was potentially limiting.

S.O.R.A. nevertheless was a brave and idealistic enterprise with few parallels in Australian art. The Melbourne social realists toyed with the idea of establishing a similar 'workshop' in Melbourne once it became clear that they were unable to impose left-wing values as guiding principles for the C.A.S. Their problem, shared by all artists, was to find a means of exhibiting work. Before the rise of an art-dealing profession in Australia, art societies of one kind or another naturally fulfilled this essential role. After 1945 the social realists withdrew from the C.A.S. and were absent from its last exhibition in 1946. The idea of establishing a Melbourne left-wing art society in a formal sense came to nothing, and by 1946 the social realists decided along with other left-wing artists to move into the Victorian Artists Society and attempt to radicalize that august body.[37] By 1946, however, the social realist group hardly existed, in spite of the ironically successful group exhibition at the new Myer's Gallery in July 1946 by Bergner, Counihan and O'Connor.

Rod Shaw and Hal Missingham organizing an exhibition of work by S.O.R.A. members in 1946 in the old *Bulletin* building in Sydney's George Street

Social Realists and the Australian Tradition

Although they were never as prolific as the Angry Penguins artists, the Melbourne social realists had been very active between 1944 and 1946. The member of the group who earned the greatest kudos during this time was undoubtedly Counihan. The three paintings he exhibited with success in the Australia at War exhibition in 1945 are among his best: *Miners Working in Wet Conditions, Miners Preparing for a Shot,* and *In the 18-Inch Seam.* In 1948 a fourth painting from this series, *Miners Waiting for the Mine Bus* (1944), won the Albury Art Prize. These four paintings were the product of a month spent by Counihan in late 1944 and early 1945 at the Wonthaggi State Coal Mine. Permission was given because Counihan had the active support of the Miners Union and because he intended the paintings as a tribute to the war effort by coal-miners, men whose union had come under severe criticism during the war because of strike action. Counihan had painted little in the latter half of 1944 and the new subject brought the artist back to art and away from cartooning, an occupation which, for a time, he had considered more important.

A S.O.R.A. soiree: artists, art students and friends at the opening of an exhibition in the George Street studio of this left-wing group, c. 1948. Roy Dalgarno is seated left foreground

Roy Dalgarno, *The Old Timer*, 1946

After the Wonthaggi experience, he indicated to Bernard Smith something of the effort involved: 'My mining pictures are self-evidently progressive steps in my painting . . . I have enjoyed painting them greatly, although the problems presented by the underground scene are *very* tough, and there are no examples as a precedent to turn to, the problem must be tackled *originally*.'[38] Counihan did, in fact, handle this difficult subject in a way that suggests Van Gogh's solution to the dark interiors of peasant houses in *The Potato Eaters* (1885). In *Miners Working in Wet Conditions*, one of Counihan's finest works, the composition is structured in a similar fashion around an oval of artificial light that illuminates the figures in dramatic chiaroscuro. The bold simple forms and stark contrasts of tone lend to the scene a sense of powerful drama, while the central figure, legs braced and straining, suggests the heroic action of Tom Roberts's *Shearing the Rams*.

Counihan went on in 1946 and 1947 to new subjects and new themes in portraiture and the satirical parliamentary paintings, but these lack the power and immediacy of the mining pictures. In a similar manner to the left-wing American William Gropper in his satirical lithographs, he produced three paintings of the State Legislative Council in 1946. His aim was to show 'decrepit and intransigent philistinism and reaction enthroned on crimson plush'.[39] The paintings make their point, but they are limited by obvious caricature. Only the *Portrait of Frank Dalby Davison* (1947) and the earlier *Portrait of William Dolphin, the Violin Maker* (1945) possess a directness of visual statement comparable to the mining pictures. In 1947 he returned to the mining theme, which he now developed further through a new medium, linocut and lithographic print-making.

In reviewing the Three Realist Artists exhibition, Clive Turnbull drew attention to the difference between such works and Counihan's earlier and more deliberately tendentious pictures. Turnbull wrote:

One has to go back a long way for the sympathetic treatment of the human scene in Australia — to Fred McCubbin, probably . . . Here is one of the most vigorous of our young painters who has a depth of feeling lacking in some of the more glamorous artists of the younger generation. He ought to have much to say.[40]

The recognition of a clear link between Counihan's work and the tradition McCubbin had helped to launch must have been especially satisfying. A concern for nationalism was a conscious aspect of left-wing culture in 1944 and this was aided by other fortuitous events.

It was not until the end of 1943 that most of the more important canvases in the collection of the National Gallery of Victoria were rehung.[41] For more than two years over one hundred canvases had been in safe storage. The whole collection, including the Australian works, was now rehung according to periods and countries. Other important exhibitions of Australian painting also appeared in 1944. In August Counihan saw a comprehensive exhibition of canvases by Heidelberg

School painters at Sedon's Gallery. He was especially moved by the sensitivity and honesty of vision apparent in the work of Conder and McCubbin. As he observed to Smith: 'I have not yet seen anything by Conder which has left me unmoved and McCubbin's impressionism and Australianism in his landscapes and his feeling for the simple folk has played a tremendous part in moulding our national painting.'[42] It is fair to say that as late as the 1940s Conder and McCubbin had been relegated to second place, if not largely ignored, in the adoration showered on the younger painters of the Heidelberg School such as Streeton and Longstaff. In 1945 the National Gallery of Victoria also put on show a major exhibition of the work of Frederick McCubbin, Walter Withers and David Davies. It was again a revelation:

These painters are very important in the development of Aust. painting and the best pictures hung make the bulk of contemporary painting look dull and unresponsible [*sic*]. These pictures are serious paintings, solving problems significant to their time, and without which no national tradition of any consequence could have developed.[43]

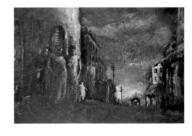

James Wigley, *Street Scene*, c. 1947

Just as Counihan's more tendentious works may be distinguished from those without conscious pedantry, so too can his enthusiastic rediscovery of a native tradition in the Australian culture be differentiated from a Party-directed 'line' on nationalism. In Counihan there seems to have been a continuing struggle for his creative soul between the artist and the politician. Fortunately the artist won out as often as not. It was the artist who had responded to the work of McCubbin and Conder in 1944. In the same year it was the voice of the politician that deplored the uneven character of Australian cultural development and the fact that, with one or two exceptions, Australian painting was politically less radical than Australian literature:

As everyone is aware Australian literature has been marked from the beginning by its plebeian and strongly rebellious character — its intimate relationship to the labor movement and its reflection of militant democracy — but look at Aust. painting — what a contrast![44]

Noel Counihan, *Miners Preparing a Shot*, 1944: with its theme of heroic labour, a prize-winning painting in the Australia at War exhibition

It was also the politician who wrote 'The Social Aspects of Australian Drawing' published in *The Australian Artist* in 1947. In this Counihan was at pains to establish that in certain key respects Australian art in the late nineteenth century provided artists with a radical legacy. The drawings of Roberts, McCubbin and Withers were, Counihan argued, original expressions of new aspects of the Australian scene. As such they deepened and broadened a newly emerging national vision by sinking roots into the Australian soil and enriching and extending the Australian visual language and vocabulary. It was not until the advent of the Great Depression that artists were presented with a comparable challenge out of which to give new life to Australian drawing. The main figures in this, Counihan suggested, were Bergner, O'Connor and James Wigley, who

'introduced into Australian humanism a critical tone, a deep compassion qualified by protest at suffering and injustice'. The difference between the realism of the Heidelberg School and social realism, for Counihan, was that contemporary artists had adopted a more critical spirit, an attitude found more strongly in Australian literature than in painting. It was a tradition in which 'there wells a splendid tide of passionate resentment and indignation at enforced poverty and social injustice'.

The politician was strong in Vic O'Connor too. But in his case the natural artist was always equally present. O'Connor seems to have felt greater affinity for the painterliness of a Walter Withers than for the more significant realism and nationalism of McCubbin and Roberts. However, this sensitive talent was swayed by other demands during these early critical years of development: a consequence of increasing family commitments, work in the Department of Post-war Reconstruction as well as Party activity, and the diversification of his cultural interests. Between 1944 and 1946 O'Connor was even more active than Counihan in polemical debates. His output was therefore a limited one. Although always more independent of influences than either Bergner's or Counihan's, O'Connor's work affected a similarly sombre palette. In *The Departure*, for example, he employs a rich use of complementary red-orange and blue, but the overall effect is low-key and appropriate to such a theme. O'Connor's illustrations to stories by Herz Bergner, especially *The Funeral* (c. 1946), are less successful than those where he was able to draw upon personal experience. In the early *Fitzroy Street* (c. 1943) there is a natural painterly flow to the shapes and an open and unforced quality about the composition — elements absent in the more selfconscious 'protest' paintings.

In 1946 O'Connor joined with Judah Waten in launching the publishing venture Dolphin Publications. The intention was to produce cheap paperbacks of quality and an annual literary journal, *Southern Stories*. Only one issue of the journal came out before the publishers went broke. They did, however, manage to print four books: John Morrison's *Sailors Belong Ships*, Raffaello Carboni's *Eureka Stockade*, Herz Bergner's *Between Sky and Sea*, and *Twenty Great Australian Stories*. Bergner's autobiographical novel was translated from the Yiddish by Waten and won a gold medal for literature. Despite being short-lived, the venture did bring O'Connor and Counihan into closer contact with Australian radical writers such as Frank Dalby Davison and Vance and Nettie Palmer.

Neither Counihan, Bergner nor O'Connor was prepared to forego a concern for social reality in art, and this was the overriding factor in determining the choice of an expressive style and the aesthetic models to which they looked for guidance. In part ideologically determined, it was also the result of selfconscious concern to produce well-crafted painting. For Counihan, 'we were basically easel painters and on the whole our work was bought by middle class people associated with the

A conspiracy of communists: Phillip Lasgourgues, Pat Counihan, Judah Waten, Vic O'Connor, Mary Bergner, Bill Dolphin, Yosl Bergner and Hyrell Waten as depicted by Noel Counihan, c. 1947

left'.[45] A change in the professional role of the artist must, he thought, await the revolution. Counihan could thus sustain a political radicalism without jeopardizing his aesthetic conservatism. Unlike others in the C.A.S., Counihan entered works for the traditional prizes: the Crouch in 1944 and the Archibald in 1946.

His views accorded well with the attitude of Party leaders on questions of art and culture, and Counihan struck precisely the right balance in the miners series in terms of his own aesthetic expectations and the political demands of the Party. It was on the basis of such wholly affirmative images painted with sureness of touch that Party leaders such as J. D. Blake were able to express a faith in the work of the social realists. Shortly before the successful 1946 exhibition, Blake proclaimed to an Arts and Sciences Conference that there were two paths open to the art worker: that of the 'contemporaries' who were at the mercy of pessimism, mysticism and escapism; and that of artists who attached themselves to progressive class forces.[46]

At one time or another each of the social realists was charged with failing to paint optimistic images or with having a morbid fascination with the outcasts of society. But it was Bergner who, in persisting with the Jewish theme, created the most suspicion. The call for a new nationalism meant for Bergner a rediscovering of his own Jewish traditions, but ironically this preoccupation, persisting after the war, helped to alienate him from his friends and associates. Shortly after the end of the war Blake called Bergner in and demanded that he cease painting Jewish themes or the *lumpen proletariat* — Aboriginal or otherwise — and depict instead the noble figure which communism would make of the worker.

Bergner was little swayed by such Party injunctions. His last Aboriginal subject picture is *Aborigines in Chains, 1946*. This image of four blacks chained to a tree in a barren landscape derived from a newspaper article in the *Herald* in that year. In 1945 Bergner continued to develop the theme of *The Jews* with *The Dead Nazi, Ghetto Uprising* and *Return to Warsaw*. The manner resembles that of his earlier works on this theme, and the titles are self-explanatory. The paintings add little to what Bergner had already said except to bring the tragic cycle to its end.[47] It was after this that Bergner's preoccupation with his own cultural heritage began to prove troublesome.

Break-up

In 1947, Bergner's last year in Australia, he added a coda to the series in two works, *Warsaw on the River Vistula* and *Street in Warsaw*. The first of these is the more interesting and is a reworking of the theme of *Pumpkins* painted six years earlier. By his use of warm colours, Bergner contrives to suggest a vision of a New Jerusalem. But by 1947 it seemed

perhaps to edge too close to Zionism for the artist's communist friends. Certainly the mood of Bergner's Jewish theme had changed by 1946 from one of lamentation to one of celebration in works such as *Under the Green Trees* and *The Arrow*.

In 1946 Counihan described such work to Bernard Smith as 'very vivacious and colourful ... they will undoubtedly unleash new aspects, and important ones too of his fertile talent'. He added, however, that their 'folk' character might militate against their acceptance in Australia.[48] In fact, it was not long before Counihan doubted this new direction and was himself unable to reconcile their Jewishness with the demands of a communist brand of radical humanism. Waten and O'Connor agreed. While the theme of the persecution of the Jews was acceptable during the anti-fascist war, by 1946-47 to remain preoccupied by a Jewish tradition was to be escapist, if not outright Zionist. The radical nationalist had, indeed, to tread warily along a narrow path of national culture to escape censure. Despite the fact that Bergner's painting found no acceptance among Australian right-wing Jewry, the charge of Zionism was easy to make. On reflection Counihan felt that the element of realism was slipping from Bergner's work. This lack of sympathy and tolerance reflected more, perhaps, a loss of the sense of intimacy and mutual support that had sustained the three artists during the war years.

The group, always more unstable than it appeared to outsiders, had simply begun to disintegrate. Bergner attended classes at the National

Yosl Bergner, *Warsaw on the River Vistula*, 1947

Noel Counihan with his portrait of the novelist Frank Dalby Davison in his East St Kilda studio in 1947, an entry for the Archibald Prize. Davison was a friend and vigorous supporter of the social realist group

Gallery with James Wigley and was seen less and less at the Swanston Family Hotel. By 1946 his marriage began to fail and this further strengthened a resolve to get to Paris as the centre of European culture. Although O'Connor remained a Party member for some years, from 1947 he too gradually drifted away from active membership. Of the three, it was Counihan who remained steadfast to the ideals to which he had dedicated himself from the age of eighteen.

The disaffection felt by Bergner and O'Connor was not that of 'fair weather' communists. It might even be questioned in fact whether Bergner was ever much of a radical, much less a Marxist. For Vic O'Connor painting and politics were not inseparable. The most left-wing of S.O.R.A.'s leaders were Cant, Dalgarno and McClintock, but as Bernard Smith recalls, 'even in those cases, I think that at heart they were basically individualists and anarchists rather than politically committed people'.[49]

Australian radicals knew from their own experience as surely as the conservative *haute-bourgeoisie* that the Australian middle-class mentality was a cultural desert. In the face of its values they opted for a belief in the values of an Australian people in whom virtue might be discovered. As O'Connor and Waten wrote in a joint introduction to *Twenty Great Australian Stories*, their aim was 'to show how the great writers of our country have faithfully recorded the democratic and progressive hope of the people; how they have striven to disclose the evils and horrors that have stood in the way of the realisation of these hopes'.[50] The search for resourcefulness, anti-authoritarianism and mateship in the Australian people became a central concern in the 1940s and 1950s of writers such as Vance Palmer, Brian Fitzpatrick and Russel Ward.[51] Whatever the facts behind the legend, the idea that such a tradition existed was held to and asserted as an unshakable article of faith. The work of the social realists and S.O.R.A. artists, as well as the writings of Bernard Smith, was likewise founded on faith. That faith was part of a great wave of radical optimism that accompanied the dream of a new Australia, a dream which, it was hoped, post-war reconstruction of Australian culture and society would bring to reality.

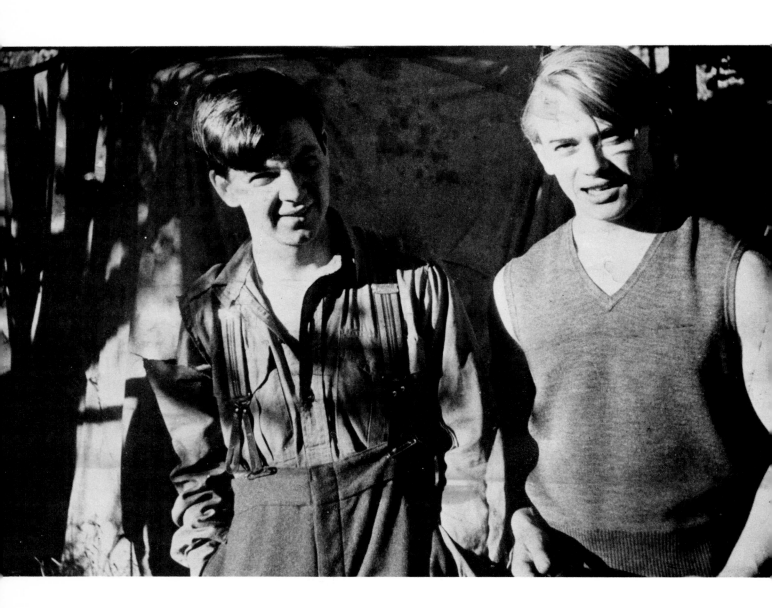

CHAPTER SEVEN
THE SEASON IN HELL
Nolan, Tucker, Boyd and Perceval

Revolt if it goes deep enough, if it is universal enough, is a revolt against a total historical situation.
Herbert Read (1942)

The support of artists during the war years by the Contemporary Art Society was imperative because of the radical nature of the modes within which Nolan, Tucker, Boyd and Perceval worked. The degree to which their work was an indictment of society and its life-denying values added to its challenge. An exhibition at Melbourne University in July 1946 entitled 'Contemporary Art' was the culmination of their work and common purpose for Nolan, Boyd and Tucker. It was extensively advertised on Melbourne trams, with a degree of gentle self-mockery evident in the names members of the group gave themselves: 'Tramway Tucker', 'Bible Boyd' and 'Ned Nolan'. Perceval did not exhibit with his friends on this occasion, perhaps because of his preoccupation with utilitarian pottery-making and also the fact that he had destroyed many of his recently completed paintings. Perceval was the youngest member of the group and comparatively late on the scene. That, and his war service, meant that his important contribution to art dates from after 1943. On show at the university were some of the finest paintings the three artists had done: powerful examples of mature works in Tucker's *Images of Modern Evil* series, early Kelly paintings by Nolan, and Boyd's key pair of works *The Mockers* and *The Mourners*. Clive Turnbull observed that if such work had been exhibited in a more public venue the sensation would have been considerable, but its being shown in the more closed and more liberal confines of Melbourne University meant that the material could be exposed 'without danger of nuclear fission'.[1]

It was clear that something remarkable had been achieved in Australian art during the war years. It was not a mere echo of things happening elsewhere, but the full and rich expression of a radical twentieth century sensibility in an Australian context. The results by 1946 were incontrovertible: the great anti-fascist war of 1939-45 had not caused the isolation of Australian artists from international trends.

Until 1939-40 Australian modernists had been able to gather a considerable understanding of radical trends in Europe. The testing

and exploration of new modes and subject matter by Nolan and others were based on this, and in their hands it led to a distinctive Australian modernism. By cutting contacts, the war prevented artists from being besotted by the European tradition. Instead, that tradition continued as a series of inspirations that were pervasive but non-threatening. The other stimulating effect of the war was to heighten a sense of Australian society as part of a universal culture. Australian concerns were felt to be as much at the centre of existential questions as those probed by French or German artists. In Nolan's case especially, entering the army and being sent to the Wimmera gave him a new awareness of Australian realities.

The C.A.S. was enormously important in the key years from 1943 to 1945 in inculcating a sense of aesthetic independence born of war-enforced isolation. As Arthur Boyd recalls, this was an exciting experience:

it was a *core* of something of which you thought there was nothing else like it either in Australia or elsewhere, and you had a very strong feeling, (at least I think most of the painters did) that you were doing something important. Because at that time things coming from England seemed unrelated and disconnected from what was being done here. There was a feeling that there was a group of people working who were doing much more original work than was being done anywhere else because the war had depleted Europe ... You had the feeling that, well, perhaps it was not impossible to have something that could be original — and it was good to be part of it.[2]

Nonetheless, the exhilaration of being part of a new movement was allied with a sense of alienation.

Albert Tucker has described his life in the early 1940s as a continual struggle to survive physically and emotionally:

all I can remember is blankness and anxiety and fear and desperation. This dominated the entire period ... this is where these rather terrifying and miserable *Images of Modern Evil* came from. It was this overwhelming oppression and sense of evil, of rejection ... My emotional problem arose from the whole social and historical pressure and my isolation as a person — my inability to fit in with what was going on.[3]

Each of the artists considered in this chapter suffered in their own ways the *angst* of social and cultural alienation to a degree few artists in Australia can have felt before or since.

Though the Angry Penguins considered themselves to be members of a social and artistic vanguard, as cultural skirmishers they felt beleaguered — by the conservative *bourgeoisie* and by fellow radicals. The philistines were not only outside the gate but also within the movement of contemporary art. It might fairly be said that, faced with the dehumanization of bourgeois society under modern capitalism, and the equally bleak prospect of mass proletarian culture which the radical Marxist-Leninists

Sidney Nolan, *Head (Angry Penguin)*, 1945. Few works by Sidney Nolan betrayed the degree of anguish so evident in his fellow 'Angry Penguins'. Only a few little-known portraits and anonymous heads convey a comparable sense of crisis

preferred, the Angry Penguins sought the reassurance of simpler and more ideal societies and values more fundamental and intuitive.[4] The connection between art and political values was never lost sight of.

The Modern Romantic Tradition

One answer to the alienation of the Australian artist lay in the creation of an art that more truly reflected human realities. This led the Angry Penguins to that stream of modernism which had its origins in symbolism, culminating in twentieth century expressionism and surrealism. Primitive and *naïf* art was central to this tradition. Australian artists also recognized that there were dimensions of the Australian experience — rural and urban, psychological and social — which had only begun to be tapped.

For social, ideological and temperamental reasons, the irrational and emotional nature of this stream, and its liberating potential, struck a deeply responsive chord. Vassilieff, an anarchic individualist of the first order, had made a total identification of life with art. Nolan saw in this identification a similar sense of wholeness to that found in the lives and work of men such as Arthur Rimbaud or Henri Rousseau — key figures in a strand of modernism which has never been labelled although it has been widely recognized in the complex weave of movements and ideas that modernism represents. The symbolist-expressionist-surrealist tradition had long been recognized by its chief apologists as an enriching extension of the earlier romantic movement, and André Breton made the link clear in the first Surrealist Manifesto in 1924. Herbert Read laboured the point in 1936. That the Angry Penguins made the same identification is indicated by Max Harris's intention at the time to publish an appreciation of their painting entitled 'Australia's Modern Romantic Painters'.[5] In Europe a re-evaluation of the romantic movement was a powerful force in helping artists, writers and other creative spirits to break the hold of realism and impressionism. The qualities of the new art were exemplified in four traits: the cult of childhood, humour and delight in the absurd, an acknowledgement of the significance of dreams, and ambiguity.[6]

Surrealists displayed continuing interest in this range of irrational phenomena, now extended and developed in the light of the psychology of Freud and the social critique of Marx. Australian artists were in turn influenced by surrealist art and the writings of Herbert Read, but there were other influences again. Nolan, for example, found exciting possibilities in the *naïf* art of Henri Rousseau. The pair of child-lovers with staring mask-like faces in *Gippsland Incident* (1945) seem to relate directly to Rousseau's apparently artless style.

But the key figure for Nolan was Arthur Rimbaud. In a tribute to the precocious French poet published in *Angry Penguins* in 1943, Nolan

concluded that 'language is what counts'.[7] Nolan therefore wrote as well as painted and, as Harris recalls, the connection was important:

Nolan was familiar with, but little obsessed with the mechanics of painting. To find the Baudelarian 'illumination' for things that must be said was to him the prior necessity. He therefore read and thought. He was as if born to the poet's psychology. His love of words rivalled his dedication to the wonders of the eye. In fact he believed the process of art consisted of the operation of the one on the other.[8]

Anna Balakian notes that Rimbaud's life and poetry offered an alternative to the finely crafted symbolism of Mallarmé and stood closer to the tradition of Baudelaire and the earlier romantics in its artistic anarchism. The Rimbaud claimed by the surrealists was the seer 'who called himself an inventor, who sang of new flowers, new love, and who intimated the upsurging of unheard-of harmonies and visions, insisting that the whole world was in need of transformation'.[9] That was also the Rimbaud to whom Nolan looked, and whose portrait he painted in 1939 from a photograph. The radical modernist of the anarchist tradition did not aim to deepen the break with society as many symbolists had done in the 1890s, thereby earning the label 'decadent'. Rather, the integrity of the individual was insisted upon as a moral principle. As with Rimbaud, Nolan felt a connection with D. H. Lawrence, whose portrait he similarly painted as a tribute in 1940. The Lawrence portrait is daubed rather than painted, and its manner is unprecedented in Australian art. Primitivism had arrived, and with it an interest in the immediacy of children's art and that of primitives and schizophrenics.

The haunting figure of Rimbaud, in one sense Nolan's psychological *doppelgänger*, was a continuing presence. Nolan and Sunday Reed worked together to produce a translation of Rimbaud's poetry, and in 1943 he painted *Royalty*, inspired by the prose poem in *Les Illuminations*.[10] *Royalty* expresses something of the same sense of wonder and magic that Rimbaud conjured in his word-picture. A man and a woman wander with arms linked through a North African village; the white houses are decked with tri-coloured bunting and flags. In *Royalty* we see a change in Nolan's style from the earlier Klee-like linearity to the flatter, more decorative manner of *Icarus* (1943) and *Bathers* (1943). There was an earlier version of *Bathers* in 1942, and in both paintings Nolan conveyed as directly as possible his recollections of childhood and youthful games at the baths in St Kilda. By such reliance on memory, Nolan was at one with Baudelaire and Rimbaud. As Nolan put it, 'Memory is I am sure one of the main factors in my particular way of looking at things. In some ways it seems to sharpen the magic in a way that cannot be achieved by direct means.'[11] While the second version is more elaborate, both employ similar disjunctions of time and space. Nolan organizes the forms of the pool, wooden walkways, diving tower, change sheds and the sea beyond into a rectilinear grid employing an elegant balance of tone and highly saturated blue

Sidney Nolan, *Royalty*, 1943 (*top*);
Icarus, 1943

and yellow. Worked through this is a rhythm of figures: boys swimming, sunbathing and skylarking. The approach is similar in *Icarus*, but Nolan has now replaced a static organization of shapes with a dynamic one. *Icarus* thus brings together different levels of reality and consciousness that are more complex and more surrealistic in their juxtaposition than are those in *Bathers*. Nolan, in performing a diving feat, becomes for a brief moment Icarus, who is also represented by the tragic figure in the distance that plunges into the sea. A ship burns on the water and a hare leaps in the foreground; bathers wave to one another. Insistent images of childhood are juxtaposed with those of a prepotent mythical past in a manner comparable to that of Yeats, Joyce or Faulkner in literature.

As in surrealism, so too in the stream of nineteenth century art that helped to nourish it, the sense of wonder that is one of the most profound experiences of childhood was held as central to transforming the vision of the adult artist. By plumbing the life of the mind that Freud had revealed as both a source of 'a new innocence and a new guilt',[12] modern man might recover the imaginative dimension of experience which would lead to new social relationships and a new art. Less sophisticated cultures and times were also valued: illustrations of primitive and medieval art appeared frequently in French art magazines in the 1930s. This reinforced for Australian artists a connection already stressed in the writings of Herbert Read: 'We can learn more of the essential nature of art from its earliest manifestations . . . than from its intellectual elaboration in great periods of culture.' In *Art Now*, Read went on to make the point that art had nothing to do with 'polite culture or intelligence'. Art was intuitive and sensory and 'there had been a deliberate attempt to reach back to the naivety and fresh simplicity of the childlike outlook'.[13]

By taking up the tradition of French art publication, *Art in Australia* accepted these notions of the avant-garde. In 1942 the fifth issue devoted much of its space to a consideration of them. It printed reproductions of work by American primitives such as Morris Hirschfield, together with comments by Alfred H. Barr. For Barr, all modern primitives shared 'the common denominator of Western culture at its most democratic level and all express the straightforward, innocent and convincing vision of the common man'.[14] Rah Fizelle contributed an article entitled 'Instinctive Expression', which argued for a more liberal approach to art education.[15] John Perceval seems to have been struck by the power of a painting which Fizelle used to illustrate the article — *The Musician*, by a 14-year-old English boy. This expressionist picture of a clarinet player appears to have been transformed by Perceval into the demonic hornblower who appears in *The Merry-go-Round* (1944). The motif appears again in the following year in *Hornblower at Night*. Nolan's *Le Désespoir a les Ailes* (*Despair Has Wings*) of 1943 seems similarly to employ forms based on a reproduction of Czechoslovakian folk art published in *Transition* in 1937.[16]

Between 1944 and 1946 *Angry Penguins* also published articles dealing

John Perceval, *The Merry-go-Round*, 1944

Sidney Nolan, *Le Désespoir a les Ailes* (*Despair has Wings*), 1943

with *naïf* art. The December 1944 issue reproduced examples of work by 'H. D.', an unknown Australian primitive painter whose work was discovered by Albert Tucker in the window of a bicycle shop in Swanston Street. The paintings were, it was eventually discovered, by one Harold Deering, an eccentric with a unique capacity for self-advertising. In 1945 Clive Turnbull disclosed that Deering, also known as 'Professor Tipper', was famed for being the first man to ride a 5″ bicycle while singing 'The Highlands and the Lowlands'.[17] This singular feat was apparently accomplished in 1925 and celebrated in paint. The rediscovered paintings were included in the C.A.S. exhibition of 1945. As Tucker commented, 'with the natural artist problems of style and

'Professor Henry Alfred Tipper' (*above*), the eccentric showman, trick cyclist and primitive artist Alfred Deering, whose unique capacity for self-advertising is here strikingly evident

One of Tipper's paintings among the impedimenta of the bicycle shop in Swanston Street where Albert Tucker uncovered a number of Tipper's works

technique matter little, the sustained intensity of his vision solves them for him'.[18] In the same issue Tucker defended the Ern Malley poems in terms of the value generally found in the work of 'savages, children and lunatics', which showed 'intuition and feeling' rather than intellectual apprehension.[19] In 1946 the *Angry Penguins Broadsheet* reproduced work by one of America's most celebrated primitives, Eilshemius.[20]

A powerful addition to the intellectual armory of the Angry Penguins was Viktor Löwenfeld's *The Nature of Creative Activity*, published in 1939. The Austrian art educationalist offered a strong argument as to the nature of art found in the natural products of unsophisticated artists and children. Löwenfeld declared that art fell into two categories: the visual and the haptic. The former corresponded to rational image-making and modes of perceiving the world. The latter — and Löwenfeld valued this mode more highly — represented a more direct response to experience, which was 'more and more confined to the processes that go on in the body as a whole, bodily sensations, muscular innervations, deep sensibilities and their various emotional effects'.[21] Haptic space was subjective, and temporally distinct events could be brought together within the one visual context. Albert Tucker resorted to Löwenfeld's dichotomy to discredit the 'neo-academicism' of communist artists in 1946. 'What we call "modern" art', declared Tucker, 'revolted against the tyranny of the eye, let the barriers down, and allowed all our subjective processes to take over in developing the final pictorial image.'[22]

Cover of *Angry Penguins* in December 1944 featuring one of Tipper's paintings. More were reproduced inside the magazine, but the full identity of the artist was still unknown at this stage

Commitment to aesthetic radicalism has had close historical links with anarchism and has laid great stress on originality, intuitive knowledge, immediacy of expression and social awareness. These were all qualities of works such as Tucker's *Wasteland* (1941), with its apocalyptic intensity. Michael Keon struck an appropriate note when he wrote in *Angry Penguins* in 1941:

The artist of today has to accept the idea of an interregnum of chaos, and be a law unto himself . . . he must evolve his own laws out of himself and his experience . . . We are to strip ourselves of predisposition and mechanical acceptance, and present ourselves in all the nervous and naked avidity of our senses to the incessant waves of shock which will pour from the new breaking life. Then . . . we can open ourselves to the subconscious, not of the nightdream, but of the daydream, and out of it we will evolve a new art.[23]

Max Harris was more specific in the same year without being any less restrained:

What must the artist and the madman do? Firstly, he must be at one with the surrealists and the revolutionaries in defeating a moral system and a moral society which expresses the victory of death, of the corruption of desire, of a masturbatory side-tracking of sexual life, so that its values cannot become real nor extend in the 'beauty of exuberance' beyond four suburban walls.[24]

Albert Tucker, *The Possessed*, 1942

Albert Tucker, *The Prisoner*, 1942
(*top*); *Death of an Aviator*, 1942

The Experience of War

The world was very much a hostile place in 1941 and 1942 for Albert
Tucker. Having spent much of 1941 avoiding military conscription, he
spent most of 1942 attempting to maintain his humanity while enduring
it. If the experience confirmed Tucker's worst fears concerning authori-
tarianism, it did not destroy his idealism. Rather it reinforced a sense
of the need to change life through art. The work of T. S. Eliot in poems
such as 'Gerontion', 'Ash Wednesday' and 'Marina' echoed his personal
sense of despair and futility while at the same time holding out hope for
salvation in 'the hope, the new ships'.[25] Radical art had to be underpinned
for Tucker by a social alternative to the alienation which was one of the
wellsprings of his art.

Tucker's drawings and paintings in 1942 fall into two broad categ-
ories: surrealist-influenced paintings such as *The Prisoner* and *Death of an
Aviator*, and more expressionist works based on the artist's experiences
in the army and at the Heidelberg Military Hospital. The surrealistic
works depict robot-like figures in a cosmic nightmare — maimed,
dehumanized and ultimately destroyed. They were shown in the Anti-
Fascist exhibition, as were *Army Shower* and *The Possessed*. In the latter
works Tucker employed a Munch-like sense of disturbed psychological
space by the use of a claustrophobic tunnel or enclosed cell. *The Prisoner*

offers the viewer a taste of the alienation of coercive army life. *The Possessed* is an expression of nothing less than the manic terror and madness that the artist feared was its consequence. Colour is discordant and serves to heighten an emotional pitch established by spatial exaggeration and the distortion of the figure. Tucker's drawings from September-October, which were also shown on this occasion, deal with specific aspects of war psychosis and represent the first of the artist's psychological portraits.

Sidney Nolan's gentle *Dream* was a far cry from the primal scream of Tucker's art. Nonetheless, Nolan's distaste for authority and the experience of regimentation ran equally deep. Nolan's first response was to cease creative work while in the army[26] — he could not know in 1942 that he would be in uniform for almost three years. In the 1942 Contemporary Art Society exhibition, however, Nolan exhibited a piece of sculpture which he called, simply, *Gun*. While stationed at Dimboola he also produced a series of depictions of heads. The head of a soldier reproduced in the catalogue of Nolan's exhibition in 1943 is a picture of mental disorder comparable to the earlier drawings by Tucker.

Both men were strongly influenced by the ideas of Dr Reg Ellery, a psychiatrist and friend of the Reeds. Ellery was preoccupied with the psychological trauma of men in conditions of war. In 1945 Reed & Harris published Ellery's book *The Psychiatric Aspects of Modern Warfare*, in which Ellery argued that the behaviour of soldiers in battle was comparable to that of schizophrenics and often ended in permanent neurosis. It was not simply that war provided conditions comparable to neurotic, psychotic and specifically schizophrenic states experienced in society generally, but that to be effective armies had to encourage an aggression in soldiers that resembled the loss of control and derangement symptomatic of schizophrenic behaviour. Soldiers were thus given a licence to release violent emotions in aggressive action and by so doing suspend all ethical checks. Nolan was sympathetic to Ellery's views and was also familiar through Ellery with the art of the mentally disturbed. Being in the army had made him feel like a 'convict' himself.[27] One of the 'heads' exhibited in 1943 was appropriately enough used by Ellery to illustrate his book. Nolan quite consciously employed a haptic mode in depicting the eyes as being round and staring, and the face twisted, the tongue lolling out to one side. The majority of the 'heads' were of anonymous figures or, not even portraits as such, were inspired by paintings from psychiatric patients. A key painting which is closely related to these studies is Nolan's self-portrait from 1943. Here the haptic qualities are mediated by a more selfconscious naivety and decorativeness. The rhythmic use of forms and the garish colours suggest a conscious reversion to children's art. Nolan painted raw red, blue and yellow stripes across the forehead and these are repeated in the daubs of colour on the artist's palette. It is less a psychological self-portrait than an experiment in expressionism.

Dr Reg Ellery, psychiatrist, socialist and writer, in his Hawthorn study in the early 1940s. Ellery's advanced professional and political views brought him into sharp conflict with medical officialdom between the two wars

Sidney Nolan, *Head of a Soldier*, 1943 (*top*); the cover design by Sidney Nolan for Reg Ellery's book on war and psychosis published in 1945 by Reed & Harris

Nolan and the Rediscovery of Landscape

The works by Tucker and Nolan of 1942 discussed thus far demonstrate above all an intense preoccupation with personal experience, but they also indicate concern for the problems of individual liberty and moral integrity inseparable from total war. Yet unlike Tucker, Nolan did not remain preoccupied with the idea of art as explicit social criticism. On the one hand Nolan felt a despair that seemed to deny the possibility of the creative life. Writing to John Reed from Dimboola, he declared that he could see 'nothing but destruction coming out of the army and the war. Spender and Communism and my own painting do not seem to belong anywhere'.[28] On another occasion he lamented the fragmentary nature of his creative output thus far: 'So many artists have found it in the past by standing apart from war but that now seems impossible ... Lyricism seems almost an enemy in these days.'[29] On the other hand this master of irony discovered a new relationship to his visual surroundings that offered a calm centre from which to oppose all that was happening around and to him. Isolated in the Wimmera wheatlands, Nolan began a rediscovery of the Australian landscape. The one work that broke into his preoccupation with the visual and experiential world of landscape and the urban environment was *Lublin*, exhibited with the C.A.S. in 1944. Lublin was the first Polish city and concentration camp captured by Soviet forces, and it fell on 27 July 1944. Nolan's strangely schematic painting was a tribute to this event.

Whereas the work of Tucker, Boyd and Perceval continued, as did that of the social realists, to maintain a high degree of emotional intensity without a break until 1946, Nolan's work could oscillate widely. At the time when Reed and Tucker's fight against Counihan and O'Connor intensified, in 1944, Nolan was able to write of the modern artist:

A lot has been talked about art reflecting the dementia of society. Man has devils in him, and doubtless always will have, but that is no reason for supposing that an attempt cannot be made to control them. There are sure to be a lot of feathers flying in the struggle, but is it wise to mistake the struggle for dementia? Much of this fashionable jargon derives from the usual failure to accept the world of phenomena around us.[30]

The way in which painting worked for Nolan — and this was its ironic function — was 'to reflect as accurately as possible the discrepancy between the normal and the actual'. In other words, the innocence of the eye had to be recaptured so that art could register a sense of the immediacy of human experience and so act as a statement of how things really were. The dichotomy between the world of the senses and of the rational mind, between the dream and the real, represented the fundamental contradiction which surrealism set itself to reconcile.

Sidney Nolan, *Landscape with Train*, 1942 (top); *Dimboola*, 1944

In character and by temperament, Nolan had none of the gritty tenacity and defiant intellectual energy and thrust of Albert Tucker. Neither did he have the acerbity and vulnerability of John Perceval, nor the diffident sense of purpose of Arthur Boyd. Nolan resembled nothing so much as Baudelaire's image of the quintessential dandy (if one understands by this a creative rather than an historical type) — an antipodean Constantin Guys, the man whose 'subtle understanding of all moral mechanisms of this world' enabled him to move through life at once detached and embracing it with passion.[31] Such a comparison helps us to reconcile the contradictions in Nolan's character. Athlete, poet and painter — each act was for Nolan one facet of a whole. Who else could so casually, yet so assuredly, work on paintings upon the refectory table at Heide while also talking with friends? Who else could sustain an innocence of the eye with such a sophistication of means? Nolan's outward image completes the picture: visualize the artist aboard a Melbourne tram, wearing conventional bohemian corduroy trousers but sporting an exquisitely darned and patched sports coat of many colours with a large pink rose in the lapel.

There was much in Nolan's early art to indicate this degree of sophistication and to earn the grudging, if puzzled, respect of older, less radical artists and critics. The freshness of vision is revealed most tellingly, however, by the first of the Wimmera landscapes, which were foreshadowed in the C.A.S. show of 1942 with *Landscape with Train* (1942) and fully revealed in the following year with works such as *Kiata* (c. 1943). There is little in these vigorous landscapes, or in Nolan's portraits and heads, of the mythical element present in works such as *Royalty* or *Icarus*. The landscapes, apparently tossed off casually in

ripolin on hardboard, present images that are immediately accessible yet which sustain a sense of rediscovery and resist popularization. As Nolan wrote, if the Australian artist was to achieve a new sense of the Australian landscape his experience needed to resound with a naturalness comparable to the relationship between the Aborigine and the land:

somewhere in our painting their fundamental simplicity is going to tell. Perhaps that & the pure mornings here with big grey trees & green parrots flying up from burnt grass will help us break through to something clean & brittle that will belong.[32]

Like Boyd, Nolan could see as early as 1943 that there might, indeed, be a benevolence in distance. It was an old argument, used now to serve radical rather than conservative ends. Yet the aim was the same — to sustain a level of creative achievement insulated from the debasers, the debauchers and the mockers of what was fruitful and worthy of celebration in the Australian experience.

In a series which Max Harris has called 'The Apotheosis of the Wheatlands', Nolan's primitive mode seems perfectly attuned to express

Sidney Nolan in his Parkville studio, c. 1945. The studio, to which Nolan moved late in 1944, was shared at various times by Max Harris and John Sinclair and must surely be one of the few such studios to have boasted a Bechstein grand piano

not only the immediacy of visual experience but also the discovery of deeper and more universal dimensions. For Nolan the Wimmera plains had a primeval essence, the look of a landscape as 'old as Genesis'. In another letter at this time he writes of the overwhelming sense of flatness and the vast stretches of golden swathes of wheat. By punctuating this space, the grain silos looked so powerful 'that seen from a distance standing up from the trees you could imagine them made by Aztecs for no other reason than to worship the sun'.[33] A mythic sense of unity between past and present, and between the immediate and the universal, flowed over in Nolan's work, from landscape to new images of childhood and urban life. *The Bathers* (1943), for example, despite being more formal and schematic, has a comparable freshness and vigour.

A considerable number of the Wimmera landscapes, nearly all of which were executed in ripolin (which from this time Nolan used almost exclusively), were painted later, from memory and from sketches, at Heidelberg and Parkville. The rest were painted at Nhill or in Dimboola, where Nolan had been able to set up a studio in a railway building. *Landscape with Train* (1942) exhibits all the qualities that characterized the landscapes of 1943 and 1944, adding up to a pictorial solution to problems inherent in a landscape lacking conventional picturesque qualities. Puzzling over the difficulties of its flatness as seen from a train, Nolan saw the solution:

It was alright while we were in sight of the Grampians and then suddenly [there] was this feeling that left nothing of the earth except a thin line. And while I was thinking about all these things it came, simply that if you imagined the land going vertically into the sky it would work.[34]

The spaciousness which this approach achieves is emphasized by the recurrent pale blue strip of sky above the straight-ruled horizon line. The two-dimensional schema of the pictures (the flat blocks of colour and the decorative rhythm of shapes — whether carriages of a train, the regular punctuations of telegraph poles or the irregular smatterings of mallee and native pine) suggests at once the primitive, but overriding this is the sophistication of decorative coloured planes belonging to the fauvism of Matisse or Marquet.

The apparently overwhelming debt to early French modernism is one of the most puzzling questions about Nolan's work at this time. Nolan had certainly seen eight canvases by Matisse and two by Marquet in the *Herald* exhibition. While we cannot now ascertain the character of most of these, we know that Nolan had seen at least one mature fauve painting and possibly reproductions. One can only speculate on the degree to which these helped transform his style from the early Klee-like works to the more open style of the Wimmera landscapes. Danila Vassilieff's style of painting might also have been a factor in Nolan's tendency now to draw more with the brush. Whatever the combination of influences, this development culminated in the informal discursive quality of later

landscapes in which nothing is imposed upon an earth that sweeps to the horizon except the stark white forms of wheat silos. This looser handling is carried through in 1944-45 to paintings of St Kilda and Heidelberg, and later the Kelly series. The ending of Nolan's exile, a frustrating but in no sense an absolute one, corresponds to the appearance of these new subjects and new themes.

Albert Tucker

The social concerns shared by Sidney Nolan and Albert Tucker, and their interest in primitivism and an art directly expressive of intuitive experience, brought the respective trajectories of their art together at one or two significant points. Tucker was not, however, prepared to sacrifice purposeful order and structure as Nolan had done. Neither was he drawn to the *alla prima* properties of ripolin. Nolan alternated between periods of introspection and mental preparation and bursts of intense and direct production. Tucker worked in an altogether more traditional manner. Few artists in Australia have drawn more prolifically than Tucker or Boyd. In Tucker's case, especially, each painting was scrupulously developed from detailed and sensitive preliminary sketches and drawings. Both Tucker and Boyd felt that the high seriousness they brought to their statements demanded the quality of permanence and tactile presence that oil paint offers the artist. Helped by Harry de Hartog's knowledge and approach to art, Tucker produced his own pigments, oils and varnishes. This ensured to the penurious artist a better supply of expensive materials and a corresponding sense of greater working freedom. Perceval and Boyd adopted the same practice from about 1943.

Although literature continued throughout the 1940s to affect Nolan's painting, Tucker had severed the link by 1943, a fertile year after the trauma of 1942. Tucker had successfully prised himself free from the authoritarianism of the military on the one hand and of Stalinism on the other. It was also an exploratory year in which his painting ranged from cubism and expressionism to a monumental realism in such widely differing works as *The Bombing, Memory of Leonski, Spring in Fitzroy, Battlefield* and *Victory Girls*. The majority of the 1943 paintings deal with aspects of the impact of war examined either directly or indirectly. Paintings of refugees and victims of war such as *The Bombing* are treated in an expressionistic way with paint applied in a raw and gestural manner. This can be compared with the later *Battlefield* (exhibited in 1943 as *Vicissitudes of War*), with its more meticulous modelling of monumental forms. The viewer is forced to confront three figures: two stricken soldiers in khaki uniforms and a third figure with hag-like face as if of death itself. These monstrosities occupy a stark landscape lit by a spectral light that throws the forms into sharp relief. The face of the

Albert Tucker, *The Bombing*, 1943 (top); *Spring in Fitzroy*, 1943; *Battlefield*, 1943

soldier on the left appears to have had its nose sliced off exposing sinus passages, no doubt much like that of the wretched victim Tucker sketched in the Heidelberg Military Hospital. Works such as these extend the theme, foreshadowed in the previous year, of war as an evil and malign force. Tucker was only able to inject into these paintings a minimal dimension of personal experience and, as wholly imaginative works, they remain rhetorical and overwrought.

One becomes aware in surveying paintings by Tucker that those which come alive do so — irrespective of whether, as in *Memory of Leonski*, there are overwhelming stylistic debts — because of the chord the subject struck in the artist. Tucker recognized that one of the dangers of haptic, like primitive art, is that inevitably it results in a static art unrelated to either sophisticated social and historical concerns or to continued aesthetic development. Tucker was prepared to acknowledge that social realism, concerned as it was with a moral critique of society, dealt with an 'active subject'.[35] The problem was that this approach rested on a passive attitude towards formal questions. In other words, it was a mode of art radical in intention but conservative in style. By contrast, radical aesthetics demanded a dynamic relationship between formal experiment and challenging subject matter. But in a fluid social environment, only the values of the individual artist could offer a fixed point of reference. This was, as Tucker put it, 'the selective principle and the integrating factor in the work of art'. Emotional experience was the crucial link between the artist and his theme.

Tucker had good reason to argue for the legitimacy of this position with such a degree of fervour. In the 1944 annual C.A.S. exhibition he had shown six paintings to which he gave the appellation 'Images of Modern Evil'. The group of over thirty-five paintings that form the series begins with a work dated 31 March 1943 and ends in 1947. In 1945 he drew back from such a specific title and opted merely for 'Night Images'.[36] The early works of 1943 show the city viewed from the still-surviving gentility of East Melbourne and Jolimont. After 1944 the locale moves to St Kilda, an area whose late Victorian and Edwardian architectural trappings formed only the thinnest of veneers over a seedy sub-structure of decaying urban life. For Tucker, urban decay was a metaphor for moral decay. From 1940 onwards the savagery of Tucker's indictment of Australian society — of society generally — was matched by the work of no other Australian artist. Beyond Australia only the Germans George Grosz and, perhaps, Otto Dix have sustained such a degree of rage. George Grosz saw cause in the streets and boudoirs of wartime Berlin. Tucker found it just as plainly in the Melbourne black-out. In neither case was the social critique intended to be localized in time or place; but specific references were not lacking to indicate that for Tucker, as for Grosz, symbolism was given strength by personal experience. That experience had its roots in alienation — an alienation sharpened by war, rather than the product of it.

Albert Tucker, *Sketch for Images of Modern Evil*, c. 1943

Arthur Boyd, *Embracing Figures and Figure with Kite Figure*, c.1943

The first painting that treats the theme of sexuality and moral decay is *Pick-up* (1941). Its original title, *The Meeting*, gives an added touch of irony to what is clearly a sexual encounter of the basest kind. This was followed in February 1943 by the Picasso-like *Memory of Leonski.* By 1943 Tucker's wider command of various modes of modernism enabled him to transfer the 'literary' irony of *The Meeting* and *Spring in Fitzroy* (1941) to the more visual irony of *Memory of Leonski* and a second version of *Spring in Fitzroy* (March 1943). In the latter two paintings the moral implications of the subjects are, on the surface at least, denied by an expressive celebration of the life-force also present. Edward Joseph Leonski was an American G.I. who was convicted in May 1942 of having strangled and mutilated three Melbourne women. He was hanged at Pentridge in November 1942. The painting is an ambiguous one combining, as it does, images of an aeroplane and a bird and of female and masculine genitalia — all brought together in terms of a monumental cubist-influenced figure whose small head consists almost solely of a red chevron-like mouth and a triangular nose. As in *Spring in Fitzroy* of 1943, it is a complex image of manic sexuality — a perversion of one of man's most basic drives.

The theme of moral corruption is further developed in *Victory Girls* (August 1943). The subject represents a reworking of *The Meeting*, now placed within the ambience of a city at war. The two main figures are teenage prostitutes, known popularly as 'victory girls' because of their choice of patriotic red, white and blue striped skirts. Tucker has painted them as sexual puppets whose bodies are represented by breasts, vermilion V-shaped mouths filled with teeth, and huge mascaraed eyes. The men are as porcine as those in the 1941 work, but they now sport khaki and slouch hats in place of flash suits and brilliantine. Clearly the form of Tucker's world had changed by 1943 even if its fundamental character had not. War had come to Melbourne in earnest in the form of battle-weary American troops from the battles of Guadalcanal in 1942. John Perceval called it 'the American occupation of Australia'.[37]

Something of the climate of this invasion is caught by Mark Kronenberg in *A Comment*, October 1943:

Dim lit Melbourne on Saturday night the 9th of January, 1943.

Under pools of light on street corners and in dark steel-concrete canyons the endless stream of pleasure seeking crowd. Overworked workers, overpainted girls, overdrunk servicemen. Indolent police and M.P's walking slowly in twos, standing on street corners, in front of dead business houses, peeping into dark shop entrances for looseness of morals.

Between prewar Melbourne and the unknown Melbourne of the future present day, wartime, blacked out Melbourne.[38]

It was just such an atmosphere that Tucker was moved to register. The soldiers he portrays in *Victory Girls* and in numerous drawings and watercolours are the familiar diggers of the Anzac tradition but the images

Albert Tucker, *Pick-up*, 1941

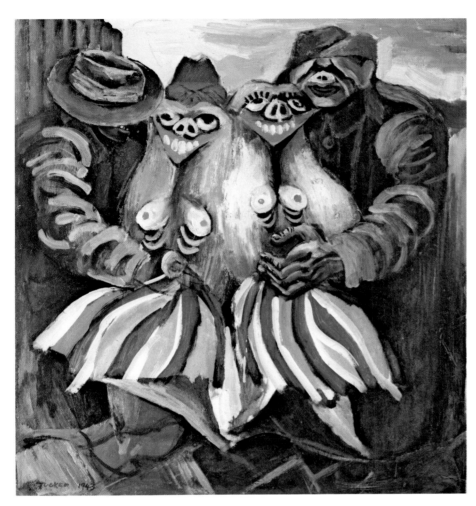

Albert Tucker, *Victory Girls*, 1943

are less than heroic: they are either uniformed satyrs or drunken and vomiting louts.

Max Harris has described another facet of Melbourne urban life, experienced at this time in Nolan's company:

In this seedy world of fly-by-night flat life we numbered amongst our acquaintance a notorious sly-grogger, the boss-cocky of one of the gambling schools that flourished at the top end of Bourke Street, and, to our secret terror, a trigger man from a Sydney underworld gang, sweating off in Melbourne while the heat was on. In the midst of this world of black marketeers, struggling 'refos' and stolid citizenry were the garish beauties of Luna Park, the desolate child at the end of the lane, the burst and spatter of Saturday night lights and laughter.[39]

Harris was undoubtedly right in claiming that 'It was peculiarly and secretly Nolan's very own world.' But, as an urban milieu, it was of only

passing interest to Nolan as an artist; for Tucker (as for Boyd and Perceval), it represented an inescapable condition of humanity.

Tucker's *Images of Modern Evil* can be directly compared with the series of drawings and water-colours which George Grosz offered in 1923 in *Ecce Homo*. An apostate communist, Grosz had retreated into an individualistic anarchism after a visit to the Soviet Union in 1922 and thereafter saw in society the presence of universal evil. As Grosz wrote:

I made careful drawings but I had no love of the people, inside or out. I was arrogant enough to consider myself a social scientist, not as a painter or a satirist. I thought about right and wrong but my conclusions were always unfavourable to all men equally.[40]

They were sentiments not far removed from those of Albert Tucker, who endured interminable arguments with communists who continued to insist upon the virtue of that distinct entity, 'the worker'. For Tucker the idea of the worker as an abstract concept of nobility was absurd. To conceive of society in terms of 'the masses' was a dehumanized way of looking at life.

Whereas Grosz and Dix identified in a precise way the characters who represented class points on the vast spectrum of Berlin society, Tucker, twenty years later, chose to employ surrealist devices to express symbolically his view that evil in Australian society could not be delineated in specific class terms. Everyday surroundings, prosaic and seedy inner urban streets became settings for the fantastic and the bizarre. Those surroundings were seen darkly at night and the iconographic symbol that Tucker developed was invariably illuminated by the harshness of street lights. The central symbolic form which dominates the psycho-sexual drama of *Images of Modern Evil* has its origins in two tendencies apparent in 1943: the almost limbless and sexually ambivalent torso in *Memory of Leonski*; and the attenuated vertical form to which anatomical details are attached in *Victory Girls*.[41] The two coalesce in the works of 1944 as a stalk-like neck to which limbless shapes with eye and mouth emblems are attached. This form was well developed by April 1944 with the *Image No. 6* and culminated in those of 1945 such as No. 14 and No. 24.[42]

However, Tucker's development unfolds with less logic than such a formal analysis might suggest. It was more in the nature of a series of intuitive flashes of insight and glimpses of recognition. The emblematic form probably had its immediate source in the series of monumental female torsos which Picasso drew in the late 1920s and early 1930s. One of these was reproduced in *Cahiers d'Art* in 1938.[43] Picasso's figure is as illogical as it is monumental: limbs are attached to the body haphazardly and it is surmounted by a long stalk-like neck upon which sits a minute head with three rope-like strands of curving hair. As with Tucker's form it is strongly modelled and spatially detached. Around this basic idea Tucker developed a highly individual image with specific symbolic aspects. The crescent mouth is an abstraction from the early *Portrait of*

Albert Tucker, *Image of Modern Evil* No. 14, 1945

Adrian Lawlor (1939), in which Tucker recalls an urge to pull up the corners of the mouth to suggest a rather agonized grimace. The triangular nose originated in the surgical studies of 1942. In *Spring in Fitzroy* the elements are already present. The demonic quality of the figure occupying a room in Jolimont beyond which can be seen the skyline of the city makes the picture far more successful than the more ambiguous *Leonski*, which it resembles. Tucker has been able to weld the symbolic sexual and the contextual aspects of the figure and its environment into a decorative and dynamic whole that is spatially and formally consistent. Another key painting is a more primitive-surrealist work, *The Return* (September 1943). The two figures in the work are little more than clumsy lumps of flesh upon which Tucker has drawn genitalia identifying the respective sexes. These would appear to be the origin of the later torsos.

Albert Tucker and Joy Hester's room and studio in Elwood, 1946: note the primitive mask on the left, and paintings by Sidney Nolan and Danila Vassilieff

Albert Tucker, *Image of Modern Evil*
No. 24, 1945

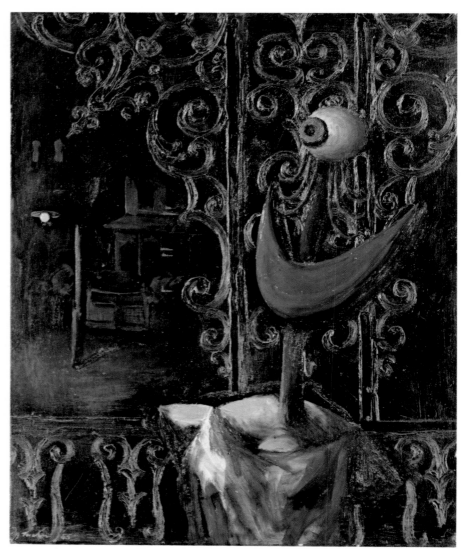

That Tucker's developing conception of his painting in 1943 and his sense of its social role can be located within the general ambit of surrealist thought is reinforced by remarks published in *Art in Australia* in 1942 by André Masson himself. In a piece illustrating *Metamorphosis of Love* entitled 'Life and Liberty', Masson declared that in an age of change the true artist could not 'conceal the disquietude of his epoch'. The artist of a romantic temperament did not paint to order:

The true artist does not need to know if 'the gods' are dead, or if others are about to be born. His mission is to express the mythical urge. Our time is one of metamorphosis.[44]

John Perceval

Perceval and Boyd also spent time in the army. Their experience was
no doubt as traumatic as that of Nolan and Tucker. Perceval had enlisted
as early as 1939 but physical disabilities from poliomyelitis prevented
any chance of combat duty and he was assigned to the cartographic
section of the Army Survey Corps. There he met Arthur and Guy Boyd
and by 1942 became an exhibiting member of the Contemporary Art
Society. Both were key events in Perceval's career, leading to support
from both the extended Boyd family and from the art fraternity of the
C.A.S., where his talent and lively mind soon won the support and
encouragement of the Reeds. From the start Perceval felt 'almost
religious' about the C.A.S. because of the sense of crusading zeal it
possessed. There was a dramatic contrast between the work of 1942,
exemplified by Perceval's two contributions to the Anti-Fascist
exhibition, *Survival* and the *Exodus from a Bombed City*, and his work of
1943.

John Perceval, *Boy with a Cat* II, 1943

Before 1942 Perceval's contact with modernism was limited. His first
paintings in the mid-thirties were modelled upon the example of Arthur
Streeton, Frederick McCubbin, W. B. McInnes and Hugh Ramsay. These
were later destroyed along with other early works. His first glimpse of
modern painting in 1939 was at one of Vassilieff's exhibitions. Despite
this, the two paintings he exhibited in the Anti-Fascist exhibition were
heavily socialist realist. The first of these works, *Survival*, was awkwardly
monumental in character. *Exodus from a Bombed City* was more loosely
handled and looked towards the work of Diego Rivera who, as Perceval
has put it, impressed him 'for five minutes'.[45] The themes of human
suffering and travail reflected Perceval's friendship in 1942 with
Counihan and O'Connor — a friendship which ended when Perceval
refused to join the Communist Party. A transitional work, *Black-Out Train*
(1943), demonstrated the development of a more personal and vigorous
style.

In the September 1943 issue of *Angry Penguins*, John Reed wrote that
although Perceval could not be said to have reached maturity as an artist,
his work had 'now reached that stage where one feels a certain guarantee
of its fruitful development'.[46] This was apparent in the shift from the
Anti-Fascist paintings to works such as *Boy with a Cat* (1943). For Reed
it showed 'a heightening of sensibility and an increase in acuteness of
observation and a developed power for concentrating emotional and
visual experience', whatever its weaknesses in terms of lack of control.
Certainly, after 1943 Perceval painted quickly and with greater fluency
and began to employ a more primitive and expressive style. It is difficult
to order or to date Perceval's rich output of work in 1943 but three
groups of works appear to have been painted in the following sequence:

expressive images of childhood; mask and jack-in-a-box paintings; and more complex expressionist-surrealist works. Whatever the differences of subject and treatment, the common theme of all three is the autobiographical depiction of childhood experience. Among the first group, *Boy Beside a Fruit Barrow* owes much to Yosl Bergner's early sombre urban images. The moody and introverted feeling of this work is transformed into the tangible cry of pain in *Boy with a Cat.*

The idea of harmless playthings and objects in the everyday world being metamorphosed into something actively malevolent is linked with the theme of early recollection: pets become rabid; a child's play mask is transformed into a death mask; a toy becomes an apparition. These small pictures often have the appearance of being crudely executed. At about this time Danila Vassilieff gave Perceval and Boyd painting lessons in which he emphasized that the image should be allowed to flow naturally from the mind through the brush; art must be 'a free flow of mind concepts', as Vassilieff put it.[47] Vassilieff's impact can be traced in the shift from solid monumentality to the expressive style of 1943. In works such as *Boy and Jack-in-a-Box* (1943) shapes are awkward, perspective and modelling at best perfunctory, and forms accentuated by a crude black line. This quality persists in the later works of 1943 which, like *Recollection of the Artist as a Small Boy Riding a Goat*, are more complex in composition and sophisticated in execution. As in *Performing Dogs No. 1*, events which on the surface might appear innocent are shown to have sinister dimensions. It is not a world of innocence that Perceval presents in these autobiographical essays, but a world from which evil

'The Brown Room', the living and dining quarters at the Boyd house 'Open Country', with John Perceval seated at the old piano on the right

and cruelty are never absent: a portrayal of the artist's own unhappy childhood.

One of the central qualities linking the work of the Angry Penguins artists is the dimension of personal experience. Whether the image is a recollected one from early memories — a 'mnemonic' art as Baudelaire called it — or based on immediate experience, the world is less external and fixed than internal, subjective and fluid. Any attempt to interpret the 1943 paintings of Perceval as contemporary social comment does not take us far. They do not offer images of the present, but a record of a past in which the vulnerability of the child is contrasted with a world in which nothing is certain except cruelty, and all things are to be distrusted.

Arthur Boyd

John Perceval, *Performing Dogs* No. 1 (detail), 1943

Boyd's painting from 1941 also deals with inner psychological realities and by 1943 his concern for a contemporary urban milieu parallels that of Tucker. This does not occur in Perceval's work until 1944. Three years older than Perceval, Boyd had produced powerful modernist paintings before the war in response to the influence of Bergner. Military service between 1940 and 1943 resulted in a break in Boyd's output,[48] but in March 1941 he painted *Progression* and in October 1942 the first version of *Butterfly Hunter*. There was less of a break in Boyd's drawing, which provided much material for the paintings of the 1943-45 period. He was of a more stoical nature than the other three artists, and his reduced output would seem a consequence of the dull routine and lack of opportunity of war service. Certainly neither *Progression* nor *Butterfly Hunter* has any direct relevance to the war and, as a completely apolitical man, Boyd took no part in the Anti-Fascist exhibition. His was, however, one of the new talents to appear in the 1942 Contemporary Art Society exhibition where *Progression* was shown.

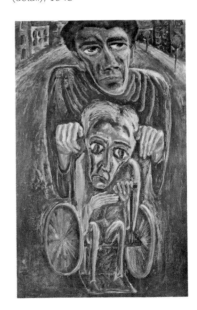

The subject of *Progression* is the painter's brother, David, pushing a crippled friend in a wheelchair. Colour is subdued and the two figures press towards the viewer. The picture's rhetorical character is reinforced by the contrast between the immediacy of the figures and the recessive pychological space. It was a device also employed by Bergner, Tucker and Perceval. Bergner and Tucker were forceful personalities and few of their immediate associates escaped their influence. Like Nolan, Tucker was not concerned that others should emulate his way of painting, but he never failed to impress by his intellectual scope and conceptual grasp of ideas. Tucker's belief in the subjective response of the artist, his interest in presenting psychological states and in expressive surrealism, helped reinforce Boyd's own direct and expressive style. All these elements are present in *Butterfly Hunter*, with its surrealistic figures pouring smoke-like from the decorative factory chimneys of Fitzroy. The

Arthur Boyd, *Progression*, 1941

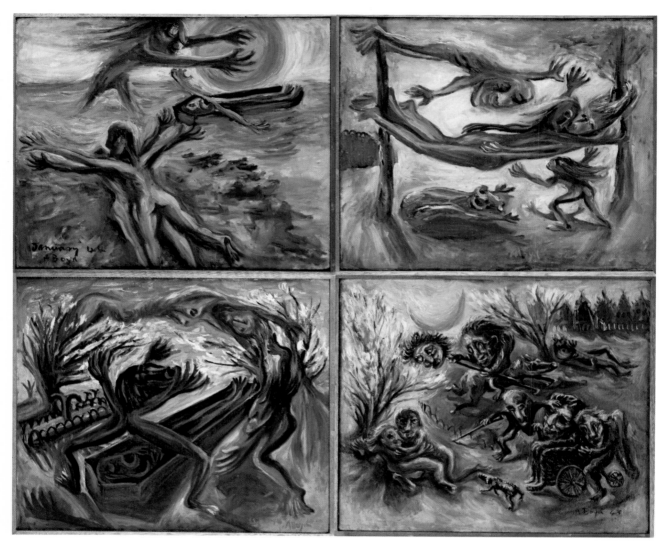

Arthur Boyd: (top) The Beach, 1944;
The Hammock, 1944; (bottom) The
Cemetery, 1944; The Orchard, 1943

central rather grotesque figure is in the act of grasping a butterfly. The presence of a dog is given greater significance in a drawing from the same period in which just such a beast reaches out towards a girl instead. Sexuality and bestiality are connected in this way in a surrealist *danse-macabre* amid grimy industrial suburbs.

Like Tucker, Boyd was able to draw on a repertoire of images in creating a bizarre world of surrealistic associations. In the C.A.S. exhibition of 1943 he exhibited a small but powerful group of works: *The Pavilion, The Kite, South Melbourne* and *Factory Girls*. Not all of these have been identified accurately and in many cases the order of works

from this time cannot now be ascertained. They were, however, prefigured by a series of important drawings done in 1942 in South Melbourne at a time when Boyd and Perceval shared a studio in South Yarra and South Melbourne with its curious sights was within easy reach. One subject to which Boyd was drawn was a woman exercising a paralysed dog. Other drawings are of lovers, both youthful and geriatric, often to be seen in the streets and on park benches along the foreshore.

The expressionist-surrealist paintings of 1943-44 evolved out of this imagery, transformed as it was by the imaginative capacities of the painter into an obsessive psychological world. Boyd has described such paintings as 'imaginary poems ... psychological or poetic fantasies perhaps'.[49] One of the earliest is *Man with Sunflower* (1943). There is a suggestion here of the psychological space of de Chirico as well as the magic of Chagall. As Franz Philipp describes Boyd's world:

Arthur Boyd, *Nude Holding Back Legs of a Dog*, c. 1941-43

environment is not an embracing entity ... but an empty stage, a platform of lonely desolation on which gestures of frenzy, desire and suffering are acted out. It is a symbolic rather than descriptive setting. The scene is that of somewhat decayed, half-industrialized inner suburban areas of Melbourne.[50]

These works of 1943-44 suggest a complex psychological symbolism attached to the images: cripples with crutches or in wheelchairs; dog-like or lizard-like beasts; levitating figures or figures crucified on kites; lovers — grotesque and ridiculous or sublime; butterflies and insects; gargoyles. The idea of metamorphosis — central to surrealism — is a recurring one: men are transformed into beasts, the inanimate into the animate; the inorganic into the organic. The distinction between love and bestiality becomes, at best, precarious. Boyd establishes a broad dichotomy between those who are free (lovers and levitating figures) and those who are imprisoned (the crippled and the maimed). It is an irrational and enigmatic world which exists somewhere in that surreal limbo between dream and reality. In the last analysis, emptiness prevails and hangs over the frenzied and obsessive action creating 'a world of anxiety, a world fallen from grace'.[51]

Arthur Boyd, *Man with Sunflower*, 1943

Images of Modern Evil

The expressive surrealism in 1943 of Nolan, Tucker, Perceval and Boyd, given the protean output of that year, represents a watershed in the development of their art. Its aesthetic quality varies greatly, but its historical significance cannot be underrated. Many of these paintings are deliberately raw, painted with an immediacy that verges on awkwardness and at times crudity. Essentially experimental, the mode finds a more mature expression in the following year and there is a corresponding refinement in the respective styles of each of the four artists.

Arthur Boyd, *The Baths (South Melbourne)*, 1943

By 1944 Tucker's *Images of Modern Evil* have less of an apocalyptic sense of melodrama and more of a sense of stylistic unity and mature symbolism. In the works of 1944-45 street lamps, cast-iron lacework, trams and the tawdriness of city streets, Luna Park and cinema interiors all contribute to a fantastic and threatening element that lies behind the facade of the familiar. In the mature work of the Angry Penguins generally and (to a lesser degree) in the contemporary work of Russell Drysdale, de Chirico's deserted and eerie piazzas, Picasso's human ciphers and Chagall's dislocations of time and space are transposed into Australian terms: streets of deserted Australian outback towns, the world behind the gaudy parade of Luna Park, the seedy streets and alleys of Melbourne and the inner urban areas, and parks with their promise of more furtive pleasures. This search for the threatened disorder behind apparent order and the menace behind the ordinary could only be communicated by a symbolism capable of expressing non-visual realities.[52] As Tucker wrote in 1944 in defence of his art: 'illusions are real to the hallucinated. I did not disbelieve my senses when world war 2 came along with new order pies floating bravely in the sky.'[53]

In communicating a sense of moral decay with its destructive sexual drives and fears, Tucker's central instrument was the emblematic form; a kind of homunculus whose sexual display stands for both carnality and vulnerability. As an iconographic symbol it anticipated Nolan's armoured Kelly form by three years. For Tucker it became the focus for the works; the crescent mouth became an essential part of the working out of each compositional scheme:

it became a symbolic form that for me stood for a lot of things that were going on then. Once the form emerged I found that I could no longer paint unless I put it down first. This was very conscious. If I tried to paint any other aspect ... the thing stayed dead; but the moment I got the crescent form in at some point it instantly sprang to life and from then on virtually did itself. It was like a trigger and the painting like automatic writing.[54]

The *Images of Modern Evil* fall into three phases. The first ten were in the primitive-surrealist phase of the East Melbourne period. The second group were painted in St Kilda and are in many ways the strongest. A third group in 1946 and 1947 demonstrate a more abstract cubism. The division is less neat than this might suggest, but it does correspond to different phases in the artist's life. The *Images* of 1945 have a strong sense of locale: those such as No. 16, No. 19 and No. 24 contain specific references in their settings to Luna Park, the St Kilda foreshore and back streets. Then, as now, St Kilda did not lack either the apparently innocent pleasures of fun-fairs and amusement parks or those of the flesh. The paintings reflect something of this contrast, as between, for example, the manic joy of the dancing figures in No. 19 and the sinister presence of a watcher on a balcony in No. 24. The constant note in the *Images* is contrast: lamplight creates stark pools of illumination in which are

Albert Tucker, *Image of Modern Evil* No. 19, 1945 (top); *Image of Modern Evil* No. 21, 1945

caught naked and vulnerable creatures that have lost the protective envelope of darkness; emblematic forms are played off against more realistically conceived backgrounds; figures close to the picture plane are contrasted with deeper psychological space; the familiar and harmless become unreal and sinister. Hoardings and billboards are transformed into apocalyptic signs. The emotional pitch of the images is enhanced by sharp contrasts of tone, an expressive brush-stroke or a discordant use of colour complementaries.

John Perceval's paintings of 1944 are far removed from those of the previous year and closer in spirit to Tucker's. There is a return to larger themes with the first of these, *Soldiers at Luna Park*. Two diggers with arms around their girls stroll through a brightly lit world of fantasy. Yet the frenzied scene does not suggest innocence. It is a world of manic action in which neither logic nor proportion is found — a world mocked rather than celebrated by the artist who appears in the composition as an outsized grinning figure.

Perceval's most ambitious painting of this period is *Negroes at Night* (October 1944). This work presents a menacing and panoramic view of nocturnal Melbourne. The foreground is filled with figures whose scale

John Perceval, *Negroes at Night*, 1944

bears no logical correlation with the rest of the work. It is a complex picture containing a group of Aborigines, a floating head of 'Fats' Waller, other negro musicians, and two children cavorting with drunks; an Aboriginal or negro house-cleaner sits with bucket and mop; the grins of the figures are echoed by a laughing jackass. A suburban rotary clothesline is transformed into a wheel upon which is straddled a broken figure. In the distance can be seen the city with its lights, rushing trains, busy harbour, and industry — the whole illuminated by a bright moonlit sky. There would seem to be certain explicit references to negro G.I.s and to the oppression which the artist felt they shared with Aborigines; and this is linked with the element of jazz. This is not, however, a very rewarding symbolism. The work is better understood as an image of a manic life-force set against an urban wasteland. War may be present as a conditioning factor but it is not central. Whereas Perceval had earlier looked back upon a painful childhood, now the world of adults was no less threatening.

Arthur Boyd, *Lovers on a Bench*, 1943

Arthur Boyd's symbolic urban imagery also continued into 1944. The main change, apart from a more fluid style, is that the figures occupy a less clearly defined milieu. It is a nether world of either the sea-shore, an orchard, a garden, or a cemetery. An increasing preoccupation is the contrast between figures locked in love or separated by death as in *The Beach* or *The Cemetery*. In the latter part of 1944, as Franz Philipp notes, Boyd's figures 'find their truly primeval setting [in] the dense wilderness of the Bush'. In *Lovers* the loving embrace of a couple in the foreground is linked with the animal lust of a ram copulating with a ewe nearby. Also for the first time we see a shepherd on horseback, a figure whose benign presence fills a warm Streeton-like pastoral landscape. This painting so shocked Norman Myer that he ordered its removal from the 1945 C.A.S. exhibition in the Myer Gallery.

A rather different mood pervades Boyd's later works. This is related to a change in the conception of the landscape, and is apparent in *The Shepherd* and *The Hunter II* (subtitled 'The Flood'). The general tone is darker, the colour more sombre, and the bush closes in to give a claustrophobic effect. In *The Hunter II*, mourning figures strike attitudes of fear or clasp one another for protection against imminent catastrophe; one figure is already being swept away by a torrent of water. The hunter, mounted on a horned beast, seems less hostile than indifferent to these events.

Arthur Boyd, *Two Lovers (The Good Shepherd)*, 1944

Well before 1944 Boyd had sketched similar mountain and wooded landscapes on trips along the upper reaches of the Yarra at Launching Place.[55] Numerous drawings on which these pictures were based were also produced before 1944. However, one of the key links in the shift from Boyd's urban to bush imagery can be easily identified. This is a landscape painted in 1943 that was a direct response to Boyd's discovery of the watercolours of Louis Buvelot.[56] The Army Survey Corps' cartographic section was close to the National Gallery and Boyd recalls

Arthur Boyd, *Landscape*, 1943

seeing the work of this artist:

There was a framed water-colour of Buvelot's which impressed me very much.
It was of Bacchus Marsh where I had been on painting excursions in the mid-30s
... I repainted my earlier impressions of Bacchus Marsh which developed into
the backgrounds of the *Hunter* pictures.[57]

Buvelot's response to the Australian landscape seemed altogether more
appealing to an artist of Boyd's temperament than did the sun-drenched
pastoral of Streeton's *Golden Summer*. The result was a large painting in
which Boyd emulated Buvelot's concern to play off massed forms against
open clearings; dark against light, creating a sense of space through tonal
recession from the dark foreground into a lighter middle ground.
Buvelot, as a product of the Barbizon tradition, might hardly be thought
of as a romantic interpreter of the Australian scene compared with von
Guérard. Nevertheless, Boyd found in this intimate response to the bush
'a slightly gloomy' view which suited his own ends in 1943-44.[58] It was
a darker aspect of the bush that made it an appropriate repository for
mythical beings and events. However, the quality that Marcus Clarke
described as the 'weird melancholy of the bush', and which D. H.
Lawrence responded to in the 1920s, is one that Boyd has grafted on
to Buvelot.

Contrary to a received opinion, it was the talent of Sidney Nolan, of these four artists, that first gained critical approbation in the later war years. In 1943 Paul Haefliger found *Kiata* one of the most original by an Australian artist;[59] less surprisingly, in the same year John Reed paid tribute to a rare talent:

Springing from a vision of unique and powerful penetration, Nolan is surely abstractionist only to the extent to which his clear and penetrating mind and eye refuse all superficial distractions. Drawing, perhaps for the first time here, on the real sources of the Australian visual image he is, first of all, a painter who paints what he sees about him, revealing to us with remarkable integration and a lovely clarity the essential heart of experience.[60]

By reference to 'the essential heart of experience' Reed indicated that capacity of Nolan to give immediate visual expression to a personal response. In 1945 Haefliger was close to the heart of Nolan's art when he likened his approach and goal as an artist to that of Paul Klee:

Nolan shows us how the best in child art, the direct and innocent expression, can be allied to the directing sensibility of the mature artist — a rare power. And no one versed in the idiom of the child's mind, or able to recall his own youth, could fail to appreciate the lyric beauty of these superior paintings.[61]

In the same year Clive Turnbull declared that those who did not enjoy the artist's work had lost the innocence of the eye.[62]

Almost every one of Nolan's paintings between 1942 and 1945 are celebrations of that innocence of vision and experience. With the exception of the early psychological portraits of 1942, Nolan — although his awareness of this dimension of life can hardly be in doubt — avoided that tragic aspect of human experience which gave to the poetry of Baudelaire and Rimbaud, or the work of German painters, such a degree of edge and toughness. During these years each of the four painters discussed in this chapter endured their 'Season in Hell'. But one looks in vain in the work of Nolan for the Rimbaud who found beauty 'embittered' and so cursed it. Rimbaud's hell, which is caught in the following lines, was the experience of others:

I called to my executioners to let me bite the ends of their guns as I died. I called to all plagues to stifle me with sand and blood. Disaster was my god. I stretched out in mud. I dried myself in criminal air. I played clever tricks on insanity.[63]

Nolan's art belongs instead to Rimbaud's celebratory *Les Illuminations*, whether in the sophisticated and light-filled Heidelberg landscapes of 1945 such as *Rosa Mutabilis* or the more primitive and haptic urban images and recollections of childhood such as *Catani Gardens* (1945) or *Under the Pier* (1945).

Both Haefliger and Turnbull were astute in recognizing their value, but the ease with which these later works were received does point to their accessibility. *Railway Yards, Dimboola* (1943) and *Dimboola Landscape*

Sidney Nolan, *Boy in Township*, 1943. Initially conceived by the artist as a picture of a dehydrated boy killed by a bushfire in the Wimmera, this may still be seen when the painting is viewed upside down

(1944), as with the Wimmera landscapes generally, were landmarks in the developing vision of the Australian scene. Nolan might nonetheless be compared with that rather similar painter, Christopher Wood, who also painted spontaneously and directly without preliminary drawings, and who held similar views to Nolan about the need to see with the immediacy of the young but to express that vision with the sophistication of the mature. Wood too had used ripolin and was, in fact, one of the first to use the medium almost exclusively because it facilitated working at high speed and enabled paintings to be finished in one session.[64] As with Wood, Nolan's repertoire of images depended greatly upon his imaginative capacity for recall. Nolan produced many fine paintings but few between *Boy and the Moon* and the Kelly series that possessed the sense of challenge which André Breton laid down as the absolute precondition of a revolutionary and subversive art. Moreover, that awareness of darker forces which contributed to the challenge in the work of the other Angry Penguins rarely appeared. Nolan's visionary landscapes and urban images were not in conflict with the tradition at its best of Streeton, Roberts or Conder. For Nolan, new visions and relationships could co-exist with those of the past. The degree of harmony which this suggests would no doubt have found full favour with Burdett, just as his successor on the *Herald*, Clive Turnbull, warmed to Nolan's humanism.

The contrast between Nolan's lyrical *mise en scène* of St Kilda and the obsessive emotional drama of the urban imagery of Tucker, Boyd and Perceval represents the difference between the spirit of a Burdett and

that of a Lawlor. It is the difference between the spirit of Rimbaud's *Les Illuminations* and *Une Saison en Enfer*. Nobody aware of the private lives of Nolan or Burdett can doubt the degree to which each suffered torment and the degree to which both rejected utterly the values of the Australian *bourgeoisie*. Both responded by an affirmation of values which in themselves implied rejection but not all-out war. By contrast, Tucker and Boyd responded with an art that clashed head-on with convention and which possessed a vehemence only matched in Australian art by the writings of Lawlor. Like Lawlor, they made no concessions during the war years either to notions of taste or to the middle emotional register. Tucker, especially, was wholly unprepared to concede in his art that Australian culture or the Australian milieu, as such, possessed anything worth celebrating. Nolan on the other hand could discover beauty in the

John Reed, Joy Hester and Sidney Nolan at Sorrento, c. 1946

landscape, joy in the spontaneity of the young, and pleasure in the sensuality of love. As we have seen, left-wing artists discovered stoical virtue in the travails of the poor and the dispossessed, and nobility and regenerative grace in working men and women. For an Albert Tucker, as for a George Grosz, the corruption that affected contemporary society could not be halted at any point across the class gradient, just as it could not be set to one side by the socially responsive artist.

Tucker had accepted the wisdom of the united front in the late 1930s that evil had to be ferreted out and fought both at home and abroad by any and every available means. He was now, however, unable to accept that 'the people' possessed any virtues that could resist the denial of humanism that was fascism. Tucker might well have defined the moral dilemma of radical liberals in similar terms to those of George Johnston through the character of David Meredith in his novel *My Brother Jack*:

I should have seen for myself that a lot of the dissonance of the world had nothing whatever to do with 'downtrodden' masses ... but was there because half the world lived in mental deserts ... and that the real enemy was not the obvious embodiment of evil, like Hitler or his persecution of the Jews or the Russian purges or the bombs on Guernica, but this awful fetish of respectability that would rather look the other way than cause a fuss ... that did not *want* to know because *to know* might somehow force them into a situation which could take the polish off the duco and blight the herbaceous borders and lay scabrous patches across the attended lawns.[65]

Practically every painting that Albert Tucker produced during this period had as its aim the stripping away of that same facade of social and cultural respectability and ideological pretence. Evil (and one makes no apologies for employing the word in this context since neither Tucker nor Johnston hesitated to use it) was present at all social levels, and right across the cultural spectrum; it was to be found in apparently innocuous circumstances as well as where the wowser traditionally sought it out. Tucker, of course, concentrated on the *demi-monde*, but as with his later portraits of murderers and sadists, the *Images of Modern Evil* represents a collective metaphor for a psychological reality masquerading behind the facade and the features of the bourgeois. The paintings of the Angry Penguins defied in the most fundamental ways all academic art that was prescriptive in method, form or subject. But of them all, it was Tucker whose art remained stubbornly wedded to an unwavering sense of social purpose.

The journalist and writer George Johnston in London after the war. Johnston's background as an art student and friend of artists enabled him to give a vivid image of the artists' world. His descriptions of urban life in Australia and the dilemmas of young intellectuals in the 1930s and 1940s remain unrivalled in our fiction

CHAPTER EIGHT
PATRONAGE AND PROFESSIONALISM
Art, War, and the
Struggle to Survive

These are my two lives now: the dream and the nightmare.

Donald Friend (1943)

The Art Boom

One of the least-known aspects of the story of Australian art in the 1940s is its extraordinary boom towards the end of the war. Comparable to the boom of the 1920s, it was so dramatic that Adrian Lawlor declared in September 1943: 'domestic walls ... people's walls ... are simply proliferating with pictures.'[1] Clive Turnbull said of the phenomenon in November that the 'sun is shining for the moment upon the artists of Australia — at least upon the "popular" artists. Sales have never been so good'. In 1943 Melbourne's seven main galleries were booked solid until the end of 1944. One-man exhibitions were often sold out by the first or second days. So many canvases sold that frames were in short supply. News spread to Adelaide and Sydney, where the *Daily Telegraph* reported that artists were 'anxious to share in the prosperity', not yet so apparent in those cities.[2]

Inevitably such conditions produced fertile ground for the mediocre and the meretricious. In November 1943 the *Bulletin* art critic claimed that an exhibition at the David Jones Gallery, 'Australia in Pictures', was a blatantly cynical attempt to cash in on the present good market for paintings.[3] It was a commercial exercise designed to have special appeal to naive and gullible American soldiers, offering an assortment of views of the Australian landscape undistinguished by aesthetic merit. Certainly, well-paid American officers spent freely on *objets d'art*, but Australians themselves began to buy more during the war years. In June 1945 the Melbourne *Herald* reported that the city's galleries were again booked out,[4] and the boom was still apparent as late as November 1946. As the *Argus* commented, 'with half a dozen art exhibitions in session, Melbourne is nearing the end of an exceedingly busy year ... Scarcely a week has passed without two or three shows being opened and frequently there have been six or seven running together'.[5] Looking back over this phenomenon, Clive Turnbull characterized it as largely 'aimless

Opposite The new generation of war artists: Lieutenant Charles Bush at work in Timor in 1945 with his guide, a commando sergeant. After service in the artillery and in camouflage work, Bush was made a 'sergeant artist' with the army in New Guinea and commissioned in 1944 as an official artist — together with other young and advanced artists — in a move to achieve a more vigorous record of Australia at war

semi-hysterical buying',[6] which had resulted in more than 5000 pictures being exhibited annually during the last years of the war. While many celebrated this as an upsurge of interest in art, he thought it represented interest of another kind, suggesting that one of the main motives was the lack of alternative consumer goods in a wartime economy. Another factor was that art appeared to offer a safeguard for the middle class, a hedge against an inflating economy.

In order to meet the demand, new galleries sprang up — and were invariably associated with emporiums and department stores. What was good for art was also good for business. The David Jones Gallery was established in Sydney late in 1943. This was followed in Melbourne by galleries at Georges' in 1944 and at Myer's in 1945. While the extra hanging space was welcome (the social realists had to wait eighteen months for a vacant gallery), the boom generally, and the commercialization of art in particular, had far from desirable effects. By 1946 Turnbull doubted whether the boom would be of 'much ultimate value to the community, unless those people whose curiosity has been aroused are able to satisfy it by means which will give them some real knowledge of the painter's intent'.[7] Indeed, the signs were apparent as early as 1943. In commenting on the phenomenon at that stage he had described it as an artist's dream, albeit a *popular* artist's and a dealer's dream.[8] The telling question was, who bought? Turnbull answered: 'a new section of purchasers who, as a result of current circumstances, find themselves with money in hand and nothing to spend it on — no house, no travel, no car, no parties, no holidays worth mentioning.' Painting was an investment and a diversion, but naturally they turned to the familiar and the safe: 'the old stagers, men with established reputations, the academicians of the Australian scene.' This was no renaissance, and radical artists were unaffected. Even competent conservative painting did not benefit, because invariably the worst work sold.

The War Artists

In the face of this commercialization the extension of government patronage seemed all the more auspicious. In 1942 and 1943 the overwhelming fact of life for Australians was war. For artists it was a polarizing factor: war was viewed as a force for either progress and integration or for social disintegration. For some it was even a force for moral and ethical corruption. Artists like Donald Friend, who eventually was appointed an official war artist, shared with the Angry Penguins a firm belief that artists had no business actually fighting and that wars inevitably generated more evil than that which they sought to end. Yet it was not exactly pacifism — the legacy of the united front was too strong for that. As John Reed argued on their behalf, they felt that they ought

to be allowed to participate in the war effort as artists.

Unlike Nolan, Tucker did not apply to be an official war artist. In this he was being more realistic, but he continued to be painfully aware of opportunities lost. Here was the chance to witness at first hand the absolute nadir of the human condition, a condition he could only examine indirectly. Tucker envied men like William Dargie and Alan Moore their appointments. Moore was actually present when Bergen-Belsen was opened, and was able to do some sketches on the spot that formed the basis of several paintings on this theme. But little that Tucker saw by official artists seemed to begin to capture the quintessential nature of such events.

In general, Tucker's judgement stands. Works produced by the more than thirty official war artists are often enough sensitive studies or appropriately bellicose, but few come to terms with the real experience of men at war. In some instances the tragic dimension was unforeseen. Stella Bowen, for example, painted a sensitive portrait of an R.A.A.F. bomber crew. By the time the painting was completed all but one of the seven men were dead.[9]

In the prosecution of the war effort, the State had become the biggest employer of artists and designers in Australia's history. But in general it was a case of an excessively narrow selection of artists, made too late in the day. The one exception was the appointment in 1941 of Ivor Hele, who was seconded from the A.I.F. while serving in the Middle East. Hele painted not only the better-known set pieces that dominate a section of the Australian War Memorial and which were commissioned after the war, but a number of smaller studies that stand as moving tributes to the soldiers. As a record of the New Guinea campaign in 1942, several of these dark-hued paintings depict the struggle to survive on the Owen Stanley Ranges, as well as the burial of men by their comrades. A quite different note is struck in *2/10 Commando Squadron Wash and Clean Up, Suain, New Guinea, November 1944.* Here Hele depicts in a direct and spontaneous oil sketch the strength, vigour and virility of young digger heroes, in terms that recall Masefield's word-picture of the original Anzacs thirty years before.

Clive Turnbull recognized in February 1943 that Hele was the outstanding discovery among artists appointed. Whereas Harold Herbert was content to paint landscapes and desert towns in which the only recognition of war was the odd piece of hardware, Hele depicted *men* at war: 'a gun crew sweating at a 25 pdr., soldiers in a casualty clearing station'.[10] The uniqueness of Hele's achievement was not apparent, however, until the New Guinea studies were exhibited in Melbourne at the Athenaeum in March 1945. Hele showed four canvases: *Battle Burial of Three N.C.O.s, Carrying an N.C.O. to Burial, Walking Wounded, Missim Trail* and *Stretcher Case Assisting Bearers.* Of these, perhaps the first is the most powerful, showing infantry standing in the mist and rain with heads

Ivor Hele, *2/10 Commando Squadron Wash and Clean Up, Suain, New Guinea, November 1944,* 1944-45 (top); *Battle Burial of Three N.C.O.s,* c. 1943

Eric Thake drawing Lieutenant-General Yamada in Koepang, Timor, October 1945, after the surrender of Japanese forces. The appointment of this mildly surrealist artist as an official war artist in 1943 was unusual. Thake was appointed to work with the R.A.A.F. and was not under the direct control of the War Memorial Board

William Dobell, *Cement Worker*, c. 1943

bowed as they lower the limp body of a dead comrade into a jungle grave. The figures of the green-clad soldiers merge with a half-lit background. As Turnbull commented:

These are grim pictures of grim events ... [Here there is] no attempt to dodge the issues of death in the jungle — a jungle of dim light, mist and mud, of Japanese bodies pulled out of fox holes and of Australian bodies, too, slumped in death.

This is no glamorous war Hele paints, but a war of rain and blood — a triumph of the human spirit over appalling conditions.[11]

These paintings of gaunt, bearded soldiers by an artist who was one of their number are the great paintings of Australia at war.

But Hele's appointment was simply fortuitous; artists of the calibre of Harold Herbert, William Dargie or Colin Colahan were not inspired choices. The intention to appoint William Dobell was another matter. In 1942 the Sydney sculptor Lyndon Dadswell said to Lt.-Col. J. L. Treloar that in his opinion Dobell 'would prove to be the George Lambert of the Australian Artists during this war'.[12] That laurel went to Ivor Hele, and it is unfortunate that Dobell was not available when an appointment was feasible in 1943, being committed to work for the Civil Construction Corps of the Allied Works Council. In that capacity, however, he did produce a remarkable record of the Australian experience of 1942-43. Works such as *Cement Worker* (c. 1943) and *Barrowman, Perth* (c. 1943) have few equals in Australian painting. Less satirical than *The Billy Boy*, the figure in the first epitomizes the laconic character and the physical presence of an Australian labourer. Whereas in the miners series Counihan universalized the image of the worker, Dobell's painting suggests a distinct as well as a distinctive national type. It must be added, however, that if ever an artist was temperamentally unfitted for the potential horrors of war reportage, or even the close male contact it involved, it was this sensitive and vulnerable man.

The war artist working in the forward areas had to produce sufficient sketches for immediate exhibitions and as raw material for later large-scale painting commissions after the war. Any artist appointed was fortunate indeed in terms of assured commissions, let alone the potential value of the experience. Those who got the jobs invariably possessed the imprimatur of the Society of Artists or bodies such as the Academy. In 1943 they included Douglas Watson, G. R. Mainwaring, Alan Moore, Harold Freedman, Arthur Murch, Frank Norton, Nora Heysen, Harold Abbott and R. Malcolm Warner. None belonged to the Contemporary Art Society. In 1943 the War Memorial Committee gave its careful consideration to appointing so radical a figure as Arnold Shore, thinking him a 'sane and reasonable modernist' (who nevertheless did not get the job).[13] 'Sane modernism' was the only acceptable alternative to academicism. The inclusion of a man like Shore had been suggested as politic in the light of criticism coming in 1942 from Murdoch's

Melbourne newspapers and the C.A.S. The proposed appointment of Dobell in 1942 as a war artist was partly based on anticipation of such criticism. Russell Drysdale too was favoured for appointment, but was rejected because of his blindness in one eye.[14]

In March 1944 the question of employing Dobell was again raised, despite criticism by senior army officers who had seen reproductions of *Portrait of Joshua Smith*. The acting director of the War Memorial, A. W. Bazley, defended the wisdom of the appointment: 'I don't see how he can be "dumped" just because a few senior officers are disposed to regard his work as "rubbish".'[15] He felt confident that Dobell would not indulge in grotesque experiments at the War Memorial's expense. Certainly the appointment of Dobell would help forestall controversy — there would be at least one 'modern' among the official artists. Dobell, however, was not appointed.

There were ethical as well as aesthetic problems. Men like C. E. W. Bean felt a profound sense of responsibility to those who were making the real sacrifices. Bean stated in 1944 that if any artist other than those of the 'conservative' school were considered, then their subjects, the men and women of the services, had a right to be consulted. It was, after all, to be their memorial. Radical artists, for their part, were, however, equally concerned with their personal rights as creative artists to respond to the war as they thought fit. Between the position of Bean and a John Reed or an Albert Tucker lay an immense gulf. The differences were as unbridgable, in fact, as those between the Angry Penguins and the communists. The social realists themselves would have made first-rate war artists, ready as they were to celebrate heroism and positive action in the anti-fascist crusade. But in the circumstances of 1944 artists tainted with any sort of radicalism had no hope of appointment. This applied as much to James Cant as to Pte Nolan of the 13th Supply Company, whose names were among the fifty forwarded to the Art Committee in May 1944. Forty such names were deemed 'quite unsuitable' and were only included 'so that it will be clear that they have "had a run for their money"'.[16] Nolan was recommended by his commanding officer as something of a landscape painter but with the damning caveat that he was an 'extremist of the modern school'.

When rumours circulated in 1944 that the Australian Academy was to recommend appointments, a public protest broke out in Melbourne newspapers. Letters from figures as diverse as Albert Tucker and Daryl Lindsay were published in the *Herald*, and in July John Reed wrote directly to the Department of the Interior demanding to know the precise appointment procedures for war artists.[17] When the new appointments were announced early in the following year, it was hoped that the inclusion of young 'moderns' (specifically Friend and Herman) would help to still the clamour.[18] However, Treloar warned Joseph Collings, as the minister responsible and chairman of the War Memorial Board, that there would undoubtedly be another adverse response from the

The old guard: Harold Herbert sketching in Syria, 1941, while his driver and guide looks on. Herbert was the first official Australian war artist and his appointment in 1941 was a direct consequence of personal friendship with Lieutenant-General Sir Thomas Blamey, G.O.C. the 2nd A.I.F. in the Middle East. Unfitted physically and artistically, Herbert lasted only a few months in the tough conditions of war

'extremely aggressive' Reed, although he hoped that the Ern Malley hoax might have subdued him.[19] It was a vain hope, of course. Reed wrote to Collings, expressing on behalf of the C.A.S. a 'profound amazement' that war artists should be selected by an antediluvian body like the Academy.[20] Reed added that even the Menzies government, which had unofficially patronized the Academy, 'did not have the temerity in the face of widespread opposition to give this body any official standing, and it [was] incredible that the Labor Government should now have done so' — a 'political twist' Bazley objected to.[21] Treloar noted that since Nolan and Reed were two of the three principals in the Ern Malley hoax, 'their obvious lack of standard in literature which made this hoax possible has discredited their judgement and their society'.[22]

The issue was larger than the question of whether the Australian Academy was a suitable selection body. It was patent that some artists being appointed were either physically or emotionally unfit for the job, were people of very mediocre talent but with impeccable connections — or, worst of all, were popularizers reviled by high conservative and radical alike. Clive Turnbull used the columns of the *Herald* in July to blast those in authority who were employing such hacks on this vital task.

Russell Drysdale, *Local V.D.C. Parade*, 1943 (top); *Albury Station*, 1943

By 1945 the Academy was no more than a shell, but this debate demonstrates the extent to which mediocrity and old-style 'slither' in Australian art still held their appeal. That this was a self-inflicted wound was demonstrated vividly by an exhibition of official British war art which toured Australia early in 1943 and included styles unheard-of by Australian officialdom.[23] The British Government's War Artists Advisory Committee had shown courage in appointing artists of the calibre of Henry Moore, Graham Sutherland, John Piper and Paul Nash. Nash painted aircraft in a surrealistic and symbolic manner; Henry Moore had produced a remarkable series of drawings in 1940 of figures reclining in underground bomb shelters, and he continued this theme as an official artist.

The British exhibition transformed Russell Drysdale's style. Until 1943 he had painted scenes of small-town Australia from the 1920s and the Great Depression in the manner of Christopher Wood. The abrupt shift is apparent in *Albury Station* and *Albury Platform*. A number of Drysdale figure drawings at this time and the soldiers in *Albury Platform* closely resemble the figures in Moore's shelter drawings. Although Drysdale had earlier dealt with aspects of the war in Australia in *Medical Inspection* (1941) and *Local V.D.C. Parade* (1943), the whimsicality and affection that pervade them belong to his Riverina phase. They are wholly affirmative images of a people rallying to the call, however ineffective and amusing the results. The change in late 1943 to the compelling image of *Albury Station* is dramatic. As with Piper, Drysdale employs carefully wrought textures and surfaces to contrive an air of mystery and a sense of vague unease, even menace.

Drysdale's work in 1943 was close to being acceptable to the

Australian War Memorial. As an example of the unofficial war art of Australia, it shared certain values with the more academic official art of Hele and yet might be linked with comparable work by Counihan. While each of these artists occupied different points on the political spectrum their work had this in common: that war was seen as potentially a constructive force. For such men war was accomplishing not merely the destruction of an external enemy, but was in the process affirming the inherent nobility, stoicism, courage, comradeship and sense of nationhood in the Australian people. For Counihan it also helped in the extirpation of reaction and social-fascism within society.

The other extreme was represented by the war-related art of the surrealist James Gleeson. Gleeson, not unlike the Angry Penguins, documented a personal response to war as a wholly destructive force. War was either a release of the mob instinct sanctified by authority, or a cynical exercise in power with a facade of patriotic values. In either case the individual lost.

James Gleeson, *The Sower*, 1944

Gleeson's first painting that successfully caught something of the tragic dimension of the war was *The Sower*, which was exhibited in the 1944 C.A.S. exhibition. Heavily indebted to the style of Salvador Dali, *The Sower* recalls the hysterical horror of Dali's *Spectre of Sex Appeal* (1934) and a later anti-war painting *Premonition of Civil War, Soft Construction with Boiled Beans* (1935).[24] In like manner, Gleeson has depicted an agonized figure that seems to tear itself apart as it rears out of a barren and rocky landscape. In turn two carnivorous creatures, metamorphosed out of its body, snap and snarl at one another. Two skulls surmount a pinnacle of rock, and one of them occupies the empty eye socket of the head. These symbols of death and destruction are set against the small and vulnerable female figure in the centre space of the nightmare. Although the debt to Dali is overwhelming, the painting was conceived and executed in a more spontaneous way than earlier pictures that exhibit a more turgid symbolism. In 1945 Gleeson produced two important works: *Landscape with Funeral Procession* and *The Citadel*. Among his most successful and important works from the 1940s, they also gave expression to a fearsome sense of apocalyptic violence. Both paintings dealt with the theme (as had *The Sower*) of an outrage perpetrated by mankind against itself. As Gleeson commented in 1945:

These are war pictures, depicting the chaos of our time. [In *The Citadel*] I have substituted for war-torn brick and stone a symbolic pattern of human flesh, bone teeth and brain . . . These are the horrors of the concentration camp and the battleground seen through the eyes of a surrealist.[25]

Painted in the first months of 1945 as the Allied advance pushed into western Germany and eastern Europe, *The Citadel* was a direct response to that climax of destruction. It was a time when the full extent of the atrocities of the death camps were being revealed.

The historical significance of these ambitious paintings was not lost

James Gleeson, *The Citadel*, 1945

on local critics. Paul Haefliger found in *The Citadel* 'horror raised to a certain confused grandeur' and made an unsuccessful plea for the work to be bought by the National Gallery of N.S.W.[26] Haefliger was more prepared to accept a metaphorical representation of this subject matter than the direct and unambiguous treatment of Yosl Bergner, which was dismissed as illustrative. A world of difference yawns, in this respect, between the two artists and the values of their respective supporters. Bergner had sought to show as graphically as possible the nature of specific horrors perpetuated against a specific race. For Gleeson, his paintings were a means of exorcising his horror at deeds that outraged all civilized values.

In a very real sense the most incisive comments on the war came from outside the ranks of officially sanctioned artists. That other alternatives were possible was again confirmed when in October 1944 Melbourne artists saw an exhibition of work by American war artists. Unlike so many Australian war artists, these men had accompanied leading assault waves in New Guinea, and flown combat missions with the 5th United States Air Force. They had experienced battle and, like Ivor Hele, could show it in their paintings. Clive Turnbull warned that their work would shock 'as it ought to do if it is to convey any of the emotions of a period of violence, flux, blood and death'.[27] Turnbull saw in this the real aim of the war artist.

James Gleeson, 1940: while his early surrealism was overwhelmingly in debt to European surrealists like Salvador Dali, by 1945 the attempt to come to grips with total war drove the artist well beyond such models

The Americans are concerned with men fighting, men dying and the passions of men close to death. In Australia, it is not officially fashionable to discuss either of these things — decay on the battlefield or abandon in release on home leave.

To me it seems that the least we as civilians can be asked to face is the truth. The facile evasions of conventional little pictures are mere escapism from the charges of moral responsibility.

For Turnbull, as for Reed and Tucker, who were not to see Hele's important studies until March 1945, Australian war art was ethically wrong — a symbol of *petit-bourgeois* values that refused to face reality before the war and were now equally incapable of doing so. Turnbull saw that this was also the case in Australian war films, which contrasted sharply with American preparedness to face issues squarely.[28]

The Angry Penguins took painting too seriously to contemplate working for the armed services in areas only vaguely related to creative art. But for the vast number of artists who did not share the good fortune of the thirty or so official artists, the main occupations during the war were in camouflage and army education. 'Camoufleurs' were usually civilians given a para-military status and attached to the Department of Home Security and the Allied Works Council under the Ministry of the Interior. The zoologist Professor W. J. Dakin, of Sydney University, was

Director of Camouflage and brought together artists, architects and designers to work on both military and non-military sites. Camoufleurs such as Rod Shaw, James Cant, Douglas Annand and Frank Hinder worked as far afield as Perth, Coffs Harbour and the Pacific Islands. Many of the more ambitious projects were abandoned after 1943 and by 1944 most artists were released.

Army education was also well under way by 1942, under the direction of Professor J. D. G. Medley of Melbourne University as Chairman of the Military Education Council, and of Lt.-Col. R. B. Madgwick as head of Army Education. Their job was to help prepare people in the services for the return to civilian life. Lectures, art exhibitions, craft courses, libraries and musical performances were organized. Richard Haughton James spent eighteen months in the Northern Territory maintaining the morale of troops in and around Katherine and vainly insisting that art was more than 'middlebrow' entertainment and that craft need not be crass.

However valuable these efforts were or were not in themselves, their significance for this study lies in the promise many artists felt they held for a wholly new relationship between artist and community. Now that the government had become the most important patron of the arts and an employer of artists, it was hoped that a new era of patronage had begun. The aim of the left was to extend the thrust of war socialism and nationalization into peace on the wave of national unity and optimism, and the organizations to achieve this were the various front bodies established between 1941 and 1945. One of the most important initiatives was based upon the Melbourne Artists Advisory Panel and the Sydney War Art Council, which were joined to form the Encouragement of Art Movement.

The Government as Patron

In the February 1945 issue of *Australian New Writing*, Bernard Smith claimed that war had ended bohemianism in Australian culture:[29] there was a new sense of responsibility on the part of the artist towards the community. In May, architect and Communist Party member John Oldham declared in a Studio of Realist Art lecture that 'during the past few years, art patronage has ceased to be the preserve of a few wealthy individuals. The Government has become an art patron'.[30] Communists argued that this was a recognition that art mattered in the lives of ordinary people. The Encouragement of Art Movement was launched in July of 1944. With exhibitions planned for workshops, offices, camps, factories and work sites, the stated aim was to make a positive contribution to 'morale and efficiency' in the war effort and, more importantly, to 'tap the vast reservoir of latent talent in our people'.[31] The meeting in July was addressed by Daryl Lindsay, Professor R. M. Crawford and

James Quinn, as well as by Alan Marshall and Rem McClintock. The following day McClintock reported that the E.A.M. was now 'on the map', adding with relief that 'Ern Malley Reed' had not turned up.[32] The movement was also linked with the Combined Arts Centre Movement (established to lobby for a new National Gallery) and the National Theatre Movement. The breadth of this support reflected the corresponding breadth of the E.A.M. programme, which encompassed music and drama as well as the fine arts. McClintock envisaged, as he put it, a virtual 'orgy of simultaneous shows' for 1945.

It is important in this context to underline the continuity of this activity; the programme was designed to extend the fight for culture in peacetime just as the Artists Advisory Panel had tried to use art in order to prosecute the anti-fascist war. In the case of both organizations the initial impulses and the organizing effort came from communists who won the support of members of the establishment and helped direct activities in their capacities as chairmen and secretaries. But because of conflict between these diverse elements, positive direction was finally lacking. In September of 1945 the E.A.M. was merged with the Country Art Movement in N.S.W. to become an Australian Council for the Encouragement of Music and the Arts — and, as befitted its name, was set on a course of increasingly conservative and limited activities.

Bernard Smith's role here went deeper than that of mere public apologist. Having helped to establish the E.A.M. in Sydney and in 1943 been secretary of the War Art Council,[33] he was able to convince Sydney Ure Smith, then president of the board of trustees of the National Gallery of N.S.W., that there was need for a more adventurous educational policy by the Gallery. The consequence was that Smith was appointed education officer, responsible for organizing travelling art exhibitions to the rural areas of New South Wales.[34] In 1944 and 1945 this brought in many of the artists from S.O.R.A. to provide lecturers in rural centres, and was part of a broad reorientation of art education for the community. The travelling exhibitions had two functions: community education and art patronage. The first exhibition, '150 Years of Painting in Australia', was followed by 'Some Recent Australian Painting', which included work by such artists as Counihan and O'Connor. There was no direct financial incentive, but exposure promoted official recognition of the work of artists. Hal Missingham, for example, bought Counihan's *At the Start of the March, 1932* for the National Gallery of N.S.W.

In August 1945 S.O.R.A. made an impassioned plea that the opportunity for reconstruction should not be squandered:

Reconstruction is an opportunity without precedent in this country, an opportunity of bringing together the planner, engineer, architect, doctor, teacher, psychologist and artist in an enormous integrated effort to improve the living conditions of the future . . . it opens up enormous possibilities that would so tax the ingenuity and creative ability of our artists that we should find a breadth

and maturity developing in their work to form the basis for a truly vigorous Australian art, and the basis of an art that was truly part of the daily lives of the Australian people.[35]

In *Place, Taste and Tradition*, Bernard Smith considered the new developments in art patronage to be as important as the appearance of realism in Australian art; behind both lay a new consciousness and a new orientation of values.[36] Further evidence for this sense of common purpose was indicated in a series of radio broadcasts given on the A.B.C. in 1943. Their content was summarized in the *Society of Artists Year Book* for 1943-44. Contributors included Sydney Ure Smith, Hal Missingham, Frank Medworth, Alleyne Zander and Sir Keith Murdoch. The common thrust by all these leading figures was the need to relate Australian art to Australian communal life.

Society of Artists Year Book, 1943-44

It soon emerged that, whereas many radicals and liberals condemned the narrow selection procedures for official war artists, only the Angry Penguins leadership of the C.A.S. demanded a laissez-faire policy in both official and unofficial Australian art. Bernard Smith, James Cant and Noel Counihan, and men like Sydney Ure Smith and Sir Keith Murdoch all sought a spirit of cultural consensus. Such was the continuing dream of cultural unity that, by the late war years, radicals of widely differing persuasions and leading liberals came together under the aegis of the united front to make a second — and as it turned out, the last — attempt to create an overbridging of regional and political differences. The monument to this effort, as we have seen, was the huge Australia at War exhibition held in Sydney and Melbourne in the latter half of 1945.

Hopes for a new society, socialistic or otherwise, had been raised by the Australian Labor Government's plans for reconstruction. With the establishment in late 1942 of the Department of Post-war Reconstruction and the appointment in January 1943 of Dr H. C. Coombs as director-general, Australian society under the Curtin government seemed headed towards a brave new future. That this reflected a mass movement in the population at large appeared to have been demonstrated by the sweeping A.L.P. victory in August 1943 in both houses of federal parliament. As the writer Lloyd Ross, a member of the Department of Post-war Reconstruction, declared in *Meanjin* in 1945, the 1940s seemed 'as glorious as the adventurous hopeful days of the Nineties'.[37]

Catalogue for the communist-initiated Australia at War Exhibition held in 1945

It was obvious that the wartime atmosphere produced in groups of the intellectual élite, such as those around *Meanjin*, the 'recurring dream of an Australian "Renaissance" '.[38] In the issue that saw the article by Lloyd Ross, the editorial declared that the foreseeable end of the war was 'an end and a beginning . . . in so far as the determination of the Australian future depends on the Australian people, it depends on their power to imagine such a future as they want and can believe in'.[39] In common with other members of the left, Ross held that no lasting cultural change could

be achieved without the development of a popular base; social and cultural change should reinforce one another. It was imperative that the A.L.P. drive towards socialization be given genuine mass support, and the associated cultural change must also begin by 'building, enriching, expanding the local, voluntary, spontaneous, development of our people — though we retain an ideal of a nation linking communities into a national endeavour'. Ross felt, as did all radicals, that Australians were 'being offered the greatest opportunity in our history — the opportunity of harnessing democratic vigor to artistic effectiveness'.[40]

The degree of this democratic idealism was attested to by the new flood of intellectuals into the Communist Party in 1944.[41] As with the earlier influx during the 1930s, it was matched by a radicalization of many who did not go so far as to profess a fellow-travelling status. Such was the case with men like John D. Moore in Sydney and Richard Haughton James in Melbourne. Moore had been a close friend of Basil Burdett in the 1920s and 1930s and his advanced liberal-mindedness and open sympathies earned him a dismissive reference by Lionel Lindsay as 'that Irishman!'.[42] Moore typified the small group of artistic liberals who wanted in the 1940s to open out and breathe new life into the established art societies.

The *Australian Artist*, 1948. After the demise of *Art in Australia* in 1942 and *Angry Penguins* in 1946, this short-lived effort was the only magazine dealing with the visual arts in Australia on any scale

In practice, where such men parted company with left-wing artists in striving for the goal of a cultural renaissance was in their firm belief that the artist's primary job was to produce the best art possible and that such art was beholden to the values of no officialdom or popular mass audience. That was the point upon which the Angry Penguins differed from those who formed the Australian War Memorial Board as well as those who put so much energy into popular front activities. Much of the energy of the Angry Penguins movement went into creating a living art, and by 1944 they had left art education and the public proselytizing to others — all that concerned them was that others should know where they stood.

Monetary Rewards

Before discussing the concept of patronage and milieu that the Angry Penguins and various groups evolved in the 1940s, it is timely to consider the financial state of the artist. What was the truth behind the art boom between 1943 and 1946? This question was a central concern of Richard Haughton James, who became one of the liveliest figures in the Melbourne art scene when he took over the editorship of the newly established art magazine *Genre* in 1946. Under James, what seemed destined to be an old-fashioned and stuffy, locally directed magazine was transformed into the imaginative *Australian Artist*. He used its pages to publish an extensive survey undertaken in 1947 on the buying habits of the Australian art public and the financial condition of artists in Australia

generally. After questioning art dealers and artists, James concluded that the demand of the Australian buyer was 'largely *confined* to landscape painting . . . because Australia has traditions in absolutely no other form of art' that could challenge it.[43] Comparing prices of paintings, Sydney's Society of Artists stood at the top. With its limited membership of fifty artists, it commanded an average price for oil paintings between 25 and 35 gns. With regard to private galleries, the best price recorded for an oil painting in 1947 by the Athenaeum was 25 gns, while Georges' Gallery reported 20 gns.

As far as the Contemporary Art Society was concerned, the sum total of sales from the 1944 annual exhibition was a mere £122 5s 0d. This was for thirteen pictures from an exhibition whose attendance was estimated at 5000 and at which 1600 catalogues were sold; Reed thought the result quite satisfactory.[44] Quite clearly the expectations of radical artists and their supporters were not great, and none of the leading members from either Melbourne or Sydney sold work on this particular occasion. Nonetheless, the prices asked for their paintings seems relatively high, even compared with those of the Society of Artists. One must dismiss the subsequent conviction that masterpieces could be had for a pittance in those days. In comparing listed prices with today's (and these were what purchasers were expected to pay), C.A.S. paintings were not cheap. Boyd, Nolan, Vassilieff and Counihan, for example, were asking an average of between 30 and 50 gns after 1943. This was a considerable increase in Nolan's case from his exhibition at Sheffield's newsagency in Heidelberg in 1942 where the highest price for a painting was £3; but that was an occasion when, as Reed recalls, Nolan felt 'that they should be accessible to anybody at all who might want them irrespective of what they could afford'.[45] As Reed also recalls, none were sold even at these prices.

The figures give an indication of what artists could expect to be paid for a canvas that accorded with bourgeois preferences or with the criteria of those in authority in the various state galleries. They do not, of course, give any indication of the relationship between aesthetic quality and monetary value. Haughton James reaffirmed the point that, far from elevating art, or being the product of an improved public taste, the art boom gave galleries 'a shoddy harvest'.[46]

If it was rare for any of the Angry Penguins or the social realists to sell work through C.A.S. exhibitions, occasional sales might be made to friends or lay members of the Society. John and Sunday Reed bought Albert Tucker's *The Futile City* from the C.A.S. exhibition in 1940 for 25 gns. This, however, was an exception, for as a rule the Reeds felt that their ceiling was 10 gns. Prices like these gain perspective when compared with other art sales. Major works by the leading exponents of the pastoral tradition always commanded the highest prices: in 1940 the National Gallery of Victoria acquired McCubbin's *The Lost Child* for 100 gns and Gruner's *Bellingen Pastorale* for 300 gns, while Streeton's

Sidney Nolan's second unconventional exhibition: paintings in the window of Sheffields' newsagency in Heidelberg, c. 1942. In attempting to reach ordinary people in the street, he priced the works between 5s and £3.

Arkwright Valley commanded 600 gns.[47] The Streeton purchase was the highest price paid for an Australian canvas by the Felton Bequest up to 1946. By comparison, the National Gallery of N.S.W. was prepared to pay £1500 for what was thought to be an early Gauguin. Even Australian modernist works, however, did not necessarily fare badly compared with European modernism. The National Gallery of N.S.W. paid £250 in 1939 for a Derain landscape, while in 1945 Russell Drysdale received £210 for *Walls of China*.[48]

Closer to reality, most Australian painters had to be content with less. The National Gallery of Victoria paid Arnold Shore 40 gns in 1940 for *Vegetable Garden*; the National Gallery of N.S.W. bought William Dobell's *Boy at a Basin* for £42 in 1939, and in 1944 Sali Herman's *McElhone Stairs* for £27 6s 1d. The great win for any artist was a prize such as the Archibald. Its value varied, but in 1943 Dobell received £429 16s 7d.[49] If foremost artists ought reasonably to expect to earn an income approximately equivalent to the annual salary of the head of the painting school at the Melbourne National Gallery, then such a win would be about equal to it. In 1946 this position was advertised for between £400 and £500 per annum, and that of drawing master for £300.[50] Compared with these figures most artists fared poorly, although it is impossible to be precise. As a comparison James used the annual salary of a Grade A journalist, £780.[51] He spoke for most artists when he lamented the unhappy situation in Australia where much lip-service was paid to art but precious few could live by it. Even an artist who was as successful by 1945-46 as Drysdale was unable to rely on painting sales for a living.

If art was to make its fullest contribution to Australian life, new ways of supporting and remunerating artists had to be found. One way was to make art cheaper and more accessible. James held that 'Today's patrons should not only be the rich but also the ordinary man on ordinary wages, not only the State or the Church, but also the business house, the public corporation and the Trades Union.'[52] Education was important but so too were new ways of selling art. While in Sydney he had persuaded artists to sell lesser works at bargain prices and after his discharge from the army he continued the practice in the Victorian Artists Society. During the rise of the Contemporary Art Society the V.A.S. had tended to languish, becoming a body for amateur and Sunday painters. Unlike the Society of Artists in N.S.W., it had no membership restriction and the presence of artists of the standing of James Quinn, George Bell and Orlando Dutton lent it an aura of professionalism. James, however, was at a loss to understand the complacency over poor sales in the traditional spring and autumn exhibitions. Elected to the council in 1947, he attempted to refurbish not only the Society's magazine but its whole structure and approach to art. In this he had the support of other liberal-minded members like Len Annois and James Quinn and laymen like Percival Serle; and above all, the new communist members, who included Noel Counihan, Vic O'Connor, Yosl Bergner,

The facade (dating from 1892) of the Victorian Artists Society premises in East Melbourne after a face-lift in the early 1950s

Rem McClintock, Nutter Buzacott and James Wigley. Doubtful about liberalization, let alone radicalization, of the V.A.S. were men like George Bell and William Dargie.

Haughton James used the *Australian Artist* as his main vehicle for the assault, but earlier shafts had been launched from *Genre*:

Today radically different views must be taken of Art Societies. Since the time when the machine age came fully into its own, artists have been little more than decorative adjuncts to those classes who could afford their services. They were driven together for mutual protection and solace in an unfriendly world ... What are the functions of an Artist's Society if not to enrich to the utmost, through the diverse gifts of its members, the whole community?[53]

The aim was to make the V.A.S. a centre for Melbourne's cultural life through a co-operative social and aesthetic revival and to take full advantage of its impressive premises. Accordingly, James launched a whole raft of proposals intended to carry the Society into a more prosperous and exciting era. Most of the ideas for change remained on the drawing board but the *Australian Artist* was a first-rate publication. For a brief Indian summer new life was breathed into the Society. The 'bargain sale' of sketches and studies in March 1947, for example, was but one of a series of regular exhibitions on different aspects of art held in 1947 to replace the twice-yearly exhibitions.[54] Members were allowed to submit four works each and no picture would be priced above 3 gns. Although conservative members felt uneasy, fearing that this would lower the status of their own more imposing efforts, the result was a spectacular sell-out. Not only that, but people who might normally have thought the

Work at Heide: John Reed bringing up the cows, c. 1945. Milking itself might involve anybody, artist or poet, who happened to be present

purchase of a painting beyond their means flocked to Albert Street to get the best pickings. The *Argus* reported that nothing like it had ever happened in Melbourne before: 'there was shuffling room only when the exhibition was declared open.'[55]

By this time the Adelaide and Melbourne branches of the C.A.S. were moribund, and the Sydney branch was safely in the hands of more cautious modernists. In retrospect it is possible to see that the final breakdown of any co-operative effort in 1944 was a turning-point. Communist members had directed their main efforts elsewhere, while for their opponents more informal supportive groups were increasingly important. Like James, others began to explore less conventional forms of patronage.

None of the artists considered in this study, whether radical in political or aesthetic terms, or both, was able to survive in the 1940s by sales of individual pictures alone. Yet at the same time, the Angry Penguins especially were committed to the belief that the business of being an artist was a full-time affair and a way of life. Whereas others sought solutions in new kinds of public patronage, the Angry Penguins turned to private arrangements.

Support and Nourishment

Tucker's is the best documented of such efforts and illustrates both the strengths and weaknesses of such support. In 1941, when he was simultaneously avoiding military authority and struggling as a freelance illustrator, he hit upon a novel scheme. He sent copies of a letter to twelve lay members of the C.A.S. proposing that each might consider contributing 7s 6d a week; this would add up to a living income and provide him with freedom and the time to work. After six months contributors could each select a painting, in effect bought by instalments. All except John Reed and Guy Reynolds, however, either refused or neglected to reply. In Reed's case the idea was a basis for the support which he and Sunday extended to the artist for more than ten years, continuing after the artist left Australia for Europe. From about 1942 Tucker received from them a regular weekly stipend of £2: in January 1946 the arrangement was put on a more formal footing and increased to £6. Reed made this offer on the basis, as he put it, of a recognition of Tucker's 'value to the community as a painter and as a social thinker'.[56] Under the scheme the Reeds occasionally accepted paintings in return while also buying works. Such is the nature of the artist-patron relationship that although the association was of value to both parties, it was often strained near breaking-point, as we have seen. In fact, Tucker replied to Reed when the offer was made that he could only accept because Reed offered it without any specific obligations.[57] He was able to supplement his income with occasional sales to other friends and the odd portrait commission.

'Shuffling room only': a bargain sale of sketches and drawings at the Victorian Artists Society, 1947

For a time he also worked for Arthur Boyd and John Perceval in their Murrumbeena pottery, where they manufactured moulds for crockery.

John and Sunday Reed extended similar support to Nolan and Perceval. After 1943 Perceval received a weekly stipend of £1, which he collected from the *Angry Penguins* office. It was understood that any paintings acquired by the Reeds in return were in the nature of gifts. The degree of direct financial support given to Nolan is not known but help was given before he entered the army at the end of 1941 and continued after he left it at the end of 1944. Nolan's relationship with the Reeds, like Max Harris's, was closer than that of fringe-dwellers like Tucker, Perceval and Boyd. Nolan was supplied with masonite and ripolin as well as other artist's materials. After 1940 he spent much time at Heidelberg and, as a partner of the Reed & Harris firm, no doubt drew some kind of salary.

A gathering in Arthur Boyd's Murrumbeena studio, c. 1945: David Boyd, Mary Boyd, Arthur Boyd, Joy Hester, Myra Skipper and Matcham Skipper

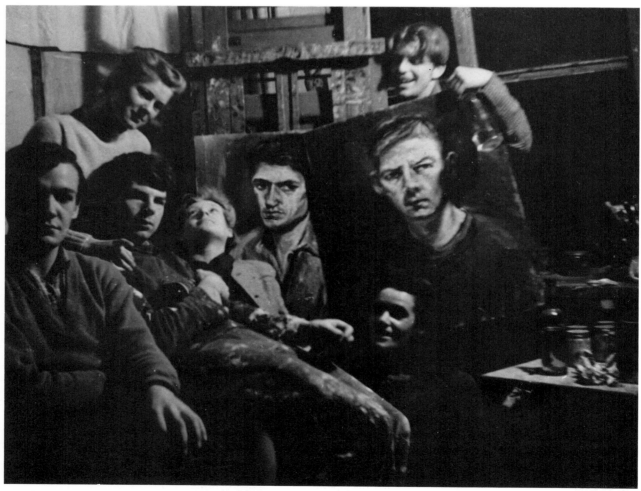

In relative terms Arthur Boyd probably sold better in the late 1930s and in the 1940s than most of his artist friends. He could always produce a landscape that would sell and was not averse to the occasional 'pot-boiler'. Success had come early; in 1940, when Boyd exhibited in a joint show with Keith Nicol, Murdoch bought six of the pictures on Basil Burdett's advice. It was less easy to sell the later more expressionistic and experimental work but young academics and university students bought the occasional painting after patronage by wealthy buyers fell away. By 1944 Boyd too was married and out of the army. Together with John Perceval and Peter Herbst, a student of philosophy and newly arrived refugee on the *Dunera*, he started a pottery in an old butcher's shop. The immediate aim was mass manufacture of utilitarian crockery to meet the demand caused by wartime shortages. Later more decorative ware was produced but at this stage products were marketed through the Ministry of Labour and National Service. Profits were meagre but the three were able to make a living and also to hire Tucker. The aim was always to earn enough to live and therefore to paint.

The unique studio designed for Arthur Boyd by his cousin the architect Robin Boyd in the grounds of the Boyd house at Murrumbeena

By dwelling on the bread-and-butter aspect of the relationship between artists and art supporters, one risks underplaying other dimensions of support. These involved the creation of a supportive and nourishing cultural milieu. In Melbourne at this time there were three general focuses for artists of advanced views: the Reed household at Heidelberg, the Boyd 'commune' at Murrumbeena, and the houses and establishments of the left in the city and inner suburbs. Patronage cross-connected between these and occasionally overlapped — not always with happy results. Artists from whom the Reeds bought paintings but who were shut out from additional support might be inclined to think of the Reeds' buying attitude as parsimonious. Even the lifestyles of each group could vary sufficiently to occasion friction. Yosl Bergner visited Heide only once. This dispossessed refugee was at a loss to understand why apparently wealthy people, Australian representatives of the *haute-bourgeoisie*, should affect a peasant-like simplicity in the food they ate and the manner in which it was served on a scrubbed refectory table. He explained, rather defiantly, that his own lack of decorum was due to the fact that he had only come for vitamins and protein.

Communist artists were more comfortable at the drinking bouts of the Swanston Family Hotel or in the intellectual atmosphere of the homes of Vance and Nettie Palmer, Frank Dalby Davison or Jewish friends. Davison, who opened the 1946 Three Realist Artists exhibition, referred to the social realists and their friends in affectionate terms as the 'Irish-Hebrew clan'.[58] The Jewish families in Carlton and Princes Hill, many of them recent arrivals from Poland and Germany, tended to be separate from the established Australian Jewish community centred in St Kilda. Many such refugees, the Tauman, Lippmann and Singer families, for example, brought with them an appreciation of art and a cultural breadth rare anywhere in Australia. Vic O'Connor recalls a respect and under-

standing that he hardly ever received elsewhere. Added to this was the close sense of community that characterized Carlton Jewry — in itself a protective response to the alienation of the surrounding Australian suburbs and the inaccessible enclave of established Jews. Many Jews were left-wing and in the war years the Kadimah cultural centre provided a focus for meeting and for occasional exhibitions. Jews occasionally bought paintings, but the more important support was the warm sense of community and the values of a wider world of European humanism which they brought with them as cultural baggage.

Arthur Boyd sometimes visited Heide, but not as regularly as John Perceval. For Boyd, a visit to the Reed establishment was an event: 'it was really *going out* when you went there.'[59] Nolan's latest paintings were invariably on show, and occasionally recent work by Tucker. While this was stimulating, as was the always lively discussion, there were also dangers to be encountered in the strong partisanship of the group and the certainty with which judgements were made and applied. As Boyd recalls: 'I found that it was best to keep a fair distance because you could get "eaten up" . . . you could be absorbed into a world where you could feel too inhibited to break out of and I never liked that idea.' Rivalries could also often disrupt the harmony of Heidelberg. Perceval once upset everybody by telling Nolan that he could not draw. Albert Tucker's references to Nolan's art as 'magnificent trivia' were also sufficiently ambiguous to occasion friction.

Boyd tended, then, for both temperamental and artistic reasons, to stay aloof from the Reed-Nolan-Harris circle. His closest connections were with a quite different circle of intellectuals, a Melbourne University-based group of whom Peter Herbst and Max Nicholson were the leading lights. Also generally left-wing in tone, it foregathered in the private rooms of the Mitre Tavern Hotel, or in the rooms above Rawson's Left Book Shop in Exhibition Street. This group also included Brian Fitzpatrick, Bill Cook, George Paul, Tim Burstall, Brian O'Shannassy and Dyn Howell, while the followers of Justus Jorgensen might sometimes join them. As a mark of their university backgrounds they were sceptics by training as much as by nature and looked askance at the 'line' which Reed & Harris ran in *Angry Penguins*. Herbst saw them either as gifted autodidacts or 'originality mongers', whose note of high seriousness all too often sounded precious when it was not pompous.[60] By contrast he and Nicholson strove for incisiveness in their analytical attacks on questions ranging widely through the fields of art, aesthetics, society, culture and ethics.

These values distinguished the tone of the afternoon and evening gatherings in the Boyds' 'brown room' and in the backyard studios designed by Robin Boyd at 'Open Country', the Boyd house in Murrumbeena. They were invariably lively, utterly unpretentious, and always refreshing in the unpredictability of proceedings that might range from intellectual games involving discussion of sophisticated philosophical

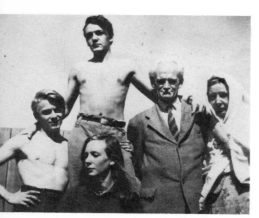

'Aristocratic poverty': the potter Merric Boyd and his wife Dorris with David and Mary Boyd and Mary's husband John Perceval (left) at Murrumbeena

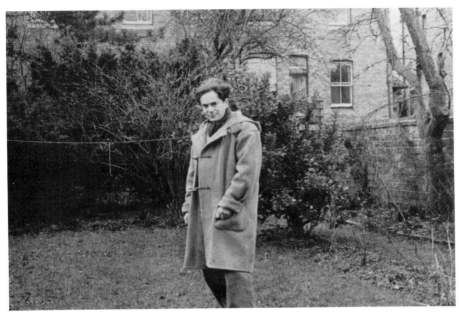

Peter Herbst, a refugee who arrived on the *Dunera* in 1940, was soon a student of philosophy, a potter, and a friend of John Perceval and Arthur Boyd

Max Nicholson, a close friend of the Boyd family and a lively presence on the Melbourne art and intellectual scene in his self-appointed role of guide and mentor

questions in which only the most prosaic language was allowed, and readings from Dostoyevsky by Max Nicholson, to Biblical declamations by the imposing prophet-like figure of Arthur Boyd's father, the potter and patriarch of the tribe, Merric Boyd. Heide gatherings, for all the communal bohemianism, had a certain rarefied air. Murrumbeena exhibited a rather more relaxed style where get-togethers resembled nothing so much as an Aboriginal jamboree. Franz Philipp quotes a friend of the Boyd family: 'In my teens I loved to go to the Boyds because they were so unconventional — always interesting people and stimulating conversation on art, books, philosophy and religion.'[61] Many of the Herbst-Nicholson push might be present but almost certainly there would also be Alan McCulloch, John Perceval (by 1944 married to Mary Boyd), and David and Robin Boyd. Albert Tucker was also a frequent visitor. The casual and eccentric character of the Boyd milieu was, as Franz Philipp notes, 'hardly middle class suburbia — neither materially nor in its mental climate ... The old rambling home with its overgrown garden ... sheltered an artist family which tended to overflow into an artist's colony. The ordinary problems of daily life and sustenance were treated with insouciance if not disregard'. Such a lifestyle was the product of three generations of artists and represented, as Reed has written, 'the closest we can find yet in Australia to a sense of tradition'.[62]

In the 1930s there was, as we saw, a more conscious attempt to flee from that encircling belt of culturally constrictive suburbia. By the 1940s the Reed farmhouse was established as a focus for radical artists, writers, jazz musicians and intellectuals generally. If some visitors felt constrained by the intellectual, even the emotional, intensity of the

Sunday afternoon gatherings, there was always another face to the activity. There were, for example, the notorious wild nights of jazz with the Graeme Bell band in an adjacent shed. There was almost always at least one artist or writer in residence — sometimes in flight from military authority. Nolan, for example, rejoined the Reeds at Heidelberg when he went absent without leave from the Watsonia barracks at the end of 1944. Around this old farmhouse, now painted in a Mediterranean pink mixed by Nolan, the contrasts were striking. At the front was an immaculate English garden bounded by a lavender hedge and a long, curving, raked-gravel driveway; behind the house lay a less formal landscape in which the grass grew long and open paddocks extended down to the banks of the Yarra. The roof itself of Heide for a time in 1941 displayed the huge yellow symbolic form of *Boy and the Moon*. This was soon painted out, however, when military authority objected to so striking a landmark adjacent to a strategic bridge over the Yarra. The poet Barrett Reid has provided a vivid description of the scene at Heide when he arrived in Melbourne early in 1947:

That first morning when I walked in, the hall was full of paintings. The dining-room was a studio with tins of ripolin, bottles of oil, a scrubbed long table and on the walls many charcoal drawings of bearded heads. I saw real painting, free and authentic, for the first time.[63]

Barrett Reid, young Brisbane poet and editor of the magazine *Barjai*, c. 1947

There was another facet of Heide, the attempt to live in a 'natural' and harmonious state with both the physical environment and with others. It is as easy today, given current fads, to parody such attitudes and lifestyles as it was in 1950 when Angus Wilson described the decor of a somewhat similar radical-liberal household as all 'oatmeal fabrics and unpolished oaks'.[64] Yet the real meaning of John Reed's 'organic' values and relationships can be seen in contemporary photographs of him bringing cows up from the Yarra flats, for milking, of Sunday Reed's gardens (the large, functional kitchen garden and the walled 'heart' garden), and in the free and intimate relationships between friends. It was a world of work as well as play, with everybody contributing, a world far from the conventional image of patron and patronized. Certainly, not everyone found it to his taste. Albert Tucker, whose photographs so graphically preserve such moments, never warmed to a world that could all too often be precious, nor to the intimate relationships that were altogether too 'hot-house' for a man of his temperament.

The important thing was that ideological values were reflected in everyday matters. The world of Heide was a real attempt to locate art and the artist, together with those who worked with artists, in a more natural and nourishing milieu. The Reed & Harris firm was more than a publishing venture, just as the relationship between artist and patron was more than monetary. For John and Sunday Reed, the patron was the one who benefited: the artists 'patronized *us* by admitting us into their creative world'.[65] The very word 'patronage' was a pejorative one.

The view north from Heide, looking over the contrasting formal walled 'heart' and kitchen gardens to the milking shed with the tree-lined Yarra beyond

Neither then nor since have the Reeds thought of art works as articles of commerce — an attitude also shared by the artists. Nolan, Tucker, Perceval and Boyd made a point of not having the prices of their paintings printed in the 1943 C.A.S. catalogue. This would appear primarily to have been a gesture of protest against the idea of an artist hawking paintings in the public market-place; instead, the prospective buyer was required to negotiate on a private basis. Only Tucker and Perceval continued the practice in 1944, although Nolan adopted it again in 1945. In supporting a small handful of artists whose work seemed to be the most aesthetically radical, and the most adventurous in terms of subject matter, John and Sunday Reed sought to share a common creative concern for new aspects of human experience. Where appropriate, the relationship between artist and supporter was based on friendship or, at the very least, on a sense of mutual involvement. As Reed has put it, 'Painters were just painting and we were just with the painters and we loved the paintings and the painters'.

Without underestimating the enormous value of financial support to

the artists concerned, the creation of a sense of community, with whatever tensions this in turn often generated, was the crucial thing. For Reed, the role of the patron was to promote. In this enterprise, journalism and art, the publication of poetry and prose, leadership in the Contemporary Art Society and financial support of artists, conjoined as one effort:

We felt ourselves involved with the tremendous upsurge of vitality in the total art world which included literature as well as painting and came to include music as well. We wanted to play our part in it and our part seemed to be to act as a stimulus and also as, so to speak, the intermediary between the artist and public [through which] the public could make contact with the artist.[66]

Attitudes towards questions of patronage on the part of artist and patron alike lie at the very heart of the artist's perception of his role as an artist and the function of his art. Dore Ashton writes of the experience of the American artist:

each successive revolt, every attempt to create a national standard of professionalism, seemed to founder on the problem of patronage. The very first art academy in New York distintegrated when its founders — the wealthy partners and *their* artists — demanded obeisance. The choice was almost always to be a dutiful artisan, a polite courtier, or a pariah.[67]

Australian artists were familiar with each of these types of expectation on the part of the wealthy and the powerful. Their response during the war years was to attempt to develop new relationships between artist and community. If the left advanced ideas of a public art, realistic and accessible, based on the notion of a mass audience of the people, the Angry Penguins tied the needs of individual artists to small communities of sympathetic supporters, whose role was to help promote new values and new art. Given the atmosphere of intolerance which the war years engendered, it is hardly surprising that anarchists should have seen the activities of communists as populist politicizing, or that the left should have seen them, in turn, as élitist and opportunist. From a broader perspective we can now see that the efforts of Bernard Smith, John Reed or Haughton James were, each in their own way, attempts to end the alienation of Australian artists who refused to act as 'dutiful artisans' to any master. Yet beyond that there was considerable truth in the respective ways in which communists and anarchists saw each other. The left did argue that the artist was but one member of a people and that the values of the people determined, *ipso facto*, that art must be popular. Their opponents argued that the artist, as an individual, possessed (if he were radical in an aesthetic sense) a uniqueness that set him quite clearly apart from the larger community. To underscore this rejection of popular values, in 1944 *Angry Penguins* published an aphorism by Nietzsche under the heading 'A Post-War World': 'A nation is a detour of nature to arrive at 6 or 7 great men — Yes, and then to get around them.'[68]

Summer at Heide: John Sinclair with one of many pets that were part of the extended family

The Angry Penguins movement was unashamedly élitist as to intellect and the creative spirit. In defending élitism, Harris, Reed, Nolan and Tucker faced .a difficult task. On the one hand, like Nietzsche, they believed in the rarity of the creative individual and his capacities as a seer and social critic which set him apart and, perhaps, above others with lesser imaginations and capacities. On the other hand, they also believed, as much as their opponents, that the artist was inextricably linked, socially, psychologically and culturally with community and place. In resolving this apparent contradiction, Herbert Read's ideas were central. As Read stated in *Art and Society*: 'We are all born artists . . . and become insensitive citizens in a bourgeois society.'[69] There is, in these terms, a psychological level that links the creative spirit in all men. We begin with this heritage and it is the artist who retains or rediscovers a human capacity in the face of adverse social pressures and conditioning. For Herbert Read, the aim of the individual man and of society had to be a return to this lost state.

If their language and attitudes, which stressed the uniqueness of the activity of the creative artist, left the Angry Penguins open to charges of subjectivism and élitism, they were unrepentant. As Reed made clear to the War Memorial Board, the artist should not be expected to conform to normal social strictures and mores. The 'normal' was in their eyes contrasted with the 'natural'. Whereas the conservative and communist expected the artist to articulate the values of a people, Reed could see

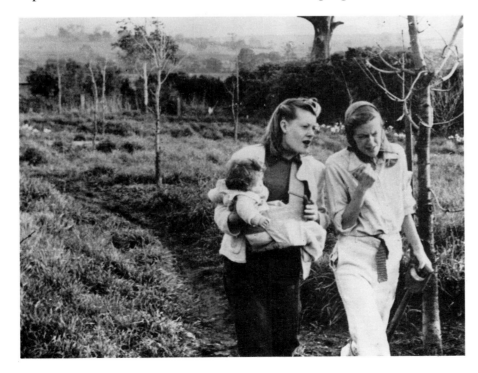

Joy Hester holding her son Sweeney with Sunday Reed at Heide, c. 1946: a world in which art, talk and chores were all part of a natural daily regimen

no obligation except being true to one's own subjective or psychological experience.

In *Australian New Writing*, Reed repudiated the claims for popular realism made in the vociferous campaign of the left. This, he held, invariably led to dogmatism and a misunderstanding of the true nature of the role of the creative artist. Reed argued that it was unrealistic to expect that an artist should tailor art to meet the demands — invariably debasing demands — of a mass audience. People had to be educated up to the level of the artist since levelling was self-defeating in art. Instead of the left-wing catchcry, 'take the art to the people', it should be 'take the people to art'.[70] The artist led the way in the recovery of innocence and a new awareness of where the forces resided that denied the fullness of experience. Nine years later Harris still found it necessary to defend these ideas against left-wing attacks upon the 'spurious richness of the inner life'.[71] Harris wrote:

Our sort of humanism lacks direction in your eyes. You do not believe that art reflects human authenticity at all levels, and you resent the concept of freedom that such a belief implies.[72]

After 1943 the chief dangers to the Angry Penguins' values and beliefs were seen to come from the left. In the late 1930s they had also come from artists like George Bell who believed in an art based on formalist principles. By 1954 the pendulum had swung back to the point where

A gathering of friends: Christmas at Heide, c. 1945, with Sidney Nolan, Sunday Reed, John Sinclair and John Reed. This picture captures the flavour of the new relationship between artist and supporter that the *Angry Penguins* circle fostered

Reed and Harris had to defend an art of individual experience against communists, on the one hand, and more abstract painters on the other. In 1954 James Birrell summed up the aims of the art for which the Angry Penguins had campaigned over two decades. Artists must believe, he wrote, in human personality and creativity if they are to express contemporary reality in emotional terms. They 'must find the symbols that will relate man to tradition, discover harmonies between his soul and his environment and lead him to a new integration of life'. Otherwise the depths in man, from which might come the most creative impulses, will merely be discharged in 'instantaneous animal grimaces, and civilization will deteriorate'.[73] Ten years later John Reed continued to affirm that society's greatest asset is in the individual artist as a 'creative personality':

The artist must be ... encouraged to speak freely in the 'language' which he feels is essential to him for his self-expression, and we must try to learn the language.[74]

John Reed agreed with Herbert Read that the cause of the divorce between the artist and the public is the nature of modern society, which is reflected in a corresponding failure to achieve the unity of primitive societies.

For Counihan, O'Connor or Bernard Smith, concepts of anarchism in life and an autonomous art represented the last gasp of bourgeois society. But as Max Harris put it in 1953 in defending the integrity of laissez-faire social views:

The creative process just happens: it is not directed by political convictions. Social responsibility as one man against other men, is a matter of conscience. There are no special roles.[75]

A more Australian Max Harris at Heide, c. 1946

This position, and the patronage that went with it, produced some of the best painting in Australia between 1943 and 1946. But by the end of this period all radical artists felt like outsiders. The left-wing aspirations for a brave new Australia collapsed in the face of the reaffirmation of bourgeois values in the years following the war. But until the post-war years both groups wrought for themselves a sense of community in keeping with their respective conceptions of the role of the artist. It was a response that was in both cases potentially creative but which carried the seeds of its own disintegration once faced with real changes in Australian culture and society. Harris saw this very clearly when he wrote in 1946 that 'A war generation finds itself in a strange state of dispossession, and is forced to a level of social superficiality which is root cause of its triumph and its tragedy.'[76] In the short term, neither group managed to make deep-rooted changes in the patterns of patronage within official art institutions or in the wider art public. By 1946 both were faced with new and unsympathetic cultural interests that confronted them at every turn.

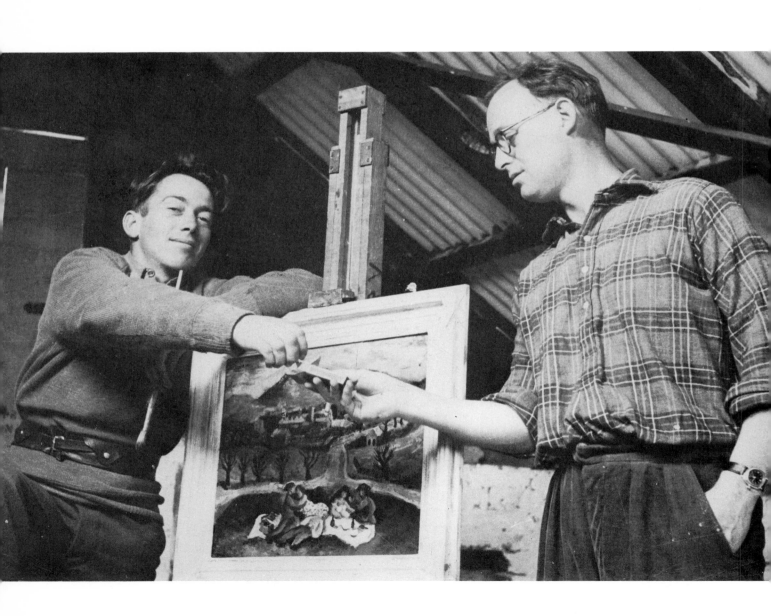

CHAPTER NINE
CULTURAL RECONSTRUCTION
The Rise of a New Establishment

This is a period of transition, we are at the beginning of a new cycle, and ours
is a new spring.
 Paul Haefliger (1946)

A changed political climate was evident by 1944. Progressive artists of
all kinds looked towards a new Australia founded on new professional
roles for the artist and on new institutions of patronage. But the changes
were rather different from what radicals had hoped to see. By the end
of the war it became clear that an establishment had emerged whose
benign face masked attitudes as intractable as those of the old guard.

The Dobell Affair

The Archibald Prize litigation of 1944 illustrates the changes. On the
face of it, the dispute over the award of the Archibald Prize to William
Dobell was a victory for modernism and for artistic radicalism — that,
at least, is the conventional interpretation. The outcome, it is said,
decided nothing less than the future of Australian art. This is a judgement
rarely challenged, but it is neither accurate nor realistic.

 The Sydney *Daily Telegraph* charted the early moves in a case that
aroused unprecedented public interest and became a *cause célèbre*. Soon
after the prize was announced in January 1944 a group of six artists,
all members of the Sydney Royal Art Society, formed a committee to
contest the award. All except the unfortunate Mary Edwards and Joseph
Wolinski, who drew the short straws, remain forgotten. The *Telegraph's*
art critic, Raymond Lindsay, spoke for most observers in describing the
attitude of Dobell's opponents as 'mean and intolerant'. Almost immedi-
ately a second group of conservatives calling themselves 'Citizens inter-
ested in art' each subscribed £40 towards the cost of a court action.[1]
At the same time the Contemporary Art Society passed a resolution
supporting the decision of the trustees of the National Gallery of N.S.W.
The final line-up of individuals and groups is highly revealing. The chief
witness supporting Edwards and Wolinski was J. S. MacDonald, whose
views and values had never been in doubt. However, the appearance on

Opposite Donald Friend and Russell
Drysdale in 1943 in Drysdale's studio,
a refurbished barn near Albury: the
painting on the easel is by Friend who,
being stationed in a nearby army
camp, also worked here

William Dobell, c. 1946

A photograph of Joshua Smith published in the *Studio*, 1945: the truthfulness of Dobell's image was all too apparent to anyone seated in the courtroom

their behalf of John Young is one of the curious aspects of the case. Young was a man who, as a one-time owner with Basil Burdett of the influential and advanced Macquarie Galleries, had the reputation of a liberal, and his decision to give evidence against the trustees confounded old friends like Sydney Ure Smith. The subsequent loss of the case and alienation from his friends turned Young into a recluse. The plaintiffs themselves were saddled with legal costs of £1500. Wolinski complained bitterly to reporters in November 1944 that what had begun as a large committee had soon dwindled to six and finally to the two of them.[2]

On the other side Dobell, as one of the victors, hardly fared better. Though the prize was confirmed, Dobell was mentally and physically debilitated by his public ordeal. He also lost the friendship of the unfortunate Joshua Smith, whose normal diffidence, which the portrait caught so brilliantly, degenerated into recessive paranoia. Among several trustees there was likewise much anguish and soul-searching. Lionel Lindsay had, for example, voted for Dobell. On the one hand Lindsay thought the portrait a subtle and imaginative work, but he was also troubled by an aspect which he described as a 'melange of Rembrandt's glamour and Daumier's caricature'. Within one day of the vote his doubts were such that he could only describe it as a work of extreme decadence: 'a macabre transfiguration of that sick and famine exhausted Joshua (Son of None!) ... a sort of bloated rococo statement — Rembrandt, emasculated and a cocaine addict!'[3] Lindsay decided that he had betrayed his own principles as well as his responsibility towards the trust and ought therefore to have abstained from voting. Now he felt he should resign.

What is abundantly clear is that by 1944 the conservative hegemony of art patronage and institutions had long since ceased. By 1940-41 the Society of Artists was no longer the old comfortable club; conservatism was in retreat there too. Indeed, by 1944 the Society of Artists was more like the open and catholic-minded body Ure Smith had hoped the Academy might become, and the Archibald case was won by its leading members: Frank Medworth (a recent arrival, lecturer in charge of art at the East Sydney Technical College and briefly acting director of the National Gallery), Douglas Dundas, the sculptor Lyndon Dadswell, and Dobell himself. If the trial demonstrated anything, beyond what Whistler had discovered long before (that the law had no business with aesthetics), it was that a new establishment had already emerged. The idea that the Supreme Court of N.S.W. between 23 and 24 October 1944 was the stage on which the old guard was utterly routed does not fit the facts. The forces of reaction and radicalism were, in fact, not nearly so neatly lined up. Mr Justice Roper's finding in favour of the defendants, the trustees of the National Gallery of N.S.W. and Dobell, that the *Portrait of Joshua Smith* was a portrait and not a caricature, did not change the *status quo* one iota. That change had occurred three years before. The litigation was nothing more than a desperate rearguard action by those

already passed over. Otherwise, the case is of interest only to the degree that it devastated the key participants.

Sir Keith Murdoch, Proconsul

Although the Contemporary Art Society supported Dobell because it recognized a common enemy in academic mediocrity, the Melbourne leadership held serious doubts about the whole affair. It was increasingly clear that the idea of a 1930s-type confrontation between reactionaries and modernists was a smokescreen. By 1944 Sydney artists like Russell Drysdale and William Dobell were the kind of artist preferred by the new establishment. Drysdale, Dobell and Donald Friend were, John Reed argued, representatives of a group whose style of painting was acceptable to 'a certain type of person . . . unable to perceive where the truly creative impulse of the community lies'.[4] These were people like Sir Keith Murdoch, Warwick Fairfax and Sydney Ure Smith. They in turn set the tone for lesser patrons, and for National Gallery administrators. While rejecting the banality of academic painting and while aware that art must progress, they were careful to ensure that it did so within limits.

William Dobell, *Portrait of Joshua Smith*, 1943

In the Melbourne *Herald* Clive Turnbull made no secret of his preferences. In November 1943 he declared that, given the wherewithal, he would buy canvases by Rupert Bunny, William Dobell, Russell Drysdale and Peter Purves Smith, and he commended others to do likewise.[5] These, he later reiterated, were Australia's foremost contemporary artists. Reed's rejection of Ure Smith and Turnbull's opinions was less a rejection of the work of such artists than of the spurious claim that they represented the best. Dobell, he believed, had given way to what Adrian Lawlor would have called 'slithering', and the degree of his popularity testified to it. This was a harsh judgement but, as Dobell's subsequent career indicates, it was not far from the mark.

The rise of a new élite that included Daryl Lindsay as director of the National Gallery of Victoria was a major setback to Melbourne radicals. Lindsay, Reed later claimed, was 'the worst possible man that we could have as director and we really fought him much harder than we ever fought Jimmy MacDonald. He proved our worst enemy. We continued to fight him right up to the day of his retirement'.[6] The problem was that a man like Lindsay who had been associated with George Bell and the early Contemporary Group had a reputation for liberalism. The art-buying public that took its cue from taste-makers like Lindsay shared in full measure his bias against aesthetic radicalism.

The development of a new establishment can be traced in the changes to institutions such as national galleries and in patterns of patronage associated with them. A programme of reform and re-education had been launched by leading liberal art *cognoscenti* and administrators,

commencing in Melbourne through the partnership of Murdoch and Lindsay at the National Gallery. Their values, and to a lesser degree those of Clive Turnbull, gave the changes their shape and substance.

The association between Murdoch and Lindsay, beginning in friendship as early as the 1920s, only became significant after Lindsay's appointment as director of the National Gallery in March 1941. The power of a director and a chairman of the board of trustees working in harmony was felt immediately, following as it did a year of acrimonious dispute. 'Now that it is all over', Lindsay wrote to Murdoch, 'I do want you to know how truly I appreciate both the interest you have taken, and the confidence you placed in me ... It is not going to be easy but I look forward with the greatest interest to working in conjunction with you towards the same end.'[7] Lindsay had been groomed for the job for some time and the advertising for a new director to replace MacDonald was nothing more than 'going through the motions'. The chief regret that Lindsay now expressed to Murdoch was that Burdett was no longer available to act as the Felton Bequest adviser in London. Burdett's wider sympathies and more humanistic qualities had indeed acted as a counterbalance to Lindsay's conservative views when the former advised Murdoch on purchases for his private collection.

But while in matters of taste Murdoch made obeisance to his artist and art-loving friends, in empire-building, whether in art or in newspapers, he was his own man. Sir Kenneth Clark found himself in 1949 introduced to a man who 'pictured himself as a great proconsul' and was amused to discover an imposing bust of Julius Caesar in the hallway of Murdoch's house.[8] Whatever surprise this might have occasioned for Clark, Murdoch's reputation as an imperialist and king-maker was well known in Australia. From 1942, when he became chairman of directors of the Herald and Weekly Times organization, his power over public opinion and his corresponding influence in matters of art and politics were enormous.

That changes in the Melbourne art establishment and in the National Gallery might dim the hopes of radicals was foreshadowed as early as the opening of the *Herald* exhibition in October 1939. In a *Herald* editorial astute radicals might have found a note of warning. The Australian people, the editorial declared, did want modernism but not 'an unbridled adulation of modern art; what is wanted and what is most valuable is a just appreciation, based on sound knowledge'.[9] Like George Bell, a man whom he admired greatly, Murdoch attempted to take cognizance of the momentous changes in twentieth century thought and art by little more than a mild trimming of aesthetic sensibilities. The editorial in question made it clear through the use of such phrases as 'a just appreciation' and 'sound knowledge' that any artist who had the temerity to flirt with a radical and challenging modernism would find as little acceptance with the new men like Murdoch as they had with the old like MacDonald. What after all had such cautious phraseology to do with the dynamic

Daryl Lindsay, director of the National Gallery of Victoria, 1941-55

values of movements such as expressionism, vorticism or surrealism?

Murdoch frankly confessed his partisanship in September 1943 when he opened the annual exhibition of the Melbourne Contemporary Artists Group. This body was George Bell's answer to the C.A.S. and was comprised mostly of his students or ex-students. Though much of the work on show by artists such as Isabel Tweddle, Clive Stephen and Connie Stokes might be technically proficient, it was never enterprising. But, as Murdoch confessed, 'this Melbourne group is a line of country that suits me very well'.[10] Murdoch noted with satisfaction that such artists did not stray into perverse whims or inaccessible abstraction, nor did they 'convey their thoughts . . . by the dissections and vivisections of animals and humans and the painting of numerous [melting] watches and lurid colour planes'. He added that he had 'not been able to pass the language test'. Even more revealingly, Murdoch confessed that he had asked Burdett to remove Dali's *L'Homme Fleur* from the *Herald* exhibition on the grounds that it was 'an obscenity of the first order'. It was a sincere judgement and cannot be passed off as a gibe at the excesses of modernism.

Like Ure Smith, Murdoch saw the development of Australian art as something steady and continuous. The principal enemy was aesthetic parochialism as exemplified in the uncritical lauding of artists as narrowly academic as Harold Herbert and Charles Wheeler, and as mediocre as Ernest Buckmaster. Murdoch was not, however, prepared to accept any art that crossed certain boundaries of taste. One of these limits stemmed from a deeply rooted puritanism, which accounted for his rejection of canvases possessing any degree of sensuality, however innocuous. One example of fruit thus forbidden was the Renoir nude *Femme Couchée*, the purchase of which by the Felton Bequest Murdoch vehemently opposed. As he commented to Lindsay: 'I am sorry it is a nude. People do not like to see nudes displayed in public galleries.'[11] Since for Murdoch art was a civilizing force in Australian culture and society, it ought never to offend prevailing standards of public decency.

This preoccupation with the morally elevating capacity of art is a continuing theme in the words and actions of patrons, teachers and administrators who became central figures in the new Melbourne establishment: Murdoch, Lindsay and the occupant of the new chair of fine arts at Melbourne University, Professor Joseph Burke. Above all else, art that was expressive of the highest cultural values — of civilization, no less — could be identified by qualities of moderation, technical competence and comprehensibility. In 1943 Murdoch gave an A.B.C. talk called 'The Place of Art in Post-War Reconstruction'; it expressed his aesthetic credo:

Believing as I do that beauty of environment; beauty in the workplace, beauty in the living room, and in the things we touch, see and think about — beauty of form and colour and of the ideas they express — because I believe that this

Clive Turnbull, journalist and art critic, who inherited Basil Burdett's mantle on the *Herald* (top); Turnbull's short account of Australian art, *Art Here*, was published in 1947 and significantly subtitled *Buvelot to Nolan*

beauty has an ennobling, enlarging and developing influence on the human mind and spirit, and because I believe that the principles of the beauty can be set out, studied and accurately applied, I advocate a definite place for art amongst the authorities of the nation.[12]

Murdoch ended with a plea for an authoritative body to exercise control over all art matters affecting the nation.

Refurbishing the National Gallery of Victoria

Early in 1942 a campaign was launched for a new and independent Victorian gallery free from the demands of its sister institutions, the Museum and the Public Library. A committee headed by Murdoch was formed and a series of recommendations were adopted in principle in February 1944.[13] The site of Wirth's Park was reserved for a new building and the unwieldy single body of trustees was dissolved.

The delicate negotiations for the new trust took place early in 1945. One difficulty lay in the strong support commanded by R. D. Elliott (for long a trustee and enemy of Murdoch) in the ranks of the Victorian Country Party. Elliott was an especially close friend of the Chief Secretary, H. J. T. Hyland, as well as being the son-in-law of the powerful newspaper owner Theodore Fink, who had become alienated from Murdoch, a one-time protege, in 1940. Elliott unleashed a torrent of criticism against plans for reconstructing the National Gallery through his extensive rural newspaper chain. Murdoch fought back, albeit less publicly. But Elliott was reappointed, and so too was Max Meldrum after being briefly replaced.

Despite the setbacks, Murdoch declared in a press statement that the new and more streamlined trust was a 'liberal, cautious body'.[14] Both adjectives were accurate. Following the announcement in March, Daryl Lindsay wrote to Murdoch from America: 'I imagine you have had some trouble about the fixing of the Trustees Appointments. It's bad luck about R.D. . . . still we should have a working majority.'[15] Not only had Murdoch achieved this end but as a gesture towards radicals he had carried out a masterly stroke in obtaining the appointment of Allan Henderson, once a prominent member of the C.A.S. and personal friend of John Reed. The announcement was received as nothing less than outright defection to the enemy. Reed was 'horrified and shocked' and, as he recalls, 'very sadly shocked because I was a very close friend . . . I would have thought that I was completely in his confidence, but not so'.[16] Stung by the attack from a longstanding friend, Henderson wrote to Murdoch: 'I am of course to some extent hurt by his letter but I believe it will really do me good, as anyone (like the Premier for instance) who was nervous about my appointment because I might prove to be too modern, can now see that I am disowned by John Reed!'[17] Murdoch gave a laconic assurance,

'We are accustomed to rude letters from John Reed.'[18]

The leaders of the C.A.S. had earlier held hopes that restructuring of the National Gallery would benefit young artists. But the new trust was an 'anaemic compromise' and not the dynamic, democratic and catholic-minded body that vigorous change demanded.[19]

Professor without Portfolio

The idea of setting up an educational institution as an arbiter of public taste was first announced in 1943. 'I believe', Murdoch had stated in his radio broadcast, 'that the founding of a Chair at each University in Australia would be a contribution to the beautification of Australian life more practical than any other single action. The influence of one recognized leader in each community would be incalculable, for at present there is, nowhere, true authority to whom to turn.'[20] Murdoch envisaged, then, a series of locally based cultural élites, endowed with authority and giving leadership to the community by virtue of their superior aesthetic discernment.

'An Admirable Crichton of the Fine Arts': Professor Joseph Burke, who was appointed to the first chair of fine arts in an Australian university in 1945

At a dinner held in the Melbourne Club in 1944 the vice-chancellor of the University, J. D. G. Medley, estimated that the cost of establishing a chair would be £40 000.[21] Murdoch undertook that same night to put up the money, but the *Herald* endowment was intended to create a very different chair from that which finally emerged.

Even before the chair was established, Murdoch had his man. Late in 1944, while overseas, Daryl Lindsay had found a candidate in the young English art scholar Joseph Burke, a student of Reynolds and Hogarth and an authority on the art of the eighteenth century. Burke was then working in the British Ministry of Home Security. He and Murdoch were equally enthusiastic, and Murdoch confided to Burke in November 1945 that he was the favoured man for the job; the appointment was confirmed in December.[22] Once assured that Burke was not hopelessly conservative, Murdoch seems not to have seriously considered any other applicant.

Soon after his arrival in Australia the 33-year-old scholar restated the aims of the enterprise: 'to combat the deterioration of taste from which Australia, like England and America, suffers today.'[23] The means Burke favoured were based on academic scholarship. While paying lip-service to the ideals of the original very wide brief, the department he founded was modelled on the institutions where he was himself educated: Yale and the Warburg and Courtauld Institutes at London University. There were alternatives, but Burke chose an orthodox path in his difficult and ambiguous role of 'an Admirable Crichton of the Fine Arts in the cloak of a Professor without portfolio'.[24] He argued that the study of the history of the fine arts had a special significance at a time when the decline in public taste was 'so serious and widespread that only a strong

educational effort would remedy it'.[25] In the long term the educating of a community of scholars to staff Australia's main public galleries and art institutions, and the founding of similar chairs, have indeed helped to develop a more sophisticated community. But this was not a solution calculated to bring short-term benefits, or one that directly fostered a concern for Australian art as such.

The Sydney Gallery

In Melbourne reconstruction of cultural institutions was directed by a man of immense power and ambition. Although no less idealistic or ambitious, Sydney Ure Smith wielded no such power in the northern capital. One consequence was that the emergence of a new establishment there was more successfully challenged by other parties, and the Sydney art scene remained more open. A further effect was that the task of cleansing the National Gallery of N.S.W. was an infinitely more frustrating and difficult matter than the Melbourne changes. A Labor Party government made the contest more even, and curious alliances became possible. Bernard Smith established a close relationship with Sydney Ure Smith, while Peter Bellew found much in common with the less radical Paul Haefliger.

From 1940 onwards the National Gallery of N.S.W. was both a target for those favouring radical change and a battleground upon which various groups manoeuvred for power and influence. The Gallery first came under attack in mid-1940, as has been shown, for banishing forty-four works from the *Herald* exhibition to the Gallery cellars. In September the issue of the hidden canvases was raised in state parliament. By November resistance crumbled and a selection of the paintings went on show as 'An Exhibition of Continental Art'.[26] The whole issue polarized opinion and Ure Smith found himself caught in the crossfire. As a voice for moderation, he only earned the charge from John Reed of being 'semi-tolerant and patronizing'.[27]

In 1941 the rebels found a powerful friend in the new Labor Minister for Education, Clive Evatt, younger brother of H. V. Evatt. The unremitting campaign was carried through into 1943 by Haefliger, who had succeeded Bellew as art critic on the *Sydney Morning Herald*. Haefliger pointed out the antediluvian nature of a trust that had only acquired five canvases from the *Herald* exhibition but which continued to find nineteenth century academic art such as *The Sons of Clovis* (Evariste Luminais) and *The Snake Charmer* (Alphonse Dinet) worth rehanging.[28]

Radicals gained their first toehold in the Sydney Gallery when Mary Alice Evatt was appointed to the trust in March 1943.[29] Another chance followed the death of the 83-year-old Walter Lister Lister. But as late as March 1944 there was still no appointment. Everybody knew that the government had overruled the nominations of the trustees; the result was

a deadlock for three successive cabinet meetings, since Clive Evatt continued to insist that Peter Bellew should be appointed.[30] The difficulty was that, of the trustees, only Mary Alice Evatt supported him. Certainly Ure Smith felt scant affection for the man who had been given the editorship of *Art in Australia* — a man he referred to as 'The Modern Art Tramp'.[31]

Another difficulty in infiltrating the National Gallery was that these events were linked with moves to appoint a new director. Louis McCubbin, then director of the Art Gallery of South Australia, was the most favoured candidate. James McGregor reported to Lionel Lindsay that he had telephoned McCubbin to say that he was 'fixed but that as a "quid pro quo" we might have to stomach Bellew as the new trustee'.[32] Lindsay and McGregor fought to avoid this imposition at all costs, but when McCubbin heard that several trustees were on the point of resigning over the Bellew affair, he withdrew his application.[33]

Bellew also had had enough, and in a letter to Clive Evatt asked that his nomination be withdrawn.[34] In the end, William Dobell was appointed in his place. For the trust it was a Pyrrhic victory since it lost McCubbin as a consequence of McGregor's ill-considered action.

So ended one of the least edifying episodes in the history of the National Gallery of N.S.W. Apart from Mary Alice Evatt, the trustees were divided between outright conservatives who were determined to exclude the new men at all costs, and those like Sydney Ure Smith and Charles Lloyd Jones who, while disliking the presence of disruptive radicals, were attempting to give the Gallery a more liberal character. Whereas Murdoch could begin anew in Melbourne, Ure Smith had to struggle in order to drag his more conservative friends into the modern world. He continued the effort until his resignation from the trust after the collapse of his health in 1947.

Whereas Sir Keith Murdoch and Daryl Lindsay identified a reactionary conservatism in Melbourne that had to be eliminated, Ure Smith fought to reconcile all but the most parochial of conservatives and the most unreasonable of radicals. The result was a lack of effective leadership in the Sydney gallery. Between May 1944 and September 1945 it was administered by four acting directors: H. P. Heseltine, John Young, Frank Medworth and Bernard Smith. Hal Missingham was finally appointed director. The only positive achievement during the war years beyond Bernard Smith's programme of exhibitions was victory in the Archibald case. In reviewing the events of the past few years in January 1946, Ure Smith summed things up for Lionel Lindsay:

It's a hell of an uphill fight to make something of our gallery. The mess and the muddle to be cleared away is terrific and all that waste of time with Acting-Directors hasn't helped. I think that Missingham is a hard worker and quickly gets results once he can build up a decent staff around him.[35]

In the short term Missingham appeared to promise much and quickly

Louis McCubbin, son of the artist Frederick McCubbin, and director of the Art Gallery of South Australia, 1936-50

severed any connection with the Studio of Realist Art that might damage relations with the more conservative trustees. Ure Smith was more successful as a reformer in the Society of Artists. The character of this society was almost solely his creation and stood as a testament to his ideals.

Nowhere is the difference during these years between the Melbourne art scene and that of Sydney more sharply defined than in the art patronage of the respective centres. More centralized than Sydney's, art in Melbourne rested more heavily on official patronage. The achievement of radical artists and their supporters in Melbourne was great but they remained quite powerless. In Sydney the more open and diverse cultural climate was largely determined by the N.S.W. Society of Artists.

The Academy collapsed because the leaders of the National Gallery in Melbourne and those of the Society of Artists in Sydney agreed that it was a mistake. In Melbourne, the leaders of the C.A.S. knew that to survive they had to destroy the monopoly of official patronage; this was not the case in Sydney. The Sydney C.A.S. could only succeed by displacing the Society of Artists from its hegemonic quasi-official status as the real 'academy' of Australian art. The position of Daryl Lindsay as director of the National Gallery of Victoria could be equated with that of Sydney Ure Smith as president of the N.S.W. Society of Artists. In terms

Paul Haefliger, *Abstract with Violin*, 1938

The Swiss-born artist and art critic on the *Sydney Morning Herald*, Paul Haefliger: Haefliger's European-centred vision was a powerful force in shaping the direction of many young Sydney artists

of an Australia-wide culture in the 1940s this was where real authority lay. But as we saw, Ure Smith, in contrast to Murdoch, had constantly to rely on the support of wealthy, influential and all too often difficult friends. He also had to contend with opposition from the powerful interests of the Fairfax and Packer presses. Strong links existed in the war years between the Fairfax press especially and the Sydney branch of the Contemporary Art Society because of the prominent roles in its affairs played by Peter Bellew and Paul Haefliger. The Society was able, therefore, to mount a serious challenge to the Society of Artists.

By 1945, however, the Contemporary Art Society in Sydney was no longer united. It spanned groups with directions and ambitions of their own. While S.O.R.A. was attempting radical change, the aims of the Sydney Group were more modest, but in fact set the pattern for future developments in Australian art. Since it relied on mobilizing conventional patronage, it succeeded where S.O.R.A. failed. As its nominal leader, Haefliger was an ambitious and effective spokesman for a group that claimed many of Sydney's foremost artists. Since Haefliger was a personal friend of Warwick Fairfax and was also art critic of the *Sydney Morning Herald*, he was able to woo several artists away from the Society of Artists. The formation of the Sydney Group was, in this sense, a formidable challenge to its power and to its leader.

Neo-Romanticism

The Sydney Group was very different in character from either the mass movement of the early C.A.S. or the academy-like Society of Artists. It was almost totally informal. The influential Swiss-born Haefliger and friends such as Wallace Thornton and David Strachan set the tone for the group and determined who would be invited to exhibit and who would be excluded, decisions made at Haefliger and Bellette's house in Double Bay. The first exhibition of the Sydney Group held in 1945 contained work by Wolfgang Cardamatis, Eric Wilson, Strachan, Francis Lymburner, Thornton, Justin O'Brien, Geoffrey Graham, Gerald Lewers, Haefliger and Bellette. In the following year, Drysdale and Dobell also participated. For Haefliger, such an arrangement made for a 'beautiful group':

I think it's the only way any artists' group should be formed because, fundamentally speaking, there was nobody in charge. There was never a secretary or president. My wife, I and Wallace Thornton got together and said, 'wouldn't it be nice to make an exhibition together. Let's ask all the painters we think are *the best available* and have a show together' ... Nobody paid any fees, nobody attended anything.[36]

Yet Haefliger knew well which artists would find each other's company and work to their liking. Their values were, for the most part, urbane

A Byronic Loudon Sainthill, c. 1946: the heavy-handed romanticism of Alec Murray's photograph reflects something of the character of the world created by many Sydney artists as a barricade against the realities of wartime Australia

and European. Almost everybody had spent a considerable period in the 1930s studying in Europe. A number also belonged to that loose melange of painters, designers and aesthetes known as the Merioola group.

Now collectively labelled as the 'charm school', the art of these peculiarly Sydney talents found its verbal apotheosis in Haefliger's sentimental and emotional prose. In reviewing the first Sydney Group exhibition, Haefliger pointed out its wide variation in approach: from the Poussin-like character of Jean Bellette's classically inspired imagery, as in *Electra* (1944) to the symbolism of David Strachan and the sentiment of Drysdale's early outback towns. There was for Haefliger, nonetheless, a common quality: 'the effervescent flavour of the unexpected'.[37] Increasingly, in the eyes of those who opposed his views, Haefliger came to represent the values of 'neo-romanticism'. And to a considerable degree the preoccupations of the central members of the group reflected Haefliger's fascination with the tradition of French symbolism and symbolist art criticism. Discussing Anne Wienholt's painting *Girl in Bed*, Haefliger wrote in 1943:

David Strachan, *Lovers and Shell*, 1945-46

The poetry . . . is sheer joy. The girl is barely visible, yet the tumbling bunch of flowers — carelessly thrown upon the bed, with their fragile colours faintly sparkling in the great expanse of a faded green bedcover — seems to testify to her tender youth.[38]

Like Bellew, Haefliger was especially attracted to the writing of the French art critic (and art historian of sorts) Elie Faure. Haefliger went further than Bellew and emulated Faure's flowery prose style, together with the prose of Huysmans and the poetry of Mallarmé. Rupert Bunny's painting *South of France* was described as 'a product of that indeterminate and transitory state of mind which seeks to hold in luminous patterns the image of a passing sentiment — the almost vain endeavour to recapture the exact quality of an elusive day dream, founded on reality yet far removed'. Though Faure's style was more often purple than any other hue, it did offer a way of approaching and writing about art that avoided outright radicalism and arid formalism. Haefliger remained art critic on the *Sydney Morning Herald* until 1957 and for fifteen years his writings imitated this approach.

David Strachan, c. 1946: the *fin de siècle* mood of Strachan's paintings accorded perfectly with the sensibilities of his close friend and champion Paul Haefliger

In general, apart from the writings of Bernard Smith, art criticism in Sydney lacked the sense of social purpose and conscience that Burdett had exemplified in Melbourne. Turnbull maintained Burdett's liberalism but lacked his knowledge and deep feeling for art. As far as Haefliger was concerned, beyond the validity of expressing a personal response to art, he felt that the role of the art critic was one of 'utter uselessness'.[39] He had accepted the job as art critic because a regular remittance from his family had been cut off by the war. Criticism, for this urbane dilettante, was something of a literary complement to the artistic good life. He painted, but only imitatively, and talked superbly — better than he wrote. After 1942 he had supplanted Bellew as champion for the new

talents. By then Bellew was in the navy; but he was, in any case, out of favour with Fairfax by virtue of having more successfully (even if rather dangerously) wooed the ballerina Helene Kirsova, whom he later married.

In retrospect it might seem extraordinary that Haefliger's introverted approach to art and art criticism was accorded such importance. In Melbourne a radical conception of art was opposed by those whose views were firmly stuck in the values of Edwardian England. In Sydney radicalism was opposed by an attempt to recreate something of the world of *fin de siècle* Paris. Although aspects of surrealism find a place in the work of artists like Nolan and Drysdale, two artists whom Haefliger admired, he nevertheless had little sympathy with the expressionism of others of the Angry Penguins group or the more aggressive painting styles of the left-wing painters. For Haefliger, their impatience was 'alien to that air of reflection, of contemplation which alone matures art'.[40] Haefliger favoured artists like Strachan and O'Brien, whose work lay in an enclosed and highly personalized world. The ambiguous and dream-like character of a fantasy such as Strachan's *Lovers and Shell* (1945-46) was perfectly tailored to his language. While being careful not to over-generalize — since Drysdale and Dobell exhibited with them, as did Nolan — the work of these artists *was* charming, but under this charm lay an avoidance of the realities of twentieth century modernism and the immediate realities of Australian life.

Other associations of Sydney artists displayed isolationism. Some of them were men and women who felt more European than Australian and for whom war meant forced domicile in alien territory. Such was the character of the Merioola Group, which inhabited a Victorian mansion overlooking the sea at Edgecliff. Here lived Donald Friend, Justin O'Brien, Arthur Fleischmann, Roland Strasser, Peter Kaiser, Cedric Flower, Francis Lymburner and other artists, writers and dancers. Some were genuine exiles, like Fleischmann, Strasser and Kaiser, others exiles of the spirit like Friend and O'Brien. Here was created a byzantine world, exotic in lifestyle as on canvas.

The leaders of the Sydney Group suffered such social isolation less than a sense of acute cultural deprivation. Support and solace were found in Sydney 'society', a world depicted by the photographer Alec Murray as a 'playground for sophisticates', and described thus by David McNicoll.[41] Nothing could have been more calculated to turn the stomachs of Melbourne radicals.

The New Court Painters

Whatever differences divided Haefliger from Ure Smith, or characterized Ure Smith's struggle for change in the Sydney art scene as against that of Murdoch in Melbourne, one thing remains clear. The position

Justin O'Brien (*top*) and Cedric Flower, c. 1946: two prominent inhabitants of Merioola and exponents of Sydney charm

of the radical modernist in Australian art was markedly different by the end of the war from the situation before 1940. New forces were acting to put a brake on revolutionary change. Moreover the Contemporary Art Society, fractured and split as it was by the end of the war, was unable to offer any effective resistance. Indeed, a number of its most prominent early members such as George Bell and Russell Drysdale now formed the base of the new establishment. One branch of the modern movement in Australia had suddenly become respectable.

In 1944 Clive Turnbull once again supplied a list of the artists who found favour with the new order.[42] In New South Wales these were William Dobell, Russell Drysdale, Donald Friend, Arthur Murch, Elaine Haxton, Joshua Smith, Eric Wilson, Douglas Wilson, Adrian Feint, Francis Lymburner, Douglas Annand and Margaret Preston. In Victoria, Turnbull listed Danila Vassilieff, Arnold Shore, William Frater, Len

Russell Drysdale in his Sydney studio, c. 1946: the most spectacularly successful of a new generation of Australian modernists

Annois, Eric Thake, Noel Counihan and Lina Bryans; in South Australia, Max Ragless, Jeffrey Smart and Jacqueline Hick. The most important older men were Roland Wakelin and George Bell, with Rupert Bunny hailed as 'the doyen of Australian painters'. Conspicuously absent from this list were the Melbourne Angry Penguins, despite Turnbull's wide range. John Reed counter-attacked by stating that critics such as Turnbull gave an erroneous and grossly oversimplified impression of the true position of advanced art in Australia.[43] Australians must cease thinking in terms of the academic versus modernist division of the 1930s. The picture was now complicated by the fact that the contemporary movement was being made 'respectable' by a new kind of academic painter: 'painters who, consciously or unconsciously, [used] the modern idiom not as a vital and growing thing, but as a fashionable convention to conceal essentially unoriginal thought and expression.'

Sali Herman and Francis Lymburner, 1940: two of the most prominent new men of the 1940s. Like Drysdale, Herman had studied in Melbourne under George Bell before settling permanently in Sydney

The danger Reed saw was that bourgeois values would undermine radical modernism as inevitably as the tradition of the Heidelberg School had been debased. That this seemed to be so was borne out by the survey carried out in 1947 by Haughton James. He found that the most popular artists in terms of the general public were Dobell and Drysdale, who were held to be 'modernist', and Buckmaster, Septimus Power and Ragless, who were thought more 'traditional'. Perhaps the most accurate index as to the beneficiaries of the new patronage is the list of artists who were offered work as official war artists, or who won major art awards. Usually the one depended upon the other. A short list of the new men and women would include Russell Drysdale, William Dobell, Sali Herman, Donald Friend, Charles Bush, William Dargie, Joshua Smith, Nora Heysen, Harold Abbott, Douglas Annand, Douglas Dundas, Elaine Haxton, Douglas Watson and Jean Bellette. Almost all were either members of the Society of Artists or regularly participated in its exhibitions. One of the most promising of this generation of young artists, Charles Bush, recalls that after the war there was a recognized Ure Smith 'stable' of painters. That these artists were, in the main, actively promoted is verified by a cursory survey of reproductions in Ure Smith's Society of Artists publications.

Sergeant Charles Bush outside Port Moresby, 1943: Bush's later commission as an official war artist and his win in the Crouch Prize in 1945 together launched a promising career

The 'slitherers' of the 1940s were less easy to detect than their academic predecessors, but there were clear examples of a sophisticated version that was acceptable to a new establishment. All artists of this kind except Dobell thought of their art in advanced terms. The artists of the Angry Penguins group found their point of departure in primitivism, the modes of Picasso, expressionism, surrealism, and the German new-objectivity movement. By contrast Drysdale, Herman, Purves Smith and Friend tended to respond more to the work of artists who were at second remove from these radical notions. This was, in part, a legacy of the teaching of George Bell. While work by Sali Herman and Donald Friend demonstrated how limiting this could be, Drysdale, working within a similar idiom, was able at his best to transcend it.

Herman painted little during the early war years between 1941 and May 1944 because of the demands of camouflage work. When he resumed work, the early monumentality of *The Black House* (1941) gave way to the lighter Utrillo vein of *McElhone Stairs* (1944). The latter won the Wynne Prize in 1945 and with this work Herman began a series of paintings in and around the Sydney suburb of Woolloomooloo. By comparing such works with those of the late 1930s, it is possible to see how Herman had moved from a *faux-naïf* approach to the more sophisticated-looking style and picturesque imagery of the pictures of Sydney slums.

Just as Herman's work met with immediate acceptance in 1944, so too did that of Drysdale. The immediate and enduring popularity of Drysdale's painting can be attributed to two qualities: a modernistic manner making full use of theatrical devices, and accessible subject matter. Early work such as *Monday Morning* (1938) and *The Rabbiter and His Family* (1938) testify to an interest in Modigliani, Wood and Moïse Kisling. (There were two versions of the latter subject, both apparently painted in 1938.)

What distinguishes the work of Drysdale, like that of his close friend Peter Purves Smith, is a degree of sophistication and awareness that was a result of their years in London and Paris in 1938-39. The work from this period reflects the impact of their seeing canvases by Matisse, Braque and Picasso at first hand. Drysdale received no direct instruction there and sought none, feeling that he was beyond this point. There was more value in visiting the Louvre and the National and Tate galleries in London.

Sali Herman, *McElhone Stairs*, 1944

Drysdale's Australian works from 1940 are curiously far more adventurous than his rather imitative Paris exercises. *Man Feeding his Dogs* (1941) suggests that Drysdale shared in equal measure the fascination of his contemporaries with surrealism. This was one of the first of the paintings of the Riverina, an area where he had spent his boyhood and to which he returned in 1940. The 'folksy' character also present soon overshadowed any other dimension, however, as Drysdale responded between 1941 and 1944 to the theme of life on the land. There is a strong flavour in pictures such as *Moody's Pub* (1941), *Sunday Evening* (1941), and *Going to the Pictures* (1941) of the American regionalist painters of the 1930s, Grant Wood and Thomas Hart Benton.

Drysdale's experience of Riverina townships in 1940, and later for six months in 1942-43, formed the basis for the theme of small-town Australia: *Back Verandah* (1942), *Home Town* (1943), *Local V.D.C. Parade* (1943) and *Ennui* (1944). They are images of a little-known world on the fringes of Australian society, a world that is at once innocent, static and inert. It had never been painted before and Drysdale was conscious that, in turning to the theme of rural poverty and struggle, together with their simple virtues, he was reacting against the pastoral tradition that

Russell Drysdale, *Moody's Pub*, 1941

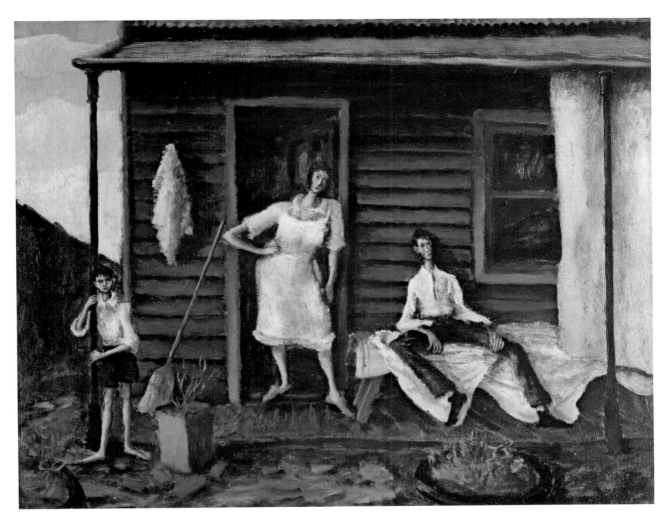

Russell Drysdale, *Back Verandah*, 1942

insisted upon lush painterly representations of £20-an-acre country. As Drysdale has put it:

> nobody seemed to be interested in the marvellous old towns and the clap-board buildings and the kind of life that people led. They're pretty monumental some of those people; they were people I'd known and I was terribly impressed with their stoicism in times of adversity.[44]

The paintings are less images of contemporary life than ones drawn and sketched from memory — recollections of an earlier Australia, the Australia of the 1920s and the years of the Great Depression. This may account for their extremely mannered character: figures in selfconscious poses are propped — 'stage-managed' is hardly too strong a description

Peter Purves Smith, *The Nazis, Nuremberg*, 1938

Peter Purves Smith, *The Café*, 1938

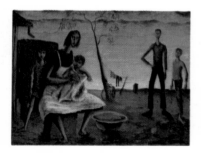

Russell Drysdale, *Sunday Evening*, 1941

— within theatrical settings. The combination of emotionally charged subject matter with an apparently graceless style was something that contemporary critics were quick either to celebrate or to condemn. When these pictures were shown at the Macquarie Galleries in 1943, Haefliger described the exhibition as one of the best that he had ever seen in Sydney. 'When an artist, intoxicated with new ideas, imparts his excitement to the spectators so forcibly,' Paul Haefliger declared, 'it is time to forget his ways and means and faults.'[45] John Reed, on the other hand, pronounced them 'banal and insignificant'.[46] What was not in question, however, was that the Riverina series had established Drysdale alongside Dobell as the foremost painter of the new generation.

One of the striking aspects of these paintings between 1942 and 1944 is that they owe almost nothing to the French artists whom Drysdale had studied so assiduously. The debt is a less direct one, dating back to the training the artist had received under George Bell. It was through Bell and the discoveries of the more adventurous Purves Smith that he absorbed the forms of European modernism that were now put into effect. In *Moody's Pub* the planes around which the composition is organized, as well as the rhythms of the figures themselves, reflect Bell's preoccupations. So too does the obvious respect for traditional techniques of modelling and glazing. Drysdale has also followed Bell's injunction to 'carry no luggage'. Once beyond studio exercises, Bell had encouraged students to work wherever possible from memory. The basis for *Moody's Pub* was youthful memories of arriving in Seymour late in the evening on a two-day motoring trip from Albury to Melbourne. This partly accounts for that reliance upon the work of other artists which is invariably present in the artist's paintings of the 1940s. *Man Feeding his Dogs* and *Going to the Pictures*, for example, both powerfully suggest the influence of Purves Smith's work in the late 1930s, work that was after the manner of Henri Rousseau and Christopher Wood. In the following year, perhaps as a consequence of Drysdale's seeing contemporary British painting, the wry humour and whimsicality that pervade these works was absent.

It was the very accessibility of the art of Drysdale, Dobell and Herman that made their expressive portrayal of 'social realities' acceptable to new patrons and to communists alike. In *Place, Taste and Tradition*, for example, Bernard Smith lamented the general failure of Australian artists to respond to the experience of the Great Depression, but commended Drysdale as an exception.[47] In so doing Drysdale had been able to avoid any 'rooted-in-the-soil' myth. Together with Dobell, he had 'found a way of employing modern technical innovations in form and colour to produce an art which is both national and contemporary without being chauvinist'.

Of all the artists who explored new dimensions of the Australian experience, the one most acceptable to the new establishment was indeed Russell Drysdale. The most successful paintings in this regard belong

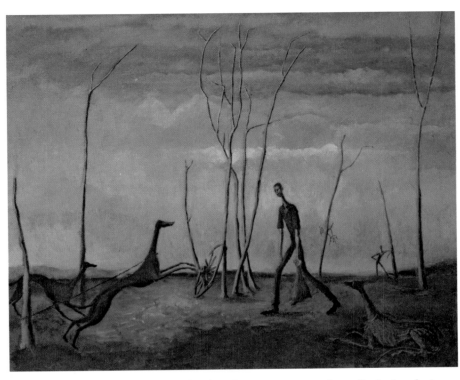

to the drought series of 1945-46; they represent for all their obvious eclecticism important milestones in a developing sense of Australian consciousness. The subject was the drought that devastated the marginal country of New South Wales in 1944 from Forbes, West Wyalong and Wagga Wagga to Wentworth and the South Australian border. Wartime censorship had curbed publicity concerning the disaster and late in 1944 Warwick Fairfax commissioned Drysdale and a journalist, Keith Newman, to cover the story for the *Sydney Morning Herald*. The journey took just over a month. Drysdale later recalled the extraordinary nature of the experience: the shock of seeing vast areas denuded of vegetation and topsoil; the bizarre shapes of the roots of fallen trees; sandhills crested with shrubs that on closer inspection were seen to be the tops of mallee trees; the teeth of dead sheep lined up by the wind like strings of pearls.

The experience moved Drysdale as nothing had before. Thumbnail sketches done on the spot were used to illustrate Newman's story, which was published in December as 'An Artist's Journey into Australia's "Lost World"'. They also provided the basis for the paintings of 1945 and 1946 as the drawings were slowly worked into a major painting statement — a series that Warwick Fairfax later attempted unsuccessfully to claim, saying that all the paintings belonged to the Fairfax Press by virtue of a verbal agreement in 1944. The main group of works was exhibited at

the Macquarie Galleries in November 1945. In fine symbolist manner, Haefliger lavished praise upon the artist for works such as *Deserted Outstation*, *Walls of China* and *Desolation*. Some of them were, indeed, hardly less rhetorical than Haefliger's prose.

In the works of 1945 Drysdale combined the demands of a unique subject and the influence of British neo-romantic style, especially that of Paul Nash and John Piper, with the more surrealist biomorphic forms of Graham Sutherland and Henry Moore. The result is the quasi-surrealism of *Deserted Outstation* and *Walls of China*, which employ two devices characteristic of late surrealism: metamorphosis and deep theatrical space, both fully exploited by Dali. Paradoxically, while Dali's psychological self-flagellation could not be tolerated by Murdoch or Daryl Lindsay, Dali-like devices when employed to emphasize an Australian sense of emptiness and agoraphobia in the landscape were wholly acceptable. *Deserted Outstation* is one of the finest examples of the series, and a work in which Drysdale fully exploits these elements. The foreground is taken up with a frieze of charred wood, twisted galvanized iron and the base of an uprooted tree. The charred stump of the tree looks like a malevolent creature and as such occupies a key role in the 'action' of the foreground. Behind these forms Drysdale has created deep spatial recession, a contrast heightened by the dramatic foreshortening of the trunk of the tree. The shapes are etched in strongly by means of sharp contrasts of light and dark. There is an absence of the human figures found in many of the other works; consequently Drysdale avoids that awkward disjunction which invariably occurs in many of his stylized landscapes. Neither has he resorted to the unconvincing use of the allegorical devices found in *Crucifixion*. Whereas later Drysdale opted for earth colours and glazed, scratched and scumbled surfaces, the intense hues of *Walls of China* and the complementary colours of *Deserted Outstation* serve to heighten their expressive character.

In the drought paintings of 1945 Drysdale pushed well beyond the precepts and preoccupations of fellow Bell students. Yet in spite of the surrealist devices and the bold new theme they remain firmly embedded in a British neo-romantic style. Drysdale's work remains linked with the work of Herman or Friend in its fundamental respect for traditional modes of painting. Moreover, although Drysdale maintained a high standard, few of the paintings after 1945 are equally forceful or daring. Between 1946 and 1950, he travelled extensively throughout New South Wales and also lived for a time with Donald Friend at Hill End. Out of these experiences came works in a similar vein: *Sofala* (which won the Wynne Prize in 1947), *The Rabbiters* (1947), *The Cricketers* (1948) and *West Wyalong* (1949). In one sense they collectively represent a return to the pre-drought paintings — in which Drysdale locates the quintessential nature of Australian experience in the past. At the same time this experience is now shorn of its innocence and its sense of security. It is this new sense of psychological reality that finds expression in a work

Russell Drysdale, *Deserted Outstation*, 1945

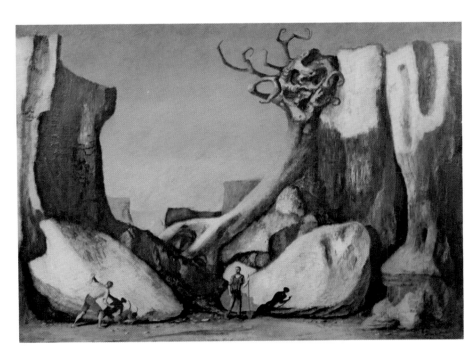

like *The Rabbiters*, a far cry from *The Rabbiter and His Family* painted a decade earlier. The point may be stressed without qualification that a facet of the Australian experience here finds visual expression for the first time. Drysdale's achievement, along with that of Nolan, was to reinstate subject painting in Australian art in such a way as to offer convincing images for Australians of where they had been. It was a testament to the continuation of a pioneering struggle (whether humble or heroic, tragic or prosaic) in the face of harsh geographical and historical realities.

To celebrate these paintings in terms of a democratic humanism attaching to the Australian people is to find assurance where none is offered. To denigrate them because any appeal to the past must run the risk of sentiment and theatricality is to ignore the fact that art has a legitimate social as well as an aesthetic role. This role was especially important in the war and the immediate post-war years. Drysdale's art between 1944 and 1949 still produces less a shock of recognition than one of discovery.

Acknowledgement of this quality led critics such as Haefliger and Turnbull to defend Drysdale from any and every attack, just as both later recognized in Nolan's work a comparable challenge and vision. Yet, whereas Nolan's aesthetic radicalism challenged assumptions about painting as well as culture, Drysdale's art preserved a degree of craftsmanship, a respect for 'finish', and a sense of seriousness that guaranteed

Warwick Fairfax, c. 1946: Fairfax, through the power of his press interests, challenged men like Sydney Ure Smith by his patronage of new art groups on the Sydney scene

immediate acceptance and a success enjoyed at that time by few other artists. As Max Harris noted in 1946, journalism in Australia had been getting together 'with literary and painting gents'. If Sydney society had taken up Dobell, the Murdoch press 'discovered Art With A National Conscience, and Russell Drysdale arose, lean and gaunt like one of his Mid-West American Australians, from out the eroded pages of the Herald'.[48]

Of all the artists taken up by the new establishment, only Drysdale and Purves Smith displayed any direct concern for Australianism as such. In the late 1930s Purves Smith had anticipated key subjects found in the post-war work of Drysdale and Nolan: Burke and Wills, Aborigines, drought. The tragedy was that Purves Smith returned to Australia in 1946 with war wounds from which he died in 1949.

Drysdale was a success, one might say, in spite of his themes. Nationalism was not a quality or an attitude much valued by the leaders of the new establishment, with the exception of Ure Smith. Artists like Bush, Friend or Dobell possessed little or no sense of being 'Australian' artists. Indeed, the question of identity probably never occurred to them beyond signifying the limitations and myopia of the Australian pastoral painters. Whereas Burdett never forgot that he was an Australian as well as a man of the world, and considered that Australians should be aware of this double identity, all too often in the 1940s men like Daryl Lindsay and Paul Haefliger based a belief in art wholly on notions of British or French cultural excellence. The result was almost complete failure at this time to recognize the real creative vision of the period.

In 1944 Daryl Lindsay set out a buying policy designed to strengthen the Australian collection of the National Gallery of Victoria. Four years later he reported that his aim had been to acquire works which conformed with a National Gallery standard plus some borderline works, but that few contemporary artists had met that standard. Most purchases between 1944 and 1948 that did were by artists of an earlier generation: Roberts, Phillips Fox, Bunny, Streeton and Withers. Lindsay concluded that 'the general standard of painting today is not high — certainly not as high as it was in certain periods in the past — and I doubt if it would be possible to purchase more than ten works per year that would weigh up to the standard required'.[49] On this basis the Melbourne National Gallery chose to neglect completely the works of artists like Nolan, Tucker or Perceval. In 1947 Reed put before Lindsay a number of works by Tucker, who was by then in London. The trustees expressed no interest whatsoever in acquiring any of them.[50]

While Turnbull shared something of Burdett's conception of an *Australian* culture, the loudest and most powerful voices in the art world of the 1940s and early 1950s were those of Haefliger, Ure Smith, Lindsay and Murdoch. All shared a belief in a world of 'civilized' values, a world of English and French high culture of which the Australian artist and his plutocratic patron were a natural extension. The character of

this attitude is nowhere better summarized that in Ure Smith's *Society of Artists Book 1945-46*. The contributions by Charles Lloyd Jones, Daryl Lindsay, Hal Missingham and Sir Keith Murdoch amount to a manifesto of the new establishment. Among them the text of Murdoch's speech opening the 1945 Society of Artists annual exhibition is especially revealing. Murdoch declared that the Society was the foremost body of artists in Australia by virtue of the fact that it, above all other bodies, had *maintained standards*:

It is exceedingly important for Australia, because we must seek and attain a standard placing us alongside the best in the world. That is the hope for great art in Australia. I am not at all sure that some members of your Society — largely by this rigorous insistence on standard — have not now reached that position.[51]

Society of Artists Book, 1945-46

The most pernicious effect of such a claim was that where the humanism and true liberalism of Ure Smith, Burdett or Turnbull were absent, insistence on standards meant avoiding most of what was aesthetically radical and challenging — and therefore life-giving — in Australian art. Daryl Lindsay's buying policies exemplified the resistance to real change. The belief in absolute aesthetic standards of taste denied any acceptance of an art in Australia that reflected the central concerns of twentieth century culture. The belief persisted that there was something called 'civilization' elsewhere and that Australia might have a slice of it if its art somehow embodied the supposed standards upon which it was based. And yet there was an arbitrariness about the way this criterion was employed. If Drysdale was regarded as acceptable, what could be found in his paintings that was civilized? The answer was, of course, that Drysdale's *means*, however far he strayed into forbidden pastures, did not transgress accepted notions of fine art. But in other important aspects he was a maverick. However much Melbourne radicals refused to acknowledge the link, his best work, like theirs, was not intended to add gloss to the unpolished surface of Australian reality.

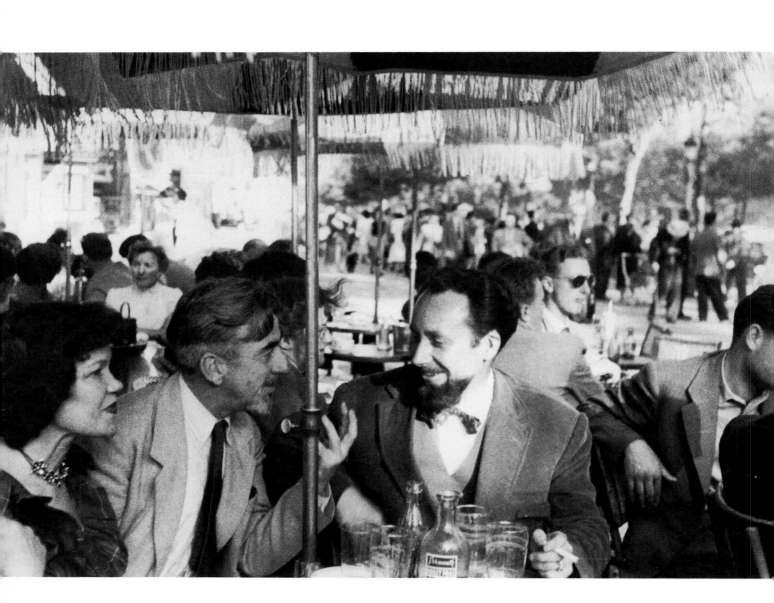

CHAPTER TEN
THE RADICAL DIASPORA

Great nations write their autobiographies in three manuscripts; the book of their deeds, the book of their words, and the book of their art. Not one of these books can be understood unless we read the two others; but of the three, the only quite trustworthy one is the last.

John Ruskin (1877)

Angry Penguins acknowledged the end of the European war with the observation that it had 'left behind a faint hope, deeply tinged with cynicism and marked by a profound despair'.[1] This was despite the fact that between 1945 and 1947 Nolan, Tucker and Boyd produced many of their most outstanding paintings. Whereas for others the end of hostilities engendered hope, the Angry Penguins had few illusions about the post-war world. This was not so much a matter of political sophistication but rather that they had long ceased to share such dreams. In the absence of public support, and in the face of outright hostility from some quarters, they retreated further into private worlds.

In some cases the answer lay in flight and exile. In others, individual aesthetic preoccupations took precedence. The collapse of journals and magazines such as *Angry Penguins* in 1946, and the virtual demise of the C.A.S. in Melbourne in the following year, coincided with the dispersal of Australia's radical artists. These events appeared to bring a unique decade to a close: in the short term it seemed to contemporary observers as nothing less than the demise of radical culture itself. We may now, however, see the directions into which these impulses were channelled and the degree to which they continue to sustain life.

Arthur Boyd and the Australian Judgement

The most marked change in the art of the Angry Penguins after 1945 was from highly personalized images towards more explicit comments on Australian society and the Australian experience. The artists who moved furthest from the earlier preoccupations were Arthur Boyd and John Perceval. Towards the end of 1944 there was an increasing awareness, in Boyd's work particularly, of the tensions and dislocations of the

Opposite Refugees on the left bank, c. 1956: Robert Close and Albert Tucker on the pavement of the Café Flore on the Boulevard Saint Germain. Close's novel had been translated into French and was apparently less shocking to Parisian sensibilities than to Australian. Close remained an expatriate; Tucker returned in 1960 after thirteen years in Europe and America

Arthur Boyd in front of his 1943 *Landscape*: the direction of Boyd's work in the late 1940s was to take the artist into new and more ambitious themes

war. Whereas earlier these were oblique references, now there was a sense of war as human tragedy on an incomprehensible scale.

Boyd was undoubtedly affected in this by the emotions and thoughts of Jewish friends. As a refugee and a philosopher Peter Herbst, especially, talked a great deal about the moral dimension of war. Reports of atrocities gave immediacy to one of the great problems of history: that of reconciling twentieth century civilization with modern barbarism. To handle a tragedy of this dimension, Boyd turned to biblically related themes and metaphors.

The first suggestion of change from the earlier personalized renderings of mental *angst* is found in *The Hunter II*, painted late in 1944 and subtitled 'The Flood'. This was quickly followed by a powerful and more explicit work, *The King* (1944-45), in which a less ambiguous use of metaphor is suggested by its subtitle, 'The Deluge'. A god-like king casts a griefstricken and impotent gaze upon the plight of a terrified mass of humanity that is being swept into the sea. A pair of preoccupied lovers

appear to be among the elect. These are early essays on a theme that finds its strongest expression in two of Boyd's most important works, *The Mockers* and *The Mourners* of 1945. The young Viennese-trained art historian Franz Philipp, who had arrived with Herbst as a refugee on the *Dunera*, responded to their religiosity by calling the paintings a diptych. Philipp recognized in Boyd's work an authentic religious element, an ethical component that went beyond mere choice of motif, a use of biblical allegory found in comparable works of the old masters. In the first major evaluation of the artist's work Philipp argued that religious themes traditionally offered the artist vehicles for expressing complex intellectual and emotional responses to contemporary historical events:

It seems very obvious to the writer that Boyd's diptych is dominated by bewilderment and terror of the violent and sanguineous events we have all witnessed during the last years. In the 'Mockers' we are bluntly faced with evil run amok; with an eye to this, the artist shows us in 'the Mourners' mankind's grief and compassion.[2]

Arthur Boyd, *The King (The Deluge)*, 1944-45

As Philipp recognized, these works go well beyond any specific protest against the abominations of fascism. By using allegorical devices of this order, Boyd attempted one of the most ambitious statements about war by an Australian artist. Through the enduring theme of crucifixion he sought to stress not simply horror but something of war's moral dimensions.

The dominant note is a universal pessimism. In *The Mockers*, a frenzied mass of humanity celebrates the agony and death of a distant Christ. In the centre of a vortex of crazed people, an impassive god-king sits in the branches of a tree: this figure with stern and implacable features has turned its back upon all manner of cruelty and suffering. There seems no hope of redemption as the damned are dragged into a hellish abyss. As a fine scholar and as a victim himself of what he chose to call 'the St. Vitus dance of a possessed humanity', Philipp was in a better position than other critics to respond to this new direction in Boyd's work. Clive Turnbull, for example, found the paintings 'wholly distasteful' in content, and the manner of painting 'unprofitable and misguided'.[3] He was not alone: Boyd's new direction was to prove equally unacceptable to one-time supporters and friends.

The change in Boyd's painting style and the attempt to handle large-scale historical and social themes — an attempt found also in contemporary works by Nolan, Perceval and Gleeson — was marked by a sharp break from the earlier psychological subject matter as well as from the earlier expressionistic style. Boyd quite consciously borrowed the manner and compositional mode of Pieter Bruegel and Hieronymous Bosch together with their uses of allegory. Through Tucker, Boyd was familiar with Doerner's book of techniques. But, whereas Tucker used it as a means of getting hold of cheaper materials, Boyd deliberately set

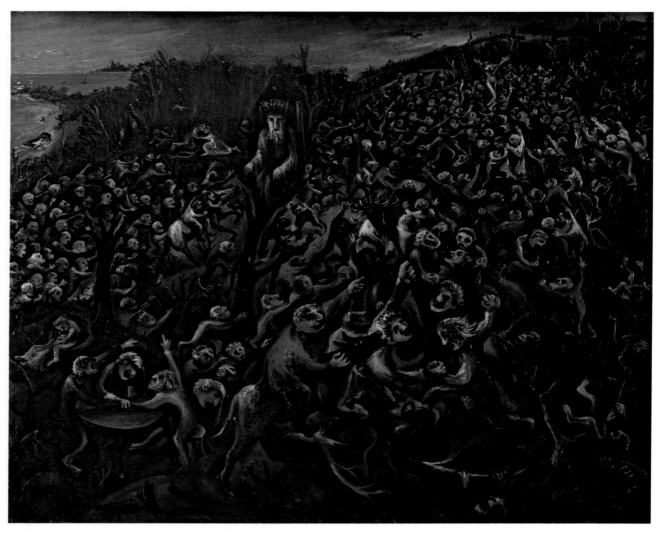

Arthur Boyd, *The Mockers*, 1945

about emulating the finish of the old masters by using a mixed medium of tempera and oil. Boyd and Perceval's paintings came to resemble those of mannerist and baroque masters, with their aged and unrestored, honey-brown and yellow varnish-covered hues. The approach alienated some critics, who thereby missed the essential spirit of the new subjects.

As with Bruegel, the allegorical dramas are played out in familiar settings. *The Mockers* is set along the scrubby shore of Port Phillip Bay with the dark skyline of Melbourne on the distant horizon. Many of Boyd's major works from 1946-47 thus cast biblical incidents in the social context of Melbourne's suburbs: *The Golden Calf* (1946), *The Mining Town (Casting the Money-Lenders from the Temple)* (1946-47), *Christ Bearing the Cross* (1946-47), and *Melbourne Burning* (1946-47). They may be read,

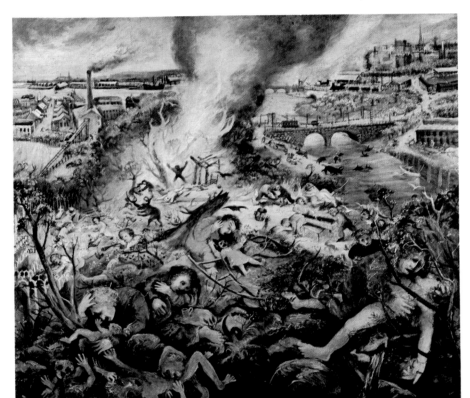

Arthur Boyd, *Melbourne Burning*, 1946-47

therefore, as a critique of life-denying values in this Australian context. One did not have to journey to Dachau, Dresden or Buchenwald, nor to Los Alamos, to find evil.

If such an interpretation sounds overdrawn, one need only refer to the most impressive of these post-war paintings, *Melbourne Burning* — an even more apocalyptic image than *The Mockers*. If in *The Mockers* evil was triumphant, in *Melbourne Burning* Boyd has gone further and painted quite literally an image of an Australian apocalypse. In so doing he had in mind the holocaust of Hiroshima, an image that cross-connects here with a vision of the Last Judgement. The panoramic composition conveys a sense of the sprawling Australian suburbia within which the events take place. In the centre a cataclysmic fire overtakes man and beast amid the everyday round of life; an angel sounds the last trump calling forth the dead from their graves to face with the living that final and most terrifying of ordeals. Some attempt vainly to flee; others resign themselves to their fate. The damned are already being cast down into the abyss of the foreground. There is no god, only a sinister figure with arms outstretched in the centre of the inferno itself — less a potential saviour than avenging angel. In the art of Bruegel and other early masters, the burning city is invariably employed as a metaphor for the fires of hell.

In earlier allegories, Boyd suggested that those blessed with the grace of love were among the elect or were perhaps the *only* elect; in *Melbourne Burning* there appears to be no salvation for anyone. One might suggest that this work of great seriousness and power deals less with the end of an anti-fascist war than of something approximating an Australian Thirty Years War: one in which the enemy was within Australian society itself and corresponded therefore to the life-denying forces painfully apparent to young artists of the thirties and forties. If there is one overriding theme in Boyd's work — in the work of the Angry Penguins as such — it is this continuing preoccupation.

John Perceval also developed an old-masterish approach between 1944 and 1948. He too employed themes and incidents from the New Testament, placing them in the context of sweeping genre scenes of outer suburbia, full of incident and autobiographical reference. Paintings range from expressive scenes such as *Oakleigh Landscape* (1946) to the Bruegel-like *Christmas Eve* (1947-48) and the Tintoretto-influenced *Ecce*

Arthur Boyd and John Perceval at work, c. 1945, in the Murrumbeena pottery established in an old butcher's shop in Neerim Road. The artists and their friends produced utilitarian ware to provide an income

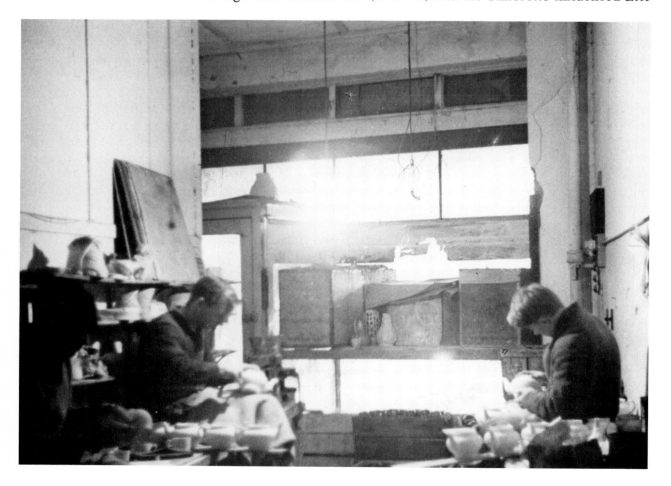

Homo (1947). There is, however, an absence of the social criticism that dominates comparable paintings by Boyd. Certainly, Perceval sought in such works a new artistic role as a recorder of contemporary life. The more selfconscious style of both artists at this time suggests that the earlier obsessive autobiographical element has been replaced by the idea of the artist as a more independent observer and commentator. But Perceval, unlike Boyd, chooses to celebrate positive, life-enhancing aspects: spontaneous play, the pleasures of day-to-day living, a sense of community. Perceval implies a rejection of certain values by inversion and not by direct condemnation as in the case of Boyd.

The last occasion on which Perceval exhibited with the C.A.S. was in 1944. His absence from subsequent exhibitions was less a consequence of his involvement with the Murrumbeena pottery than of his deliberate destruction of many works because of their severe criticism from John and Sunday Reed. The Reeds pronounced all the genre and religious works from this period as worthless except *Murrumbeena Railway Station*, which was given to Sunday Reed. Thus, for all the *joie de vivre* evinced in the few surviving works, the artist's own spirit was at a very low ebb. In 1947 he told the Reeds that unless he achieved something worthwhile within three years he would give up painting and cease to worry any more about it.[4] Although he held a one-man exhibition in 1948 at the Melbourne Book Club, he painted little between 1948 and 1954, devoting most of his time and energies instead to pottery.

John Perceval, *Murrumbeena Railway Station*, 1946

More sure of his direction than John Perceval, Arthur Boyd was conscious that his aesthetic values were developing independently from those held at Heide. Boyd chafed at the demands of pottery because it left so little time for painting. By 1948 the conflict was resolved by the return of his uncle, the novelist Martin Boyd, who set about restoring the old à Beckett family home at Harkaway. In attempting to establish a cultured European ambience for himself, Martin Boyd offered his nephew a commission of £500 for a large mural on the walls of the dining room in 'The Grange'. For the artist it provided a lever with which to extricate himself and he moved his family to Harkaway.

John Reed was no more enthusiastic about the direction of Boyd's work after 1945 than he was about Perceval's. In 1954 he published an appreciation of Boyd's career in which he expressed views long held but previously only expressed in private. Reed wrote that the allegorical works of 1945-48 were 'devoid of that very emotional quality they would seem to imply'.[5] The artist had failed to ally his natural sensibility to his new more selfconscious approach and had correspondingly failed to realize the promise of the early work. Such a comment reveals much about Reed's own expectations of art and its role. What Reed saw as a failure to connect with imaginative experience reflected a more general decline in the work of Australian artists after the war — a slump in the quality and quantity of art activity. Compared with that of Nolan, the work of Boyd and Perceval was viewed as aesthetic backsliding.

The Kelly Paintings and Australian Myth

Sidney Nolan's chief preoccupation in 1946-47 was the Ned Kelly series. The subject itself was far from new. In the 1940s others had revived an interest in Kelly; Douglas Stewart's verse play *Ned Kelly*, first performed in a radio broadcast version in 1942, was especially important. The play had a considerable impact in literary and artistic circles with its concern for

The writer Vance Palmer, an ardent left-wing nationalist whose writings stressed a sense of a continuous and evolving tradition

courage, bravado, daring action, considered in themselves; the relation of the leader to those who are animated by his mind and will; the breaking of the dream against actuality; the contrast between the wild and the tame, the bush and the town, the natural and the artificial.[6]

Such themes are the essential stuff of myth — and Australian myth was already a central preoccupation of Australian writers. Max Harris argued that the only way for creative artists to make a significant modern statement in Australia was to turn to 'that world which still exists pure as entity ... personal myth'.[7] In other words, the artist must search out for himself that which stems from Australian folk traditions, which endows places with legend and gives to the peoples who inhabit them a sustaining spirituality.

The writer Vance Palmer was at work in the 1940s preparing the manuscript for *The Legend of the Nineties*. In it Palmer defined more precisely the nature of this relationship:

It has been said that men cannot feel really at home in any environment until they have transformed the natural shapes around them by infusing them with myth ... there is no other word for the folk-impulse that makes men let their minds play around the world familiar to them, creating heroes and sacred places. It is the original urge towards art: it creates food without which the imagination would starve.[8]

Harris found enriching literary myth in the landscape and history of the South-east of South Australia where he had grown up. In 'The Tantanoola Tiger', a prose piece written in 1945, Harris affirmed the prepotent hold that the story of a marauding tiger in this cave-ridden area had upon his youthful imagination. In discussions with Nolan the subject of myth, then, went beyond mere speculation: Harris and Nolan found for themselves personally sustaining stories in their own backgrounds. In his first public statement on the Kelly paintings, Nolan affirmed their mythical significance:

I find that the desire to paint the landscape involves a wish to hear more of the stories that take place within the landscape. Stories which may not only be heard in country towns and read in the journals of explorers, but *which also persist*

Sidney Nolan, *The Trial*, 1946-47

in the memory . . . In its own way it can perhaps be called one of our Australian myths. It is a story arising out of the bush and ending in the bush.[9]

In pursuit of these stories and a sense of place, Nolan and Harris hitch-hiked in 1945 through the Kelly country in north-eastern Victoria.

Kelly-related studies by Nolan date from as early as 1944 in a number of red chalk monotypes. A more intense preoccupation with the theme began after his return to Melbourne and his unofficial escape from army life. No doubt the fact that Nolan was himself in hiding in a Parkville studio (where he was also joined on occasion by Max Harris and John Sinclair) gave the Kelly story immediacy. There was the added Irish connection through his grandfather, who had been a member of the Victoria police in the 1880s. The two important written sources were J. J. Kenneally's *The Complete Inner History of the Kelly Gang,* first published

in 1929, and the Royal Commission Report of 1881. Nolan also studied contemporary newspaper reports in the Public Library.

In terms of the richness of Nolan's visual sources, the Kelly paintings are a unique achievement in Australian art. Whereas the embryonic studies of 1945 are decidedly primitive and expressionistic, the twenty-seven mature works of 1946 and 1947, which comprise the series, are of a quite different order altogether. By giving his sources as 'Rousseau and sunlight',[10] Nolan indicated the two quite distinct visual facets of the series as a whole: an exploitation of many sources of unsophisticated imagery, on the one hand, and a direct response to the landscape of the Kelly country on the other.

There are two pictorial modes here. One group of expressive and loosely painted landscapes exploits to the full an *alla prima* method of working that ripolin makes possible. *Township* is one of the more straightforward examples, and suggests an extension of the Heidelberg paintings of 1945 in the use of conventional perspective devoid of spatial or temporal incongruities. The second mode is more schematic and decorative and is seen at its best in *Constable Fitzpatrick and Kate Kelly*. Here figures are painted in a primitive manner and set against a pattern of hard-edged and flat geometrical shapes. Against these Nolan imposes the dominating symbolic form of the Kelly armour and helmet that provides the central motif.

The sources employed in the second mode are extraordinarily rich

Sidney Nolan, *Death of Constable Scanlon*, 1946-47

Sidney Nolan, *The Chase*, 1946-47

and diverse. In *Ned Kelly*, for example, the linear form of the horse probably derives from illustrations in a nineteenth century book on farriery.[11] Other works in the series such as *The Trial* may well owe a considerable debt to American primitive painting. Yet Nolan was even more adventurous than these observations suggest. Forms in *The Chase* bear a striking similarity to corresponding images in a fifteenth century picture of the god Mars in his chariot, reproduced in 1939 in the French art magazine *Verve*.[12] The decorative armour worn by Mars and the shape of his flail find a reflection in Kelly's armour and rifle, as does the shape of the white horse of the pursuing constable. While a formal connection only, it does link the story of Kelly with wider mythology.

The Trial demonstrates the degree to which Nolan was able to weld expressionistic, lyrical, conceptual and symbolic elements into the convincing pictorial schema that characterizes the most accomplished works in the series: *Ned Kelly*, *Quilting the Armour*, *Death of Constable Scanlon* and *Glenrowan*. In these, Nolan achieves a masterly resolution of the apparently contradictory modes to encapsulate one of his stated preoccupations: 'One is always trying to put something in front of the bush in some relationship to a primeval background.'[13]

Sidney Nolan, *Burning at Glenrowan*, 1946-47

The archetypal figure of Kelly is closely related to that in the Stewart play, but the problems of literature are not, of course, the same as those of painting, even where the aims are apparently close. Bergner and Tucker had pioneered the idea of painting *en série*; for Nolan too it was a way of making a visual statement dealing with comparable questions. Not long after completing the Kelly series, Nolan wrote that the idea of producing a series of paintings around a given theme was 'a space-time solution' to the problem of presenting an allegory, which he defined as 'the stringing out into narrative form of a single essence'.[14] In Nolan's work of this period the 'single essence' involved relating a humanizing myth to the landscape in the way that Vance Palmer argues is a fundamental step in the growth of national consciousness and maturity.

If our concern here is principally the position Nolan's art occupies within a developing Australian intellectual ambience, then the significance that these works held for John Reed, as one of the small group of people intimately concerned with their conception, is important. In relation to the Kelly series, Reed wrote later:

we come to realize that we have never before seen — and perhaps have not seen since — such an inspired realization of the Australian bush. Here we find all those strange qualities — the apparent harshness, the apparent rejection of man — which have so disturbed Australians, and to some extent alienated them from their land . . . But at the same time Nolan has penetrated beneath this first vision and revealed the deep soft beauty of the bush, with all its subtleties.

Through the story of 'a figure of the Dreamtime, who strode through the world larger than life, performing superhuman feats and stirring in us a deep awareness of man's potential greatness and the tragedy of his

The refectory table at Heide: here Nolan painted the Kelly series. A Nolan painting stands on the mantelpiece, and other works are stacked in special racks to the left

eternal inadequacies', we glimpse, Reed suggests, something of an 'authentic national vision'.[15]

The phrase 'authentic national vision' encapsulates a range of values and attitudes that had long been the preoccupation of Angry Penguins artists and intellectuals. They had set themselves against the debasement of an older landscape tradition, against any forms of prescriptive Australianism whether dictated by the right or the left, and equally against those who acted as displaced Europeans. Each alternative was inherently artificial and made the artist subservient to programmatic values. As the Kelly series demonstrated, this 'authentic national vision' does not deny intellectual and historical understanding; it does demand originality and a questioning sensibility.

Albert Tucker and the Australian Condition

By 1946 it seemed that artists would pursue solitary rather than collective paths in search of a workable Australian cultural tradition. Not surprisingly, for the man whose sense of alienation ran deepest, Albert Tucker chose the loneliest path of all.

Unlike Nolan, whose Kelly series was favourably received by both Turnbull and Haefliger, at no time in the 1940s did Tucker receive favourable comment from any critic. In a survey of contemporary Melbourne painters in 1946, Haefliger found in the surrealism of Tucker's art a 'crude force'.[16] The most that Turnbull could say about the portraits Tucker exhibited in 1946 was that they were 'ingeniously ugly'.[17] Critical responses of this order were not only superficial; they were completely unrelated to the central concerns of Tucker's art. By attaching a date to each of the four portraits in *Faces, 1946*, Tucker had suggested that they ought to be viewed as statements about the human condition, Australian and otherwise, in the year following the war. By 1946 he had largely exhausted the pictorial possibilities of the *Images of Modern Evil*, the last being primarily abstract arrangements of form. The sense of moral corruption found in the earlier works was now rechannelled.

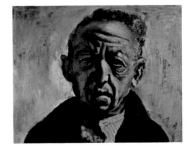

Albert Tucker, *Man's Head*, 1946

Albert Tucker, *Portrait of Martin Smith*, 1946

Two of the 1946 paintings (now both entitled *Man's Head*) were based on photographs clipped from a newspaper and an English crime magazine. They depict pathological states of mind and Tucker coined the phrase 'psycho-expressionism' to describe their style. Its power does not rely on surrealist devices or expressionist mannerisms for emotional effect. Instead, the artist has built up a heavy painted surface on which the pigment is scraped and scumbled. The use of chiaroscuro gives both heads a mordant intensity and a presence unrivalled in Australian painting except, perhaps, for the infamous *Portrait of Joshua Smith*.

Portrait of Martin Smith is less obviously an essay in the macabre. It is nonetheless an equally compelling psychological study. Tucker recalls that the young poet turned up in Melbourne after having simply walked away from his unit in New Guinea. The soldier had reached a point at which he was unable any longer to bear the stench of rotting corpses. Something of the horror of this experience still attaches to the gaze of the figure. The blank look of the eyes is contrasted with a sense of vulnerability conveyed by the sensitive line of the mouth and jaw. The two earlier *Heads* are statements of Tucker's low view of humanity in general, but the *Portrait of Martin Smith* is a study of war psychosis and therefore relates back to the studies of 1942. Whereas the earlier paintings and drawings strike a note of hysteria, the 1946 portrait suggests a wider and more profound sense of the searing of sensibilities from the experience of war. Tucker has described a face as 'a kind of refracting prism in which there's all the human world and universe conveyed'.[18] Although it would not have been recognized as such at the time, this *Face* of 1946 is one of the most powerful statements of Australian unofficial war art.

Refugees from Australian Culture

By 1946 Albert Tucker's art accurately reflected his sense of increasing personal alienation. In 1947 he leapt at the chance to leave Australia and in February began a three-month visit to Japan with Harry Roskolenko, who had managed to get a journalistic assignment with the occupying forces. Tucker was to illustrate Roskolenko's articles. On his return the sense of personal *angst* was further exacerbated by the break-up of his marriage. Joy Hester left the artist at a time when, unknown to herself, she was suffering from Hodgkin's disease, from which she died thirteen years later. For Tucker everything appeared to have collapsed, and he sailed for London in August. Apart from the work in Japan, Tucker had painted little during 1947 and this hiatus was followed by the thirteen years of a difficult exile in Europe and America. Tucker declared on the eve of his departure that his quest was now for 'the grey Gothic of our beginnings'.[19] His parting words are reported to have been: 'I am a refugee from Australian culture'.[20] Many artists and intellectuals in Australia shared this sense of disillusionment by 1947.

By the end of 1946 the firm of Reed & Harris began to wind down: the last issue of *Angry Penguins* appeared in a reduced form and projected books lapsed. Harris resigned his partnership in October and decamped to Adelaide, his finances in a parlous state. *Angry Penguins* had never broken even, and had incurred even greater losses in 1945-46 at a time when the intellectual and cultural rewards appeared to justify the financial sacrifice less and less.

In the penultimate issue of *Angry Penguins* in 1946, Harris pointed to a quality of 'destructive intolerance' that characterized Australian

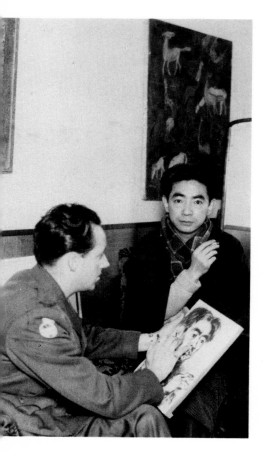

Albert Tucker sketching the Japanese artist Guēn Inokuma in Tokyo, 1947. The uniform is a consequence of the artist's having been given officer status in his role as an art correspondent attached to the occupation forces

bourgeois society and which set itself against the work of some of the liveliest Australian minds in the 1940s. In relation to the aftermath of the Ern Malley affair, Harris wrote:

When a society shows an attitude of intolerance and malice towards part of the organic process of its cultural development, it is acting malevolently towards the whole culture as well as towards the part of the organism ... it does not merit a living culture.[21]

Worse than active philistinism was a pervasive apathy that favoured the second-rate and the meretricious.

The last venture of Reed & Harris was a victim of such apathy. The short-lived magazine *Tomorrow* was intended to bring in sorely needed capital. As a news-sheet sold on the streets, *Tomorrow* had topicality, an irreverent bite and a freshness that distinguished it from other weekly and monthly magazines and journals. With its anti-establishment temper (it featured, for example, a cartoon character called 'Bob Superming'), it was a premature venture given the social and cultural apathy of which Harris complained. It never recouped the cost of publication and distribution, and by the end of 1947 Reed decided to close everything down. In August 1948, after the Kelly series had had a disappointing reception at the Velasquez Galleries, John and Sunday Reed salvaged what they could from their tax savings and left for Europe. There they remained for a year.

In a retrospective review of the 1940s John Reed wrote that after the war 'Some organic change seemed to take place in the community, a

A copy of the 'outspoken monthly' *Tomorrow* in March 1946, with a cover indicating one of the issues of the times

Tomorrow's editors John Sinclair and Jack Bellew, the brother of Peter Bellew and an ex-chief of staff of the Sydney *Daily Telegraph*

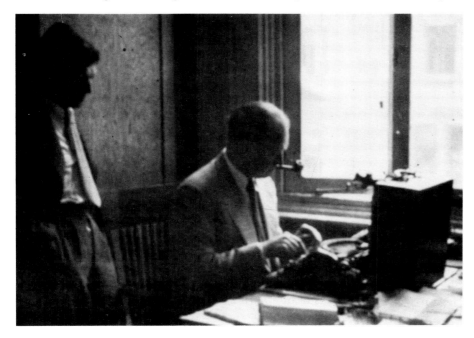

lessening of sensitive awareness, or perhaps a mere dissipation of energies into numerous channels, irrelevant to creative talent'.[22] 'In any event', Reed concluded, 'there were few artists who were not affected.' If that was the general outcome, then one important contributing factor was the ending of the close, and in some cases intimate, personal relationships that had characterized the Angry Penguins coterie. Writing to Tucker in April 1948, Reed described the Kelly exhibition as being both sad and lovely:

sad because of what I have already told you & because of the complete lack of public interest, & lovely because of its own intrinsic qualities. There has never been anything like it & how the magic of those paintings could fail to move even Melbourne is more than I know . . . they looked so beautiful and natural on the walls.[23]

Beyond the public's lack of interest, the note of sadness refers to the fact that Nolan had left Melbourne permanently after marrying Cynthia Reed in Sydney in March 1948. He had flown to Queensland in the previous year and travelled extensively with the young poet, Barrett Reid. Out of the Queensland experience came the material for the Mrs Fraser series and the rural imagery on which Nolan worked in Sydney in 1948.

Writing to Tucker in April 1948, while the Kelly paintings were on show in Melbourne, Nolan described his feelings at this time:

My life seems to have moved away from Melb. permanently. There has been a lot of upset . . . I went down to Heide with Cynthia the day after we were married but came back the same day. There is no way I feel now in which our respective lives can lay [*sic*] against each other.[24]

John Reed, Sidney Nolan and Sunday Reed, c. 1946

The break with Melbourne and with John and Sunday Reed was complete, though the Reeds continued to crusade for the recognition of the artist's work. In December 1949 the Kelly paintings were shown at the Paris headquarters of UNESCO with help from H. V. Evatt and from Peter Bellew, who was now head of art publications there. In the following year they were exhibited in Rome. Meanwhile Nolan remained in Australia until 1951, travelling extensively in New South Wales and central Australia. By then he had found a greater measure of acceptance in Sydney than Melbourne provided. In 1948 he was invited to show with the Sydney Group and in 1951 was elected, together with Justin O'Brien and James Gleeson, to membership of the N.S.W. Society of Artists.[25] Nolan was well on the way to becoming the doyen of Australian modernism. Such recognition stemmed from Sydney openness and not from any change at that stage in the views of Melbourne's establishment. A measure of the degree to which it remained out of touch with international thinking can be gauged from comments to Reed on the Kelly series by Professor Joseph Burke:

In London, he will have to stand ... comparison with artists like Henry Moore and Graham Sutherland, who are just as creative ... and at the same time infinitely more accomplished technically. It is just on this side of technique ... that I fear critics might come down against Nolan.[26]

Burke concluded that the future of Australian art depended on artists like Nolan, but only if 'they can overcome the handicaps imposed by the absence of teachers of the standard of George Bell'.

The ending of wartime restrictions was a powerful factor in helping to break up groups and disperse artists. Escape was once again possible. In Melbourne two figures who left at the same time as Tucker were Gino Nibbi and Alister Kershaw. In Sydney two of the most dynamic members of the C.A.S., Peter Bellew and James Gleeson, also left Australia on the first passages available. Bellew's move was permanent.

In left-wing circles there was a corresponding loss of unity and sense of purpose as friendships declined and the political climate grew rapidly colder. At the end of 1947 Bergner left for Paris with James Wigley. Survival in Paris was difficult, although the two artists managed to hold a joint exhibition in November 1948. After a depressing period of struggle, in 1949 Bergner went to Israel, where he remained. Noel Counihan, always the last man to abandon ship, left Australia somewhat later in 1949. He remained overseas for three years, working in Czechoslovakia, Hungary, Poland and England. One stated purpose of the trip was to represent trade unions in the Australian delegation to the first World Peace Conference at Salle Pleyel in Paris in April 1949. The real reason, however, was to experience at first hand the great works of the Western tradition.

By 1947 there was a return to the old style of Communist Party politics and Bergner and O'Connor were not alone in finding Party attitudes

Albert Tucker on the left bank, 1951: Tucker is sitting alongside a caravan he built and in which he lived for five months on the bank of the Seine opposite the Ile Saint Louis

increasingly intolerable. By 1946, Bernard Smith's views had greatly mellowed: his attitudes became more catholic at a time when the Party line was hardening. In 1945 moves began that were to take him away from communism: he began a part-time degree at Sydney University and in 1948 won a British Council Scholarship; he spent over two years in Europe investigating the background to Australian art. In 1950 he began a post-graduate degree at the Warburg Institute of London University, out of which came two key studies of Australian art: *European Vision and the South Pacific 1768-1850* (1960) and *Australian Painting* (1962).

In keeping with the general retreat of the immediate post-war years, the Studio of Realist Art lost momentum even though it survived into the 1950s. The unsympathetic climate of the late 1940s caused leading members to fade from the scene. Roy Dalgarno left for England in July 1949, while James and Dora Cant left in 1950 and stayed away for five years.

Colder Winds and the End of the Contemporary Art Society

The slackening of the artistic tempo was general, but perhaps because the Melbourne scene had been the liveliest, the change of cultural climate was felt most intensely there. With the dispersal of artists came the collapse of the Melbourne branch of the C.A.S. in 1947. Its end marked also the end of the creative ferment which it had helped to fuel. By 1946 the C.A.S. no longer had any reason to exist as a national institution. Instead of a structure capable of sustaining a radical critique of Australian culture, it had become a rickety scaffold barely able to support its own weight. It was now further weakened by the disaffection of many lay supporters. In 1946 O'Connor, Bergner, Counihan, Perceval and Gleeson were absent from the annual exhibition. Much of the old fire went with them. After 1947 all activity ceased for six years, until Barrett Reid arrived from Queensland determined to re-establish an *Angry Penguins* and reactivate the Melbourne branch of the C.A.S.

The Melbourne art world was left with a vacuum. Arthur Boyd was painfully aware of the loss and lamented to Tucker in June 1948: 'I never see anybody these days. People just aren't sociable here anymore. There are no good painters here. I think to do good work you have to be among good painters.' [27] The C.A.S. did not actually fold up in Sydney or Adelaide but it lost any semblance of a radical character and in Adelaide, especially, led an attenuated existence. Peter Bellew resigned from Sydney's branch over a motion of no-confidence in May 1946, claiming that he was being expelled.[28] He was replaced by the artist Desiderius Orban, who now presided over a more conservative society. As Haefliger commented: 'the rebels themselves have been tamed ... henceforth we can dispense with the idea that "modern art" is a novelty in Australia.' [29]

Haefliger was not quite correct. It was not so much that modernism

had been tamed but that most of the radicals had gone. The Sydney branch of the C.A.S. continued an unbroken existence, but after 1947 there was little evidence of its early crusading zeal. It did provide a springboard in the mid-fifties for an aggressive abstract movement led by young artists such as John Olsen. Nevertheless it had become what its radical founders had battled against, no more and no less than another exhibiting society.

The resistance to change after the war sometimes went further than the passive resistance against which the Contemporary Art Society and the Studio of Realist Art battled in vain. Where radicals made inroads into established groups such as the Victorian Artists Society, they were effectively removed by the end of the 1940s. Even liberal-minded men of the calibre of Haughton James were considered too disruptive. When some of the more conservative members of the V.A.S. council resigned, James Quinn once again found himself with the unenviable task of attempting to mediate between hostile factions in the small Melbourne art world.

The conflict revolved around the issue of the Society's enterprising magazine the *Australian Artist*. Haughton James fought for its life against more conservative members led by George Bell and William Dargie, who opposed it on the grounds that it had become a vehicle for left-wing politics. The real reason was that, like its editor, the *Australian Artist* was too intellectual, too radical, and therefore too dangerous. After James was relieved of editorial responsibility, he declared in an unpublished editorial, 'Swan Song':

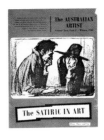

The final issue of the *Australian Artist*, winter 1949, with a lithograph by Will Dyson featuring an appropriately conspiratorial subject

It can never be said that the 'Australian Artist' died from public neglect . . . Art had a voice in Australia, and now it hasn't. I suppose that's all there is to it.[30]

Never a communist — nor for that matter even a fellow traveller — he was a man of the widest sympathies and outlook. By the end of the 1940s it was clear that such values were unwelcome.

The affair of the *Australian Artist* might be thought a minor postscript to the story of the demise of radical art and art activity in the late 1940s. It does, however, indicate graphically one aspect of the illiberal climate in Australia as the Cold War intensified. In August 1949 Rem McClintock, once leader of the Encouragement of Art Movement alongside eminent establishment figures, was asked to resign from the V.A.S. because of charges involving communist activity made at the Royal Commission into Communism in Australia.[31] Alan McCulloch recalls pressure from the *Argus* management to write critically of left-wing artists. McCulloch lost his job in 1947 for being too outspoken, and he left for the United States and Europe.

A recession in the art market began, too, in 1947. It was dramatic in its effects. The *Argus* reported in May 1947 that buyers of paintings were not so keen to purchase as they were during the war and early post-war period 'when money was extra plentiful and petrol was extra scarce'.[32]

By the end of the 1940s Australia saw an exodus, then, of many of its leading artists and intellectuals. Many were refugees from Australian culture at a bleak moment in the political and — for artists at least — economic climate. The retreat to the suburbs became by the 1950s a vast migration, as triple-fronted brick veneer bungalows overran old boundaries and spilled over into the countryside. Resisters moved further into the bush. While cultural repressiveness is hard to measure, it was felt on a wide front. The editor of *Meanjin*, Clem Christesen, commented bitterly in 1951 on the shattering of radical hopes:

The collapse has grown progressively worse, until today I believe the social climate is no longer one in which serious writers can work with enthusiasm.[33]

One writer has concluded that, at the end of the 1940s, what was at stake was no longer the sort of social role artists should adopt, but the survival for Australian intellectuals of 'the life of the mind itself'.[34]

A Workable Tradition

That this intellectual life did survive is a matter of historical record. *Meanjin* did not, for example, go under. The disintegration of the Melbourne branch of the C.A.S. in 1947 and the opposition by a new establishment to the causes it espoused did ensure several years of eclipse for radical and national modernism in Australian art. It is not correct, however, to say that the tradition had come to an end. Artists who had pioneered the movement might have rarely reached again the plateau of achievement attained between 1943 and 1947, but they continued to explore an art that was both Australian and modernist. In addition, the work of the radical artists of the 1940s was aesthetically ambitious. Without all three of these attributes it is unlikely that the work of Drysdale, Nolan and Tucker, especially, should have been given the degree of recognition it won abroad in the 1950s. This culminated in the large Whitechapel exhibition held in London in June 1961, the Antipodean Vision exhibition at the Tate in 1962, and subsequent exhibitions in America and Europe during the 1960s. These exhibitions were landmarks because they confirmed that for the first time Australian artists had an international audience that was sympathetic and receptive.[35]

As we have seen, the national cultural vision did not mature uniformly, and the artists who formed the Angry Penguins were far from unanimous about its character. After an early phase of internationalism, Nolan was the first of them to face squarely the question of an Australian art. In his case this culminated in the Kelly series, and Nolan was quite conscious that his was a different vision of the Australian experience from that of the Heidelberg School. In 1945 he wrote from the Kelly country to Sunday Reed that he was concerned with aspects of the

Clem Christesen, editor and founder of *Meanjin Papers*, 1944

country 'that Roberts, Streeton did not touch in their preoccupation with exploring the transparent light'.[36]

Arthur Boyd, too, had undertaken a short-lived journey into national imagery. In 1943, in Reed's view, Boyd confronted the question of creating a tradition by producing a richly expressive and symbolic painting of great imaginative vividness and originality. When the urban drama was transferred to a bush setting it was 'to a bush we had never really known before — the Australian bush, but seen with a new understanding and revelation and peopled with new figures: men and animals who haunted us, as they themselves were haunted'.[37] If the 1940s saw the emergence of such an Australian art, these years also revealed the cultural dilemma that confronted Australian artists. There was nothing to fall back upon when artistic gifts faltered or the imaginative well dried up. The wrong solution, John Reed argued, was to slip into the 'ready-made but inappropriate tradition of Europe'.[38]

For some artists a comparable sense of a special role as Australians came rather later. This was the case with Albert Tucker, whose work did not identify with specific Australian values and themes dealing with the landscape until 1955. In the 1940s Tucker had been preoccupied with the theme of urban life: in one of the world's most urbanized societies the relationship between man and the city was a key dimension of the Australian experience. But as an expatriate he found that the confrontation with European culture created an intense awareness of his Australianism in more familiar terms. He realized that there was no need to cringe. On his arrival in England in 1947 he was surprised to find that in general the standard of contemporary English art was not much superior to that of Australian modernism. Reed wrote to Tucker agreeing, and adding that perhaps Australia possessed something the artist could not hope to find in Europe: 'Something which is of vital importance to the development of western culture. That is what I have always felt and reached out for'.[39] That 'something' was a sense of latent power, an energy that might help to reinvigorate an exhausted tradition.

The important note struck in this exchange was that what happened in Australia *mattered*; that Australian art had a potentially vital contribution to make to twentieth century art. Such an attitude was the reverse of that of Daryl Lindsay or Paul Haefliger. For these men a provincial culture could only be a pale reflection of the values of the cultured and civilized centre, whether London or Paris. For them, as for past expatriate artists, Australians had to meet European artists on European terms. As Angry Penguins saw it, 'for the next generation of painters it will probably be an advantage to be Australian'.[40]

While Reed was nominally in favour of a suggestion by Tucker for an overseas exhibition of Australian art, he stated, apropos of the inclusion of Nolan, that that artist did not yet feel the need to make a mark in Europe. For Nolan, the centre that still mattered was Australia. Reed wrote: 'I know he feels that somehow things must move from Australia

itself, that he personally wants to be accepted in Australia first'.[41] Drysdale also felt that the real significance for an Australian art lay in an Australian context. Like Nolan and Boyd, he was prepared to stay rather than attempt to win acclaim on a wider stage. Success could be measured in Australian terms with an Australian audience responding to an art drawing upon Australian sources.

Of all the artists dealt with here, it was Nolan whose work showed the strongest thread of nationalism and who undertook the most considered exploration of man in an Australian ambience. Where Nolan differed fundamentally from left-wing artists on this question was that he did not believe that the relationship was fixed. It was something that had to be continually created. This process of re-creation is clearly seen in Nolan's development after 1942. As Nolan stated to Tucker, by drawing upon Australian sources in Queensland he had found something close to the origins of authentic Australian experience.[42] Out of this awareness 'one gets a hint of a workable tradition. And this is true in a literal sense'. There in the north, wrote Nolan in the following year, was to be found a large part of Australia's 'energy' — a product of the clash between the memories of early settlers and explorers and the impact of the new Australian scene. This clash was particularly evident in the north because lingering traces were still to be found in the outback. Such a dialectical relationship between man and land was a central concept in the Wimmera and the Kelly series and was continued in Nolan's work on later themes: Eliza Fraser, Burke and Wills and central Australia. For Nolan, once 'our own tradition . . . [is] fully exposed to the daylight . . . we can reach out to find what are our real focal points'.[43]

The forging of this tradition took place in the 1940s; in the next decade it was tempered by contact with international standards. There were both losses and gains. If the absence of tradition had given Australian artists freedom to express what was unique to themselves and their place in the world, the price paid was often an aesthetic *gaucherie*. As the much more radical painting of the 1940s bore witness, Australian artists often lacked an inherent sympathy for the materials of art, a sympathy that was the hallmark of French art. But they produced art that, in local terms, challenged all conventional assumptions about art and the role of the artist. Their concern for originality ensured that the artistic response avoided the superficialities of the conservative pastoral tradition as well as the prescriptive injunctions of 'popular' art. 'Before painting the gum tree and the Australian landscape, as all these painters have subsequently done', wrote John Reed, 'it was first necessary for them *to discover themselves* as artists in their own immediate environment [italics added].'[44] Individuality and personal sensibility were the major cultural resources in a country without longstanding traditions.

The concept of a workable tradition was more clearly seen by its champions in the 1950s than in the more fluid situation of the 1940s.*Ern Malley's Journal*, which appeared in 1952, was devoted to it. By the end

Russell Drysdale, *North Australian Landscape*, 1959

Sidney Nolan, *Musgrave Ranges*, 1949

of the 1950s Bernard Smith became one of its most energetic supporters, and a spokesman for many of the artists whom Reed also favoured. The Antipodean exhibition of August 1959 brought together Arthur and David Boyd, John Perceval, Clifton Pugh, Bob Dickerson, John Brack and Charles Blackman. The once-controversial manifesto that appeared in the catalogue resounds with phrases familiar to any Angry Penguin. While the manifesto denied that the artists were seeking to create a national style, as such, it argued that artists must draw inspiration from their own lives and the lives of those around them. This necessarily involved myth-making: 'in the growth and transformation of its myths a society achieves its own sense of identity. In this process the artist may play a creative and liberating role. The ways in which a society images its own feelings and attitudes in myth provide him with one of the deepest sources of art.'[45] The Antipodeans, like the Angry Penguins before them, sought an art that would be at once Australian and universal.

Reed's energies in the 1950s continued to be channelled into more open-ended enterprises like *Ern Malley's Journal*, a revived Contemporary Art Society and later the Museum of Modern Art of Australia. The appearance of *Ern Malley's Journal* was a minor, if significant, event. Its main initiators were Barrett Reid and John Reed; Max Harris, somewhat

reluctantly, also became a joint editor. Modelled on *Angry Penguins*, but much more modest, it reflected the times as clearly as had its bolder predecessor. Unfortunately it failed to elicit a deep response from artists and writers and, in the illiberal atmosphere of the early 1950s, appeared to be no more than a faint bleating in the wilderness. Yet its aim was an ambitious one — to sustain the embryonic tradition of the 1940s: 'What has been built up over the past may be in danger of being dispersed by the mass negation of the post-war years ... It has to be made known to endure.' The choice of the name was in itself a celebration of these values. Malley lived and would continue to live insofar as his spirit could animate Australian art and literature. Born of *Angry Penguins*, Malley was a figure from the dreamtime of the 1940s — one whose mythical power for Harris was no less than Kelly's had been for Nolan. Malley stood as a metaphor for the condition of the modern humanist: alienated, ignored and universally alone. But as the editors declared in the first issue in 1952:

Ern Malley's Journal, 1954

Alike as poet and as a symbol of creative living, of a sense of adventure, of a sense of enthusiasm, and of a sense of the imaginative quality ... he has held a place of unique prominence in the community. Who can doubt that he did in fact live?[46]

One of the foremost doubters was Albert Tucker. After reading the first issue, Tucker's response was hardly delicate; he had, he wrote, the 'oddly unpleasant sensation that so many of these familiar people haven't shifted in time or space, or any other bloody dimension'.[47] It was time to give Malley a decent burial instead of making careers out of 'literary necrophilia'. Tucker's judgements were uncompromising and inadvertently wounding, but from a distance of 10 000 miles he saw the need for a broader movement building upon the past rather than an attempt to breathe life into a corpse. The price Tucker paid for his candour was the final disintegration of a delicate fabric of support and friendship. Reed in his reply pointed out that 'the situation and the scene have changed considerably since the old days of [*Angry Penguins*] and ... I have from the outset been doubtful if there is enough good work to justify a journal at all'.[48] Moreover he no longer had any idea where Max Harris was going. One-time friends and confreres had thus become isolated from one another. Yet each continued to set down something of the Australian experience. Its authenticity was measured by whether it rang true in terms of their individual sensibilities as Australians, as artists, and as men and women aware of psychological realities common to all humanity.

If one of the central functions of art is to record the experience and sensibilities of a people, then the radical art of the 1940s played an important role uncompromisingly: it is stamped by a profound humanism. For left-wing artists this formed the basis of a chiliastic belief in an imminent Australian utopia. The problem was that all too often art

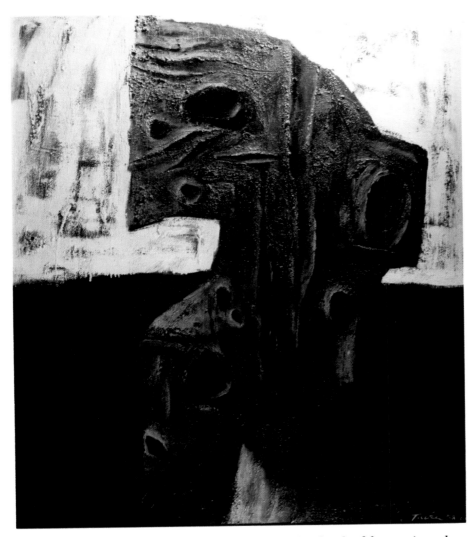

Albert Tucker, *Cratered Head*, 1958-60. Like the Central Australian landscapes of Russell Drysdale and Sidney Nolan, Albert Tucker's series of heads in the late 1950s, with their eroded and pitted surfaces, continued and expanded the preoccupations of his formative years

played second fiddle to political activity. The kind of humanism that located virtue in the popular will and integrity of 'the people' usually led to activities far from the central preoccupation of the creative artist. There was too little of that self-interest that seems indispensable for artists.

The chief complaint of critics like Clive Turnbull (and, earlier, Basil Burdett) was that Australian artists had failed to address themselves to the life around them. 'They have not', Turnbull wrote, 'been good enough human beings.'[49] The charges cannot be sustained against the radicals of the 1940s, however. In that decade it was less a question of who was humanist and who not than a matter of the appropriate means to achieve a society that was creative, dynamic and open, and an art that challenged

REBELS AND PRECURSORS

The catalogue for the important
'Rebels and Precursors' exhibition at
the National Gallery of Victoria in 1962.
The cover features sketches by Sidney
Nolan for the ballet *Icare*

assumptions and faced squarely the realities of the Australian experience. This meant fighting everything that opposed such an ideal — censorship, and the narrow, intolerant and complacent attitudes that supported it. The conflict was bitter to a degree unparalleled in Australian cultural history because issues of such magnitude were at stake.

In the 1940s Counihan and Drysdale found stoicism and indomitable strength in the struggle of Australian 'battlers'. Bergner located it in the Jewish tragedy and in the predicament of similarly dispossessed peoples. In contrast to such specific identification, Nolan explored a more universal world of human experience in terms of lovers and children, and later in figures of heroic stature. Tucker, Perceval and Boyd all produced evidence of a profound concern for man's fate in the face of destructive social and psychological forces: the humanism of this art was like the insistent ache of an exposed nerve.

Where the Angry Penguins differed fundamentally from other radicals in the 1940s was in the degree to which a concern for aesthetic radicalism was linked with a radical critique of culture and society. If the painting that resulted was more often raw and aggressive than lyrical and stylish, that was the consequence of these artists carving their own paths into twentieth century art. It can be compared to British and American artists' responses to isolation as a product of war. Following closely upon the influences of European modernism, it released artists from provincialism. Each took different routes in pursuing national traditions of modernism in the 1940s and 1950s. American art moved towards a powerful and ultimately triumphant abstract expressionism which flowed outwards from New York. Australian artists of the 1940s, by contrast, remained firmly wedded to figurative modes. In general, Australian artists failed to make comparable inroads into patronage, even allowing for the more modest scale of the local art scene — and this was one cause of the radical diaspora of the 1940s and 1950s.

We have seen that the Australian modernist movement did not disappear totally; but whatever its recognition elsewhere, it barely survived in Australian soil. A sense of continuity was maintained, albeit tenuously, by the proselytizing efforts of John Reed and Bernard Smith. A small handful of artists had access to the Reed collection. Fred Williams, newly returned to Australia, was, for example, given the job in 1958 of restoring Nolan's Kelly series, an experience that was significant in developing his approach to the Australian landscape. Others, however, had to wait until the beginning of the 1960s and revived critical interest for recognition that the art of the 1940s had laid the foundation for a living tradition. The seminal event was the 'Rebels and Precursors' exhibition in 1962; this show at the National Gallery of Victoria demonstrated the links between Nolan, Tucker, Boyd, Perceval, Vassilieff and Bergner. One can appreciate Clifton Pugh's angry reaction, on seeing

the exhibition, that he and others had been denied access to key expressions of their own heritage in the intervening years.

The humanistic pulse that so marked the art of the 1940s has been described as running like a 'dark vein' throughout Australian post-war art.[50] It is a misleading metaphor; there has been no such continuity. Rather, it was like an underground river that wells up to give life briefly, only to sink once more. The tradition thus nourished may be recognized as much in the post-war abstraction of a John Olsen as in figuratism. Since it was fundamentally a challenging response to Australian life, it was not limited to the visual arts. It is no coincidence, for example, that Sidney Nolan and George Johnston became close friends and shared the experience of expatriation in the 1950s.

Sufficient links exist between writers, art critics and artists, not only during the period with which this study deals but in more recent years, to provide revealing illumination by one mode of expression upon another. Thus a key statement of this tradition was Robin Boyd's *The Australian Ugliness*, published in 1960. Robin Boyd, a close friend of his cousin Arthur, concluded his critique of Australian attitudes to their environment in these terms:

The Australian ugliness begins with fear of reality, denial of the need for the everyday environment to reflect the heart of the human problem, satisfaction with veneer and cosmetic efforts. It ends in betrayal of the element of love and a chill near the root of national self respect.[51]

Whereas the artists and novelists expressed their criticism of Australian philistinism and the facade of Australian bourgeois culture with more oblique rhetoric, Robin Boyd stated the dilemma in blunt and unequivocal prose. Every literate Australian knew what 'featurism' was. In Australian painting its equivalent was Adrian Lawlor's 'slithering'. The radical response to this phenomenon was an attempt to come to grips with the realities of the Australian experience — whether geographical, social or historical. The Angry Penguins affirmed by every means at their disposal the need for self-awareness, a respect for individual sensibility, and a search for original modes of expression. Their hope was that aesthetic and personal autonomy would produce art that would reveal qualities of authentic national experience, the nature of which could not be imposed or otherwise predetermined. Like the art, that experience would rarely afford any degree of comfort or reassurance and would guarantee nothing other than a measure of self-knowledge.

NOTES

Chapter 1: Reaction and Progress

1. Geoffrey Serle, *From Deserts the Prophets Come* (Melbourne, 1973), p. 154.
2. J. S. MacDonald, 'Present Day Art' (1940). This was later published with other pieces as *Australian Painting Desiderata* (Melbourne, 1958), p. 140.
3. Lionel Lindsay, *Addled Art* (Sydney, 1942), p. 1.
4. Norman Lindsay, 'A Homage to Julian Ashton' (October 1940), in Julian Ashton, *Now Came Still Evening On* (Sydney, 1941), p. xii.
5. Croll to Lionel Lindsay, 15 September 1942. Lindsay Papers, MS 9104, La Trobe Collection, State Library of Victoria.
6. MacDonald, op. cit., p. 142.
7. Lionel Lindsay, op. cit., pp. 1-7.
8. J. S. MacDonald, 'Arthur Streeton', *Art in Australia*, series 3, no. 40 (October 1931), p. 22.
9. Ashton, op. cit., p. 86.
10. Introductory essay to the catalogue, *The Exhibition of Australian Art in London* (1923).
11. Lionel Lindsay, op. cit., pp. 59-60.
12. MacDonald, op. cit., p. 131. Alan McCulloch suggests in the *Encyclopedia of Australian Art* (Melbourne, 1968), p. 349, that this phenomenon might well explain MacDonald's own fanatical concern to preserve conservative values in art.
13. In a review of *Addled Art* (12 August 1946), included by Lindsay in *Comedy of Life*, p. 268.
14. Derek Hudson, *For Love of Painting: The Life of Sir Gerald Kelly* (London, 1975), p. 82.
15. Lionel Lindsay to Ure Smith, 27 March 1943. Ure Smith Papers, MS 31, folder 6, Mitchell Library.
16. Lionel Lindsay to Daryl Lindsay, September 1943. Lindsay Papers, op. cit.
17. Bowles to MacDonald, 22 August 1946. MacDonald Papers, MS 430, folder IV, National Library.
18. *Sydney Morning Herald*, 4 June 1946.
19. ibid., 5 April 1945.
20. Quoted in Robert Hughes, *The Art of Australia* (Ringwood, 1970), p. 65.
21. Bernard Smith, *Australian Painting 1788-1970*, 2nd edn (Melbourne, 1971), p. 181.
22. Max Meldrum, *The Invariable Truths of Depictive Art* (Melbourne, 1917), p. 60.
23. Quoted by Jan Gerraty, 'Basil Burdett: Critic and Entrepreneur', B.A. thesis, Monash University (1978).
24. Graeme Inson interview, 1 July 1974.
25. Adrian Lawlor, 'A Note on the Origins of Modern Art in Australia' (1937). This seems to have been unpublished. Lawlor Papers, MS 8122, La Trobe Collection, State Library of Victoria.
26. Alan McCulloch, op. cit., 2nd edn (1977), p. 413. In both editions of this work McCulloch has transposed the dates of arrival and of the establishment of the bookshop.
27. Nettie Palmer, *Fourteen Years* (Melbourne, 1948), p. 132.
28. McCulloch, op. cit., p. 197. This is confirmed by Nourma Abbott-Smith, *Ian Fairweather: Profile of an Artist* (Brisbane, 1978), p. 53.
29. Gino Nibbi, 'Ideas Behind Contemporary Art', *Art in Australia*, series 3, no. 80 (August 1940), p. 25; p. 26.
30. Arnold Shore, *Forty Years Seek and Find* (Melbourne, 1957).
31. ibid.
32. William Frater interview, 6 December 1973.
33. The fullest accounts of Lhote's ideas and influence are found in the notes and inclusions of the following catalogues: Daniel Thomas, introd. to *Balson, Crowley, Fizelle, Hinder*, Art Gallery of N.S.W. (5-30 October 1966); Daniel Thomas, biographical notes for *Grace Crowley*, Art Gallery of N.S.W. (10 May-8 June 1975); Grace Crowley, 'A Personal View — The Student Years', in *Australian Women Artists: One Hundred Years 1840-1940* (1975-76).
34. George Johnston, *My Brother Jack* (London, 1964), p. 78; p. 76.
35. ibid., pp. 257-8.
36. ibid., p. 75.
37. The picture was acquired by E. C. Dyason. In 'A Note on the Origins of Modern Art in Australia', op. cit., Lawlor states that, like Roberts, Atyeo had made the figures deliberately wooden in order to stress the design of the composition.
38. John Reed interview, 6 August 1973.
39. McCulloch, op. cit., p. 70.
40. *Herald*, 26 April 1937.
41. Noel Barber, *Conversations with Painters* (London, 1964), p. 91.
42. Biographical details of Nolan's early years are given in the catalogue, *Retrospective Exhibition of Sidney Nolan: Paintings from 1937 to 1967* (1967-68).
43. John Sinclair, 'His Student Years', *Art and Australia*, vol. 5, no. 2 (September 1967), p. 436.
44. James Gleeson interview, 23 May 1975.
45. Smith, op. cit., p. 128.
46. Hal Porter, *The Paper Chase* (Sydney, 1966), p. 98; p. 71.
47. *Argus*, 3 May 1938.
48. Hermann Glaser, *The Cultural Roots of National Socialism*, tr. and introd. Ernest A. Menze (London, 1978).
49. Adrian Lawlor, *Arquebus* (Melbourne, 1937), p. 9.
50. Official records show that Lawlor was born Andrew Lawlor, 13 August 1889. Biographical note in the Lawlor Papers, op. cit.
51. Alister Kershaw interview, 20 January 1977.
52. 'The Art of Adrian Lawlor', *Art in Australia*, series 3, no. 80 (August 1940), p. 16.
53. *Herald*, 29 April 1940.
54. ibid.
55. Adrian Lawlor, 'Modern Art and the World of Appearance', *Art in Australia*, series 3, no. 62 (February 1936), p. 17.
56. Kershaw interview, op. cit.
57. Unpublished review of *Addled Art*. Lawlor Papers, op. cit.
58. The text of this talk was included in *Arquebus* (op. cit.) but there is no indication of the precise date on which it was given.
59. ibid., p. 111.
60. *Herald*, 4 May 1937.
61. ibid., 6 May 1937.
62. Lawlor, *Arquebus*, p. 133.
63. ibid., pp. 117-18; p. 123.

Chapter 2: The Politics in Painting

1. Wakelin to Ure Smith, 2 November 1938. Ure Smith Papers, MS 31, folder 8, Mitchell Library.
2. Bunny to Ure Smith, 10 August 1938. ibid.
3. Heysen to Lionel Lindsay, 1931. Quoted by John Tregenza, 'Hans Heysen: a Biographical Outline' in the catalogue, *Hans Heysen Centenary Retrospective 1877-1977*, p. 104.
4. Bernard Smith, *Australian Painting 1788-1970*, 2nd edn (Melbourne, 1971), pp. 195-6.
5. Mary Eagle, 'Modernism in Sydney in the 1920's, in Ann Galbally and Margaret Plant (eds), *Studies in Australian Art* (Melbourne, 1978), p. 89.
6. Sir John Rothenstein, *An Introduction to English Painting* (London, 1963), p. 132.
7. Minutes of general meeting, N.S.W. Society of Artists, 10 February 1936. Minute book at present in the possession of Lloyd Rees.
8. Heysen to Ure Smith, 12 March 1936. Ure Smith Papers, op. cit., folder 4. In writing a reply to Ure Smith, Heysen summarized Ure Smith's views, which are stated here.

9. *Argus*, 23 April 1937.
10. Croll Papers, MS 8910, La Trobe Collection, State Library of Victoria.
11. *Argus*, 9 March 1937.
12. Norman Lindsay to Ure Smith, 12 March 1937. Ure Smith Papers, op. cit., folder 6.
13. Croll to Ure Smith, 12 March 1937. ibid., folder 3.
14. *Argus*, 11 May 1937. Quoted by Adrian Lawlor, *Arquebus* (Melbourne, 1937), p. 78.
15. Carter to Ure Smith, 21 July 1937. Ure Smith Papers, op. cit., folder 2.
16. Ure Smith to Carter, 25 December 1937. ibid.
17. *Argus*, 23 April 1937.
18. ibid., 6, 11 March 1937.
19. Lawlor, op. cit., p. 15.
20. George Bell, 'The Australian Academy: Its Influence on Australian Art', *Australian Quarterly*, vol. X, no. 2 (June 1938), p. 46; pp. 46-7.
21. *Argus*, 6 March 1937; 11 March 1937.
22. Smith, op. cit., p. 189.
23. William Moore, *The Story of Australian Art* (Sydney, 1934), vol. 2, p. xxi.
24. Shore to Lionel Lindsay, 1937. Lindsay Papers, MS 9104, La Trobe Collection, State Library of Victoria. Although undated, the subjects referred to indicate that it was written late in 1937.
25. Catalogue for the first annual exhibition of the Australian Academy of Art, 1938.
26. Croll to Ure Smith, 14 March 1937. Ure Smith Papers, op. cit., folder 3.
27. Ure Smith to Carter, 8 February 1938. ibid., folder 2.
28. Murdoch to Ure Smith, 30 January 1941. ibid., folder 7. In this letter Murdoch summarizes Ure Smith's views, which were stated in earlier correspondence.
29. John Young, 'The Academy Show', *Art in Australia*, series 3, no. 79 (May 1940), p. 41.
30. John Reed, 'The Contemporary Art Society of Australia: An Outline of the History of the Society in Melbourne', part 1, C.A.S. Broadsheet, no. 4 (February 1955), p. 5.
31. *Argus*, 11 July 1938. John Reed and Allan Henderson had drafted the constitution, using that of the Victorian Artists Society as a precedent.
32. ibid., 14 July 1938. These were also written into the constitution.
33. George Bell, 'A Comment on "Outline of the History of the Contemporary Art Society"'. Bell Papers, in the possession of Antoinette Niven. This unpublished MS. is an account of the early C.A.S. and was written in response to a brief history by Reed (op. cit.), which Bell called 'mislead-

ing and egregious'. This suggests that it was written in 1955.
34. John Reed interview, 6 August 1973.
35. *Argus*, 6 June 1939.
36. *Herald*, 5 June 1939.
37. Introduction to C.A.S. catalogue, first annual exhibition (6-25 June 1939). MS 9349, La Trobe Collection, State Library of Victoria.
38. Charles Hill to Ure Smith, 28 November 1941. Ure Smith Papers, op. cit., folder 5. The actual vote that formally ratified the agreement was not taken until 1943.
39. Memorandum, A. W. Bazley (Acting Director, Australian War Memorial) to Sen. the Hon. J. S. Collings (Chairman of the War Memorial Board), 10 July 1944. Appointment of War Artists Papers, Australian War Memorial. Earlier correspondence between Bazley and Lt.-Col. J. L. Treloar indicates clearly that Bean had initiated the move.
40. J. C. Aisbett (hon. sec. and treasurer of the Academy) to James Minogue (hon. sec. of the V.A.S.), 7 December 1949. V.A.S. Papers, MS 7593, 583/1B, La Trobe Collection, State Library of Victoria. The last meeting of members was on 25 November 1949.
41. Murdoch to Ure Smith, 15 March 1937. Ure Smith Papers, op. cit., folder 7.
42. Notes for the *Biographical Encyclopedia of the World*, dated 1944. MacDonald Papers, MS 430, folder IV, National Library.
43. Longstaff to MacDonald, 14 March 1936, and Menzies to MacDonald, 8 October 1936. ibid.
44. Longstaff to MacDonald, 14 March 1936. ibid.
45. Daryl Lindsay to Lionel Lindsay, 27 August 1936. Lindsay Papers, op. cit. Daryl Lindsay was a close friend and intimate of Sir Keith Murdoch.
46. Leonard Cox, *The National Gallery of Victoria 1861-1968: a search for a collection* (Melbourne, 1970), p. 143.
47. *Herald*, 25 May 1937; 12 April 1938.
48. Lionel Lindsay to MacDonald, 1 November 1942. MacDonald Papers, op. cit., folder I.
49. Cox, op. cit., pp. 119-20.
50. *Argus*, 21 December 1937.
51. ibid., 22 December 1937.
52. I am indebted here to Jan Gerraty's study of Burdett's criticism, 'Basil Burdett: Critic and Entrepreneur', B.A. thesis, Monash University (1978), p. 19, for this summary of views expressed by Burdett over a period of years, as I am for other aspects of her research on Burdett.
53. Lawlor, op. cit., p. 12.
54. Harold Rosenberg, 'The Academy in

Totalitaria', in Thomas B. Hess and John Ashberry (eds), *Academic Art* (London, 1963), pp. 130-1.
55. Reed interview, op. cit., 6 August 1973.
56. ibid.

Chapter 3: Democracy and Modernism

1. The most comprehensive account of the exercise is in an unsigned article, '£200,000 Modern Art Show', *Australia: National Journal*, no. 3 (December-February 1937-40), pp. 52-70.
2. *Herald*, 7 July 1937.
3. Reed to author, 24 February 1979.
4. The details which follow here are derived from the more extensive of the two catalogues available. This contains brief notes and some monochrome illustrations. The exhibition opened in Adelaide (21 August), then was on show in Melbourne (16 October-1 November), and finally went to Sydney and Brisbane in 1940.
5. *Herald*, 16 October 1939; 6 July 1939.
6. Quoted in Leonard Cox, *The National Gallery of Victoria 1861-1968* (Melbourne, 1970), p. 164.
7. The facts of these purchases were published in the *Herald* (25, 28 October 1939).
8. John Reed interview, 6 August 1973.
9. Albert Tucker interview, 7 February 1974.
10. Ian Turner, 'My Long March', *Overland*, no. 59 (Spring 1974), p. 25.
11. Herbert Read, 'Introduction' in H. Read (ed.), *Surrealism* (London, 1936), p. 28.
12. Editorial, *Art in Australia*, series 4, no. 1 (March/April/May 1941).
13. Albert Tucker, 'The Flea and the Elephant', *Angry Penguins*, no. 6 (Autumn 1944), p. 57. It is difficult to date Tucker's association with this group but about 1938 to 1941 is likely.
14. John Reed, 'Reply', *Angry Penguins*, no. 8 (1946), p. 107. Reed was defending himself against charges from Counihan of being anti-left.
15. John Sinclair interview, 3 April 1974.
16. Lawlor to Tucker (undated). Tucker Papers, in the possession of the artist. Although the letter is undated, its tone and the issues raised leave no doubt that it was written in September 1939.
17. This notice is dated 23 September 1939. A copy is in the Bell Papers, in the possession of Antoinette Niven.
18. George Bell, 'A Comment on "Outline of the History of the Contemporary Art Society"', ibid.
19. This point corrects a widespread

misapprehension that Bell resigned simultaneously from the presidency and the Society. That Bell resigned before the meeting is confirmed by a letter to members signed by John Reed as hon. sec. (11 September 1940). That he resigned in the month of June is indicated in a letter from Reed to Bell (13 June 1940). Both are in ibid.

20. Reed to author, 31 October 1973.
21. Bell, op. cit.
22. Letter to C.A.S. members signed by Reed, 11 September 1940 (op. cit.).
23. Kenneth Wilkinson, 'Contemporary Art Arrives', *Art in Australia*, series 3, no. 81 (November 1940), p. 15.
24. *Sydney Morning Herald*, 24 September 1940.
25. Frank Hinder interview, 5 July 1974.
26. Letter to editor, *Sydney Morning Herald*, 27 September 1940.
27. Introduction to catalogue, C.A.S. annual exhibition (1941).
28. 'Art Jitterbugs Het-Up', *Truth*, 1 November 1941.
29. John Reed, 'The Contemporary Art Society of Australia: An Outline of the History of the Society in Melbourne', part 1, C.A.S. Broadsheet, no. 4 (February 1955).
30. Minutes of the N.S.W. branch of the C.A.S., 25 February 1941. Mitchell Library. These events are also recorded in the *Sydney Morning Herald*, 8, 25 February 1941.
31. *Sydney Morning Herald*, 4 March 1941.
32. Other members included Victor Adolfson, Shirley Keene, Charmian Kimber, John Dowie, Bob Pulleine, Marjorie Gwynne and Ruby Henty.
33. This account of the early history of the South Australian branch is based on a number of unsatisfactory and incomplete accounts, supplemented by interviews with Francis.
34. Ivor Francis, diary entry, 9 July 1942. Francis Papers, in the possession of the artist.
35. The other members of the committee were Joan Dallwitz, Douglas Roberts, Victor Adolfson, Jacqueline Hick, Shirley Adams, Ruth Tuck and Ivor Francis.
36. Reed to Evatt, 22 July 1942. Evatt Papers, Flinders University Library.
37. Alistair Davidson, *The Communist Party of Australia* (Stanford, 1969), pp. 80-2.
38. C.A.S. catalogue, annual exhibition (1942).
39. 'W.S.', 'Australia's Most Important Exhibition', *Art in Australia*, series 3, no. 77 (1939), p. 17.
40. Max Dimmack, *Noel Counihan* (Melbourne, 1974), p. 13.

41. Bernard Smith, *Australian Painting*, 2nd edn (Melbourne, 1971), pp. 221-3, summarizes the artist's colourful career.
42. *Herald*, 15 September 1937, 17 October 1938.
43. Vassilieff admired Herbert Read's ideas on art and education. His teaching to students at Koornong (of whom Burdett's daughter was one) was based on these principles.
44. *Herald*, 4 March 1940.
45. *Argus*, 1939. The critic was John Harcourt.
46. *Sun*, 1939. Cutting supplied by the artist.
47. The original title is given in the C.A.S. annual exhibition catalogue, 1942, op. cit. It has since become confused with *The Pie Eaters*.
48. *City Lane* was exhibited in the C.A.S. exhibition of 1941. Until 1943 Bergner used his first name Vladimir (the familiar of which is Vladek and which his friends used). He only began to use his second name Jossif (Yiddish form Yosl) from the time of the C.A.S. exhibition in 1943. This was often misspelled as 'Jossel'.
49. Franz Philipp, *Arthur Boyd* (London, 1967), p. 28.
50. Yosl Bergner interview, 15 August 1978.
51. Noel Counihan interview, 5 May 1975.
52. Doerner's book was translated by Eugen Neuhaus. A revised edition has been published (London, 1969).
53. Counihan interview, op. cit.
54. 'The Social Origins of Surrealism'. A copy of the paper is in the Tucker Papers, op. cit. The statement is quoted in Christopher Uhl, *Albert Tucker* (Melbourne, 1969), pp. 15-16.
55. George Orwell, *Keep the Aspidistra Flying* (Harmondsworth, 1970), p. 21.
56. ibid.
57. Many details of Nolan's early career and work are provided by Jaynie Anderson, 'The Early Work of Sidney Nolan 1939-49', *Meanjin*, vol. XXVI, no. 3 (110) (September 1967), pp. 313-17. Since this article contains no footnotes it is difficult to document much of the information given. This period of Nolan's career has been the subject of considerable scrutiny, beginning with Elwyn Lynn's *Sidney Nolan: Myth and Imagery* (London, 1967), and most recently Maureen Gilchrist's unpublished B.A. thesis, 'The Art of Sidney Nolan: the first decade 1937-47', Melbourne University (1975).
58. *Sun*, 11 June 1940.
59. *Herald*, 10 June 1940.
60. Sinclair interview, op. cit.
61. John Reed interview, 10 September 1973.

62. Sinclair interview, op. cit.
63. Anderson, op. cit., p. 316.
64. Gilchrist, op. cit., p. 5.
65. Brian Adams, 'Sidney Nolan — At Sixty', *Quadrant*, vol. XXII, no. 4 (129) (April 1978), p. 8.

Chapter 4: Liberalism and Anarchism

1. Hugh Stretton, *The Political Sciences* (New York, 1969), p. 145.
2. Further details of Burdett's career are contained in the author's entry on Burdett for the *Australian Dictionary of Biography*, vol. 7, 1891-1939 (Melbourne, 1979), p. 482.
3. Related to Jan Gerraty in an interview with Lloyd Rees, 28 September 1978.
4. *Herald*, 8 August 1940; 6 May 1937; 29 February 1940; 21 November 1936; 22 March 1938; 19 March 1938; 9 May 1940; 22 August 1936; 26 January 1937.
5. Basil Burdett, 'Some Contemporary Australian Artists', *Art in Australia*, series 3, no. 29 (September 1929).
6. Nettie Palmer, *Fourteen Years* (Melbourne, 1948), p. 69.
7. Lloyd Rees, *Small Treasures of a Lifetime* (Sydney, 1969), p. 96.
8. Daryl Lindsay to Lionel Lindsay, 29 August 1936. Lindsay Papers, MS 9104, La Trobe Collection, State Library of Victoria.
9. ibid., 5 August 1938.
10. Michael Keon interview, 30 September 1979.
11. Gerald Brenan, *The Literature of the Spanish People* (New York, 1953), pp. 421-6. Unamuno died in 1936.
12. *Herald*, 15 July 1939.
13. John Tregenza, *Australian Little Magazines 1923-1954* (Adelaide, 1964), p. 54.
14. Editorial by Cecily Crozier and Irvine Green, *A Comment*, no. 1 (1940).
15. Tregenza, op. cit., p. 54.
16. Max Harris interview, 29 January 1980.
17. Hal Porter, *The Paper Chase* (Sydney, 1966) p. 176.
18. The most recent account of Jindyworobak poetry and ideas is by W. F. Mandle in *Going It Alone* (Ringwood, 1978, pp. 152-4). The group's outlook and contribution to Australian literature have also been sympathetically treated by Tregenza (op. cit., pp. 49-53), Geoffrey Serle, *From Deserts the Prophets Come* (Melbourne, 1974), pp. 132-3, and Humphrey McQueen, *The Black Swan of Trespass* (Sydney, 1979), pp. 124-32.
19. Harris to Turner, 11 April 1939. Harry Hastings Pearce Papers, MS 2765, folder 2/10, National Library. Between 1939 and 1941 Harris maintained a correspondence with Turner in which he provided a great

deal of information regarding his activities and ideas during this early stage of his career.

20. Christesen to Ingamells, 5 December 1941. Ingamells Papers, MS 6244, La Trobe Collection, State Library of Victoria.
21. Harris to Turner, undated, op. cit. The matters referred to in this letter make it certain, however, that it was written in 1940.
22. *Angry Penguins*, no. 2 (1941), p. 22.
23. Harris to Turner, undated. op. cit.
24. Margaret M. Finnis, *The Lower Level: A Discursive History of the Adelaide University Union* (Adelaide, 1975), p. 186, notes the date of this talk as 24 June 1940.
25. *Bohemia*, no. 5 (August 1939), p. 9.
26. Harris to Turner, undated. op. cit.
27. ibid. The date of this letter is almost certainly August-October 1941 since the event referred to is reported as 'Swimming Notes' in the issue of the university magazine *On Dit*, vol. XI, no. 17 (6 August 1941). See Finnis, op. cit., p. 184.
28. *Australian*, 18 September 1976.
29. Harris to Smith, July 1943. Smith Papers, in the possession of Bernard Smith.
30. Max Harris, 'Let Sporus Tremble', *A Comment*, no. 3 (Christmas 1940/1941).
31. Max Harris, 'Eliminations', *A Comment*, no. 7 (September 1941).
32. Adrian Lawlor, 'Night Thoughts from Broom Warren', *Art in Australia*, series 4, no. 1 (March/April/May 1941), p. 53.
33. Kershaw to Ingamells, 27 November 1941. Ingamells Papers, op. cit. Stephensen had formed the Australia First Movement in the previous month.
34. Bernard Smith, 'Art and Mr. Lawlor', *Australian Quarterly*, vol. XV, no. 1 (March 1943), p. 8.
35. Alister Kershaw, 'Salute to an Aristocracy', *A Comment*, nos 9, 10 (January 1942).
36. Adrian Lawlor, 'Present Discontents in Australian Art', *Australian Quarterly*, vol. XIV, no. 4 (December 1942), p. 34.
37. Published anonymously in *Number Two, 1944* (a sequel to *The First Booke of Fowle Ayres*, Sydney, 1943).
38. The company was filed on 25 June 1943 with an equal partnership between Max Harris, John Reed and Sunday Reed, with offices in Collins House. Support for *Angry Penguins* from Reed began much earlier than the establishment of the firm, possibly as early as 1941.
39. Peter Bellew, editorial, *Art in Australia*, series 4, no. 1 (March/April/May 1941).
40. MacDonald to Lionel Lindsay. Lindsay Papers, op. cit.
41. Bellew interview, 28 February 1977.

42. Max Harris, editorial, *Angry Penguins*, no. 4 (1943).
43. Max Harris and John Reed, 'Editorial: On the Subject of Policy', *Angry Penguin*, no. 5 (September 1943).
44. *Meanjin Papers*, vol. 2, no. 2 (Winter 1943), p. 33.
45. Harris and Reed, op. cit.
46. John Reed interview, 22 October 1973.
47. Albert Tucker, 'Art, Myth and Society', ibid., no. 4 (1943), p. 51.
48. Noel Counihan, 'How Albert Tucker Misrepresents Marxism', *Angry Penguins*, no. 5 (September 1943).
49. Tucker, op. cit., p. 54.
50. Max Harris, 'Art and Social Integration', *Australian Quarterly* (March 1943), p. 24.
51. George Woodcock, 'Anarchism: A Historical Introduction' in Woodcock (ed.), *Anarchism* (Glasgow, 1977), pp. 47-8.
52. George Woodcock, 'The Writer and Politics: part 1', *Angry Penguins Broadsheet*, no. 4 (April 1946), pp. 5-6.
53. Woodcock, 'The Writer and Politics: part 2', ibid., no. 5 (May 1946), p. 15.
54. Woodcock, 'A Reply to Max Brown', ibid., no. 8 (September 1946), p. 3. Woodcock here was quoting from his own study *Anarchism or Chaos*.
55. John Reed, 'Taking Art to the People', *Australian New Writing*, no. 2 (1944), pp. 43-6.
56. Albert Tucker, 'The Flea and the Elephant', *Angry Penguins*, no. 6 (1944), p. 55; p. 56; p. 58.
57. Editorial, *Angry Penguins*, no. 7 (1945), p. 2.
58. Serle, op. cit., p. 144.
59. Editorial, *Angry Penguins Broadsheet*, no. 2 (1946), pp. 2-3.
60. A more exhaustive list would also include John Sinclair, Francis Brabazon, Peter Cowan, Reg Ellery, Harry Roskolenko, Clive and Janet Nield (whose school, Koornong, was based on anarchistic educational principles), Danila Vassilieff, Martin Smith and Michael Keon.
61. The content of Tucker's letter (which must have been written late in 1945 or in January 1946) can be deduced from Reed's point by point reply to Tucker's arguments and demands (Reed to Tucker, 10 January 1946. Tucker Papers, in the possession of the artist).
62. ibid.
63. Tucker to Reed, 17 January 1946. ibid. The letter is in the form of a draft copy.
64. Herbert Read, *Art and Society* (New York, 1966), p. 133.

Chapter 5: Dissent and Division
1. Robert Hewison, *Under Siege: Literary Life in London 1939-1945* (London, 1977), pp. 145, 148.
2. ibid., p. 146. See D. D. Egbert, *Social Radicalism and the Arts* (New York, 1970), pp. 497-501, for a more detailed account of this organization.
3. Noel Counihan interview, 5 May 1975.
4. *Herald*, 20 December 1941.
5. Adrian Lawlor(?), 'Notes of the Month', *A Comment*, no. 13 (October 1942).
6. Ure Smith to McClintock, 5 August 1942. Ure Smith included a typewritten copy of Curtin's letter. Counihan Papers, in the possession of the artist.
7. Alistair Davidson, *The Communist Party of Australia* (Stanford, 1969), pp. 73-6. One consequence was that in 1937 the C.P.A. campaigned as a party supporting the A.L.P. and representing the Australian democratic labour tradition.
8. Robert Hughes, 'Albert Tucker', *Art and Australia*, vol. 1, no. 4 (February 1964), p. 254.
9. Davidson, op. cit., pp. 83-4.
10. Ian Turner, 'My Long March', *Overland*, no. 59 (Spring 1974), p. 25. Turner's comment here relates to his conceptions of his role as fellow traveller and Party member.
11. Catalogue, Anti-Fascist Exhibition, 8-18 December 1942.
12. Noel Counihan, 'How Albert Tucker Misrepresents Marxism', *Angry Penguins*, no. 5 (September 1943).
13. John Reed, 'Anti-Fascist Art', *Angry Penguins*, no. 4 (1943).
14. Max Harris, 'Art and Social Integration', *Australian Quarterly* (March 1943), p. 32.
15. Notice of C.A.S. general meeting, 4 September 1942. Tucker Papers, in the possession of the artist.
16. Reed to Tucker, 8 September 1942. ibid.
17. The Victorian council included regularly, as members, John Sinclair, Nolan, Perceval, Harris and Boyd. Other supporters included Allan Henderson and Alannah Coleman.
18. Harris to Smith, undated. Smith Papers, in the possession of Bernard Smith. There is little doubt that it was written in June 1943 since Smith, always a prompt correspondent, replied to it on 2 July 1943.
19. ibid. This second letter appears from its contents to have been written shortly after the previous one. The date is, therefore, probably July 1943. It is unlikely that Harris was an active member in 1943.
20. ibid., June 1943.
21. ibid., July 1943.
22. Reed to Smith, 20 August 1943. ibid. The reference here to Harris's lack of tact

relates to the claim made by Harris to Smith that he, Harris, was the 'already acknowledged leader of the progressive writers in this country'.

23. ibid., 16 February 1944.

24. *Meanjin*, vol. 6, no. 4 (Summer 1947), p. 279.

25. Editorial, *Australian New Writing*, no. 1 (1945), p. 4; p. 5; p. 6.

26. Davidson, op. cit., p. 83.

27. Bernard Smith, *Place, Taste and Tradition* (Sydney, 1945), p. 204.

28. Bernard Smith, 'Art and Mr. Lawlor', *Australian Quarterly*, vol. XV, no. 1 (March 1943), pp. 76-81.

29. Smith, *Place, Taste and Tradition*, p. 206; p. 215.

30. *Sun*, 24 August 1943.

31. *Argus*, 24 August 1943.

32. *Herald*, 24 August 1943.

33. Albert Tucker, 'Two Melbourne Exhibitions of Paintings', *Angry Penguins*, no. 5 (September 1943).

34. O'Connor to Smith, 27 April 1944. Smith Papers, op. cit.

35. Harris to Tucker, undated. Tucker Papers, op. cit.

36. O'Connor to Smith, 6 June 1944. Smith Papers, op. cit.

37. ibid.

38. Reed to Harris, 16 June 1944. South Australian C.A.S. Papers, in the possession of the Adelaide C.A.S.

39. O'Connor to Smith, 20 June 1944. Smith Papers, op. cit.

40. ibid., 3 July 1944.

41. ibid. O'Connor gives the actual voting figures of 57 to 56 and the results are confirmed in a letter from Reed 3 July 1944, to Mrs Pat McClintock, the secretary of the N.S.W. branch (C.A.S. Papers, Corr. 1944-49, MS 2440, Y 23054, Mitchell Library).

42. M. Harris, 'Australian Communists and Intellectuals', *Social Survey*, vol. 14, no. 9 (October 1965), p. 297. (Report of the Work of the Central Committee from the 13th to 14th National Congress, June 1945). N.B. The author is not Max Harris.

43. O'Connor to Smith, 24 February 1944. Smith Papers, op. cit.

44. ibid., 29 September 1944.

45. Reed to McClintock, 31 August 1944. C.A.S. Papers, op. cit.

46. C.A.S. Memo, 'Exhibition for Museum of Modern Art', 26 October 1944. ibid.

47. Noted in the minutes of Melbourne branch meetings sent to Sydney. ibid.

48. The story has been told many times, most recently by W. F. Mandle in *Going It Alone* (Ringwood, 1978), pp. 155-9. In addition there is the piece by A. N. Jeffares,

'The Ern Malley Poems', in Geoffrey Dutton (ed.), *The Literature of Australia* (Melbourne, 1964). Harris has republished the poems in *Ern Malley's Poems* (Adelaide, 1970).

49. Harris to Reed, 8 November 1943. Reed Papers, MS 10822, La Trobe Collection, State Library of Victoria.

50. Reed to Harris, 9 November 1943. ibid.

51. Max Harris, '"Vogelsangs at Eventide": the social relations of literature in Australia' (1945). Unpublished article, Harris Papers, Barr Smith Library.

52. *On Dit*, 30 January 1944.

53. 'Apology by Max Harris', ibid., 21 July 1944.

54. Adrian Lawlor(?), 'Angry Adelaide', *A Comment*, no. 21 (October 1944).

55. O'Connor to Smith, 6 July 1944. Smith Papers, op. cit.

56. Victor O'Connor, 'A Criticism of Adelaide "Angry Penguins"', *Communist Review* (August 1944), p. 303.

57. O'Connor to Smith, 6 July 1944. Smith Papers, op. cit.

58. The draft proposals were included with a covering letter by Reed to McClintock, 13 April 1945. C.A.S. Papers, op. cit.

59. The proposal was sent by Tucker to Reed with a covering letter, 21 November 1944. A carbon copy is in the Tucker Papers, op. cit.

60. *Sydney Morning Herald*, 7 August 1945.

61. Gleeson to Plate, 30 July 1945. C.A.S. Papers, op. cit.

62. *Sydney Morning Herald*, 28 June 1944.

Chapter 6: Communism and Culture

1. See David Caute, *The Fellow-Travellers: A Postscript to the Enlightenment* (London, 1973), p. 5.

2. Bernard Smith, *Australian Painting 1788-1970*, 2nd edn (Melbourne, 1971), p. 239.

3. Pinchas Goldhar, 'Yosl Bergner: On the Occasion of his Debut at the Art Exhibition at the Kadimah', *Jewish News* (1942). This review is in Yiddish.

4. Charles Merewether, 'Social Realism: The Formative Years', *Arena*, no. 66 (1977), p. 66. Merewether offers a full account of communist cultural activities during the 1930s.

5. Quoted in Max Dimmack, *Noel Counihan* (Melbourne, 1974), p. 26.

6. Both paintings have since disappeared. One was exhibited in the Three Realist Artists exhibition, as *Aborigines Arriving in the City*.

7. Counihan to Smith, 9 May 1943. Smith

Papers, in the possession of Bernard Smith.

8. O'Connor to Smith, 28 August 1943. ibid.

9. Noel Counihan, 'How Albert Tucker Misrepresents Marxism', *Angry Penguins*, no. 5 (September 1943).

10. Smith to Harris, 2 July 1943. Carbon copy in the Smith Papers, op. cit.

11. Smith to Noel Hutton, 10 March 1943. Carbon copy, ibid.

12. ibid., 2 July 1943. Carbon copy.

13. 'Goya' (Bernard Smith), 'The Fascist Mentality in Australian Art and Criticism', *Communist Review* (June 1946), pp. 182-4; (July 1946), pp. 215-17. The section was replaced by the emasculated chapter 7, 'Aestheticism and Nationalism in Australian Art and Criticism' in *Place, Taste and Tradition* (Sydney, 1945), pp. 160-70.

14. Smith, *Place, Taste and Tradition*, op. cit., p. 245; p. 219; p. 217; pp. 245-7.

15. Smith also published a substantial part of this argument in a piece entitled 'The New Realism in Australian Art' in *Meanjin Papers*, vol. 3, no. 1 (Autumn 1944), pp. 20-5.

16. Smith, *Place, Taste and Tradition*, op. cit., p. 258.

17. ibid., p. 259; pp. 265-9.

18. Smith, 'The New Realism in Australian Art', op. cit., p. 21.

19. Counihan to Smith, 12 December 1943. Smith Papers, op. cit. This is quoted by Smith in *Place, Taste and Tradition*, op. cit., pp. 247-8.

20. Max Brown, 'Some Views on the Contemporary Art Show', *Communist Review* (October 1943), p. 142.

21. Smith, *Place, Taste and Tradition*, op. cit., p. 14; p. 21.

22. Smith, 'The Fascist Mentality' (July 1946), op. cit., p. 217.

23. Smith, *Place, Taste and Tradition*, op. cit., pp. 20-1; p. 21.

24. Counihan to Smith, 6 December 1943. Smith Papers, op. cit.

25. ibid., 12 December 1943.

26. ibid.

27. ibid., 3 June 1943.

28. Vic O'Connor interview, 13 January 1975.

29. C.A.S. catalogue, annual exhibition (1944).

30. James McGuire, 'Sora Soirees', *Angry Penguins Broadsheet*, no. 1 (1945), p. 2. Rod Shaw recalls a meeting in 1945 over the issue of figurative versus formalist art (interview, 27 June 1974).

31. These details of Cant's career are from Elizabeth Young, *James Cant* (Adelaide, 1970); a biographical statement published by S.O.R.A. in March 1945 issue of the

bulletin; and an interview (10 July 1973).
32. S.O.R.A. *Bulletin*, no. 1 (April 1945).
Cant was elected S.O.R.A.'s first chairman.
33. McGuire, op. cit., p. 2.
34. S.O.R.A. *Bulletin*, op. cit.
35. McGuire, op. cit., p. 5.
36. Editorial, *Angry Penguins*, no. 9 (1946).
37. O'Connor to Smith, undated (1946).
Smith Papers, op. cit.
38. Counihan to Smith, 30 July 1945. ibid.
O'Connor complained to Smith at this time
that he thought Counihan too obsessed with
cartooning (O'Connor to Smith, 29 July
1944. ibid.).
39. Counihan to Smith, 26 May 1946. ibid.
40. *Herald*, 15 July 1946.
41. *Argus*, 3 September 1943.
42. Counihan to Smith, 4 September 1944.
Smith Papers, op. cit.
43. ibid., 30 July 1945.
44. ibid., 26 January 1944.
45. Noel Counihan interview, 5 May 1975.
46. J. D. Blake, 'Arts and Sciences and the
Working Class Struggle' (speech given to
the Victorian Arts and Science Conference,
16 June 1946), *Communist Review* (August
1946), p. 249.
47. There are in all fourteen paintings in the
series. Most have since disappeared and the
only surviving evidence for them are
transparencies taken at the time.
48. Counihan to Smith, 26 May 1946. Smith
Papers, op. cit.
49. Bernard Smith interview, 15 January
1975.
50. Vic O'Connor and Judah Waten,
introduction, *Twenty Great Australian Stories*
(Melbourne, 1946).
51. Brian Fitzpatrick's *The Australian People*
was published in 1946. In the same year
Southern Stories published Fitzpatrick's
article 'The Australian Tradition'. Vance
Palmer's *The Legend of the Nineties* appeared
in 1954, and Russel Ward's *The Australian
Legend* in 1958.

Chapter 7: The Season in Hell
1. *Herald*, 23 July 1946.
2. Arthur Boyd interview, 3 December
1974.
3. Albert Tucker interview, 7 February
1974.
4. See D. D. Egbert, *Social Radicalism and
the Arts* (New York, 1970), p. 712, for a full
discussion of this dilemma in relation to
European modernists.
5. *Angry Penguins*, no. 7 (1945), p. 184. The
publication did not eventuate, no doubt a
casualty of the break-up of the publishing
firm by 1947.

6. See Roger Shattuck, *The Banquet Years:
the Origins of the Avant-Garde in France 1885 to
World War 1* (New York, 1968). Shattuck
offers a reinterpretation of modernism
different from the more formalist one,
which has always emphasized the import-
ance of post-impressionism and the abstract
stream of development.
7. *Angry Penguins*, no. 4 (1943), p. 44.
8. Max Harris, 'Apotheosis of the
Wheatlands', introd. to the catalogue
Wimmera Paintings of Sidney Nolan, David
Jones Gallery, March 1970.
9. Anna Balakian, *Surrealism: The Road to
the Absolute* (London, 1972), p. 214; p. 41.
10. Wallace Fowlie (tr.), *Rimbaud: Complete
Works, Selected Letters* (Chicago, 1966):
'Royauté', pp. 246-7.
11. Jaynie Anderson, 'The Early Work of
Sidney Nolan', *Meanjin*, vol. XXVI, no. 3
(110) (September 1967), p. 317. Anderson
gives no indication of the source.
12. The phrase is from Malcolm Haslam,
The Real World of the Surrealists (London,
1978), p. 70.
13. Herbert Read, *Art Now* (London, 1936),
p. 46; pp. 45-6.
14. *Art in Australia*, series 4, no. 5. (March/
April/May 1942), p. 44. This was probably
taken from the Museum of Modern Art
catalogues of the exhibitions.
15. ibid., pp. 48-52.
16. The water-colour *Peasant in a State of
Ecstasy* was an illustration for a piece by
André Lhote on the intuitive aspect of art in
'The Unconscious in Art', *Transition*, no. 26
(1937), p. 83.
17. *Herald*, 28 August 1945.
18. Albert Tucker, 'Paintings by H.D.: an
Unknown Australian Primitive', *Angry
Penguins*, no. 7 (December 1944), pp. 23-6.
19. Albert Tucker, 'Clear the Air', ibid., p. 13.
20. *Angry Penguins Broadsheet*, no. 7 (July
1946), pp. 8-9. Three works are reproduced
together with an important example on the
cover, *The Prodigy*.
21. Quoted by Christopher Uhl, *Albert
Tucker* (Melbourne, 1969), p. 24. Viktor
Löwenfeld, *The Nature of Creative Activity*, tr.
O. A. Oeser (Hartford, 1939).
22. Albert Tucker, 'Exit Modernism', *Angry
Penguins Broadsheet*, no. 2 (1946), pp. 9-12.
23. Michael Keon, 'Call Down Today',
Angry Penguins, no. 2 (1941), p. 19.
24. Max Harris, 'A Sermon for Madmen', *A
Comment*, no. 4 (March 1941).
25. The quotation is from T. S. Eliot's
'Marina'. See T. S. Eliot, *Collected Poems
1909-1962* (New York, 1963), p. 106.
26. Joy Hester to Albert Tucker, 1942.
Tucker Papers, in the possession of the
artist.

27. Anderson, op. cit., p. 315.
28. Nolan to Reed, c. 1942. Reed Papers, in
the possession of John and Sunday Reed.
29. ibid., c. 1943.
30. C.A.S. catalogue, annual exhibition
(1944).
31. Charles Baudelaire, *Selected Writings on
Art and Artists* (Harmondsworth, 1972), p.
399.
32. Nolan to Joy Hester, 1943. Tucker
Papers, op. cit.
33. Anderson, op. cit., p. 317.
34. Nolan to Sunday Reed, 4 May 1942.
Reed Papers, op. cit.
35. Tucker, 'Exit Modernism', op. cit., pp.
9-12.
36. The first title appeared excessively
dramatic — perhaps even histrionic in tone.
More recently Tucker has returned to the
original title.
37. Margaret Plant, *John Perceval*
(Melbourne, 1971), p. 22.
38. Mark Kronenberg, 'Saturday Night', *A
Comment*, no. 17 (October 1943).
39. Max Harris, 'Nolan at St. Kilda', *Art and
Australia*, vol. 5, no. 2 (September 1967), p.
437.
40. Quoted in introd. by Ruth Berenson and
Norbert Muhlen in Herbert Bittner (ed.),
George Grosz (New York, 1960), p. 14.
41. See Uhl, op. cit., pp. 32-8 for a more
detailed analysis of the development of this
emblematic form.
42. I have opted here for the classsification
used by Uhl (ibid., pp. 95-6) as being the
most convenient. Uhl notes that his order is
not necessarily an accurate one although
several items have specific dates.
43. *Cahiers d'Art*, nos. 3-10 (1938), p. 97.
44. André Masson, 'Life and Liberty', *Art in
Australia* (March/April/May 1942), p. 11.
The piece would have had a special appeal
to Tucker because it was largely an attack
on socialist realism.
45. John Perceval interview, 18 December
1975.
46. John Reed, 'Introduction to John
Perceval', *Angry Penguins*, no. 5 (September
1943).
47. Perceval interview, op. cit.
48. Franz Philipp, *Arthur Boyd* (London,
1967). Boyd went first into a machine-gun
unit before being transferred to the Army
Survey Corps. He entered the army in
about 1940 and not, it appears, in May
1941 as Philipp maintains, p. 28 (letter to
author, 8 June 1975).
49. Quoted in Philipp, op. cit., p. 28.
50. ibid.
51. ibid., p. 34.
52. Bernard Smith, *Australian Painting*, 2nd
edn (Melbourne, 1971), p. 249, refers to

this phenomenon in art as a 'realistic correl-ative'.

53. Albert Tucker, 'The Flea and the Elephant', *Angry Penguins*, no. 6 (1944), p. 55.

54. Albert Tucker interview, 14 February 1974.

55. Letter to author, op. cit.

56. Philipp catalogues this work as 5(1) (op. cit., p. 245) and gives the date as 1945. The explanation is that the 3 can be misread as 5 and the work appears not to fit in with the earlier urban imagery of 1943.

57. Letter to author, 5 May 1975.

58. ibid.

59. *Sydney Morning Herald*, 29 July 1943.

60. John Reed, foreword to Exhibition of Paintings by Sidney Nolan, August 1943.

61. *Sydney Morning Herald*, 9 November 1945.

62. *Herald*, 20 August 1945.

63. Quotation from Fowlie, op. cit., p. 173.

64. John Rothenstein, *Modern English Painters* (London, 1974), p. 28. It appears that Picasso had introduced the young English artist to the medium.

65. George Johnston, *My Brother Jack* (London, 1964), pp. 258-9.

Chapter 8: Patronage and Professionalism

1. Adrian Lawlor, *Art Front Bulletin*, no. 2 (12 September 1943). Copy in Lawlor Papers, MS 8122, La Trobe Collection, State Library of Victoria.

2. *Herald*, 6 November 1943; *Daily Telegraph*, 9 January 1944.

3. *Bulletin*, 3 November 1943.

4. *Herald*, 18 June 1945.

5. *Argus*, 30 November 1946.

6. Clive Turnbull, *Art Here* (Melbourne, 1947), p. 32.

7. ibid., p. 33.

8. *Herald*, 6 November 1943.

9. John Reid, *Australian Artists at War 1940-1970*, vol. II (Sydney, 1977), p. 6.

10. *Herald*, 1 February 1943.

11. ibid., 16 March 1945.

12. Treloar to Bazley, 18 February 1942. Records of the Australian War Memorial, Appointment of War Artists Papers, file 206/2/12 pt II. Lt.-Col. J. L. Treloar, normally director of the War Memorial, was now in charge of the Military History Section. A. W. Bazley was acting director in his place.

13. ibid., 5 September 1943. The Art Committee consisted of Louis McCubbin, Dr C. E. W. Bean, Sen. the Hon. J. S. Collings, Lt.-Col. J. L. Treloar, A. W. Bazley, Gen. Sir H. G. Chauvel.

14. Treloar to McCubbin, 13 October 1943. ibid.

15. Bazley to Treloar, 13 March 1944. ibid.

16. Treloar to Bazley, 25 May 1944. ibid.

17. Bazley to Treloar, 6 March 1945. ibid. Reed's letter was dated 13 July 1944.

18. The other appointments were Emerson Curtis, Sybil Craig, James Flett, John Goodchild and Max Ragless.

19. Treloar to Bazley, 11 March 1945. ibid.

20. Reed to Collings, 16 March 1945. ibid.

21. Bazley to Treloar, 20 March 1945. ibid.

22. Treloar to Bazley, 3 June 1945. ibid.

23. This exhibition was on show in Sydney in April 1943 at the National Gallery of N.S.W.

24. *Spectre of Sex Appeal* was reproduced in *Vingtième Siècle*, no. 1 (March 1938), a copy of which was in Gleeson's library.

25. *Daily Telegraph*, 29 April 1945.

26. *Sydney Morning Herald*, 26 April 1945.

27. *Herald*, 30 October 1944.

28. ibid., 12 August 1944.

29. Bernard Smith, 'Encouragement of Art', *Australian New Writing*, no. 3 (February 1945), pp. 23-7.

30. John Oldham, 'The Artist After the War', *S.O.R.A. Bulletin*, no. 2 (1945). Oldham had designed the Australian exhibit for the 1939 New York World Fair. In 1945 he was exhibitions officer for the Ministry of Post-war Reconstruction.

31. A. R. McClintock, circular, 'Encourage-ment of Art Movement', 3 July 1944. Ure Smith Papers, MS 31, folder 10, Mitchell Library.

32. McClintock to Bill Courcier, 14 July 1944. ibid.

33. Bernard Smith, *Curriculum Vitae*. Smith Papers, in the possession of Bernard Smith.

34. As Smith explained it in 'Art Exhibitions in Country Centres', in the *Society of Artists Book 1945-6* (p. 31), the idea was a consequence of general enthusiasm by members of the W.A.C. and E.A.M. Smith was being too modest. (Memo. urging official establishment of travelling exhibitions. H. V. Evatt Papers, Flinders University Library.)

35. *S.O.R.A. Bulletin*, no. 5 (August 1945). This was based on a group seminar on the problem of patronage organized by S.O.R.A.

36. Bernard Smith, *Place, Taste and Tradition* (Sydney, 1945), pp. 251-3.

37. Lloyd Ross, 'Building Community and Nation', *Meanjin*, vol. 4, no. 1 (Autumn 1945), p. 5.

38. John Docker, *Australian Cultural Elites* (Sydney, 1974), p. 103.

39. Editorial, *Meanjin*, vol. 4, no. 1 (Autumn 1945).

40. Ross, ibid., p. 8; p. 6.

41. Alistair Davidson, *The Communist Party of Australia* (Stanford, 1969), p. 115.

42. Douglas Dundas interview, 28 June 1974.

43. Richard Haughton James, 'Boiling the Pot', *Australian Artist*, vol. 1. no. 3 (Autumn 1948), p. 9.

44. Reed to Mrs H. McClintock, 12 October 1944. C.A.S. Papers, MS 2440, Y23054, Mitchell Library.

45. John Reed interview, 10 September 1973.

46. Haughton James, op. cit., p. 14.

47. Leonard Cox, *The National Gallery of Victoria 1861-1968* (Melbourne, 1970), p. 171; *Herald*, 11 January 1943. At an exhibition in January 1943 Streeton's top asking price was 800 gns for *St. Mark's Venice*.

48. Report (1945), National Gallery of N.S.W.

49. Alan McCulloch, *Encyclopedia of Australian Art* (Melbourne, 1968), p. 39.

50. Murdoch Papers, MS 2823, National Library. Also see Cox, op. cit., p. 186.

51. Haughton James, op. cit., p. 13.

52. Haughton James, editorial, *Australian Artist*, vol. 1, no. 3 (Autumn 1948), p. 6.

53. Editorial, *Genre*, vol. 1, no. 2 (Spring 1946).

54. Minutes, 15 January 1947. V.A.S. Papers, MS 7593, 555-7, La Trobe Collec-tion, State Library of Victoria.

55. *Argus*, 22 March 1947.

56. Reed to Tucker, 10 January 1946. Tucker Papers, in the possession of the artist.

57. Tucker to Reed, 17 January 1946. Draft copy in ibid.

58. Davison to his mother, 7 April 1946. Davison Papers, MS 764, National Library.

59. Arthur Boyd interview, 3 December 1974.

60. Peter Herbst interview, 7 February 1975.

61. Franz Philipp, *Arthur Boyd* (London, 1967), p. 23; p. 21.

62. John Reed, 'Arthur Boyd, A Personal Reaction to his Painting and Career', *Ern Malley's Journal*, vol. 1, no. 4 (November 1954), p. 29. Quoted in ibid., p. 20.

63. Barrie Reid, 'Nolan in Queensland: Some Biographical Notes on the 1947-8 Paintings', *Art in Australia*, vol. 5, no. 2 (September 1967), p. 447.

64. Angus Wilson, *Such Darling Dodos and Other Stories* (London, 1950), p. 91.

65. Reed interview, op. cit.

66. ibid., 22 October 1973.

67. Dore Ashton, *The New York School* (New York, 1973), p. 7.
68. *Angry Penguins*, no. 6 (1944), p. 58.
69. Herbert Read, *Art and Society* (New York, 1966), p. 99.
70. John Reed, 'Take the People to the Art', *Australian New Writing*, no. 2 (1946), p. 45; p. 46.
71. Elizabeth Vassilieff, 'Inside Outside' (letter to Max Harris), *Ern Malley's Journal*, vol. 1, no. 2 (March 1953), p. 6.
72. Max Harris, letter to Elizabeth Vassilieff, ibid., p. 13.
73. James Birrell, 'The Need for Content', *Ern Malley's Journal*, vol. 1, no. 4 (November 1954), p. 26.
74. John Reed, letter to *Age*, 26 February 1964.
75. Harris, letter to Elizabeth Vassilieff, op. cit., p. 12.
76. Max Harris, 'And the Sexton Tolled the Bell', *Angry Penguins*, no. 8 (1946), p. 53.

Chapter 9: Cultural Reconstruction

1. *Daily Telegraph*, 28 January 1944; 29 January 1944.
2. *Argus*, 29 January 1944 (it was reported that seven trustees voted for Dobell, three were opposed and two were absent); 9 November 1944.
3. Lionel Lindsay to McGregor, 24 January 1944. Lindsay Papers, Corr. 1940-45, MS 1969, Mitchell Library.
4. John Reed, 'Australian Present Day Art', *Angry Penguins*, no. 6 (1944), p. 105.
5. *Herald*, 6 November 1943.
6. John Reed interview, 13 August 1973.
7. Daryl Lindsay to Murdoch, 12 March 1942. Murdoch Papers, MS 2823, National Library.
8. Sir Kenneth Clark, *The Other Half* (London, 1977), p. 152.
9. *Herald*, 28 October 1939.
10. Typescript of speech given 28 September 1943 at the Athenaeum Gallery. Murdoch Papers, op. cit.
11. Murdoch to Daryl Lindsay, 1944. Quoted by C. E. Sayers, 'K.M.: A Life of Keith Murdoch, Newspaper Reporter', unpublished MS. ibid.
12. Typescript of broadcast. ibid. The talks are summarized in the *Society of Artists Book 1943-44* (Sydney, 1944).
13. Sayers, op. cit., pp. 653-5. A detailed account is also given by Leonard Cox, *The National Gallery of Victoria 1861-1968* (Melbourne, 1970), pp. 174-7.
14. *Argus*, 6 March 1945. In a letter to the editor contesting this assertion, John Reed quoted from Murdoch's press statement.
15. Daryl Lindsay to Murdoch, 14 March 1945. Murdoch Papers, op. cit.
16. John Reed interview, 10 September 1973.
17. Henderson to Murdoch, 8 March 1945. Murdoch Papers, op. cit.
18. Murdoch to Henderson, 9 March 1945. Carbon copy in ibid.
19. *Argus*, 6 March 1945.
20. Typescript of broadcast, op. cit.
21. Sayers, op. cit., p. 644. ibid.
22. Murdoch to Burke, 19 December 1945. Carbon copy in ibid.
23. Joseph Burke, 'Chair of Fine Arts', *Farrago*, 7 March 1947.
24. Joseph Burke, *Vestes: Journal of the Federal Council of the University Staff Associations*, vol. VI, no.4 (December 1963), p. 263.
25. Burke to Medley, 25 March 1947. Copy in Murdoch Papers, op. cit.
26. *Daily Telegraph*, 11 June 1940; 26 September 1940.
27. ibid., 3 October 1940.
28. *Sydney Morning Herald*, 20 July 1943.
29. ibid., 18 March 1943.
30. *Daily Telegraph*, 14, 22 March 1964. Peter Bellew interview, 28 February 1977.
31. Ure Smith to Lionel Lindsay, 31 November 1941. Lindsay Papers, op. cit.
32. McGregor to Lionel Lindsay, 21 March 1944. ibid.
33. ibid., 23 March. This comment was added as a postscript to the letter.
34. *Daily Telegraph*, 3 April 1944.
35. Ure Smith to Lionel Lindsay, 21 January 1946. Lindsay Papers, op. cit.
36. Paul Haefliger interview, 18 August 1975.
37. *Sydney Morning Herald*, 7 August 1945.
38. ibid., 14 August 1943.
39. Haefliger interview, op. cit.
40. *Sydney Morning Herald*, 16 February 1946.
41. David McNicoll, introd. to *Alec Murray's Album: Personalities in Australia* (Sydney, 1948).
42. *Herald*, 30 December 1944.
43. ibid., January 1945. The day of publication is not known but it is almost certain to have been very early in the new year.
44. Russell Drysdale interview, 21 May 1975.
45. *Sydney Morning Herald*, 14 April 1943.
46. Reed, 'Australian Present Day Art', op. cit., p. 106.
47. Bernard Smith, *Place, Taste and Tradition* (Sydney, 1945), pp. 240-1.
48. Max Harris, 'The Current Literary Scene', *Angry Penguins*, no. 9 (1946), p. 60.
49. Report of Director on Loan Exhibitions and Buying Policy, 16 July 1948. Referred to in Cox, op. cit., p. 202.
50. Daryl Lindsay to Tucker, 21 November 1947. Tucker Papers, in the possession of the artist.
51. 'Sir Keith Murdoch Speaks on Art', *Society of Artists Book 1945-46* (Sydney, 1946), p. 10.

Chapter 10: The Radical Diaspora

1. Editorial, *Angry Penguins*, no. 7 (1945), p. 2.
2. Franz Philipp, 'On Three Paintings of Arthur Boyd', *Present Opinion*, vol. 11, no. 1 (1947), pp.9-10; p. 10.
3. *Herald*, 23 July 1946.
4. Reed to Tucker, 14 November 1947. Tucker Papers, in the possession of the artist.
5. John Reed, 'Arthur Boyd in A Personal Reaction to his Painting and Career', *Ern Malley's Journal*, vol. 1, no. 4, November 1954, p. 31.
6. James McAuley, 'Douglas Stewart', in Geoffrey Dutton (ed.), *The Literature of Australia* (Ringwood, 1964), p. 373.
7. Max Harris, 'And the Sexton Tolled the Bell', *Angry Penguins*, no. 8 (1946), p. 54.
8. Vance Palmer, *The Legend of the Nineties* (Melbourne, 1956), p. 52.
9. Sidney Nolan, 'The "Kelly" Paintings by Sidney Nolan', *Australian Artist*, vol. 1, part 4 (Winter 1948), p. 21.
10. Quoted by Colin MacInnes in Kenneth Clark, Colin MacInnes and Bryan Robertson, *Sidney Nolan* (London, 1961), p. 30.
11. A copy of this book was in the Reed library.
12. *Verve* (July-October 1939). The manuscript from which the works were reproduced is in the French Bibliothèque Nationale. Nolan had access to copies of *Verve* through the Reed library.
13. Quoted in an interview with Noel Barber, in his *Conversations with Painters* (London, 1964), p. 90.
14. Nolan to Tucker, 27 May 1948. Tucker Papers, op. cit.
15. John Reed, 'Nolan's Kelly Paintings', *Art and Australia*, vol. 5, no. 2 (September 1967), p. 443.
16. *Sydney Morning Herald*, 16 February 1946.
17. *Herald*, 17 September 1946.
18. Albert Tucker interview, 7 March 1974.
19. Tucker to Nolan, 23 July 1947. Reed Papers, in the possession of John and Sunday Reed.
20. Robert Hughes, *The Art of Australia* (Harmondsworth, 1970), p. 155. As

Christopher Uhl notes in *Albert Tucker* (Melbourne, 1969), p. 90, there is no verification of this in any newspaper report in 1947.

21. Max Harris, 'The Current Literary Scene No. 2', *Angry Penguins*, no. 8 (1946), p. 101; p. 102.

22. Reed, 'Arthur Boyd', op. cit., p. 30.

23. Reed to Tucker, 18 April 1948. Tucker Papers, op. cit.

24. Nolan to Tucker, 19 April 1948. ibid.

25. Minutes of general meetings, N.S.W. Society of Artists, August 1951. Minute book at present in the possession of Lloyd Rees.

26. Burke to Reed, 16 April 1948. Reed Papers, op. cit.

27. Boyd to Tucker, 22 June 1948. Tucker Papers, op. cit.

28. C.A.S. Minutes, 9 May 1946. Minute Book of N.S.W. Branch 1945-46, C.A.S. Papers, MS 2440, file Y23053, Mitchell Library.

29. *Sydney Morning Herald*, 12 November 1946.

30. V.A.S. Papers, MS 7593, La Trobe Collection, State Library of Victoria.

31. V.A.S. Minutes, 3 August 1949. ibid.

32. *Argus*, 3 May 1947.

33. Quoted by Robin Gollan in 'Meanjin's Australianism', *Overland*, no. 48 (Winter 1971), p. 42.

34. ibid.

35. See Smith, op. cit., pp. 295-302.

36. Nolan to Sunday Reed (1945). Only a fragment of this letter now exists. Reed Papers, op. cit.

37. Reed, 'Arthur Boyd', op. cit., p. 29.

38. ibid.

39. Reed to Tucker, 17 December 1947. Tucker Papers, op. cit. In this letter Reed reiterated and replied to Tucker's responses.

40. Tucker to Reed, 11 September (c. 1955). ibid.

41. Reed to Tucker, 17 December 1947. ibid.

42. Nolan to Tucker, 6 November 1947. ibid.

43. ibid., 19 January 1948.

44. John Reed, 'The Formative Years, 1940-45'. Introd. to the catalogue of the collection of the Musuem of Modern Art and Design in Australia (1961).

45. 'The Antipodean Manifesto': this was republished in *Art and Australia*, vol. 5, no. 4 (March 1968), pp. 608-9, together with an accompanying article on the history of the group by Barbara Blackman, 'The Antipodean Affair'. The exhibition 'Antipodeans', was held 4-15 August 1959. The quotation here is on p. 609.

46. *Ern Malley's Journal*, vol. 1, no. 1 (November 1952), p. 46; p. 5.

47. Tucker to Reed, 17 March 1953. Tucker Papers, op. cit.

48. Reed to Tucker, 23 July 1953. ibid.

49. Clive Turnbull, *Art Here* (Melbourne, 1947), p. 32.

50. Robert Hughes, 'Albert Tucker', *Art and Australia*, vol. 1, no. 4 (February 1964), p. 259.

51. Robin Boyd, *The Australian Ugliness* (Melbourne, 1960), p. 235.

ACKNOWLEDGEMENTS

No book of this kind is possible without the selfless help and generous support of friends and colleagues. This study has its origins in a doctoral thesis in the History Department of Monash University, and among the many debts incurred two of the foremost are to my supervisors, Professor Alan McBriar and Dr Geoffrey Serle. Their initial enthusiasm helped to launch the study and their special insights, sympathetic support and generous and firm criticism kept it buoyant and on course. My special thanks are also due to Dr Leon Atkinson, from whose enthusiasm and faith the project sprang and whose interest and challenging comment helped to sustain it. My debt to each of these scholars is great.

Many people have helped in the research for this book — too many to name individually — but all have my sincere and grateful appreciation for their efforts. The staffs of Australia's principal research libraries in Melbourne, Sydney, Adelaide and Canberra have all been more than generous. In particular, I owe much to the friendly personal efforts of John Thompson, Joyce McGrath, Ross Gibbs, Graeme Powell and Shirley Humphries.

I have also received unstinting co-operation and tolerance from the curatorial and administrative staffs of the art galleries in each state. I am especially grateful to Philip Jago, Gavin Fry, Susan Abasa, Ian North, Sam Alcorn, James Mollison, Daniel Thomas and Alan Dodge. I also wish to thank the owners of paintings and photographs who generously made them available for reproduction.

The contemporary nature of this study has meant that I have relied greatly on the memories and papers of private individuals, without whose co-operation the book could not have been written. I wish to thank each individual and the Mitchell, La Trobe, National and Barr Smith libraries for providing access to private papers and for permission to reproduce the wealth of material there contained. I am especially grateful to all the artists and supporters of art who so willingly subjected themselves to the ordeal of tape-recorded interviews, patiently answered my questions and provided generous replies to my correspondence. The list is a long one and the names of those whom I have quoted, and of others who supplied vital background material, appear in the bibliography. Among the many to whom I owe a special debt of gratitude are John and Sunday Reed, Albert Tucker, Bernard Smith, Noel Counihan, Vic O'Connor, Yosl Bergner and Ivor Francis. All were unsparing in their response to my demands on time, attention and access to personal documents. Their interest and encouragement were a source of continuing inspiration. I should also like to mention the warm hospitality extended to me by Sam Atyeo, Peter Bellew and Harry Roskolenko, each of whom contributed to making research a social pleasure. My special thanks are due to Barrett Reid not only for his insight and information but also his enthusiastic support for the book, and his invaluable help in minimizing embarrassing errors and shortcomings in the typescript.

Even more than most art studies, this book relies enormously on visual material — both as historical source and subject. It was Albert Tucker's compulsion to record the artistic life of the 1940s that has helped give the book much of its visual life. In this regard I am also indebted to the efforts of David Baker, who devoted much time and ingenuity to the task, and to the designer, George Dale, who realized its full potential.

I would like to express my deep appreciation for the editorial labours of Margaret Barrett, who did much to eliminate my worst excesses and faults. Finally, few Australian writers can have been better served by their publisher than I have been in the enthusiasm shown for this book and the care brought to its production.

ILLUSTRATIONS

the Ghetto Wall, 1943, oil on composition board. Size and whereabouts unknown

169 Yosl Bergner (b. 1920), *Funeral in the Ghetto*, 1944, oil on composition board. Size and whereabouts unknown

170 Vic O'Connor (b. 1918), *Fitzroy Street*, c. 1943, oil on canvas, 49.5 x 67.5 cm. Private collection

171 James Cant (b. 1911), *The Deserted City*, 1939, oil on canvas, 61.3 x 45.9 cm. Collection: Australian National Gallery, Canberra

172 James Cant (b. 1911), *The Centre of the World*, 1945, oil on canvas, 60.0 x 90.0 cm. In the possession of the artist

174 Noel Counihan (b. 1913), *Miners Working in Wet Conditions*, 1944, oil on composition board, 61.4 x 79.1 cm. Collection: Australian National Gallery, Canberra

177 James Wigley (b. 1918), *Street Scene*, c. 1947, oil on composition board, 60.0 x 42.0 cm. Private collection.

177 Noel Counihan (b. 1913), *Miners Preparing a Shot*, 1944, oil on composition board, 45.7 x 61.0 cm. Collection: Ballarat Fine Art Gallery

180 Yosl Bergner (b. 1920), *Warsaw on the River Vistula*, 1947, oil on composition board. Size and whereabouts unknown

184 Sidney Nolan (b. 1917), *Head (Angry Penguin)*, 1945, synthetic polymer on strawboard, 63.5 x 75.5 cm. Collection: Art Gallery of South Australia; gift of Sidney and Cynthia Nolan, 1974

186 Sidney Nolan (b. 1917), *Royalty*, 1943, synthetic polymer on composition board, 59.0 x 90.0 cm. Collection: John and Sunday Reed

186 Sidney Nolan (b. 1917), *Icarus*, 1943, synthetic polymer on cheesecloth over composition board, 73.5 x 60.5 cm. Collection: Heide Park and Art Gallery

187 John Perceval (b. 1923), *The Merry-go-Round*, 1944, oil on cardboard, 63.3 x 41.3 cm. Collection: Australian National Gallery, Canberra

187 Sidney Nolan (b. 1917), *Le Désespoir a*

les Ailes (Despair Has Wings), 1943, synthetic polymer on composition board, 121.0 x 91.5 cm. Collection: John and Sunday Reed

190 Albert Tucker (b. 1914), *The Possessed*, 1942, oil on composition board, 54.8 x 76.0 cm. On loan to the Australian National Gallery, Canberra

190 Albert Tucker (b. 1914), *The Prisoner*, 1942, oil on plywood, 76.5 x 61.0 cm. On loan to the Australian National Gallery, Canberra

190 Albert Tucker (b. 1914), *Death of an Aviator*, 1942, oil on plywood, 74.5 x 55.5 cm. On loan to the Australian National Gallery, Canberra

191 Sidney Nolan (b. 1917), *Head of a Soldier*, 1943, synthetic polymer paint on cardboard, 75.5 x 63.5 cm. Collection: Australian National Gallery, Canberra

193 Sidney Nolan (b. 1917), *Lublin (Baroque Exterior)*, 1944, synthetic polymer on composition board, 59.0 x 89.5 cm (sight). Collection: Art Gallery of South Australia; gift of Sidney and Cynthia Nolan, 1974

193 Sidney Nolan (b. 1917), *Landscape with Train*, 1942, synthetic polymer on composition board, 61.0 x 90.0 cm. Collection: John and Sunday Reed

193 Sidney Nolan (b. 1917), *Dimboola*, 1944, synthetic polymer on composition board, 62.0 x 75.0 cm. Collection: John and Sunday Reed

196 Albert Tucker (b. 1914), *The Bombing*, 1943, oil on composition board, 30.5 x 41.5 cm. On loan to the Australian National Gallery, Canberra

196 Albert Tucker (b. 1914), *Spring in Fitzroy*, 1943, oil on composition board, 59.0 x 69.0 cm. On loan to the Australian National Gallery, Canberra

196 Albert Tucker (b. 1914), *Battlefield*, 1943, oil on composition board, 61.5 x 91.0 cm. On loan to the Australian National Gallery, Canberra

198 Albert Tucker (b. 1914), *Pick-up*, 1941, oil on cardboard, 61.0 x 45.5 cm. On loan to the Australian National Gallery, Canberra

199 Albert Tucker (b. 1914), *Victory Girls*,

1943, oil on cardboard, 64.7 x 58.7 cm. Collection: Australian National Gallery, Canberra

200 Albert Tucker (b. 1914), *Image of Modern Evil* No. 14, 1945, oil on composition board, 69.5 x 55.0 cm. On loan to the Australian National Gallery, Canberra

202 Albert Tucker (b. 1914), *Image of Modern Evil* No. 24, 1945, oil on composition board, 65.0 x 53.5 cm. On loan to the Australian National Gallery, Canberra

203 John Perceval (b. 1923), *Boy with a Cat* II, 1943, oil on composition board, 58.6 x 43.7 cm. Collection: Australian National Gallery, Canberra

205 John Perceval (b. 1923), *Performing Dogs* No. 1, 1943, oil on cardboard, 38.5 x 69.0 cm. Collection: Heide Park and Art Gallery

205 Arthur Boyd (b. 1920), *Progression*, 1941, oil on composition board, 91.5 x 56.0 cm. Collection: Heide Park and Art Gallery

206 Arthur Boyd (b. 1920), *The Beach*, 1944, oil on muslin on cardboard, 62.9 x 75.5 cm. Collection: Australian National Gallery, Canberra

206 Arthur Boyd (b. 1920), *The Hammock*, 1944, oil on cardboard, 63.0 x 75.5 cm. Collection: Australian National Gallery, Canberra

206 Arthur Boyd (b. 1920), *The Cemetery*, 1944, oil on cardboard, 63.0 x 75.5 cm. Collection: Australian National Gallery, Canberra

206 Arthur Boyd (b. 1920), *The Orchard*, 1943, oil on muslin on cardboard, 62.9 x 75.5 cm. Collection: Australian National Gallery, Canberra

207 Arthur Boyd (b. 1920), *Man with Sunflower*, 1943, oil on canvas, 54.0 x 70.6 cm. Collection: Australian National Gallery, Canberra

207 Arthur Boyd (b. 1920), *The Baths (South Melbourne)*, 1943, oil on muslin on cardboard laid on composition board, 56.5 x 75.6 cm. Collection: Australian National Gallery, Canberra

208 Albert Tucker (b. 1914), *Image of Modern Evil* No. 19, 1945, oil on

cardboard, 30.0 x 46.0 cm. On loan to the Australian National Gallery, Canberra

208 Albert Tucker (b. 1914), *Image of Modern Evil* No. 21, 1945, oil on plywood, 66.5 x 91.5 cm. On loan to the Australian National Gallery, Canberra

209 John Perceval (b. 1923), *Negroes at Night*, 1944, oil on canvas laid on composition board, 80.0 x 87.0 cm. Collection: Australian National Gallery, Canberra

210 Arthur Boyd (b. 1920), *Lovers on a Bench*, 1943, oil on hardboard, 60.6 x 46.2 cm. Collection: Australian National Gallery, Canberra

210 Arthur Boyd (b. 1920), *Two Lovers (The Good Shepherd)*, 1944, oil on muslin laid on composition board, 53.3 x 71.0 cm. Collection: Heide Park and Art Gallery

211 Arthur Boyd (b. 1920), *Landscape*, 1943, oil on composition board, 62.4 x 74.6 cm. Collection: Mrs J. Lewis

212 Sidney Nolan (b. 1917), *Boy in Township*, 1943, synthetic polymer on pulpboard, 61.0 x 72.5 cm. Collection: Art Gallery of New South Wales

213 Sidney Nolan (b. 1917), *Rosa Mutabilis*, 1945, synthetic polymer on composition board, 90.5 x 121.7 cm. Collection: John and Sunday Reed

219 Ivor Hele (b. 1912), *2/10 Commando Squadron Wash and Clean Up, Suain, New Guinea, November 1944*, 1944-45, oil on canvas, 51.3 x 61.4 cm. Collection: Australian War Memorial, Canberra

219 Ivor Hele (b. 1912), *Battle Burial of Three N.C.O.s*, c. 1943, oil on canvas, 76.3 x 91.5 cm. Collection: Australian War Memorial, Canberra

220 William Dobell (1899-1970), *Cement Worker*, c. 1943, oil on cardboard, 76.2 x 50.8 cm. Collection: Australian War Memorial, Canberra

222 Russell Drysdale (b. 1912), *Local V.D.C. Parade*, 1943, oil on three-ply panel, 44.4 x 57.1 cm. Collection: Art Gallery of South Australia

222 Russell Drysdale (b. 1912), *Albury Station*, 1943, oil on canvas, 61.0 x 76.2 cm. Collection: National

Gallery of Victoria

223 James Gleeson (b. 1915), *The Sower*, 1944, oil on canvas, 76.2 x 50.8 cm. Collection: Art Gallery of New South Wales

224 James Gleeson (b. 1915), *The Citadel*, 1945, oil on composition board, 182.5 x 122.0 cm. Collection: Australian National Gallery, Canberra

247 William Dobell (1899-1970), *Portrait of Joshua Smith*, 1943 (extensively restored after fire damage), originally oil on cardboard, 104.5 x 75.0 cm. Private collection

254 Paul Haefliger (b. 1914), *Abstract with Violin*, 1938, oil on canvas, 51.5 x 61.6 cm. Collection: Australian National Gallery, Canberra

256 David Strachan (1919-70), *Lovers and Shell*, 1945-46, oil on canvas, 37.0 x 57.0 cm. Collection: Ballarat Fine Art Gallery

260 Sali Herman (b. 1898), *McElhone Stairs*, 1944, oil on canvas, 67.3 x 56.0 cm. Private collection

260 Russell Drysdale (b. 1912), *Moody's Pub*, 1941, oil on panel, 50.8 x 61.6 cm. Collection: National Gallery of Victoria

261 Russell Drysdale (b. 1912), *Back Verandah*, 1942, oil on composition board, 40.6 x 50.8 cm. Collection: Queensland Art Gallery

262 Peter Purves Smith (1912-49), *The Nazis, Nuremberg*, 1938, oil on canvas, 71.1 x 91.4 cm. Collection: Queensland Art Gallery

262 Peter Purves Smith (1912-49), *The Café*, 1938, oil on canvas, 46.3 x 34.3 cm. Collection: Australian National Gallery, Canberra

262 Russell Drysdale (b. 1912), *Sunday Evening*, 1941, oil on fibro-cement panel 60.0 x 70.0 cm. Collection: Art Gallery of New South Wales

263 Russell Drysdale (b. 1912), *Man Feeding his Dogs*, 1941, oil on canvas, 51.0 x 61.0 cm. Collection: Queensland Art Gallery; presented by Mr C. F. Viner-Hall, 1961

264 Russell Drysdale (b. 1912), *Deserted Outstation*, 1945, oil on canvas, 86.5 x

112.0 cm. Collection: John Fairfax and Sons Pty Ltd

265 Russell Drysdale (b. 1912), *The Rabbiters*, 1947, oil on canvas, 76.2 x 101.6 cm. Collection: National Gallery of Victoria

271 Arthur Boyd (b. 1920), *The King (The Deluge)*, 1944-45, oil on muslin on cardboard, 88.3 x 111.5 cm. Collection: Australian National Gallery, Canberra

272 Arthur Boyd (b. 1920), *The Mockers*, 1945, oil on canvas laid on composition board, 84.5 x 103.0 cm. Collection: Art Gallery of New South Wales

273 Arthur Boyd (b. 1920), *Melbourne Burning*, 1946-47, oil and tempera on canvas, 90.2 x 100.5 cm. Collection: Mr and Mrs John Altmann

275 John Perceval (b. 1923), *Murrumbeena Railway Station*, 1946, casein tempera and resin mixed technique on composition board, 61.0 x 78.5 cm. Collection: Sunday Reed

277 Sidney Nolan (b. 1917), *The Trial*, 1946-47, synthetic polymer paint on composition board, 91.5 x 121.9 cm. Collection: Australian National Gallery, Canberra

278 Sidney Nolan (b. 1917), *Death of Constable Scanlon*, 1946-47, synthetic polymer paint on composition board, 90.4 x 121.2 cm. Collection: Australian National Gallery, Canberra

278 Sidney Nolan (b. 1917), *The Chase*, 1946-47, synthetic polymer paint on composition board, 91.5 x 121.9 cm. Collection: Australian National Gallery, Canberra

279 Sidney Nolan (b. 1917), *Burning at Glenrowan*, 1946-47, synthetic polymer on composition board, 91.5 x 121.9 cm. Collection: Australian National Gallery, Canberra

281 Albert Tucker (b. 1914), *Man's Head*, 1946, oil on gauze over cardboard, 71.5 x 64.0 cm. On loan to the Australian National Gallery, Canberra

281 Albert Tucker (b. 1914), *Portrait of Martin Smith*, 1946, oil on composition board, 46.0 x 61.0 cm. On loan to the Australian National Gallery, Canberra

290 Russell Drysdale (b. 1912), *North Australian Landscape*, 1959, oil on canvas, 76.2 x 127.0 cm. Collection: Queensland Art Gallery

291 Sidney Nolan (b. 1917), *Musgrave Ranges*, 1949, oil on composition board, 76.8 x 121.9 cm. Collection: National Gallery of Victoria; A. R. Henderson Bequest, 1956

293 Albert Tucker (b. 1914), *Cratered Head*, 1958-60, P.V.A. on composition board, 122.0 x 91.5 cm. In the possession of the artist

Black and White Plates

26 Noel Counihan (b. 1913), *The Troops*, 1939, pen and ink on paper, 24.5 x 29.5 cm. Whereabouts of original unknown

85 Yosl Bergner (b. 1920), *Man in Warsaw*, 1939. Size and whereabouts unknown

85 Yosl Bergner (b. 1920), *City Lane*, 1939. Size and whereabouts unknown

94 Sidney Nolan (b. 1917), *Montage*, 1940, printed paper, 36.5 x 23.0 cm. Collection: John and Sunday Reed

124 Joy Hester (1920-60), *Face*, c. 1947, ink, brush, pen on paper, 30.5 x 25.5 cm. Private collection

124 Joy Hester (1920-60), *The Lovers*, 1956, water-colour gouache and enamel on board, 57.5 x 39.0 cm. Collection: Allen D. Christensen

158 Noel Counihan (b. 1913), *Pick-up*, 1942, brush and ink on paper, 38.8 x 35.5 cm. Private collection

171 James Cant (b. 1911), *Surrealist Drawing*, c. 1936, ink on tracing paper, 20.4 x 25.5 cm. In the possession of the artist

173 Rod Shaw (b. 1915), *The Cable Layers*, 1946, oil on plywood, 76.2 x 91.5 cm. Collection: Art Gallery of New South Wales

176 Roy Dalgarno (b. 1910), *The Old Timer*, 1946, pen and ink on cardboard, 36.0 x 22.0 cm. Collection: Rod Shaw

178 Noel Counihan (b. 1913), drawing

used to illustrate a book of short stories by Alan Marshall, *Pull Down the Blind* (Cheshire, 1949), pen and ink on paper, 36.0 x 31.0 cm. Collection: Judah Waten

197 Albert Tucker (b. 1914), *Sketch for Images of Modern Evil*, c. 1943, pen and ink with pencil on paper, 9.2 x 14.5 cm. In the possession of the artist

197 Arthur Boyd (b. 1920), *Embracing Figures and Figure with Kite Figure*, c. 1943, ink on paper, 21.0 x 30.6 cm. Collection: Australian National Gallery, Canberra

207 Arthur Boyd (b. 1920), *Nude Holding Back Legs of a Dog*, c. 1941-43, ink on paper, 26.4 x 29.4 cm. Collection: Australian National Gallery, Canberra

Photographs

The author and publisher apologize to photographers whose names they were unable to obtain and record here.

KEY L = lender; P = photographer; LP = lender and photographer

Angus and Robertson L, Russell Roberts P: pp. 6, 7 (published in Lionel Lindsay, *Comedy of Life: An Autobiography* [1967])

Australian War Memorial L (neg. 120153): p. 220

Yosl Bergner L: p. 85

Jane Bill L: pp. 96, 101

Professor Joseph Burke L, Ken Nielsen P: p. 251

Charles Bush L: pp. 21 (from *Table Talk*, 28 November 1935), 216, 259

James and Dora Cant L: p. 154; Robert Record P, p. 172

Dr Clem Christesen L: pp. 147, 288

Alannah Coleman L: pp. 5 (life class only, taken for *Table Talk* in 1935), 34

Collins Publishers L: p. 215

Noel Counihan L: pp. 76, 156

Nardine Dalgarno L, Lefevre Cranstone P: p. 173. Roy Dalgarno L: p. 175 (from *Sun*)

Sir Russell Drysdale L: p. 244

Vivian Ebbott L: pp. 18, 46

John Edson L: pp. 81, 95 (*Icare* performance only), 230

Ralph Gibson L: p. 145 (published in the *Argus*, 1943)

Dorothy Green L: p. 146 (McAuley and Stewart)

Herald and Weekly Times L: p. 249 (published in the *Herald*)

Flexmore Hudson L, Mrs Flexmore Hudson P: p. 105

Joan James L: pp. 16, 95 (Lifar, Nolan and de Basil only, from an unidentified newspaper)

La Trobe Collection, State Library of Victoria L: pp. 5 (Croll only), 11, 23, 42, 55, 233, 276; Ritter-Jeppesen P, p. 231

Herbert McClintock L: p. 91

Meanjin Archives, Baillieu Library L: pp. 107, 116, 117; Ken Dicker P, p. 181

Elsa and Ida Meldrum L: p. 9

Richard Meldrum L: Les Dwyer P, p. 36; pp. 58, 221

National Library, Canberra L: pp. 4, 45, 246; Alec Murray P, pp. 51, 248, 253, 254, 255, 256, 257, 258, 266; Max Dupain P, p. 245

Antoinette Niven L, Sir Russell Drysdale P: p. 13

Vic O'Connor L: p. 170

Laurence Pendlebury L: p. 19

Dan Potts L: pp. x, 7, 57

John and Sunday Reed L: pp. 48, 53 (published in the *Herald*, 1936), 98, 191, 242, 283

Rod Shaw L: p. 175 (from *Pix*)

Mrs Arnold Shore L: p. 44

John Sinclair LP: p. 29

Professor Bernard Smith L: pp. 65, 137

Albert Tucker LP: pp. 17, 27, 28, 30, 32, 38, 49, 60, 66, 67, 70, 79, 80, 89, 93, 111, 115, 118, 123, 125, 127, 128, 134, 139, 148, 149, 182, 188, 194, 201, 204, 214, 225, 232, 234, 235, 239, 240, 241, 243, 259, 268, 270, 274, 280, 284, 285; Albert Tucker L: pp. 188, 282

John Yule L: pp. 26, 236, 237, 238

BIBLIOGRAPHY

Manuscripts

George Bell Papers. Held by the artist's daughter, Antoinette Niven.

Basil Burdett Papers. State Library of Victoria.

C.A.S. Papers. State Library of Victoria and Mitchell Library.

Noel Counihan Papers. In the possession of the artist.

R. H. Croll Papers. State Library of Victoria.

Frank Dalby Davison Papers. National Library of Australia.

H. V. Evatt Papers. Flinders University Library.

Ivor Francis Papers. In the possession of the artist.

Max Harris Papers. Barr Smith Library, University of Adelaide.

Rex Ingamells Papers. State Library of Victoria.

Adrian Lawlor Papers. State Library of Victoria.

Sir Lionel Lindsay Papers. State Library of Victoria and Mitchell Library.

J. S. MacDonald Papers. National Library of Australia.

Sir James McGregor Papers. Mitchell Library.

Sir Keith Murdoch Papers. National Library of Australia.

Harry Hastings Pearce Papers. National Library of Australia.

John and Sunday Reed Papers. State Library of Victoria, and in the possession of the Reeds.

Professor Bernard Smith Papers. In the possession of Professor Smith.

N.S.W. Society of Artists Papers. Mitchell Library.

Albert Tucker Papers. In the possession of the artist.

Sydney Ure Smith Papers. Mitchell Library.

V.A.S. Papers. State Library of Victoria.

War Artists Papers. Australian War Memorial.

Newspapers, Periodicals, Magazines

Newspapers and periodicals
These have been selectively read mainly for art criticism and articles on the arts generally in the 1930s and 1940s. In relation to

Sydney newspapers I have had the advantage of the very extensive collection of cuttings on art criticism and other art matters in the library of the Art Gallery of N.S.W.
Advertiser (Adelaide)
Age (Melbourne)
Argus (Melbourne)
Bulletin (Sydney)
Daily Mirror (Sydney)
Daily Telegraph (Sydney)
Herald (Melbourne)
Sun (Melbourne)
Sydney Morning Herald

Magazines
Dates refer only to years consulted in relation to this study.
Angry Penguins (Adelaide, 1940-42; Melbourne, 1943-46)
Angry Penguins Broadsheet (Melbourne, 1945-46)
Art and Australia (Sydney)
Art in Australia (Sydney; series 3, 1922-40, series 4, 1941-42)
Australia: National Journal (Sydney, 1939-40; after 1940 the magazine degenerated and is of little interest)
Australian Artist (Melbourne, 1947-49; first published in 1946 as *Genre*)
Australian New Writing (Sydney, 1943-46)
Australian Quarterly (Sydney, 1938-43)
Bohemia (Melbourne, 1939-40)
A Comment (Melbourne, 1940-47)
Communist Review (Sydney, 1943-48)
Ern Malley's Journal (Melbourne, 1952-55)
Manuscripts (Melbourne, 1931-35)
Meanjin (Brisbane, 1940-44 when published as *Meanjin Papers*; Melbourne, 1945-47)
Melbourne University Magazine (Melbourne, 1946-47)
Present Opinion (Melbourne, 1942-49)
Society of Artists Book (Sydney, 1942-47; 5 annual issues)
Tomorrow (Melbourne, 1946)
Venture (Adelaide, 1937-40)

Books and Articles

Australian
Alexander, J. A. (ed.), *Who's Who in Australia*, Edition XVI, *Herald*, Melbourne, 1957.
Ashton, Julian, *Now Came Still Evening On*, Angus and Robertson, Sydney, 1941.

Badham, Herbert E., *A Study of Australian Art*, Currawong, Sydney, 1949.
Barber, Noel, *Conversations with Painters*, Collins, London, 1964.
Benko, Nancy, *Art and Artists of South Australia*, Lidums, Adelaide, 1969.
Blackman, Barbara, 'The Antipodean Affair', *Art and Australia*, vol. 5, no. 4, March 1968, pp. 607-16.
Boyd, Robin, *The Australian Ugliness*, Cheshire, Melbourne, 1960.
Burke, Joseph, *The Paintings of Russell Drysdale*, Ure Smith, Sydney, 1951.
Christesen, C. B. (ed.), *The Gallery on Eastern Hill*, Melbourne, 1970.
Clark, C. M. H., 'Melbourne: an intellectual tradition', *Melbourne Historical Journal*, no. 2, 1962.
Clark, Kenneth, MacInnes, Colin and Robertson, Bryan, *Sidney Nolan: The Search for Australian Myth in Painting*, Thames and Hudson, London, 1961.
Colahan, Colin (ed.), *Max Meldrum: His Art and Views*, McCubbin, Melbourne, 1920.
Cox, Leonard B., *The National Gallery of Victoria 1861-1968: A Search for a Collection*, National Gallery of Victoria, Melbourne, 1970.
Croll, R. H., *I Recall: Collections and Recollections*, Robertson and Mullens, Melbourne, 1939.
Crowley, F. K., *Modern Australia in Documents*, 2 vols (1901-1939, 1939-1970), Wren, Melbourne, 1973.
Davidson, Alistair, *The Communist Party of Australia*, Hoover Institution Press, Stanford, 1969.
Dimmack, Max, *Noel Counihan*, M.U.P., Melbourne, 1974.
Docker, John, *Australian Cultural Elites: Intellectual Traditions in Melbourne and Sydney*, Angus and Robertson, Sydney, 1974.
Draffin, Nicholas, *Australian Woodcuts and Linocuts of the 1920s and 30s*, Sun Books, Melbourne, 1976.
Dutton, Geoffrey (ed.), *The Literature of Australia*, Penguin, Ringwood, 1964.
—— *Russell Drysdale*, Thames and Hudson, London, 1969 (first published 1964).
Eagle, Mary, 'Modernism in Sydney in the 1920s', in Galbally, Ann and Plant, Margaret (eds), *Studies in Australian Art*, Department of Fine Arts, Melbourne University, 1978.
Free, Renée, *Lloyd Rees*, Lansdowne, Melbourne, 1972.
Friend, Donald, *Gunner's Diary*, Ure Smith, Sydney, 1943.
—— *Painter's Diary*, Ure Smith, Sydney, 1946.
Gibson, Ralph, *My Years in the Communist*

Party, International Bookshop, Melbourne, 1956.

Gleeson, James, *Modern Painters 1931-1970*, Lansdowne, Melbourne, 1971.

—— *William Dobell*, Thames and Hudson, London, 1969 (first published 1964).

Green, H. M., *A History of Australian Literature*, 2 vols, Angus and Robertson, Sydney, 1961.

Greenwood, Gordon (ed.), *Australia: A Social and Political History*, Angus and Robertson, Sydney, 1955.

Harris, Max, 'Angry Penguins and After', *Quadrant*, vol. vii, no. 1, September 1963.

—— *Ern Malley's Poems*, Hyde Park Press, Adelaide, 1969.

Heathcote, Abbie, *A Far Cry: Neil Douglas Spinning Yarns with Abbie Heathcote*, Karella, Melbourne, 1979.

Hetherington, John, *Australian Painters: Forty Profiles*, Cheshire, Melbourne, 1963.

—— *Norman Lindsay: The Embattled Olympian*, O.U.P., Melbourne, 1973.

Hughes, Robert, 'Albert Tucker', *Art and Australia*, vol. 1, no. 4, February 1964, pp. 250-9.

—— *The Art of Australia*, Penguin Books, Harmondsworth, 1970 (revised edition).

—— *Donald Friend*, Edwards and Shaw, Sydney, 1965.

—— 'Irrational Imagery in Australian Painting', *Art and Australia*, vol. 1, no. 3, November 1963, pp. 150-9.

—— 'Melbourne's Forties', *Nation*, 11 August 1962.

—— 'Nolan and Boyd', *Nation*, 4 April 1964.

Johnston, George, *My Brother Jack*, Fontana, London, 1964.

Kennedy, Victor, *Flaunted Banners*, Australian poetry pamphlet, Adelaide, 1941.

Lawlor, Adrian, *Arquebus*, Ruskin Press, Melbourne, 1937.

—— *Eliminations*, Ruskin Press, Melbourne, 1939.

Lindsay, Daryl, *The Felton Bequest*, O.U.P., Melbourne, 1963.

—— *The Leafy Tree: My Family*, Cheshire, Melbourne, 1965.

Lindsay, Joan, *Time Without Clocks*, Penguin Books, Harmondsworth, 1976 (first published 1962).

Lindsay, Lionel, *Addled Art*, Angus and Robertson, Sydney, 1942 (published in London in 1946).

—— *Comedy of Life: An Autobiography*, Angus and Robertson, Melbourne, 1967.

Lindsay, Norman, *My Mask*, Angus and Robertson, Sydney, 1970.

Lynn, Elwyn, *Sidney Nolan: Myth and Imagery*, Macmillan, London, 1967.

McCaughey, Patrick, *The Limits of Vision:*

The Second Dobell Memorial Lecture, October 1977, Dobell Art Foundation, Sydney, 1978.

McCulloch, Alan, *Encyclopedia of Australian Art*, Hutchinson, Melbourne, 1968.

MacDonald, J. S., *Australian Painting Desiderata*, Lothian, Melbourne, 1958.

Main, J. M., 'Painting: Taste and Market', in Davies, A. F. and Encel, S. (eds), *Australian Society: A Sociological Introduction*, Cheshire, Melbourne, 1968.

Mandle, W. F., *Going It Alone: Australian National Identity in the Twentieth Century*, Allen Lane, Ringwood, 1978.

Melville, Robert and Moorehead, Alan, *Ned Kelly: 27 Paintings by Sidney Nolan*, Thames and Hudson, London, 1964.

Merewether, Charles, 'Social Realism: The Formative Years', *Arena*, no. 46 (1977), pp. 65-80.

Missingham, Hal, *They Kill You in the End*, Angus and Robertson, Sydney, 1973.

Moore, William, *The Story of Australian Art*, 2 vols, Angus and Robertson, Sydney, 1934.

Muirden, Bruce, *The Puzzled Patriots: The Story of the Australia First Movement*, M.U.P., Melbourne, 1968.

Murray, Alec (introd. Harry Tatlock Miller), *Alec Murray's Album: Personalities of Australia*, Ure Smith, Sydney, 1948.

Nolan, Sidney, *The Paradise Gardens: Paintings, Drawings, Poems*, McAlpine, London, 1970.

O'Brien, Patrick, *The Saviours: An Intellectual History of the Left in Australia*, Drummond, Melbourne, 1976. See especially Ch. 2, 'Zhdanov in Australia'; also published in *Quadrant*, vol. XVIII, no. 5 (Sept.-Oct. 1974), pp. 37-55.

Palmer, Nettie, *Fourteen Years: Extracts from a Private Journal 1925-1939*, Meanjin Press, Melbourne, 1948.

Palmer, Vance, *The Legend of the Nineties*, M.U.P., Melbourne, 1954.

Philipp, Franz, *Arthur Boyd*, Thames and Hudson, London, 1967.

Phillips, A. A., *The Australian Tradition: Studies in a Colonial Culture*, Cheshire, Melbourne, 1958.

Plant, Margaret, *John Perceval*, Lansdowne, Melbourne, 1971.

Pringle, John Douglas, *Australian Painting Today*, Thames and Hudson, London, 1963.

Reed, John, *Australian Landscape Painting*, Longmans, Melbourne, 1965.

Rees, Lloyd, *The Small Treasures of a Lifetime: Some Early Memories of Australian Art*, Ure Smith, Sydney, 1969.

Reid, John, *Australian Artists at War*, vol. II, 1940-1970, Sun Books, Melbourne, 1977.

Serle, Geoffrey, *From Deserts the Prophets Come: The Creative Spirit in Australia 1768-1972*, Heinemann, Melbourne, 1974.

Serle, Percival, *Dictionary of Australian Biography*, 2 vols, Angus and Robertson, Sydney, 1949.

Shore, Arnold, *Forty Years Seek and Find*, Melbourne, 1957.

Smith, Bernard, *The Antipodean Manifesto: Essays in Art and History*, O.U.P., Melbourne, 1976.

—— *Australian Painting 1788-1970* (2nd edn), O.U.P., Melbourne, 1971 (first published 1962).

—— *Australian Painting Today*, University of Queensland Press, Brisbane, 1962.

—— *Catalogue of Australian Oil Paintings in the National Art Gallery of New South Wales, 1876-1952*, Sydney, 1953.

—— *Place, Taste and Tradition*, Ure Smith, Sydney, 1945.

Stephensen, P. R., *The Foundations of Culture in Australia: An Essay Towards National Self-Respect*, Miles, London (N.S.W.), 1936.

Tadgell, Christopher (introd. Laurie Thomas), *Arthur Boyd: Drawings 1934-70*, Secker and Warburg, London, 1974.

Thomas, D., Turnbull, C. and Young, E., *Antipodean Vision*, Cheshire, Melbourne, 1962.

Thomas, Daniel, 'Art', in McLeod, A. L. (ed.), *The Pattern of Australian Culture*, O.U.P., Melbourne, 1963.

—— *Outlines of Australian Art: The Joseph Brown Collection*, Macmillan, Melbourne, 1973.

—— *Sali Herman*, Georgian House, Melbourne, 1962.

Thomas, David, *Rupert Bunny*, Lansdowne, Melbourne, 1972.

Tregenza, John M., *Australian Little Magazines 1923-1954: Their Role in Forming and Reflecting Literary Trends*, Libraries Board of South Australia, Adelaide, 1964.

Turnbull, Clive, *Art Here: Buvelot to Nolan*, Hawthorn Press, Melbourne, 1947.

Turner, Ian, *The Australian Dream: A Collection of Anticipations about Australia from Captain Cook to the Present Day*, Sun Books, Melbourne, 1968.

—— 'My Long March', *Overland*, no. 59 (Spring 1974), pp. 23-40.

Uhl, Christopher, *Albert Tucker*, Lansdowne, Melbourne, 1969.

Walker, David, *Dream and Disillusion: A Search For Australian Cultural Identity*, A.N.U. Press, Canberra, 1976.

Ward, Russel, *The Australian Legend*, O.U.P., Melbourne, 1958.

Young, Elizabeth, *James Cant*, Brolga Books, Adelaide, 1970.

General

Ashton, Dore, *The New York School: A Cultural Reckoning*, Viking Press, New York, 1972.

Balakian, Anna, *Surrealism: The Road to the Absolute*, Allen and Unwin, London, 1972 (first published 1959).

Baudelaire, Charles, *Selected Writings on Art and Artists*, Penguin Books, Harmondsworth, 1972 (trans. and introd. by P. E. Charvet).

Bittner, Herbert (ed.), *George Grosz*, Arts Inc., New York, 1960.

Bradbury, M. and McFarlane, J. (eds), *Modernism*, Penguin, Harmondsworth, 1976.

Breton, André, *Manifestoes of Surrealism*, Ann Arbor, Michigan, 1972 (trans. by Richard Seaver and Helen R. Lane).

Bullock, Alan and Stallybrass, Oliver (eds), *The Fontana Dictionary of Modern Thought*, London, 1977.

Caute, David, *The Fellow Travellers: A Postscript to the Enlightenment*, Weidenfeld and Nicolson, London, 1973.

Clark, Kenneth, *The Other Half*, Murray, London, 1977.

Doerner, Max, *The Materials of the Artist: And Their Use in Painting* (rev. edn), Rupert Hart-Davis, London, 1969 (trans. by Eugen Neuhaus).

Egbert, Donald D., 'English Art Critics and Modern Social Radicalism', *The Journal of Aesthetics and Art Criticism*, vol. 26, no. 1, 1967-68, pp. 29-46.

—— *Social Radicalism and the Arts, Western Europe: A Cultural History from the French Revolution to 1968*, Alfred A. Knopf, New York, 1970.

Fawcett, Trevor and Phillpot, Clive (eds), *The Art Press: Two Centuries of Art Magazines*, The Art Book Company, London, 1976. Includes essays by Jane Beckett and Clive Phillpot on European magazines of the 1920s and 1930s.

Fishman, Solomon, *The Interpretation of Art: Essays on the Art Criticism of John Ruskin, Walter Pater, Clive Bell, Roger Fry and Herbert Read*, University of California Press, Berkeley and Los Angeles, 1963.

Fowlie, Wallace (trans., introd. and notes), *Rimbaud: Complete Works, Selected Letters*, University of Chicago Press, Chicago, 1966.

Fry, Roger, *Vision and Design*, Penguin Books, Harmondsworth, 1961 (first published 1920).

Gershman, Herbert S., *The Surrealist Revolution in France*, Ann Arbor, Michigan, 1974 (first published 1969).

Glaser, Hermann, *The Cultural Roots of National Socialism*, Croon Helm, London,

1978 (trans. with introd. and notes by Ernest A. Menze).

Goldwater, Robert, *Primitivism in Modern Art*, Random House, New York, 1967 (first published 1938).

Haftmann, Werner, *Paintings in the Twentieth Century* (2nd edn), 2 vols, Lund-Humphries, London, 1965 (first published 1961).

Hamilton, Alistair, *The Appeal of Fascism: A Study of Intellectuals and Fascism, 1919-1945*, Anthony Blond, London, 1971.

Hess, Hans, *George Grosz*, Studio Vista, London, 1974.

Hewison, Robert, *Under Siege: Literary Life in London 1939-45*, Weidenfeld and Nicolson, London, 1977.

Higgins, Andrew, 'The Development of the Theory of Socialist Realism in Russia, 1917-1932', *Studio International*, vol. 181, no. 932, April 1971, pp. 155-9.

Lawrence, D. H., *Kangaroo*, Penguin Books, Harmondsworth, 1950 (first published 1923).

Löwenfeld, Viktor, *The Nature of Creative Activity*, Kegan Paul, London, 1939 (trans. O. A. Oeser).

Nadeau, Maurice, *The History of Surrealism*, Penguin Books, Harmondsworth, 1973 (trans. by Richard Howard).

Newton, Eric, *Christopher Wood*, London, 1938.

Ray, P. C., 'Sir Herbert Read and English Surrealism', *Journal of Aesthetics and Art Criticism*, vol. 24, no. 3 (1966), pp. 401-13.

Read, Herbert, *Art and Society*, Schocken, New York, 1966 (first published 1936).

—— *Art Now*, Faber and Faber, London, 1936 (first published 1933).

—— (ed.) *Surrealism*, Faber and Faber, London, 1936.

Rosenberg, Harold, 'The Academy in Totalitaria', in Hess, Thomas B. and Ashberty, John, *Academic Art*, Macmillan, New York, 1971 (first published 1963).

—— *The Tradition of the New*, Thames and Hudson, London, 1962 (first published 1959).

Roskolenko, Harry, *When I Was Last on Cherry Street*, Stein and Day, New York, 1965.

Rothenstein, John, *An Introduction to English Painting* (5th edn), Cassell, London, 1965 (first published 1933).

—— *Modern English Painters*, 3 vols, London, 1962 (vol. 3 published in 1974).

Rubin, William S., *Dada and Surrealist Art*, Abrams, New York, n.d.

Sandler, Irving, *The Triumph of American Painting: A History of Abstract Expressionism*, Harper and Row, New York, 1970.

Selz, Peter, *German Expressionist Painting*, University of California Press, Berkeley and Los Angeles, 1974 (first published 1957).

Shapiro, Theda, *Painters and Politics, the European avant-garde and society 1900-1925*, Elsevier, New York, 1976.

Shattuck, Roger, *The Banquet Years: The Origins of the Avant-Garde in France, 1885 to World War I* (rev. edn), Random House, New York, 1968 (first published 1955).

Short, Robert S., 'The Politics of Surrealism, 1920-36', in Lacqueur, Walter and Mosse, George L. (eds), *The Left Wing Intellectuals Between the Wars 1919-1939*, Harper and Row, New York, 1966.

Solomon, Maynard, *Marxism and Art: Essays Classic and Contemporary*, Alfred A. Knopf, New York, 1973.

Stretton, Hugh, *The Political Sciences: General Principles of Selection in Social Science and History*, Basic Books, New York, 1969.

Thoene, Peter, *Modern German Art*, London, 1938. 'Thoene' was the pseudonym of Otto Bihalji-Merin.

Valkenier, Elizabeth, *Russian Realist Art: The State and Society: The Peredvizhniki and Their Tradition*, Ann Arbor, Michigan, 1977.

Wilenski, R. H., *Modern French Painters* (4th edn), Faber and Faber, London, 1963 (first published 1940).

—— *The Modern Movement in Art* (rev. edn), Faber and Faber, London, 1935 (first published 1927).

Williams, Raymond, *Culture and Society 1780-1950*, Penguin Books, Harmondsworth, 1963 (first published 1958).

—— *Keywords: A Vocabulary of Culture and Society*, Fontana, Glasgow, 1976.

Wollen, Peter, 'Art in Revolution: Russian Art in the Twenties', *Studio International*, vol. 181, no. 932, April 1971, pp. 149-54.

Woodcock, George, *Anarchism: A History of Libertarian Ideas and Movements*, Penguin Books, Harmondsworth, 1962.

—— *The Anarchist Reader*, Fontana, Glasgow, 1977.

Theses

Gerraty, Jan, 'Basil Burdett: Critic and Entrepreneur', B.A. thesis, Monash University, 1978.

Gilchrist, Maureen, 'The Art of Sidney Nolan: The First Decade 1937-47', B.A. thesis, Melbourne University, 1975.

Haese, Richard, 'Cultural Radicals in Australian Society 1937-1947', Ph.D. thesis, Monash University, 1979.

Catalogues

Australian Women Artists: One Hundred Years 1840-1940. Compiled by Janine Burke (Melbourne, 1975).

Balson, Crowley, Fizelle, Hinder (Art Gallery of N.S.W., 5-30 October 1966).

George Bell Retrospective Catalogue (University of Melbourne Gallery, March-April 1979).

Dorrit Black 1891-1951 (Art Gallery of N.S.W., 1976).

Grace Cossington Smith (Art Gallery of N.S.W., 1973).

Noel Counihan: Paintings, drawings, prints 1943-1973 (National Gallery of Victoria, 1973).

Grace Crowley (Art Gallery of N.S.W., 10 May to 8 June 1975).

William Dobell Retrospective: Painting from 1926 to 1964 (Art Gallery of N.S.W., 15 July to 30 August 1964).

Russell Drysdale Retrospective: Exhibition of Paintings from 1937 to 1960 (Art Gallery of N.S.W., 1960).

The Heroic Years of Australian Painting 1940-1965: The Herald Exhibition (Melbourne, 1977).

Hans Heysen Centenary Retrospective 1877-1977 (Adelaide, 1978).

Modern Australian Art: A Melbourne Collection of Paintings and Drawings (pub. no. 1 of the Museum of Modern Art of Australia, 30 September to 10 October 1958). Introduction by Barrie Reid.

Rebels and Precursors (National Gallery of Victoria, 1962).

Sidney Nolan Retrospective: Paintings from 1937 to 1967 (Art Gallery of N.S.W. and National Gallery of Victoria, 1967).

Nolan at Lanyon (Canberra, 1976). Introductory essay by Maureen Gilchrist, 'Sidney Nolan: The Lanyon Paintings'.

Outlines of Australian Printmaking (Ballarat Fine Arts Gallery, September to October 1976).

Homage to Peter Purves-Smith (Joseph Brown Gallery, Melbourne, 12-28 July 1976).

The Later Work of Arnold Shore (Powell Street Gallery, Melbourne, 13 April to 6 May 1977). Introduction by Patrick McCaughey.

Albert Tucker: Works on Paper (Tolarno Gallery, Melbourne, 1978).

Roland Wakelin Retrospective (Art Gallery of N.S.W., 8-30 April 1967).

Interviews

This list includes the names of interviewees who were quoted directly as well as many who helped provide invaluable background information.

Atyeo, Sam (Vence, 27 Feb. 1977)

Bellew, Peter (Saint Paul de Vence, 28 Feb. 1977)

Bergner, Yosl (Melbourne, 15 Aug. 1978)

Boyd, Arthur (Melbourne, 3 Dec. 1974)

Bryans, Lina (Melbourne, 10 Dec. 1975)

Bush, Charles (Melbourne, 21 Feb. 1975)

Buzacott, Nutter (Tweed Heads, 10 July 1974)

Cant, James and Dora (Adelaide, 10 July 1973; 14 Apr. 1974)

Counihan, Noel (Melbourne, 5 May 1975)

Crozier, Cecily (Melbourne, 11 Nov. 1974)

Cugley, Bob (Melbourne, 14 and 20 Nov. 1973)

Drysdale, Sir Russell (Gosford, 21 May 1975)

Dundas, Douglas (Sydney, 28 June 1974)

Flower, Cedric (Sydney, 7 July 1974)

Francis, Ivor (Adelaide, 13 July 1973; 13 Apr. 1974)

Frater, William (Melbourne, 6 Dec. 1973)

Gleeson, James (Sydney, 23 May 1975)

Good, Malcolm (Melbourne, 7 Nov. 1974)

Haefliger, Paul (Sydney, 18 Aug. 1975)

Harris, Max (Adelaide, 29 Jan. 1980)

de Hartog, Harry (Melbourne, 18 Sept. 1973)

Haughton James, Richard (Melbourne, 23 Jan. 1974)

Herbst, Professor Peter (Canberra, 7 Feb. 1975)

Herman, Sali (Sydney, 30 June 1974)

Hinder, Frank and Margel (Sydney, 5 July 1974)

Keon, Michael (Melbourne, 30 Sept. 1979)

Kershaw, Alister (Paris, 20 Jan. 1977)

Inson, Graeme (Sydney, 1 July 1974)

Lindsay, Sir Daryl (Melbourne, 9 Apr. 1974)

McClintock, Herbert (Sydney, 5 July 1974)

McCulloch, Alan (Melbourne, 2 May 1974)

Nibbi, Tristano (Rome, 23 Apr. 1980)

O'Connor, Ailsa (Melbourne, 21 July 1973; 8 Jan. 1975)

O'Connor, Vic (Sydney, 13 Jan. 1975)

Perceval, John (Melbourne, 18 Dec. 1975)

Plate, Carl (Sydney, 29 June 1974)

Reed, John (Melbourne, 6 Aug.; 13 Aug.; 10 Sept.; 22 Oct. 1973)

Rees, Lloyd (Sydney, 3 July 1974)

Roskolenko, Harry (Melbourne, 16 Jan. 1974)

Shaw, Rod (Sydney, 27 June 1974)

Sinclair, John (Melbourne, 3 Apr. 1974)

Smith, Professor Bernard (Sydney, 15 Jan. 1975)

Thake, Eric (Melbourne, 9 Sept. 1973)

Tucker, Albert (Melbourne, 1 Feb.; 7 Feb.; 14 Feb.; 7 Mar.; 31 June 1974)

Warm, Mary (Melbourne, 15 Jan. 1976)

Warren, Alan (Brisbane, 11 July 1974)

INDEX

1792
6
vasa n.e.
vasa veil